The Professionals' Approach

Kenneth Kobre

Picture research by Bonnie Gangelhoff

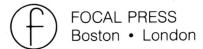

FOCAL PRESS
Boston • London

Focal Press is an imprint of Butterworth Publishers

Cover design and interior design: Katy Homans
Cover photograph: George Rizer, Courtesy *Boston Globe*

Photo credits, title page: *Left page:* top left, Kenneth Kobre, University of Houston; top right, Jim Atherton, UPI; bottom left, Huynh Cong Ut, Wide World Photos; bottom right, Robin Hood, *Chattanooga News-Free Press*. *Right page:* top left, Greg Schneider, *San Bernardino Sun Telegram*; middle left, John T. Filo, Wide World Photos; bottom left, Ken Kobre, University of Houston; right, George Rizer, *Boston Globe*.

Library of Congress Cataloging in Publication Data

Kobre, Kenneth 1946–
 Photojournalism: the professionals' approach.

 Bibliography: p.
 Includes index.
 1. Photography, Journalistic. I. Title.
TR820.K75 1985 070.4′9 85–7686
ISBN 0–240–51774–1 (pbk.)

Butterworth Publishers
80 Montvale Avenue
Stoneham, MA 02180

10 9 8 7 6 5 4 3 2

Printed in the United States of America

Photojournalism:
The Professionals' Approach

Photojournalism:

CONTENTS

1

From Flash Powder to Electronic Flash: The Development of Photojournalism ■ 2

Chapter 1 written with Julie Levinson

2

Covering an Assignment ■ 32

7
Capturing the Action in Sports ■ 140

8
Special Equipment and Techniques of the Photojournalist ■ 174

9
The Art of Picture Editing ■ 202

10
Cropping and Sizing for Impact—Captioning for Meaning ■ 224

PREFACE

Today's newspapers and magazines publish more pictures than ever before. This explosion in picture usage is partly because of the growing number of new periodicals. Along with the rebirth of *Life* magazine, many special interest magazines are hitting the newsstands. Home-delivered suburban newspapers also are multiplying; because of their use of offset printing, these papers are running better and bigger photographs. The result of this mushrooming growth in printed picture display means more opportunities for employment of free-lance and staff photojournalists, photographers who can tell a story with their cameras.

Photojournalists report with cameras; their job is to search out the news, recording it in a visual form. As a photojournalist, with your scanner radio tuned to the emergency frequencies, you must be ready to head for a three-car pile-up or a shoot-out in the fifth ward.

But photojournalists do not limit their photo coverage to tragedies. You might start your morning off looking for a way to pictorialize a government story about rising taxes. By mid-afternoon, you might change gears sufficiently to find a funny feature about a bird that smokes. You must be as adept at shooting the fast action at a football game as you are at handling the social lights at the garden club awards banquet. You might have to find time, between assignments, to work out a picture story on a crippled child learning to walk for the first time. Then, by the end of the day, you must develop and print your pictures before the 10 P.M. deadline.

Today's news photographers must combine the skills of an investigative reporter and the determination of a beat reporter with the flair of a feature writer. The resulting pictures do not merely supplement the news stories of the day as tangential illustrations or serve as ornaments to break up the gray type on the page. Today's photos represent the best means available to report human events concisely and effectively.

ACKNOWLEDGMENTS

I would like to thank my parents, Dr. and Mrs. Sidney Kobre. Without their advice and guidance I would never have written this book. My father, who has been a reporter, editor, and professor of journalism for many years, helped to give the book a clear journalistic focus. My mother, who writes fiction, suggested many ways to improve the prose style of the manuscript.

Many people have read the manuscript and offered cogent suggestions; I greatly appreciate their time and effort: Don Black, photo editor of the *San Bernardino Sun-Telegram*; Carolyn Dow Dykhouse, graduate student at Michigan State University; John Faber, historian for the National Press Photographers Association (NPPA); Jim Gordon, editor of *Press Photographer*, the monthly magazine of NPPA; Don Holt, associate professor of photojournalism at Kansas State University; Frank Hoy, associate professor of photojournalism at Arizona State University; Robert Kerns, associate professor of photojournalism at University of South Florida; Thomas Richards, Newhouse School of Public Communications at Syracuse University; Ted Stanton, editor of the *Idahonian*; Joe Swan, professor of photojournalism at San Jose State University; Bela Ugrin, chief photographer of the *Houston Post*; Kirby Upjohn, assistant professor of communications at Boston University; J.B. Woodson, Language Arts Department, West Valley College, Saratoga, California.

Photographers from across the country contributed photos to this book. The visual variety in the text would be absent without their generosity. Many pictures also came from present and former students, whose constant interest in the project and contribution of photos have proved invaluable. Sandy Shriver, Phyllis Graber-Jensen, and Michael Maher helped make some of the enlargements for the book.

Ken Harwood, Dean of the School of Communication, and Campbell Titchener, executive officer of the Department of Journalism at the University of Houston, provided the necessary release time to finish the manuscript. Typing of the manuscript extended over several years, from the original transcribed interviews to the final draft. Typing help came from: Renée DeKona, Joy Lucos, Virginia Marciano, Charlotte Rogers, Karyl Scott, Annita Suarez, and Etta Walsh. Special thanks to Christine Womack and Margi Fleishman for their many hours of work. Mary Pettibone, Boston University reference librarian, helped check the factual information in the text.

My editor, Barbara London, has taken the time and patience to smooth out my writing when the technical sections became less than clear. My production editor at Curtin & London, Nancy Benjamin, has survived many changes in the layout to produce a strong visual book. The book owes its clean design to Katy Homans. Dennis Curtin's enthusiasm and encouragement helped make this book possible.

PHOTOGRAPHERS AND EDITORS INTERVIEWED

Eddie Adams Associated Press, Pulitzer Prize winner, Photographer of the Year
Jim Atherton *Washington Post*, Political photographer
Bruce Bauman *San Jose Mercury*, Photo editor
Hal Buell Associated Press, Assistant General Manager for News Pictures
Timothy Cohane Emeritus Professor of Journalism, Boston University
Gordon Converse *Christian Science Monitor*, Chief photographer
E. Joseph Deering *Houston Chronicle*, Photographer
John Dominis *Sports Illustrated*, Photo editor
Ted Dully *Boston Globe*, Feature photographer
John Durniak Formerly with *Time* magazine, Photo editor
Harold Edgerton Massachusetts Institute of Technology, Developer of the electronic strobe
John Faber National Press Photographers Association, Historian
Ed Farber Formerly with the *Milwaukee Journal*, perfected the electronic strobe
Marty Forscher Professional Camera Repair Service, President
Ron Galella Paparazzo
Arthur Grace Sygma, Free-lancer
J. Walter Green Associated Press, Bureau chief
Russ Hamilton Cornell University, Public relations photographer
C. Thomas Hardin *Courier-Journal and Louisville Times*, Director of photography
Frank Hoy Associate Professor of Photojournalism, Arizona State University
Bob Kerns Associate Professor of Photojournalism, University of South Florida
David Krathwohl *Boston Phoenix*, Photographer
Chip Maury Associated Press, Photographer
Frank O'Brien *Boston Globe*, Sports photographer
Michael O'Brien *Miami News*, Photographer
George Reilly United Press International, Photographer
George Rizer *Boston Globe*, Spot news photographer
Don Robinson United Press International, Photographer
Frank J. Scherschel Formerly with the *Milwaukee Journal* and *Life* magazine
Pam Schuyler Author of *Through the Hoop: A Season with the Celtics*, Free-lancer
Rich Shulman *Everett* (Washington) *Herald*, Photo editor
Tom Smith *National Geographic*, Illustrations editor
W. Eugene Smith Photographer
George Tames *New York Times*, Washington Bureau photographer
Richard E. Thompson NASA, Chief of Photographic Technology Division
George Tiedemann Free-lancer, Sports specialist
Harry Trask Formerly with the *Boston Herald*, Pulitzer Prize winner
Bela Ugrin *Houston Post*, Chief photographer
Robert Wahls *New York Daily News*, Photo editor
Ulrike Welsch *Boston Globe*, Feature photographer
Dave Wurzel United Press International, Bureau chief

Chapter 1 by Ken Kobre and Julie Levinson

FROM FLASH POWDER TO ELECTRONIC FLASH: The Development of Photojournalism

COVERING A FIRE: 1877–1980

Photos into Drawings

On a balmy April day in 1877 the staff of the *New York Daily Graphic*, the first illustrated daily newspaper in the United States, conducts business as usual. Reporters labor to complete their copy in time for the morning deadline. Artists put the finishing touches on their drawings, which will comprise three and a half of the tabloid's eight pages.

In a makeshift darkroom, where a janitor stores mops and brooms, a lone photographer places 5″ x 7″ precoated, glass, dry plates into light-tight holders.

In 1877, the New York Daily Graphic, *America's first illustrated daily newspaper, devoted an entire front page to five fire pictures. The Graphic's hand-drawn sketches were often based on photographs taken at the news scene.*
(New York Public Library)

The photographer is so engrossed in the delicate operation that he barely hears the sudden commotion in the newsroom. The cause of this commotion is a passing fire engine. For the staff of the *Daily Graphic*, whose every sense is attuned to such signals, the fire engine's clanging bell tolls news.

Several reporters drop what they are doing, grab pencil and paper, and dash out to cover the late-breaking story. Someone remembers to inform the photographer about the fire alarm; he, too, puts aside his work and carefully balances his cumbersome view camera and tripod on one arm and a case, containing twelve previously prepared glass plates, in the other arm. The *Graphic* cameraman sets off with his unwieldy load.

By the time he reaches the site of the blaze, it is raging full force. He sets up his tripod and camera as quickly as possible, points his lens at the action and takes his first exposure. Normally, he would take only one exposure, or perhaps two, of a given event. Because this is such a huge fire, however, he decides to expose several of his glass plates. He has only one lens, so, if he is to get different perspectives on the action, he must change his position, pick up his bulky equipment, lug it to the new spot and take the time to set up. He then covers his head and the back of the camera with a black focusing cloth. Next he opens, focuses, closes and sets the lens. Following this he loads the plate holder into the rear of the camera body and removes the dark-slide. Finally he takes the picture.

Before he can make the next photo he must replace the dark-slide and put back the holder into his case carefully. If he accidentally knocks the holder too hard, the glass plates will shatter. Unfortunately, the crowd continually jostles him as he works.

He attracts much attention because a news photographer is still a curiosity. But the *Graphic* photographer doesn't mind; he is particularly excited about the challenge posed by this event. Usually his assignments limit him to photographing portraits of famous people or carefully posed tableaux. Because of the technical limitations of his slow film (effective index E.I. 24), he can photograph only under optimum conditions, with bright light and minimal subject movement. On this day he is able to get some action shots by carefully panning his camera with the movement of a late arriving horse-drawn fire engine.

After several hours, the *Daily Graphic* photographer finishes making his twelve exposures, and by the time he packs his case, camera, and tripod, the firemen finally have the blaze under control. But as the photographer heads back to the newspaper office, weary from his physical exertion, his own ordeal has just begun. Now he must develop his pictures in chemicals he mixes from a formula that he got out of a copy of the *Philadelphia Photographer*, one of the first photo magazines.

Enlargers are not used commonly. The negative, a 5″ x 7″, is of sufficient size for reproduction when it is just contacted on photographic paper. More than an hour after he returned from the fire, the photographer had his first picture.

After all that work, however, the photo can't be printed in the newspaper.

The photographer now hands his pictures over to an artist, who draws replicas of them. Unfortunately, the artist often changes details from the original if he thinks the new variations improve the picture. The artist, in turn, gives his drawings to an engraver, who reproduces them onto a zinc plate. The plate is then printed on a Hoe rotary press.

As may be imagined, a good deal of time elapses between the hour of the fire and the moment when these line-drawn renderings of the photographs appear in the newspaper. Yet the drawings receive front-page play.

In this typical darkroom of the 1880s, negatives were contact-printed in the frames mounted to the wall on either side of the door.

From Flash Powder to Electronic Flash: The Development of Photojournalism

Today's Photographer Captures the Human Side

One hundred years later, the great-grandson of the *Daily Graphic* photographer carries on in the family profession, but the profession has come a long way since the days of his ancestor.

As a photojournalist for a large metropolitan newspaper, our photographer's great-grandson keeps abreast of the news by listening to the emergency channels of a multiple-scanner radio. On another April day, this one in 1980, this photographer is tuned into the fire department channel while driving to work when he hears news of a two-alarm fire which has broken out in a residential neighborhood of the city. Immediately, the photographer calls his office on his two-way radio to say that he is on his way to the fire.

The photographer carries with him an accessory bag, which contains three lightweight, preloaded camera bodies, lenses ranging from 24mm to 300mm, and fifteen rolls of film, enough for 540 pictures—both black-and-white and color. Both types of film are fast, rated at ASA 400. His cameras have automatic exposure meters, so he is free to move quickly from dark to light areas without adjusting the f-stop ring. The motorized cameras allow him to take a rapid series of pictures, one after another. With a press of the button, the camera's aperture closes, the shutter opens and closes, the film advances and the aperture reopens, ready for the next shot. With his array of lenses, the photographer can stand in one place and shoot first the flaming building and then from the same position catch the expression on the face of a person climbing from a top-story window. Because of the versatility and portability of his equipment, the photographer can blend into the crowd unobtrusively and can capture different angles with an ease of movement that would have been inconceivable to his great-grandfather. Today, rather than being at the mercy of his equipment, the photographer is master of it, and he uses its technological capabilities to tell his story with accuracy and sensitivity.

Today's photographer focuses on the human side of the story. He photographs the onlooker's reactions to the fire, the physical and emotional strain of the firefighter's job, and the drama of a child being rescued. He presents both an overview of the building as well as those human vignettes that make a story memorable.

When the photographer returns to his office, he takes his rolls of film and feeds them into a Kodak Versamat Film Processor, which develops, fixes, washes, and dries the film automatically in 5½ minutes. He chooses a few shots and then enlarges and prints them on resin-coated photographic paper. In little more than 10 minutes from the time he walked into the darkroom, he delivers a finished print to the managing editor's desk.

The photo then goes to the engraver, who reshoots the picture through a halftone screen. Finally, the photograph is put onto a plate and reproduced on a high-speed offset press, printing copies of the newspaper at a rate of more than 40,000 an hour. The final newspaper image is a true facsimile of the original photograph and the original scene. Even though the fire occurred at 9 A.M., the picture can still appear in the afternoon edition of that same day's newspaper. If the event is newsworthy enough, the Associated Press, a news-gathering and distributing service, might buy the photo and send it all over the world via the AP wire service.

Evolution of the Camera Reporter

How did the photographer of 1877 evolve into the photojournalist—the reporter with a camera—of 1977? Two major factors contributed to this development. First, the technical innovations: the invention of roll film, smaller cameras, and faster lenses, and the introduction of portable light sources, enabled the photographer to shoot pictures more easily and get better results. The invention of the halftone process for reproducing photos and the improvement of printing

presses led to better reproduction of images. Meanwhile, with expansion of the wire services and the development of picture-transmission devices, photos could be sent across the nation and the world almost instantaneously.

The technological leaps made in photography in the past hundred years enable today's resourceful photographer to reach virtually any action anywhere and bring home a picture to the newspaper- and magazine-reading public. Because of these scientific and engineering discoveries, photographers can capture events previously impossible to shoot on film: night pictures, fast action, and successive motion now can all be recorded with the camera.

But technological strides are only half the answer to this evolutionary question. Photographers broadened the scope of news pictures by introducing to the newspaper feature and sports pictures. Photographers sought candid photos that revealed natural moments, rather than the posed, frozen images typical of early photo reportage. Photographers today do more than just record the news. They have become visual interpreters of the scene using their camera and lenses, sensitivity to light, and keen observational skills to bring to the reader a feeling of what the event was really like.

The ingenuity and inventiveness of the individual photographers in taking the photos also laid the foundations of modern photojournalism. From the days of the *Daily Graphic* to the present, photographers first have to figure out a way to get to the news event no matter where it is located, skyscraper or coal mine. Then they often have to work around obstacles, both physical and human. Once photographers have the picture, they face the pressure of the deadline. They have to get the picture to the darkroom and develop it in time for the next edition. The daring and cleverness of the early photojournalists represent the kind of personality traits that successful photographers have exhibited throughout the history of photojournalism.

Thus, technical advances and the imagination and resourcefulness of the photographer have gone hand in hand. The two have had complementary developments, each contributing to the gradual evolution of reportorial photography.

HALFTONE SCREEN REPRODUCES PHOTOS

Screen's First Use—1880

In 1877, our *Daily Graphic* photographer had little way of knowing that he stood on the threshold of a new age in photography. The next twenty years would see several rapid technological advances that would revolutionize the field of pictorial journalism, including light hand-held cameras, faster lenses, improved shutter mechanisms, and roll films. But perhaps the most momentous technological occurrence in the history of photojournalism was the development of the halftone printing process.

Before the introduction of the halftone process, there was no practical way to transfer the photograph directly onto the printed page. An ordinary press could print only blacks and whites—full tones—and was incapable of rendering the intermediate shades of gray, the halftones. As such, newspaper illustrations, based on artist's original sketches or photographs, consisted of black-and-white line drawings, hand-carved on wood blocks or engraved on zinc plates.

After years of experimentation, a method was found that could reproduce the full tonal range of photographic images. Still employed today, this process involves the use of a screen with an ordered dot pattern. This screen is held rigidly against a sensitized film in the engraver's camera. The engraver's camera copies the original photo through the screen, which breaks up the continuous tones of the photo into a series of tiny dots of varying sizes. The darkest areas of

Enlargement of halftone dot pattern, showing an eye.

The first photograph reproduced on a printing press. On March 4, 1880, this photograph of Shantytown dwellings appeared in the New York Daily Graphic. *(Henry J. Newton,* New York Daily Graphic, courtesy of the New York Historical Society, New York City)*

the original photo translate into a series of large dots. As the tones in the picture change from black to gradations of gray and white, the dots get progressively smaller. The engraver develops the film and contact prints it on a metal plate. The pattern of dots is chemically transferred onto this printing plate. On the press, the dots transfer the ink onto the paper; where they are largest and closest together, the image is darkest, and where they are smallest and farthest apart, the image is lightest. Thus, the resulting printed image duplicates the shadings of the original photograph. How much pictorial detail can be reproduced depends upon the fineness of the screen and the quality of the paper. By holding a magnifying glass up to any newspaper picture, you can easily see the tiny dot pattern of the halftone screen.

The *Daily Graphic* published the first halftone on March 4, 1880: a picture of Shantytown, a squatter's camp in New York City. Stephen H. Horgan, the photographer in charge of the *Graphic's* engraving equipment, produced the halftone. Although Horgan had been perfecting this process for several years, his successful experiment in 1880 did not immediately affect the look of the daily newspaper. His halftone invention, however, did encourage further experimentation.

Opposition to Photos

In 1893, four years after the demise of the *Daily Graphic,* Horgan was working as art editor for the *New York Herald* when he again recommended the use of halftones to James Gordon Bennett, the owner of the paper. After a brief consultation with his pressmen, Bennett pronounced the idea implausible.

Similarly, Joseph Pulitzer, who had been publisher of the *New York World* since 1883, also initially expressed reluctance to print halftones. In fact, Pulitzer feared that widespread use of any pictures, including line drawings, would lower the paper's dignity, so he tried to cut down on the extensive use of woodcuts, which had already made his paper famous. When circulation fell as a result, Pulitzer reconsidered his decision and reinstated the drawings.

As Pulitzer realized the paper-selling potential of such illustrations, he began to increase their size from the original one-column to four- and five-column spreads. When the halftone was finally perfected, the *World* was one of the first newspapers to make liberal use of the new process. The daily's circulation rose rapidly. Other publishers and editors soon jumped on the pictorial bandwagon. One such newsman, Melville Stone, investigated the potential of newspaper illustrations for the *Chicago Daily News.* He ultimately concluded, "Newspaper pictures are just a temporary fad, but we're going to get the benefit of the fad while it lasts."

Today we know that newspaper pictures were neither temporary nor faddish, but in the closing years of the nineteenth century, the halftone continued to struggle for legitimacy. By the late 1890s, the process had yet to achieve daily use, although the *New York Times* did print halftones in its illustrated Sunday supplement begun in 1896. Skeptical publishers still feared that their readers would lament the substitution of mechanically produced photographs for the artistry of hand-drawn pictures; also, artists and engravers were well-established members of the newspaper staff. Thus, long after the halftone was perfected, carefully drawn copies of photos continued to appear in many papers.

Gradually, however, papers adopted the halftone process. By 1910, hand engraving was becoming obsolete and the halftone, in turn, became a front-page staple.

THE MAINE BLEW UP AND HARE BLEW IN

While these technological strides were taking place in the latter part of the nineteenth century, several photographers were setting photojournalistic precedents. Jimmy Hare, one of the most colorful of the pioneer photojournalists, wrote the handbook for future photographer-reporters. During his career, Hare covered nearly every major world event, from the wreckage of the U.S. battleship Maine in Havana harbor during the Spanish-American War in 1898 to the closing days of World War I in Europe. His ingenuity and his no-holds-barred attitude when it came to getting the picture set a standard for the new profession of photojournalism.

London-born Hare, whose father crafted hand-made cameras, came to the United States in 1889. One magazine, the *Illustrated American*, committed itself to using halftone photographs and from 1896 to 1898, Hare worked as a freelancer, supplying the magazine with photos ranging from presidential inaugurations to sporting events. A month after he left the *Illustrated American*, the battleship Maine exploded, thus signaling the start of the Spanish-American conflict. The ever enterprising photographer promptly presented himself to the editors of *Collier's Weekly*, and offered to take pictures of the wreckage.

Twenty years after the Maine episode, then-editor Robert J. Collier was to recall, "The Maine blew up and Jimmy blew in! Both were major explosions!" Jimmy continued "blowing in" to important world events for the next several decades. So successful were his pictures of the Maine and of Cuba, where American soldiers fought the Spanish, that the publisher named Hare special photographer for *Collier's*, thus beginning a long and productive association.

Whether trekking over Cuban countryside, touring battlefields with author Stephen Crane, or following Teddy Roosevelt's Rough Riders, Hare and his camera remained intrepid and resourceful. Hare made use of the new folding cameras (with lenses as fast as f/6.8) and of roll film (with twelve exposures per roll). His lightweight equipment gave him more mobility than his competition, who were shooting with awkward 5″ x 7″ Graflexes, the popular news-cameras of the day.

Regardless of the reduced weight of his folding camera, Hare still had to get to the middle of the action to take a picture. In one battle during the Spanish-

Jimmy Hare, with his two folding cameras carried in their leather cases, covered the globe for Collier's Weekly. He photographed everything from the wreckage of the U.S. battleship Maine *in 1898 to the closing days of World War I in Europe in 1918. (Jimmy Hare Collection, Humanities Research Center, the University of Texas at Austin)*

American conflict, a soldier spotted Hare snapping away as wounded bodies dropped all around him. "You must be a congenital damn fool to be up here! I wouldn't be unless I had to!" the soldier shouted. Hare's evenhanded reply: "Neither would I, but you can't get *real* pictures unless you take some risks."

In addition to the Spanish-American War, Hare's photographic escapades brought him to the combat lines of the Russo-Japanese War, the Mexican Revolution, the First Balkan War, and the First World War. Hare described these experiences as "one-sided adventures in which it was always my privilege to be shot at but never to shoot." But shoot he did—with his camera, that is—and his pictures contributed greatly to *Collier's* rapidly rising circulation and national prominence.

Hare Covers First Flight

Not all of Hare's exploits took place on the battlefield, however. The story of how Hare managed to record on film the experiments of the Wright brothers in 1908 is indicative of his tenacity and his skill. The Wright's first successful flight had taken place in 1903 but, five years later, the public remained unconvinced that men had actually flown. Rumors abounded but no one had documented proof of any flight. The brothers refused to allow reporters to witness their experiments at Kitty Hawk. Hare was determined to check out the rumor for *Collier's*, however, and along with four reporters from various newspapers, he secretly went to the Wright's testing area. The five intrepid men spent two days hiking over the sands of Kitty Hawk, North Carolina. Approaching the site of the rumored flights, the newsmen took cover in a clump of bushes and anxiously waited for something to happen. Covered with mosquito bites and tired of lugging his camera, Hare was tempted to dismiss the rumors as false and head back home. But suddenly an engine noise was heard, and, as the reporters watched in disbelief, an odd-looking machine glided across the sand and gradually rose into the air. Hare ran out of the bushes and managed to snap two photographs of the airborne machine. The party of reporters then sneaked back to their base and prepared to reveal their booty to the world. Because Hare was far away from the plane, the image in his photo was small and indistinct. But *Collier's* was proud to publish the picture in its May 30, 1908, issue. The photo proved, at last, that man, indeed, could fly. Hare had the distinction of taking the first news photograph of a plane in flight.

Hare began chronicling his world during photojournalism's infancy. When *Collier's* first published his photos, editors considered pictures mere embellishments of the text. But through his dogged efforts to capture, with his camera, a sense of immediacy and excitement, Hare served as a catalyst in the growth of the photographer into a full-fledged reporter-with-a-camera.

WOMEN ENTER THE FIELD

Since 1900, female photojournalists have made their mark in the world of the newsroom. Frances Benjamin Johnston, an indomitably spirited woman, managed to transcend the constraints usually imposed on Victorian ladies. Johnston documented early educational methods in black, white, and Indian schools. She shot a series of photographs on the activities in the White House and on the visits of foreign dignitaries. Then, Johnston sold her pictures to the newly formed Bain News Service, and became its photo representative in Washington. Bain suggested that she photograph Admiral George Dewey aboard his battleship after his successful takeover of the Philippines. With great ingenuity she made her way to Italy, where Dewey's ship first docked, and covered the story. She managed to endear herself to the crew, and when it came time to fill out an enlistment

Frances Benjamin Johnston,
an early photojournalist
around 1900, represented
the Bain News Service in
Washington, D.C.
(Library of Congress)

record, she earned 5 out of 5 possible points for everything from seamanship to marksmanship, but only a 4.9 for sobriety.

Jessie Tarbox Beals was another pioneer in the field of photojournalism. She started out as a school teacher but soon discovered the lure of photography. In 1902 the *Buffalo Inquirer and Courier* hired her as a press photographer. During her two years with them, and later in St. Louis and New York, she exhibited an important skill of the photojournalist—the "ability to hustle," as she once put it. Before her career ended, Beals sneaked photographs through a transom at a murder trial, rode the gondola of a balloon above the St. Louis World's Fair for a photo, and photographed Mark Twain.

THE CAMERA AS A REFORMIST'S TOOL

Social documentary photographers, notably Jacob Riis and Lewis Hine, demonstrated that the camera could provide not only a record of events but could serve as a potent tool for social change. Hine once summarized his goals as a concerned photographer: "There were two things I wanted to do. I wanted to show the things that had to be corrected. I wanted to show the things that had to be appreciated." As America moved into the new century, crusading photographers chose to concentrate on the former aim, the social objective. Riis and Hine were among the first to press the camera into service as an agent for social awareness.

Their photographic pleas for reform placed them in the ranks of such social muckrakers as Upton Sinclair, Lincoln Steffens, and Ida Tarbell. Together with these writer/reformers, the camera journalists probed the underside of city life, exposing the unimaginable, and bringing out into the open what had previously been shielded from view. The tradition Riis and Hine helped to establish carried through to the 1930s with the photographers of the Farm Security Administration who recorded, with their cameras, the faces of Depression-ridden America.

Riis Exposes Slum Conditions

Neither Riis nor Hine, in fact, began as a photographer. The Danish-born Riis started in the 1870s as a carpenter and then got a job as a reporter for the *New York Sun*. He wrote first-hand accounts of the indignities and iniquities of immigrant life. When he was accused of exaggerating with his written descriptions of life in the city slum areas, he turned to photographs as a means of documenting the human suffering he saw.

For Riis, the photograph had only one purpose: to aid in the implementation of social reform. Pictures were weapons of persuasion that surpassed the power of words and the absolute veracity of the photographic image made it an indispensable tool. As Riis stated, "The power of fact is the mightiest lever of this or any other day."

But Riis was up against many obstacles as a photographer. The crowded tenements that he wished to capture on film were shrouded in darkness and shadows. To show the perpetual nighttime existence in the slums, Riis pioneered the use of German *Blitzlichtpulver*—flashlight powder—which, although dangerous and uncontrollable, did sufficiently illuminate the scene. Lugging a 4″ × 5″ wooden box camera, tripod, glass plate holders, and a flash pan, Riis would venture into the New York slums with evangelical zeal. With a blinding flash and a torrent of smoke, he got his pictures. His recorded scenes of immigrant poverty shocked and goaded the public into action for reform.

With flash powder lighting the way, Jacob Riis exposed New York's slum conditions endured by recent immigrants. This man slept in a cellar for four years.
(Jacob A. Riis Collection, Museum Of The City Of New York)

The Riis pictures are remarkably poignant glimpses of ghetto life. Grim-faced families stare at the camera with empty eyes. Shabbily clothed children sleep amid the garbage of a tenement stoop. A grown man stands in the middle of the street and begs for someone to buy one of his pencils. An immigrant sits on his bed of straw. In a coal bin, a newly arrived American citizen prepares for the Sabbath.

Unfortunately, when Riis was photographing, the halftone had yet to achieve widespread use. As such, his actual pictures were not directly reproduced in printed sources and so were seen by only limited numbers of people, such as those attending his lantern-slide shows. At these talks, he used his pictures to buttress his plea for attention and reform. When his first book, *How the Other Half Lives*, was published in 1890, it consisted of seventeen halftones and nineteen hand drawings modeled on his photographs. The halftones were technically poor—somewhat fuzzy and indistinct—but the pictures exerted a powerful influence that drew attention to slum conditions nonetheless, and they remain moving documents of human suffering.

Hine's Photos Help Bring in Child Labor Laws

Lewis Hine began as an educator and, like Riis, turned to photography as a means of exposing "the things that had to be corrected." In turn-of-the-century urban America, a great many conditions begged to be noticed and changed. The influx of immigrants into the cities and the simultaneous growth of industrialism were important characteristics of the new century. With the reformer's commitment, Hine set out to catalogue how people survived in this new way of life.

In 1908, the magazine *Charities and the Commons* published a series of his pictures of immigrant life. The series included some of Hine's most famous

Lewis Hine took pictures with his auto Graflex view camera for the National Child Labor Committee. He tried to show the harsh conditions that young children toiled under. This five-year-old child who picked cotton in the fields of Oklahoma, "ain't old enough to go to school much but he can pick his 20 lbs. a day." (Lewis Hine, The International Museum of Photography at George Eastman House)

Lewis Hine photographed the soot-blackened faces of children who worked in the coal mines. In part because of Hine's photos, Congress passed child labor laws. (Lewis Hine, Collection Library of Congress)

pictures: portraits of newly arrived immigrants at Ellis Island. The power and eloquence of these pictures attracted much attention. With the further refinement of the halftone, Hine, unlike Riis before him, published his work in books and magazines and gained a good deal of public exposure for his social issues.

That same year, Hine began to work as an investigator and reporter for the National Child Labor Committee. His work took him everywhere, from St. Louis slums to California canneries. To get past the doors of the offending factories and mines, Hine posed as every type of worker, from a fire inspector to a bible salesman. One time he packed his camera in a lunch pail, filed with the workers into a clothing factory, and surreptitiously snapped pictures of the sweatshop conditions. Hine juxtaposed the diminutive children against the huge machines. The weary stares of young knitting mill operators and seamstresses spoke more eloquently than any words. The impact of these photographs along with others he took, such as the soot-blackened faces of child coal-miners, helped the Child Labor Committee to get the new Child Labor Laws passed by Congress.

VISUALS FOR THE MASSES

Immigrants Understand Pictures

The immigrants Hine and Riis photographed couldn't read English very well, but they could understand pictures. At a time when the country was teeming with non–English speaking immigrants, photographs became a universal language and along with movies, a visual handle on the new world. Also, because of the new industrialism, people had more leisure time to spend reading news-

papers and magazines. With the wiring of the city for electricity, families could study published pictures long after dark.

National Geographic Starts

In 1903, the *National Geographic* magazine ran its first halftone—a Philippine woman at work in the rice fields. The public soon demanded more such pictures, and the *Geographic* photographers began travelling all over the world. The *Geographic* was a members-only, nonprofit corporation and its magazine could not be bought on the newsstands. As the readership responded more enthusiastically to its beautiful photographs, the *Geographic* developed the format for which it is still famous today: big pictures of far away places and cultures, with short explanatory copy.

Rotogravure and Picture Page Appear

In 1914 the *New York Times* began publishing the first Sunday rotogravure section, and several other newspapers soon followed. That same year the *Times* also started the *Mid Week Pictorial* to absorb the rash of war pictures pouring in from Europe. Presses of the period were technically incapable of interspersing pictures with print and achieving good halftone reproduction throughout the paper. Therefore, almost all the photos were grouped together on one single page. Printers achieved this improved reproduction by putting a specially designed ink blanket on the press cylinder which carried the halftone engravings. Thus a Page One story would have its corresponding picture printed inside on this special "Picture Page." Today many dailies and weeklies still devote one inside page to a roundup of news and feature photographs.

The Tabloid Sells Thrills at 3 Cents a Copy

In the 1910s and 1920s, another journalistic phenomenon caught the public's fancy: the tabloid, a half-the-standard-size newspaper which the commuter could easily read on the trolley or subway. The tabloid was designed for the less-educated masses and newly arrived immigrants.

The first twentieth-century tabloid in the U.S. was the *New York Illustrated Daily News*, launched in 1919. Circulation of the heavily illustrated *Daily News* soared rapidly, and it became one of the most remarkable success stories in journalism. The name of the paper was changed to *The News, N.Y.'s Picture Newspaper* and survives to this day with the largest circulation of any daily newspaper in the U.S.

In its early days the *News*'s stock and trade was titillation of the public with crime and sex scandals—vicarious thrills for only 3 cents a copy. One of the most famous stories illustrating the lengths the *Daily News* would go to get a provocative picture involved the electrocution of Ruth Snyder in January 1928. In what was dubbed "the crime of the decade," a jury found Snyder, with the aid of her lover, guilty of murdering her wealthy husband. The *Daily News* editor felt the public was entitled to see Snyder's execution, but photographers were barred from the scene of the electric chair. The editor devised a plan to sneak a cameraman into the room. Thomas Howard, a news photographer from the *Chicago Tribune*, sister paper of the *Daily News*, was brought in for the occasion. He strapped to his ankle a prefocused miniature glass-plate camera. The camera had a long cable release running up Howard's leg into his pants pocket. Howard aimed his camera simply by pointing his shoe and hiking his trouser leg. So ingenious was this contraption that, when the time came, Howard was able to expose the plate three times—one for each shock administered to the body of Ruth Snyder. The following day, Friday the 13th, the picture ran full page with a single-word headline: "DEAD!"

Average net paid circulation
of THE NEWS, Dec., 1927:

Sunday, 1,357,556
Daily, 1,193,297

Vol. 9. No. 173 56 Pages

DAILY ☐ NEWS

EXTRA EDITION

NEW YORK'S PICTURE NEWSPAPER

New York, Friday, January 13, 1928

2 Cents IN CITY LIMITS 3 CENTS Elsewhere

DEAD!

—— Story on page 3

(Copyright: 1928; by Pacific and Atlantic photos)

RUTH SNYDER'S DEATH PICTURED!—This is perhaps the most remarkable exclusive picture in the history of criminology. It shows the actual scene in the Sing Sing death house as the lethal current surged through Ruth Snyder's body at 11:06 last night. Her helmeted head is stiffened in death, her face masked and an electrode strapped to her bare right leg. The autopsy table on which her body was removed is beside her. Judd Gray, mumbling a prayer, followed her down the narrow corridor at 11:14. "Father, forgive them, for they don't know what they are doing?" were Ruth's last words. The picture is the first Sing Sing execution picture and the first of a woman's electrocution.—*Story p. 3; other pics. p. 28 and back page.*

Faked News Photo Invented—The Composograph

If the *News* was "a daily erotica for the masses," it still paled in comparison to its fellow scandal monger, the *Evening Graphic*, commonly known as the "Porno Graphic." In the *Evening Graphic*, the composograph, the first staged and faked news photo, was born. The occasion for its conception was the Kip Rhinelander divorce trial. Rhinelander, a wealthy blueblood, wanted to annul his marriage, claiming that his wife concealed from him that she was part Negro. She, in turn, insisted that this had been obvious to him even before their marriage. As part of the evidence, her lawyers had her undress to the waist in court. To the *Graphic*'s dismay, however, the judge expelled photographers from the courtroom before this shocking scene took place.

Ever-resourceful editor Emile Gavreau decided that if he couldn't get a real picture, he would run the next best thing: a convincing looking composite. He and Harry Grogin, the *Evening Graphic*'s assistant art director, set up a fake courtroom scene, in which a chorus girl substituted for the accused Mrs. Rhinelander. Then, Grogin retouched the picture and superimposed real faces of the courtroom characters onto posed bodies. Grogin called the faked photo a *composograph*. Grogin used twenty separate photos to arrive at the one famous shot, but for the *Graphic*, it was well worth the effort. The paper became notorious overnight and circulation soared from 60,000 to several hundred thousand readers.

As might be expected, the *Graphic* continued to exploit the popularity of the composite picture while admitting in tiny print at the bottom of the composograph that the pictures were faked. One time in the newspaper office, while staging a phony hanging of Gerald Chapman, a thief, Grogin called upon one of his assistants to pose with a noose around his neck, bound hands and feet, and a mask over his head. The man stood on an empty box which would later be

Because they couldn't take a picture inside the courtroom during the sensational Rhinelander divorce trial, the Evening Graphic's Emile A. Gavreau and Harry Grogin staged the courtroom scene at the newspaper office with actors playing the parts of the real individuals. Faces of the actual participants were pasted on later. They called the technique a composograph.
(Harry Grogin, *New York Evening Graphic*)

The New York Daily News, *a tabloid, hired Thomas Howard to get a picture of murderess Ruth Snyder's electrocution in 1928. Howard strapped a miniature glass-plate camera to his ankle and released the cable as he hiked his trouser leg. He exposed the plate three times, once for each electric shock administered to Snyder.*
(Thomas Howard, *New York Daily News*)

blocked out of the picture. Just as the picture was about to be snapped, the stand-in victim accidentally kicked the box away. Luckily, Grogin acted with lightning reflexes and caught the suspended man seconds before the would-be hanging became a real one.

Of course, not all of the tabloid pictures were composographs. If a real-life picture was gruesome and lurid enough to satisfy the thrill-hungry public, the *Graphic,* the *Daily News,* and their fellow-scandal sheets were more than happy to run the photo.

WEEGEE, KING OF THE CRIME PHOTOGRAPHERS

The most famous photographer to capitalize on the tabloid mentality and concentrate his energies on the seamier side of city life was Arthur Fellig, universally known simply as Weegee. Weegee acquired his name because, like the Ouija board, he supposedly had an uncanny ability to predict what would happen when and where, and he would miraculously be there often ahead of the police. This news sense, of course, is a helpful quality for a photojournalist and, with the advantages of his police radio and a strategically located living quarters near the police station, Weegee managed to keep on the scent of the city's assorted crimes, auto crashes, and fires. The city was his working space, the night was his time, and violence was his specialty. Too independent to be tied to any one publication, Weegee remained a free-lancer and a free spirit for most of his career. Each night he would cruise the city streets in his car, always ready to cover the happenings of urban nightlife.

Weegee poked his inquisitive camera into every dark corner of the city, photographing life as he saw it, stark and uncensored. His book *Naked City* was later made into a movie and then a television show. Its title is an apt summation of his style and his subject; in his photographs, the city was indeed naked—unadorned and exposed.

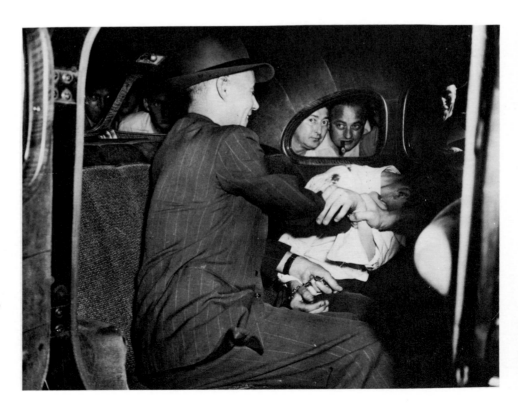

Weegee intuitively understood the fascination of crime, which attracted the attention of both the bystander at the scene and the reader at home. Weegee was the first photographer to use a police radio to get early tips about gangland shootings.
(Arthur Fellig)

Weegee knew not only how to get a picture but how to sell it as well. He explained his technique, "If I had a picture of two handcuffed criminals being booked, I would cut the picture in half and get 5 bucks for each." For a photo of a bullet-ridden corpse, he had an entrepreneur's price scale. Weegee's going rate: $5.00 per bullet! Never one for modesty, he would stamp the back of his pictures, "Credit Weegee the Famous." The stamp was hardly necessary, though, as his direct, unflinching style identified him as much as his signature or his omnipresent cigar.

Weegee reveled in his role as a special character and he played it to the hilt. With his chewed-up stogie, crushed felt hat, and bulging eyes, he sometimes looked like the popular stereotype of a crime photographer. He gloried in beating the cops to the scene of the action. Rushing from his car he would point his camera at the subject without bothering to focus or adjust the f-stop. Ten feet at f/11 with flash covered most situations.

Besides covering violent scenes, Weegee also shot ordinary life—people relaxing at Coney Island, fans at Frank Sinatra concerts, children sleeping on a fire escape. Later in his career he took many pictures of Hollywood stars.

In Weegee's work the explosion of the flashbulb intruded on the night's protective darkness, violating its cover and exposing the startling scenes that he was a party to. In all of his photos, the flash bulb is a real presence—it is evident in the strong tonal contrasts from the harsh light of a flash used on the camera. Somehow, in Weegee's world, everyone looks like a victim, caught unawares by the insistent light of the camera's flash.

THE SEARCH FOR A CONVENIENT LIGHT SOURCE

Dangers of Flash Powder

Weegee had to replace the flash bulb after each exposure, yet flash bulbs proved infinitely more convenient than the flash powder used earlier in Jacob Riis's day.

Stories of the inconveniences of flash powder are legion. Flash photographers in the old days wore special cuffs so the powder wouldn't roll down and burn their arms when the chemical was ignited. Eddie McGill, a *Chicago Tribune* photographer, suffered a skull fracture when a big flash pan bent as it fired; another Chicago photographer, Nick McDonald of the *Chicago Herald-Examiner*, lost a hand from exploding powder as he poured it from a bottle onto a hot flash pan. When there were several photographers on the scene, it was necessary to decide which of them would set off the flash powder. Once the substance was lit, smoke filled the room, eliminating the possibility of anyone taking a second picture. An additional problem, of course, was the subjects gasping for air, sometimes between curses. Needless to say, photographers and their flash pans were not exactly welcome in most places.

Three kinds of flash lamps were available for the photographer: the Caywood, the Imp, and the Victor. The Caywood flash was used for indoor portraits and group pictures. The Imp lamp, manufactured by the Imperial Brass Co., worked well for large groups indoors. Outdoors, at night, when lots of light was needed, the news photographer used a long Victor flash pan.

A photojournalist could choose between three types of flash powder manufactured by the Excel Fire Works Company. Powder in the red label can burned the fastest (1/25 sec.), so it was selected for sports. Yellow-labeled powder fired slower but brighter. Blue-labeled powder, used for portraits, burned the slowest but gave off the most light.

Photographers always filled the flash pan with four times as much powder

Flash bulbs replaced flash powder. The bulbs were smokeless and safe, yet they were large, cumbersome, and awkward.
(Files of the National Press Photographers Association, courtesy John Faber)

Flash powder fired in a pan left the room filled with smoke, unfortunately eliminating the possibility of taking a second photo. Harry Rhodes here demonstrates his flash technique. Rhodes, it is hoped, never breathed in at the wrong time.
(Files of the National Press Photographers Association, courtesy John Faber)

as needed to make sure they would have enough light, remembers Frank Scherschel, who was a news photographer in those days. He said that besides packing his camera and plates he always carried a tube of Unguentine in case he burned his hands. With the lens set at f/16 the news photographer fired the flash lamp and prayed.

Flash Bulbs—Safe but Inconvenient

Although smokeless flash powders were developed over the years, it was not until 1925 that a superior method of lighting was found. In this year Paul Vierkotter patented the flash bulb—a glass bulb containing an inflammable mixture that was set off by a weak electric current. Four years later, the flash bulb appeared in an improved form, with aluminum foil inside. Although these bulbs were infinitely preferable to the smoky, noisy, and dangerous flash pans, the flash bulbs still were inconvenient for the press photographer. Some of the biggest bulbs were close in size to a football. Static electricity or electromagnetic energy could cause them to fire. In addition, the bulbs had to be replaced after each shot, a delay that could cause the photographer to miss important pictures.

Edgerton Develops the Electronic Flash

The forerunner to the modern electronic flash was designed by Harold Edgerton of the Massachusetts Institute of Technology in the early 1930s. Edgerton was investigating motors and developed an electronic stroboscope which flashed at repeated fixed intervals, synchronizing with the moving parts of the machine. Edgerton later used his stroboscope to take single and multiple image photos not only of moving machine parts but also of tennis players, golfers, and divers, as well as humming birds in flight. Basically, his electronic flash worked by discharging a high voltage from a capacitor through a gas-filled tube, producing an extremely brief burst of light. The light was powerful enough for photography even with the relatively insensitive films available at the time. Though an observer would not be aware of it, the light from the electronic flash exceeded the combined output of 40,000 50-watt bulbs.

Edgerton designed his electronic flashes for research. George Woodruff, a photographer with the International News Photos (INP), heard about Edgerton's invention and dropped by the scientist's M.I.T. lab. Woodruff asked Edgerton if the electronic flash had any use in news photography. Edgerton answered by helping Woodruff lug three flash units to the circus playing in town that night.

Each strobe—all are still in use according to Edgerton—had a large capacitor that put out 4000 volts (9600 watt seconds). The flash duration lasted less than 1/50,000 of a second. On successive nights, the pair tried their strobe set-up at a variety of sporting events. With Woodruff on camera and Edgerton on strobe, the team of photographer and scientist managed to stop the action of runners, boxers, and swimmers in their natural environments.

A photojournalist working for the *Milwaukee Journal*, Edward Farber, designed an electronic flash that could be synchronized with a common shutter found on most press cameras. Farber's first working electronic flash weighed ninety pounds and had oil capacitors and an AC power supply. The *Journal* sent Farber back to the lab to design a more portable model. By October 1940, Farber had the flash's weight down to twenty-five pounds. Powered by a motorcycle battery it also had a plug for household current. In the fall of 1941 Farber found a lighter battery, and around it he built a "dream" portable stroboflash, weighing only thirteen and a half pounds. In the 1950s the electronic flash design was sold to Graflex Inc., in Rochester, New York, and remained for many years a standard piece of equipment for the news photographer.

CAMERAS LOSE WEIGHT AND GAIN VERSATILITY

About the time that the flash bulb was perfected, another invention was being developed which allowed pictures to be taken in dim indoor light without any artificial illumination at all. The candid camera, as it came to be known, was to change the course of news photography and redefine the role and the potential of the photojournalist.

Graflex Used Until 1955

At the beginning of the century, the most widely used press camera was the Graflex and its German counterpart, the Ica. These cameras were portable, although still heavy; they used either a 4″ x 5″, 4″ x 6″, or 5″ x 7″ glass plate. Because of the large size of the negative, the resulting print was of high quality and had adequate detail.

The Graflex looked like a large rectangular box with a hood on top. To

The Graflex, nicknamed Big Bertha when fitted with a telephoto lens, was the basic news camera from the turn of the century to the 1920s. Even after the introduction of the smaller and lighter Speed Graphic (top row), photographers continued to shoot sports with the Graflex (bottom row) until 1955. (Collection of Don Robinson, UPI)

Standing atop a special vehicle fitted with a body built to resemble a camera and holding his Graflex, Robert Taylor covered picture assignments for the Milwaukee Journal. The vehicle was also equipped with a complete darkroom. Taylor was the Journal's first photographer, hired at $15.00 a week in 1909. (Milwaukee Journal)

view through this oversized single-lens reflex camera, the photographer would look down the hood at an angled mirror which would reflect what the taking lens saw except that the image was reversed left to right. The photographer could fit on a 40-inch telephoto lens for shooting sports from the press box. (When the Graflex carried the telephoto it was affectionately known as Big Bertha.) The large negative produced by the Graflex meant that photographers did not have to frame perfectly on every play, yet they were secure in the knowledge that if they captured the action on at least part of the film they could make a usable blow up. James Frezzolini, a news photographer, modified the Big Bertha for rapid focusing between first, second, and third bases at a baseball game with the use of a notched lever. According to John Faber, historian of the National Press Photographers Association, some photographers continued to shoot with the Graflex at sports events until 1955.

Speed Graphic—The Badge of the News Photographer

For general news events the Speed Graphic replaced the Graflex in the 1920s and 1930s. The front of the Speed Graphic folded down to form a bed with tracks. The lens slid out on these tracks. A bellows connected the lens to the box of the Graphic and expanded or contracted as the photographer focused the lens. The film was carried in holders, two shots to a holder. Whereas a rangefinder came attached to the side of the camera, a seasoned photographer often removed this device and just guess focused. The Speed Graphic held up to intensive pound-

Although Harold Edgerton first developed the electronic flash to study the moving parts of engines, he soon realized that stroboscopic light could photograph any moving object. With a series of electronic flashes, on one sheet of film Edgerton recorded the individual stages of a diver leaving the board and entering the water.
(Harold Edgerton, Massachusetts Institute of Technology)

ing, and even after the development of the small 35mm camera, many press photographers continued to shoot with their Speed Graphics.

Robert Gilka, now director of photography for the *National Geographic*, but in 1955 picture editor of the *Milwaukee Journal*, issued a memo, which read in part, "This 35mm stuff may be okay for magazines . . . but we might as well face the facts. We are wasting our time shooting the average news assignment on 35mm." Robert Boyd, a past president of the National Press Photographers Association, was once asked what the press camera could do that the 35mm couldn't. Boyd put the big camera on the ground and sat on it.

The days of the Speed Graphic, however, were numbered.

The 4 x 5 Speed Graphic was the standard news camera of the business from the 1920s to the 1950s. Experienced photographers didn't focus; they just guessed at the distance. Old Speed Graphic users claimed the camera had only three distance settings: here, there, and yonder. This group of photographers worked for the Providence Journal-Bulletin. (Wide World Photos)

Leica Lightens the Load

The earliest miniaturized camera was the Ermanox, a German-designed small camera that took single glass plates and had an extra fast lens. The lens, at f/1.8, had an almost incredible light-gathering capability for the period. The manufacturer of the Ermanox lens proudly claimed, "This extremely fast lens opens a new era in photography and makes accessible hitherto unknown fields with instantaneous or brief time exposures without flash-light. . . ." He was right that the lens opened a new era in photography. But, unfortunately, because of one major drawback the Ermanox was destined for extinction: the camera used only individually loaded 4.5 x 6 cm glass plates—an obvious inconvenience for news photographers. Still, the Ermanox was important in that it was the forerunner to the camera which would revolutionize photojournalism.

Oskar Barnack, a technician at the E. Leitz factory in Germany, invented the Leica. Like the Ermanox, it had an extremely fast lens but, rather than glass plates, the Leica used a strip of 35mm motion picture film with as many as forty frames per roll possible in the original models. Barnack continually worked on his design and, in 1924, the first Leicas were put on the market. By 1932, Leitz mass-produced the camera in fully refined form with extremely fast, removable lenses and a built-in rangefinder.

The implications of this handy, small-format camera were wide-ranging. Now, with existing light, the photographer could snap pictures without having to bother with flash bulbs. The Leica's lightness, ease of handling, and fast lens allowed the photographer to move freely, unencumbered by heavy camera accessories, flash attachments, clumsy tripods, or glass plates. Because the film could be rapidly advanced, photographers could make exposures one after an-

other, thus enabling them to capture the unfolding of an event without stopping between pictures.

The Leica gave the news photographer unprecedented mobility and the ability to take a picture unobtrusively. The photographer no longer had to stop life in its tracks to snap a picture; people no longer posed for the camera's lens. Now, subjects could be more relaxed and natural and the photographer, in turn, was free to concentrate on atmosphere and composition rather than on technical matters. These new capabilities did nothing less than change the relationship between photographers and the world. Because they could use available light and remain unrevealed, press photographers could imbue their pictures with a new sense of realism, of life in the making.

The Leica revolutionized photojournalism. The camera was light, small, and quiet, making candid photos possible. The German camera took 35mm film, allowing the photographer without reloading to shoot a series of pictures. (Leitz, Inc.)

ERICH SALOMON—FATHER OF THE CANDID

The man who first exploited this photographic impression of life was Erich Salomon. Often called "the father of candid photography," he was probably the person who coined the term *photojournalism* to describe what he was doing. Salomon began his photography career in 1928 with the new Ermanox camera. Salomon's arenas of action were diplomatic gatherings and government functions; his subjects were the foremost statesmen and political personalities of Europe. When he initially tried to penetrate these carefully guarded events, the officials refused to let him in, claiming that flash powder and large cameras would disrupt the orderly proceedings. But when Salomon demonstrated the capabilities of his unobtrusive camera, he was not only given entry into these private quarters but he became a regular habitué of diplomatic circles, causing French Prime Minister Aristide Briand to remark, "There are just three things necessary for a . . . conference: a few Foreign Secretaries, a table and Salomon."

However, even the ingenious Salomon could not charm his way into all top-level, top-secret meetings. When barred from an important conference, the dapper photographer would don his top hat, white gloves, and tails and set to work concocting some scheme to allow him to gain entry into this private world for picture-making. The ruses that Salomon used are legendary. One time he managed to take pictures in a courtroom, which was off-limits to photographers: he shot his film by cutting a hole in the crown of his hat and hiding his camera there. Following the success of this technique, he used a similar ploy to photograph a roulette game in Monte Carlo: he hollowed out several thick books and hid his camera inside. While Salomon appeared absorbed in the game, he was actually busy clicking away with his concealed camera.

The urbane, multilingual Salomon moved with ease among dignitaries and heads of state, capturing with his camera the personalities of the people who shaped history and the atmosphere of their inner sanctums. With the Ermanox, and later with the Leica, he penetrated the masks of the public persona to reveal those very human characteristics which lay underneath—of dozing diplomats, bored-looking royalty, down-to-earth movie stars.

There is a remarkably intimate quality to Salomon's work; because his camera enabled him to catch these prominent people off guard, his pictures give the impression that the camera, rather than being an intruder, is simply a watchful observer who happens to be present at the scene. Salomon's candid photography attracted a good deal of attention and he numbered among his subjects such luminaries as Albert Einstein, President Herbert Hoover, Marlene Dietrich, and William Randolph Hearst.

Salomon later died in one of Hitler's concentration camps. As one of the first to demonstrate the possibility of recording events with the candid camera, Salomon truly deserves the title of photojournalist.

THE PHOTO ESSAY

Salomon's candid camera style proved that current events could be captured pictorially. The impact of this discovery was felt strongly in Germany, where in such picture magazines as the *Müncher Illustrierte Press* the photo essay first appeared in embryonic form. Stefan Lorant, editor of the magazine, developed the notion that there could be a photographic equivalent of the literary essay. Previously, if several pictures appeared together, they were arranged either arbitrarily or sequentially, with little regard for the conceptual logic of the layout, captions, cropping, or picture size. Lorant and his colleagues began experimenting with a new photographic form in which several pictures appeared, not in isolation but, rather, as a cohesive whole.

Illustrated magazines were not a new phenomenon in the U.S. As early as the nineteenth century, *Leslie's Illustrated Newspaper* and *Harper's Weekly* relied on drawings to elucidate their articles. After the invention of the halftone, such publications as *McClure's*, *Cosmopolitan*, and *Collier's* continued the tradition of adding pictures to supplement their stories.

The difference between these early magazines and the two great American picture magazines, *Life* and *Look*, lay not only in the number of pictures used but also in the way they were used. In the new magazines, several pictures were grouped together with an overall theme and design, and picture editors discovered truth in the old adage, "The whole is worth more than the sum of the parts." Accordingly, the role of the picture editor became all-important; along with the photographer, the picture editor shaped the story and, with the aid of shooting scripts, mapped out the photographer's plan of attack.

Life Comes to Life

Life was the brainchild of Henry Luce, the publisher of *Time* and *Fortune* magazines. Spurred by the success of similar European ventures, Luce and his colleagues felt the time was ripe in the United States for a new, large-format picture magazine. Hence, *Life* came to life in the 1930s. In its manifesto, the new magazine stated its credo:

> To see life, to see the world; to eyewitness great events; to watch the
> faces of the poor and the gestures of the proud; to see strange things—
> machines, armies, multitudes, shadows in the jungle and on the moon;
> to see man's work—his paintings, towers and discoveries; to see things a
> thousand miles away, things hidden behind walls and within rooms,
> things dangerous to come to; the women that men love and many
> children; to see and to take pleasure in seeing; to see and be amazed; to
> see and be instructed.

For the first issue, November 23, 1936, *Life*'s editors dispatched Margaret Bourke-White to photograph the construction of a WPA dam in New Deal, Montana. In the 1920s Bourke-White had made a name for herself as a free-lancer and later as a top-notch industrial photographer on the staff of *Fortune* magazine. Her pictures celebrated the burgeoning machine aesthetic of the time, and her expertise in capturing on film structural and engineering details made her the perfect candidate for the industrial assignment.

When she returned with her pictures, however, the editors of *Life* were in for a surprise. Not only had she captured the industrial drama of the dam under construction, but she took it upon herself to document the personal drama of the town's inhabitants as well. Bourke-White turned her camera on the details of frontier life—the hastily erected shanty settlements, the weather-beaten faces of the townspeople, the Saturday night ritual at the local bar—and enhanced her story by adding the human dimension.

On the cover of the first issue of *Life* is a picture of the huge dam in all its geometrical splendor. And inside is Bourke-White's photo essay: nine pages of carefully laid out, strategically chosen pictures of the people of New Deal. This photo essay became the prototype for a form that flourished in the pages of *Life*, a form that expanded the scope of photojournalism and redefined the way we see.

Look Publishes

The astounding success of *Life* was matched by that of its fellow picture magazine—*Look*. *Look* was begun by the Cowles brothers, a Minneapolis newspaper publishing family, who commissioned George Gallup to find out what part of the newspaper was most widely read. When Gallup's poll revealed that the picture page was most popular, the brothers founded *Look*, which first appeared in January, 1937. Although similar to *Life* in its visual design, *Look* concentrated more on feature stories than on news events. The two magazines quickly grew in circulation, continuing to prosper for forty odd years. Between the two magazines, they counted among their ranks such illustrious photographers as Bourke-White, Alfred Eisenstaedt, W. Eugene Smith, Leonard McCombe, Peter Stackpole, Arthur Rothstein, Paul Fusco, and Stanley Tretich.

The success and style of the picture magazines had some important effects on newspaper photojournalism. The photo essay layout influenced many newspapers to adopt a similarly simple and direct arrangement of pictures about one subject. Likewise, newspapers began running more feature stories, and using larger size pictures.

Left: The first cover of Life *magazine taken by Margaret Bourke-White showed a WPA dam in New Deal, Montana.*
(Margaret Bourke-White, © 1936 Time Inc. Courtesy of *Time* Incorporated)

Right: Look *magazine's first issue was published in 1937 by the Cowles brothers, who owned newspapers in Minneapolis.*
(*Look* collection, Library of Congress)

PHOTOGRAPHERS ORGANIZE

Because the public began to recognize such names as Margaret Bourke-White and Alfred Eisenstaedt, the photographer at last achieved parity with the writer. Originally, the photograper began as a second-class citizen in the newsroom. According to one common story, when a news photographer's job opened up the editor would find the nearest janitor and hand him a camera, telling him to set the lens at f/8 and shoot. Photographers were thought of as the people who chased fires and took cheese-cake pictures. Taking cheese-cake pictures involved meeting the incoming steamship to take snaps of pretty women with "lots of leg showing."

Along with steamships, cheese-cake pictures slowly went out of vogue. Editors began acknowledging the contribution of pictures as a means of reporting the news. The photographer's status gradually rose.

In 1945 Burt Williams, a photographer with the *Pittsburgh Sun-Telegraph*, started organizing a professional association for photographers, The National Press Photographers Association. He obtained financial backing from the Cigar Institute of America for the organization and began the groundwork with a ten-city coast-to-coast telephone conference in which leaders in press photography took part. At a meeting in New York City on February 23 and 24, 1946, the group adopted a constitution and elected officers: Joseph Costa, *New York Daily News,* president; Burt Williams, *Pittsburgh Sun-Telegraph,* secretary; and Charles Mack, Hearst Metrotone News, treasurer. Today the organization holds an annual meeting and publishes an attractive well-written magazine, *News Photographer,* edited by Jim Gordon. The association also administers a photo contest and sponsors educational programs in photojournalism. The organization lists over 6,000 members including working pros and students.

More and more college graduates enter the field of photojournalism each year. The first college grad to work on the picture side of a newspaper was Paul Thompson, who graduated from Yale in 1902. Today many schools offer courses and even complete degrees in the field of photojournalism. According to Horrell's survey of photographic education, over ninety colleges offer at least one class in news photography. Some universities even grant a Ph.D. in journalism or communications with an emphasis in photojournalism.

DISTRIBUTING PICTURES ACROSS THE LAND

Bain Creates Picture Service

In 1898, a newspaper writer and photographer, George Grantham Bain, started the Bain News Photographic Service in New York City. As manager of the Washington, D.C., United Press office in the 1890s, Bain realized that he could accumulate pictures and sell them to subscribers. After Bain left the United Press, he began his own photo service. He catalogued and cross-indexed photographs he had bought from correspondents or newspapers that subscribed to his service. From newspapers throughout the country, he received pictures, copied them, and sent the copies to his list of subscribing newspapers. Bain's business expanded rapidly, and by 1905 he had acquired a million news photographs. Many of his pictures were first of their kind, including the first federal courtroom pictures, the first photos of the Senate in session, and the first automobile race. Although a massive fire in 1908 completely destroyed Bain's archives, he immediately set about rebuilding his collection.

A typical picture from the Bain News Photographic Service about 1908 showed unemployed persons getting coffee in New York's Bowery. George Grantham Bain formed his Photographic Service to provide a steady supply of photos to member papers around the country. (Bain Collection, Library of Congress)

Other picture services developed, including Underwood and Underwood who started out making stereoscopic pictures. Newspaper editors would call on the Underwoods for pictures to illustrate stories about remote countries where the Underwoods had operators. The Brown brothers saw the possibilities of selling news pictures from their experience as circulation managers on *Harper's Weekly*. Soon the Underwood, Brown, and Bain photographers were all competing for scoops.

By 1919 the Hearst organization formed International News Photos; Wide World Photos followed. In 1923 Acme News Pictures appeared. The Associated Press News Photo service began in 1927. These services sent their pictures by train, giving a tip to the porter to hand deliver the package of photos for extra quick service. Today Acme and INP are combined into United Press International (UPI), and Wide World Photos is owned by the Associated Press (AP).

Pictures Transmitted Instantaneously

Ever since newspapers began publishing pictures, the search was on for a way to transmit the pictures over long distances. As early as 1907 Professor Alfred Korn of the University of Munich, Germany, had demonstrated an electrical system using a photocell, which would transmit and receive a picture over a telegraph wire. His basic principle remains in use today. In the same year, *L'Illustration* of Paris and the *London Daily Mirror* inaugurated a cross-channel service which later included other capitals of Europe.

Not until 1925 was there a permanent transmission line set up in America. In that year the American Telephone and Telegraph Co. opened a commercial wire between New York, Chicago, and San Francisco. It was first-come, first-serve and cost $60 to send a picture coast-to-coast. A.T. & T. sold the wire to the Associated Press in 1934. The AP bought the Bell Lab equipment, leased A.T. & T. wire and set up twenty-five stations. On January 1, 1935, the AP serviced an aerial picture of a plane that went down in the Adirondack Mountains, and the age of rapid wire transmission began in the United States. Soon other picture services, including International News Photos and Acme started their own wire photo transmission networks.

Among the one million pictures that Bain collected and serviced were news photos as well as feature pictures. Here a model yacht race starts in New York City's Central Park. (Bain Collection, Library of Congress)

For a long time, such uncontrollable factors as weather conditions would influence the quality of pictures sent on long-distance transmission lines. But today, because of digital-laser techniques, the wire services can send photos instantaneously all over the world, with the quality of the final product looking as good as that of the original.

The development of laser transmission, the improvement in fast lenses, the introduction of lighter cameras and more sensitive film have freed the photojournalist from many of the earlier limitations of the equipment. The improvement in technology has led to a greater range of photo styles and subjects for the news photographer. Instead of cheese-cake and composograph photos taken with flash-on-camera, the new journalist can produce creative and expressive photos. These in-depth pictures, taken with available light or light from portable strobes, can maintain a candid look impossible in the days of the *New York Daily Graphic*.

WHERE TO FIND NEWS

HOW TO ASSURE VISUAL
VARIETY

WHEN AND WHERE TO SELL
NEWS PICTURES

2
COVERING AN
ASSIGNMENT

WHERE TO FIND NEWS

Looking for Scoops

**Five Senses
Provide First Clue**

The police arrested a suspect following a night-time riot. By sheer luck, sometimes the photographer just happens to be present when a hard-news story like this breaks. (Ken Kobre, University of Houston)

I was walking my Saint Bernard dog late one evening, when I noticed a group of white teenagers running past me with bottles in their hands. I saw another group of black teenagers racing down the street in hot pursuit. By the time I returned the dog to my apartment, grabbed my Nikons and some film, and returned to the street, a riot was in progress. The two gangs of teenagers were from low-income housing projects located at opposite ends of the block. When I arrived, the teenagers were throwing bottles and shouting racial slurs at each other. Ducking behind a car, I steadied my camera against the car's hood, and began photographing. Police, wearing riot helmets and face shields, and carrying night sticks, arrived. I looked around, noticing that I was the only photographer there. By the time the police had cleared the street and arrested several teenagers, photographers from the other daily newspapers began to arrive, but by then, of course, it was too late. I had the only pictures of the riot in progress. United Press International sent the photos out over its wires.

This story illustrates two points. First, if I hadn't been walking my dog at the right time, which was pure coincidence, I would have missed the incident altogether. Here, luck came into play. Second, I observed the situation with my eyes, heard the shouting with my ears, and, based on my news or sixth sense, knew that the situation had the potential for good journalistic pictures.

Innumerable photographs, many of which won Pulitzer Prizes, have been taken because the photographers happened to be in the right place at the right time. Trooper Henry Derey happened to be about twenty miles from Salina, Kansas, when he saw and took the first clear pictures of a tornado developing. His gripping, violent pictures appeared on the Associated Press wires, distributing the photos to all parts of the country. John Gilpin, 22, a student accountant and amateur photographer, happened to be testing a lens at the Sydney, Australia, airport, when he snapped a picture of a DC-8, 200 feet off the ground. When the film was developed, he discovered that he had a picture of Keith Sapsford, who tried to stow away in the wheel housing of the DC-8 but fell to his death as the plane was taking off. The accountant's picture of the man falling from the plane got worldwide distribution.

Luck can't be learned, but if luck is not accompanied by good technique and the sense of what to do with the exposed film once it's been shot, then the photographer won't be able to turn the accident into a prize-winning profitable picture.

**Scanner Radio Signals
Fires and Accidents**

Previous page: The overall photo of the Thunderguard Bike Club establishes for the viewer the size of the motorcycle gang. (Fred Comegys, Wilmington [Delaware] News Journal)

Only rarely will you stumble over a big breaking news story. "Anticipating spot news is like trying to predict where lightning will strike," says Robert Bowden of the *St. Petersburg (Florida) Times.* How does a news photographer know when a story is breaking? One way is to monitor the emergency-band radio frequencies for a tip-off on a major spot news break.

Police monitors or scanners once were bulky pieces of equipment. Today monitors can be carried clipped to your belt or stuck in your jacket pocket so that no matter where you are, you can get the news. You can also plug the scanner into the cigarette lighter of your car and the radio will work off your car battery. The monitor once could pick up only one channel; today's monitors will cover sixteen channels in rapid sequence, stopping at a channel when there is a message.

Most newspaper photographers monitor the police band because cops are usually the first ones called to a murder, robbery, or accident. Police use three bands: low (35–50), very high VHF (152–174), and ultra high UHF (450–470). You can find the exact frequency by asking your local police department, or

obtaining from an area radio store a directory that lists all emergency frequencies in the region. To learn quickly about a major transportation disaster, monitor the international frequency for airplanes (121.5) or marine frequency (156.8) for distress calls at sea. Additional frequencies that enable you to get a jump on fast-breaking events include those of the state police, county sheriff, and fire department. Also consider monitoring the national weather alert and civil defense.

Expensive scanners are designed so that you can program them for any frequency that you want. For less expensive scanners, you can buy individual crystals that are sensitive to only one frequency. You buy the particular crystal for the wavelength you want to monitor.

Normally, the police talk in codes; for instance 10-42 means traffic accidents at . . . ,10-70 means fire at The codes are published, but sometimes the police broadcast their calls through a scrambler, so you might have to purchase an unscrambler to understand the information.

Before you invest heavily in monitoring equipment, check your state and local laws. Some states do not allow scanners in the home or office; Florida police, in a little-used statute, arrested a photographer for carrying a permanent scanner in his car.

What else do photographers use to keep in touch with the news pulse of the city, especially when they can't afford a monitor? One alternative is an all-news radio station or a station that specializes in frequent news or updated news reports. A station with an all-news format interrupts any on-going programming immedi-

John Gilpin, an amateur photographer, happened to be testing one of his camera lenses at the Sydney, Australia, airport when he snapped the photo of a man falling from the DC-8 plane. Chance often plays a major role in catching unusual spot-news pictures.
(John Gilpin, Wide World Photos)

News Radio Good in a Pinch

A gasoline truck overturned. A scanner radio tuned to the police and fire department frequencies could provide the spot-news photographer with the first tip-off at an accident like this. (John Connolly, *Herald* File, Print Division, Boston Public Library)

ately if an emergency arises. These stations monitor several scanner channels, including the fire and police departments, and will announce over the air any time a major fire alarm or multi-car accident occurs. The all-news station also has its own reporters who cover breaking stories, giving live updates. The radio's weather forecaster will predict a natural disaster such as a hurricane or tornado, and a reporter will describe the damage when the disaster hits. News radio does not provide as immediate information as the scanner, but the radio will often suffice.

Tips Help

Newspapers often get leads on top news stories when people call the city desk with tips. Some newspapers, in fact, offer reward money for tips. The *News American* in Baltimore gives $50 for any tip that results in a published story. The city desk sizes up the event, then, if the decision is "yes," the City Editor or an assistant may send out a reporter and photographer.

Special-interest groups call in tips to the newspapers if the members think the publicity will do them some good; if blacks, welfare mothers, gays, or anti-nuclear groups, for example, are going to stage a protest, they want coverage, and might telephone the newspaper with the time and place of their planned demonstration.

Most newspapers assign reporters to cover a certain beat: city hall, hospitals, police headquarters. Beat reporters keep up with the news and events on their specialty; consequently, these reporters know when to expect a major story to break. The city hall beat reporter may call in to the city desk and say, "The mayor is greeting some astronauts today. It will be worth a good picture." The editor agrees and assigns a photographer.

Beat Reporter Knows the Territory

Whether a photographer stumbles into an event in progress, finds out about it from a scanner radio, or gets a tip, he or she still must evaluate its news and picture worthiness, photograph the activity, and rush the picture to a media outlet in time for the next deadline.

Sources for Planned News

The mayor will arrive at his office at 9 A.M. He leaves for the airport at 10:15 A.M. to dedicate a new runway. He will be at the Golden Age Senior Citizens home from 11:30 A.M. to 12:30 P.M. Then, during a 1:00 P.M. lunch at the Parker House, the mayor will meet with the Committee for City Beautification.

PR Office Is There to Aid You

If you want to know the whereabouts of the mayor practically every minute of the day, just consult the schedule. The mayor's personal or press secretary arranges the itinerary weeks in advance. Mayors, Congress members, Senators, and the President of the United States have carefully laid out schedules, available through their press officers.

Companies, schools, hospitals, prisons, and governmental departments also have press or public relations offices. These offices, sometimes called public affairs or public information departments, generate a steady stream of news releases, announcing the opening of a new college campus, the invention of a long-lasting light bulb, or the start of a new special education teaching program. Many of these PR releases suggest good picture possibilities. The public relations person and the photographer sometimes can benefit one another. The PR officer wants pictures of a politician or institution published, and the photographer wants usable pictorial news tips.

Finding the mayor of a city or town is easy: almost all daily activities are listed, often in a published schedule.
(Louis Tucci)

Paper Prints Schedules

Another source for upcoming news events comes daily to your doorstep rolled and held with a rubber band. The daily paper carries birth, wedding, and death announcements. The paper prints schedules of local theaters, sports events, parades, and festivals. When the circus arrives in your town, the paper will list the time and place of the Big Top Show.

Trade Magazines Supply Unusual Leads

For more unusual activities, check special interest newspapers and magazines. Dog and cat, motorcycle, plumbing, skateboard, mental health, and environmental groups all publish magazines that announce special events.

To keep track of upcoming happenings with visual possibilities, newspapers and wire services maintain a log book listing the time, place, and date of each future activity. The notation in the book includes a telephone number of the sponsoring organization in case the photographer needs more information before going on the assignment. The log book idea works well for free-lancers, also.

HOW TO ASSURE VISUAL VARIETY

A photojournalist plans coverage of a news event just as a Hollywood director maps out the shooting of a film scene. For instance, when the director laid out the shooting script of *Gone With the Wind*, he knew he had to introduce his theater audience to Tara, Scarlett O'Hara's southern plantation. He needed to have the camera far enough back on the set for an overall shot to show the grand

dimensions and idyllic setting of the white-columned mansion. For variety, the director wanted to zoom in for a close-up of the beautiful Scarlett. He didn't want the audience to miss Scarlett's face when she saw Rhett Butler for the first time. And, of course, between sweeping overall shots of the plantation grounds and tight dramatic shots of the heroine, the director arranged the camera for medium shots so the viewer could see the action as it unfolded. *Gone With the Wind's* director planned each shot carefully because he knew that if he missed an angle, reshooting would cost the production thousands of dollars a day.

Photojournalists think like movie directors, looking for locations for overall shots and ways to move in for close-ups. But camera reporters, usually, have to plan their shots on the spot. They don't have the luxury of weeks to prepare a shooting script. They work under the pressure of the moment. And they know that if they miss a crucial angle, they can't call for a retake. Reshoots don't exist in the news business.

Overall Shot Sets the Scene

If newspaper readers come to a news event, they could stand in the crowd and move their eyes from side to side to survey the entire panorama. The overall photo gives the viewers at home this same kind of perspective. The overall allows the viewers to orient themselves to the scene.

For some stories the overall might include only a long shot of a room. For other stories the overall might cover a city block, a neighborhood, or even a whole town. The scope of the shot depends on the size of the event. The overall shows where the event took place: inside, outside, country, city, land, sea, day, night, and so on. The shot defines the relative position of the participants. In a confrontation situation, for example, the overall angle would show whether the demonstrators and police were a block apart, or across the street from one another. The overall shot also allows the reader, by judging crowd size, to evaluate the magnitude of the event.

Margaret Bourke-White, a member on the original photo staff of *Life* magazine, always took overall pictures on each assignment, even if she didn't think these shots would be published. She explained that she wanted her New York editor to see the shooting location so that he could interpret the rest of the pictures she had taken.

Generally, the overall requires a high angle. When you arrive at a news event, quickly survey the scene to determine what is happening. Then search for a way to elevate yourself above the crowd. In a room, a chair will suffice; but outside, a telephone pole, a leafless tree, or a nearby building will give you the high vantage point you need for an effective overall shot. When caught in a flat area, even the roof of your car will add some height to your view.

The wider-angle lens you have, obviously, the less distance from the scene you will need. On a major news story that encompasses a vast area, such as a flood, hurricane, or conflagration, you may need to rent a helicopter or small airplane to get high enough to capture the dimensions of the destruction.

Medium Shot Tells the Story

The medium shot should "tell the story" in one photograph. Shoot the picture close enough to see the action of the participants, yet far enough away to show their relationship to one another and to the environment. The medium shot contains all the story-telling elements of the scene. Like a lead in a news story, the photo must tell the whole story quickly by compressing the important elements into one image. The medium shot summarizes the story.

An accident photo might show the victims in the foreground, with the

wrecked car in the background. If the picture contained the victim without the wrecked car in the background, the photo would not tell an essential detail of the story. The reader wouldn't know the cause of the victim's injuries. If the photo included only the crumpled car, the reader would wonder if anyone was hurt in the accident. The combination of the elements—car plus victim—briefly tells the basic story.

A medium shot gains dramatic impact when the photograph captures action. Even though the camera can catch fast action on film, you may still have difficulty: action often happens so quickly that you have no time to prepare.

Shooting news action is like shooting sports action (see Chapter 7, "Capturing the Action in Sports"). In both situations you have to anticipate when and where the action will take place. If a man starts a heated argument with a police officer you might predict that fists will fly and an arrest will follow. You have to

aim your camera when the argument starts and not wait until a punch is thrown. If you hesitate, the quarrel might end while you are still fiddling with your equipment.

For the medium shot, a wide-angle lens, such as a 24mm or 28mm works well, although a normal 50mm will do. J. Walter Green, a top photographer with the Associated Press, notes that he takes most medium shots with his 24mm lens. With this lens, Green gets extremely close to the subject to fill the entire negative area. According to Green, the resulting pictures tend to project a more intimate feeling between the subject and the viewer. Because Green works close to the subject, few distracting elements intervene in front of his camera when he is shooting. Also, at this close distance, Green can emphasize the subject. Finally, Green's wide angle takes in a large area of the background, thus establishing the relationship of the subject to his surroundings.

Buying a wide-angle lens however, is not a photographer's panacea. The wider the angle of the lens, the greater the chance for apparent distortion. This is because you can focus very close to a subject with a wide-angle lens and the closer any part of a subject is, the bigger it will appear. For example, if you stand relatively close to and above a person, and tilt the camera down to include the subject's full length, head to feet, the wide-angle lens will exaggerate the subject's head to the size of a basketball, while shrinking the feet small enough to fit into baby shoes. If you stand at the base of a building and point your wide-angle

When published alone, a medium shot in a newspaper needs to tell a complete story in one picture. Without the victim in this crash photo, the viewer wouldn't know if anyone was hurt. If the picture were printed without the crumpled vehicle, the viewer wouldn't know how the people were injured. (Frank Hoy, Washington Post)

lens up to include the whole height of the structure, the resulting pictures will look as if the building is falling over backwards. This happens with any lens, but particularly with a wide-angle lens used close to the building. To avoid distortion with the wide-angle lens, you must keep the back of the camera parallel to the subject. When shooting a building, you must either get far enough away, or high enough, so that the back of your camera is perpendicular to the ground and therefore parallel to the structure.

Close-up Adds Drama

Nothing beats a close-up for drama. The close-up slams the reader into eyeball-to-eyeball contact with the subject. At this intimate distance, a subject's face, contorted in pain or beaming in happiness, elicits empathy in the reader.

How close is close? A close-up should isolate one element and emphasize it. All close-ups don't have to include a person's face. Sometimes objects can tell the story even when the story involves human tragedy. A close-up of a child's doll covered by mud might tell the story of a flood better than an aerial picture of the entire disaster.

Longer lenses enable the photographer to be less conspicuous when shooting close-ups. With a 200mm lens, a photographer standing 10 feet away can still get a tight facial close-up. The telephoto lens decreases the depth-of-field, blurring the foreground and background, thereby isolating the subject from the unwanted distractions.

Rather than a telephoto for close-up work, the photographer can employ a macro lens or a standard lens with an extension tube. With either of these lenses, the camera can take a picture of a small object such as a contact lens and enlarge it until it is easily seen.

A close-up of this woman putting in a contact lens adds visual drama to this otherwise routine event. This photo was taken with a macro lens.
(Ken Kobre, University of Houston)

Saturation Method Increases the Chances

When you are on assignment, take several frames from each vantage point. Milton Feinberg, the author of *Techniques of Photojournalism,* calls this approach the *saturation method.* He recommends taking at least six shots from each position. Then move over a few feet and shoot more frames. A slight change in perspective can bring important elements in the scene together to make the picture more visual. Keep shooting, Feinberg counsels. A slight change in your subject's facial expression or body language can turn a routine picture into a prizewinner.

Don Robinson, of the United Press International wire service, describes his shooting approach this way, "I shoot one frame, then another and another. I am trying to improve each picture. I may be looking for a certain expression or gesture, or watching for something to happen. I may get something that is unusual, but in the next frame, I might get something much better."

Photographers stay at each location until they secure on film the best picture they can get within their time limits. Amateur photographers take a few snapshots of a scene and hope for the best. Professionals, by contrast, search for the decisive moment and know when they get it. The pro might have to take a hundred or even a thousand frames to get the perfect moment, but, luckily, 35mm film is cheap. Even a newspaper publisher knows that film is the least expensive budget item.

Said George Tames, photographer for the *New York Times,* "If you see a picture, you should take it—period. It is difficult, if not impossible, to re-create a picture, so do not wait for it to improve. Sometimes it's better and you will take that picture also, but if you hesitate and don't click the shutter, you've lost the moment and you can't go back."

Use the saturation method. Take several frames from the same location,
changing the angle slightly. If you see a picture, take it, because if you hesitate
you've lost the moment forever.
(Ken Kobre, University of Houston)

WHEN AND WHERE TO SELL NEWS PICTURES

Staff Photographer vs. Free-lancer

What should you do when you've snapped a good spot news picture?

The answer to this question depends on whether you are a staffer or a free-lancer. If you are a staff photographer for a paper and you've stumbled on a major train disaster, you should shoot your pictures, then get to the nearest phone and *call your editor*. Give the desk editor a brief description of the accident and your photos. Your editor will weigh the importance of the train wreck story against other news of the day, and will decide whether you should remain at the scene of the accident and send in your film by messenger or return to the office to process and print your photos before deadline. If you are a free-lance photographer and you have a good spot news photo, you have, under the same circumstances, many more options for your pictures.

Marketing Spot News: A Case Study

Steve Laschever, a young photographer, searched the newspapers for a lead on a story to fulfill his class news assignment. He read about an old woman in Quincy, Massachusetts, who, threatened with eviction, had barricaded herself in her home. She kept the police department at bay with her shotgun. The police, of course, did not want a shoot-out with this kindly grandmother. They could imagine the headlines: "Police Storm Home of Grandmother." So the cops set up a 24-hour surveillance, hoping the woman would run out of supplies and relent. The media heard about the story and played it big in the papers and on the air. Photographers were assigned to the house around the clock.

Steve hitchhiked a ride to Quincy to cover the siege. Arriving at 12:30 P.M., he noticed all the photographers were gone. Later he learned that all the pros had decided to go to lunch together so that they would not scoop one another. Just as Steve reached the front lawn, the police, thinking there were no photographers around, entered the house and arrested the woman. Reflexively, Steve put the camera to his eye and snapped away as the old woman was forcibly removed from her home.

Although he was not sure if his negative was focused, or exposed correctly, Steve knew he had an exclusive. Unfortunately, he didn't know what to do with his catch.

Determining the Market

The photo student's pictures certainly had area-wide, and probably national, interest. The young photographer was in a good bargaining position because he had exclusive images that the media wanted. He should have called the city desk of the nearest metro daily as well as the local television stations to see how much they would offer for the rights to the photos. As the story had national play possibilities because of its strong human interest appeal, Steve should have telephoned the office of the nearest wire service, either the Associated Press (AP) or the United Press International (UPI). Both services depend a great deal on stringers and free-lancers. Neither service maintains a large enough photo staff to cover the country—or the world—thoroughly. Many photos, appearing in print and carrying the AP or UPI credit line, were taken by independent photographers.

The amount of money that newspapers, magazines, or wire services pay for a picture depends on the value of the photo at the time of publication. In 1963, *Life* magazine paid Abraham Zapruder between $25,000 and $40,000, ac-

cording to the *New York Times,* for his 8mm movie film of President John F. Kennedy's assassination. In contrast, AP and UPI pay a standard rate of $10 to $20 for most pictures they buy from free-lancers. Still, each photo is unique, and its value must be dealt with on a case-by-case basis.

Let us return to Steve's situation. After the old woman had been stowed safely in the police cruiser, Steve put down his camera, surprised that he was the only one taking pictures of the arrest. At that moment, a representative from a local Quincy paper appeared, offering Steve a few dollars for his negatives. Steve had never sold a picture before. Without fully appreciating the value of his property, Steve turned his film over to this buyer, who published the picture.

Time Element Is Crucial

The next day Steve realized the potential of his pictures and he retrieved the film from the newspaper. He called the big dailies, T.V. stations, and wire services only to find out that his material was 24 hours old. The story had been published—no one was interested in his pictures by that time. His photos were stale.

The point of the story is: (a) don't underestimate the value of your pictures, and (b) don't wait too long to find a buyer for them. Even if other photographers are present at the scene of an accident or fire, their equipment might fail, or you might have a shot from a better angle. For the price of a telephone call, you can find out if an editor is interested and would like to see your film.

Because of the time element, the best market for spot news is a newspaper or wire service. If you have a timely fire, accident, or crime picture, the curious editor will ask you to bring the raw film to the newspaper office or will have it picked up by cab. A lab technician at the publication will develop the film, and an editor will quickly scan the negatives to determine if the photo has news value for that paper. If the story has significant national appeal, a news magazine like *Time, Newsweek,* or *U.S. News & World Report* might buy the photo. These magazines maintain very small full-time photo staffs, so they also buy outside photos. Good editors don't mind a quick telephone call on a spot news story, because they can't afford to ignore you and possibly miss the chance of publishing a Pulitzer Prize-winning picture.

**RIZER SHOOTS A FIRE FOR
THE *GLOBE*—
A CASE STUDY**

**FIRES:
Catching the Flames Without
Missing the People**

**ACCIDENT AND DISASTER:
Photos Grim But Necessary**

**CRIME:
A National Problem**

3
SPOT NEWS PICTURES:
Covering Fires, Accidents, and Crime

RIZER SHOOTS A FIRE FOR THE *GLOBE*—
A CASE STUDY

I was talking to George Rizer, *Boston Globe* spot news photographer, when suddenly a "beep-beep" pause "beep-beep" sound emanated from his jacket pocket. Without breaking stride in his conversation, George tilted his head a little, listening just a bit more intently. In a minute or two George knew whether the series of beeps signaled a false alarm, one of 50,000 in Boston every year, or whether the signal was the first sign of a fire that might cause major damage or even death.

Rizer, a leading young *Globe* photographer, carried his scanner radio in his jacket wherever he went. This portable device, no bigger than a transistor radio, fits easily into his pocket and has four crystal channels tuned to the fire emergency frequency. The beeper going off on the scanner indicated that someone had pulled the alarm on a fire box. Every fire box in the city has a code so that firefighters know its location. As soon as the alarm sounds in the nearest station the firefighters drop whatever they are doing and head for the pole. They slide down, jump into their boots and roar off in their trucks in the direction of the fire box. The trucks usually arrive within one to two minutes after the alarm begins to ring. The firefighters first determine whether there is a fire or a false alarm. If they discover a fire is in progress, the firefighters immediately radio back the size and extent of the hazard.

Rizer, whose friends call him "Sparky," listened for this first on-scene report. He had to decide whether the fire was big enough and therefore would last long enough for him to get there in time. One photographer cannot cover every city fire; most fires would be out by the time the photographer arrived. If the radio report indicates a false alarm or one alarm, generally Rizer passes it up; but if the on-air scanner report says "working fire," that signifies a substantial blaze—rated as one-half a second alarm.

When Rizer heard the alarm signal, he grabbed his camera bag and dashed out of the door. He knew the location of the fire by checking the code against a published list of the signals and their corresponding fire box locations. Thus, 2 long-4 short-2 long signals indicated that the box was at First and Main in Boston's Dorchester section. " 'Working fire' means the fire is literally working its way through a building," said Rizer. "With a fire of that magnitude, I'll have time to get there." The number of alarms indicates the extent of the emergency. With two alarms, additional fire companies with their added trucks, ladders, pumps, and hoses arrive and spread out down the street. A two-alarm fire ties up several companies for some time. Five alarms mean a major conflagration is under way.

The key to outstanding photographic fire coverage, according to Rizer, is getting to the fire on time. "If you can't arrive at a fire within a few minutes of the time the first alarm sounds, you might as well stay home," he cautioned.

As Rizer headed for the fire, he checked his map to determine the best short-cut route. Rizer admits that he "bends" the traffic rules to get to a fire quickly, but is careful to look out for apparatus of various fire companies which might be rushing to the same fire. To avoid the possibility of colliding with other fire trucks, he shut off his radio, opened his window, and listened for fire engine sirens. If he follows a fire truck, Massachusetts law says that he must stay at least 300 feet behind the vehicle.

The *Globe* photographer found a parking place that didn't block fire hydrants. Rizer cautions photographers to plan a good escape route. "You might be ready to get your film back to the office before the firemen are prepared to leave. If they are parked in back of you, you will be stuck until the fire is over and all the men have packed up their equipment. You'll miss your deadline."

Arriving at the scene of the fire, Rizer sized up the situation. Flames were

Previous page: *Caused by an electrical short, this fire in an airliner accounts for some of the $6 billion in property damage from fires each year.*
(George Rizer, courtesy *Boston Globe*)

Photojournalism: The Professionals' Approach

shooting out of the wooden triple-decker house. Rizer hunted for the right spot to take an overall shot of the scene. "You need a good record shot of the event, one that will tell the whole story," he said. Rizer stayed a distance from the scene and looked for a point of elevation. On a disaster story such as this one, he sometimes walks several blocks away from the fire, climbs on the roof of a building, and uses a wide-angle lens to capture the flames, the smoke, and the building in a single photo. For this fire, he needed to go only down the block, ask permission of the resident, and shoot from the second-floor porch.

After completing his overall shots, Rizer moved in closer to the fire, aiming his lens toward the firefighters as they battled the blaze. The intense heat hit Rizer in the face. The sparks shot off the building like Fourth of July firecrackers, dangerously arching down into the street. Changing direction, the wind blew a cloud of thick, black smoke which stung his eyes and scorched his lungs. For a minute the scene in front of him disappeared in the smoke cloud. The firefighters, busy hauling hoses, climbing ladders, and manning pumps, ignored Rizer. He moved around the house, staying out of their way, but still shooting all the action.

Rizer tried not to be pushy in a sensitive, tragic situation like this home fire. Discreet use of the camera and lenses of longer-than-normal focal length enabled him to work unnoticed, as he caught the shocked and saddened faces of the building's residents and the tired and soot-covered faces of the firefighters. He also took pictures of the faces of the crowd, who always gather at a fire.

Finally, he recorded the extent of the damage—what was left of the building. To get this type of photo, when he does not have a pressing deadline, Rizer waits until the fire is extinguished, then goes inside the building to take his pictures.

Rizer's editor will not accept unidentified pictures, so he always tries to get factual data such as the firefighters' names and companies. After the Dor-

Above left: "A person being rescued is perhaps the best picture any editor would want," said George Rizer.

Above right: George Rizer knew that he had a strong story-telling photo when he tripped the shutter for this picture.
(George Rizer, courtesy *Boston Globe*)

chester fire was under control, Rizer interviewed both the fire and police chiefs for cutline information. He learned the cause and the exact location of the fire, the number of alarms sounded, and the companies that responded. After he asked the fire chief to estimate the extent of the damage, Rizer inquired about the names of the injured and what hospitals they were taken to.

I asked Rizer what kind of fire photo his editor liked best. He responded that a person being rescued was perhaps the best picture any editor could want. He added, "If you can tie certain story-telling elements together in one photo, such as a man being carried down a ladder with the burning building in the background, you have a strong publishable photo. If you snap a fireman giving mouth-to-mouth resuscitation to a victim, you have a photo which will not only grab an editor's interest but will rivet the reader's attention."

Rizer pointed out, however, that rescue pictures are rare; as soon as the firefighters reach a burning structure, they bring out the occupants. "Firemen usually rescue tenants within ten minutes of the time the fire starts," said Rizer. "Typically the photographer arrives too late for this dramatic shot, although I have seen fires where they were rescuing victims for over half-an-hour."

When Rizer reached the *Boston Globe* offices he headed for the darkroom. He knew he had a dramatic news shot on his film. At the fire he had quietly snapped a candid picture of a child watching her own house burning. A tear rolled down the child's cheek. Rizer clicked the shutter. The photo of the child ran three columns wide on the front page of the *Globe* the next morning.

FIRES:
Catching the Flames Without Missing the People

Fires Cost Money and Kill

Reporting fires is an important job of the photojournalist. Each year more than a half-million homes catch fire. Besides homes, fires start in apartment houses, stores, office buildings, and factories. Fires sweep through schools where children are having classes. Autos and trucks burn up, and fires devastate forests in all parts of the country. Altogether three and a half million fires were reported in 1977, costing $6 billion in property damage. Still, more serious than monetary loss, over six thousand people died in fires during that year.

Why Take Fire Pictures?

Although they have read the news about fires, people want to see pictures of the disaster. Fire pictures tell a tale that words can't describe. A writer would have difficulty capturing the agony of a homeowner as she watches her house burn down with all her worldly possessions inside. An author would have to stretch for words to relate the exhaustion of the firefighter who has battled flames and smoke continuously for eight hours.

A photo can show not only the emotion of the participants, but also the size of the fire better than words can describe it. If a fire breaks out on the twenty-third story of a building from which an occupant might jump, a photo can supply the reader with a clear idea of just how high twenty-three stories really is. The reader can quickly grasp the danger of jumping from that height. If a wooden warehouse catches fire, requiring four companies to halt the spread of the flames, a photo can give the reader an idea about the vastness of the blaze. After the fire has been extinguished, a photo of the charred remains carries impact beyond a

Out-reached hands safely caught this baby, who was dropped carefully out the window as a fire raged through the triple-decker wooden house.
(David G. Mugar)

mere statistical description of the loss. A photo of a house burning or an office worker trapped in a building initiates an emphatic reaction in the viewer, who thinks, "that could be my house . . . , that could be *me* in that building." The photo brings home the impact of the fire.

Most people have an inherent fear of fires, yet they are curious about them. A photo enables readers, while sitting in the safety of their living rooms, to study closely a fire with its leaping flames and billowing smoke.

Judging the News Value of a Fire

Every newspaper reports local fires, but their relative significance depends not only on the size of the fire but also on the size of the newspaper. On a small-town paper, a photographer covers almost every fire because residents know their neighbors and are interested in their welfare. Readers want to know if anyone has been hurt or killed, and what damage has been done. A metropolitan newspaper limits its fire coverage to a major conflagration of disastrous proportion, except when people are involved and extensive property damage results. National magazines and newspapers report fires only if they are extensive, engulfing a skyscraper or a whole city.

In addition to the size and the number of people involved in the fire, picture newsworthiness depends on the nature of the burned building. If the town's 200-year-old-white-columned historic church located on the main square burned down last night, local residents want to know how it happened. When a factory that employs two thousand of the city's residents goes up in flames, the public desires to learn every detail, even if no one died.

Sometimes a fire that carries little news value as a written story can result in an excellent photo story. For instance, a picture of a tough-looking fireman administering oxygen to a tiny dog grabs at the heartstrings of the reader, even if the fire was minor and caused no damage.

Opposite page: This fireman battled through an ice-cold New England night to suppress a blaze. A photo like this produces an impact on the viewer that words cannot match. (George Rizer, courtesy Boston Globe)

The tough-looking fireman, with his cigarette dangling from his mouth, administers oxygen to a tiny dog. This scene adds human interest to the event and, therefore, carries news-value, regardless of the size of the fire. (Bruce Gilbert, Miami Herald)

Photo Possibilities at the Fire Scene

Overall Shot Sets the Scene

When you first see a fire, you should take a record shot since you don't know if the fire will flare up or die down. Later, to establish the size of the blaze, the location of the trucks and the type of building that is burning, you might look for a high vantage point from which you can shoot an overall photo.

This overall shot, taken from a high angle, established the size of the blaze, the location of the trucks, and the type of structure that was burning. (J. Walter Green, Wide World Photos)

Victims, Firefighters, and Crowd Add the Human Side

Once you have your overall, look for the human side of the tragedy. Are people trapped in the building? Will the firefighter bring up ladders to rescue the occupants or have they already escaped? Do the firefighters have to administer mouth-to-mouth resuscitation or other kinds of first aid?

Meanwhile, don't overlook the efforts of the firefighters to put out the blaze. Without interfering with their work, shoot the ladder and pump companies as they spray water on the flames. Keep an eye out for people overcome by smoke or exhaustion.

Fires inevitably attract people. Whether in a big city or a rural town, whether neighbors or just passersby, a fire brings out an audience. The crowd stares with wide eyes and open mouths, seemingly transfixed. Try to capture on film this psychological attraction.

Property Damage Presents Economic Angle

Show the dimensions of the incident so that the reader learns whether the fire was a minor one or a major conflagration. Take a picture that indicates the kind of structure burned—single-family home, apartment house, business, or factory. Show how near the burned building was to other threatened structures in the neighborhood.

As the fire subsides, seek out a location where you can shoot a summary photo showing the extent of the damage. If you can accompany the fire inspector into the building, you might be able to photograph the actual cause of the blaze. When the fire marshal suspects arson, detectives will be called in to investigate. Investigators at work supply additional photo possibilities.

A photographer can return to the scene of the fire the following day to photograph the remains of the charred building. Often, residents return to salvage their property. The next day's photo of the woman carrying out her water-soaked coat might communicate more pathos than the picture of flames and smoke of the night before. You can also follow up a fire story by checking to see whether there has been a series of fires in the same area over the past year. If you find that certain blocks of houses or stores tend to have an unusually large number of fires, suggest that the editor run a group of fire pictures on one page, demonstrating the persistency of the fire hazard in that neighborhood.

The human side of a news event almost always carries more reader interest than does a record of the property damage.
(Randy Trabold, North Adams [Massachusetts] Transcript)

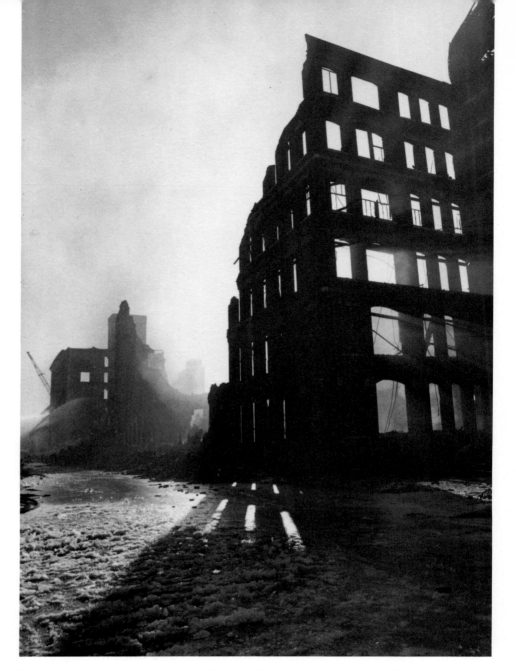

The photographer checked back after this fire was extinguished to get this eerie picture of the damage.
(Nick Passmore)

Features Highlight the Sidelights

Besides spot news, a photographer can find good material for feature photos at fires. A picture story about the Red Cross worker who attends every fire might provide a sensitive side-bar story. A small town may have an all-volunteer company, including a dentist who drills teeth and a mechanic who repairs cars when not battling flames. Capturing this split life in pictures offers a unique photo feature story to your readers.

Night Fires Are Difficult

Night fires have a tendency of sneaking up between midnight and 6 A.M. Generally, at this time, people are sleeping, and the smoke goes unnoticed. Arsonists choose the nighttime for this reason. Because fires are not reported quickly at night, they tend to be larger and more frequent. Photographically, nighttime fires pose difficulties.

Rizer does not take a light-meter reading at nighttime fires. He says, "Why bother? It wouldn't do any good anyway. A meter reading will be misled by the

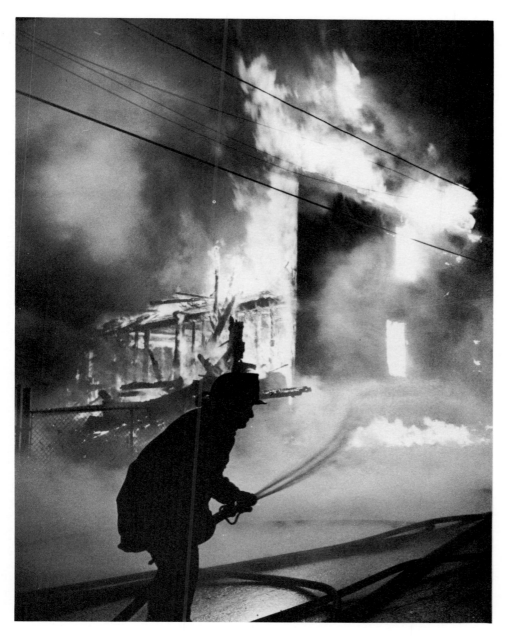

Night fires, like this one, tend to grow large because occupants are asleep and don't notice the smoke. If the building is burning like a Christmas tree, as in this photo, use 1/15 sec. at f/2.8 with Kodak Tri X film. (Donald T. Young, Herald File, Print Division, Boston Public Library)

light from the flames and will not give you an accurate indication of the amount of light reflected off the sides of the building." At night with Tri-X film, Rizer uses a slow shutter speed, a wide aperture, and an electronic flash to help light nearby areas. For the overall shot of the building, he uses ¼ of a second, f/2.8 with a 35mm lens, and a Honeywell handle mount electronic flash. A ¼-second exposure is slow enough to catch the flames and pick up any available light hitting the building. At a faster shutter speed, the flames would still appear in the print, but the building would go completely black. Within 50 feet, the flash also helps to light up the building. At ¼ second, however, the photographer has to be careful to avoid any slight camera movement during the exposure. Rizer recommends resting the camera on a car, a fire hydrant, or holding the camera tightly and leaning against a lamppost to cut down camera movement.

Rizer doesn't use his flash when the flames start shooting out of every window in the building. He says, "If it looks like a Christmas tree, you can shoot in available light with a shutter speed of 1/15 of a second and you'll get great action-packed fire pictures."

Spot News Pictures: Covering Fires, Accidents, and Crime

ACCIDENT AND DISASTER:
Photos Grim But Necessary

100,000 Die in Accidents Each Year

(Dateline Baltimore)—One Man Dies, 21 Hurt in Bethlehem Steel Gas Blast
(Dateline Houston)—Fatal Accident on the Southwest Freeway Kills Two
(Dateline Topeka)—Tornado Causes $1 Million Property Loss

So read the daily headlines, as accidents take their toll of more than 100,000 lives and ten million injuries each year, according to the National Safety Council. Almost half of the accidents in the United States involved motor vehicles. But people also die from falls, burns, drownings, gunshot wounds, poisonings, and work-related accidents.

Accidents make news. If a million Los Angeles residents drive home on the freeway safely Friday night, that's not news. But if two people died in an auto crash at the Hollywood Boulevard on-ramp to the freeway, then newspaper buyers want to read a story and see a picture of the accident.

With a kiss of life, a power lineman saved his co-worker. But other employees are not so lucky; 13,000 persons die in work-related accidents each year.
(Rocco Morabito, Florida Publishing Co.)

Accident Pictures Shock the Reader into Caution

First, accidents and disasters occur. Mines collapse. Hurricanes strike. Cars collide. They happen. They are facts of life. To record what goes on in the city and to keep readers informed about what's happening constitute two of the major roles of the press.

Second, readers are curious about accidents. Note how many people slow down and look as they pass a collision on the highway. Listen to what people talk about when they get home. Few people will fail to mention a major accident on the turnpike.

Third, people want to see what they read about. A thousand dollars worth of damage means little until the reader sees some visual evidence. When a story says a car was totally wrecked, readers believe it only when the story is accompanied by a picture of a Volkswagen mashed into the shape of a tin can.

Fourth, accident pictures grab the emotional side of the reader. Accidents can happen to anyone. A mangled body, lifted from a wrecked car, reminds readers that but for chance they might have been in that car. The picture brings the tragedy home. The photo may shock readers into avoiding similar accidents themselves. If cutlines indicate the place of the accident, readers may make a mental note to be more careful when approaching that intersection.

Not All Accidents Merit Coverage

"Two car pile-up at Main and Broadway . . . ambulance on the way," crackles over the scanner radio in the photographer's car. The photojournalist must make

Lucky, lucky, lucky — driver and passenger escaped unharmed. The value of a picture like this is that it will shock many readers into slowing down the next time they cross railroad tracks.

(John Connolly, *Herald* File, Print Division, Boston Public Library)

a news judgment: Is the accident important enough to cover? Will a picture of a multiple-car crash get play in the next day's paper?

Some factors that influence a decision about the newsworthiness of an accident might include:

■ Were people rescued, hurt, or killed? If the driver died and the attending physician puts the passenger on the critical list, the story of the accident will probably get coverage.

■ Was the damage excessive? When an oil refinery blows up, putting people out of work for months, the economic impact of the accident merits strong play in the paper.

■ Was the accident large? The size of the accident, even if no one was hurt, gives the incident importance, especially if the mishap involves buses, trains, or planes.

■ Was a public official or celebrity involved? If the mayor accidentally shoots himself with a gun, the story gains interest beyond a routine firearm accident.

■ Was the mishap unique in any way? Did one of the cars, for instance, land in a swimming pool? Did a husband in one car and his wife in another run into one another?

The news value of an accident picture sometimes depends on factors other than the nature of the collision. For example, a paper in a small town might feature

The driver was rescued by a rope when the cab of this trailer truck went over a bridge. A dramatic rescue like this adds news-worthiness to any accident picture.
(Virginia Schau, Wide World Photos)

A truck lands in a swimming pool. The unusual nature of this incident adds news value to the accident picture. (Michael Murphy, Houston Chronicle*)*

an accident photo that would not even run in a major metro. Fender-benders happen so often in a big city that some dailies don't even bother to cover such accidents.

The introduction of television's electronic news-gathering (ENG) equipment has cut down on the traditional amount of accident coverage in the newspaper. A major collision on the freeway at 5 P.M. rush hour can roll on the 6 P.M. local news show. Coverage of the same accident in the next day's newspaper seems dated.

Individual policy of the paper can also determine the play of an accident picture. Some editors feel that, because auto accidents happen every day, they are no longer new, and therefore do not qualify as news. By comparison, other editors view the alarming rate of injuries and deaths by motor vehicles as a trend—a trend their readers are talking about. These editors feature accident pictures to bring home the horror of reckless driving. The editors print wreck pictures to try to scare their readers into better driving habits (see chapter 9, "The Art of Picture Editing").

Photo Possibilities Range from Tragic to Bizarre

If a hundred accidents take place during a day in a typical city, no two will be identical. However, all accidents have certain points in common for the photographer to look for.

Concentrate on the human element of any tragedy. Readers relate to people pictures.

Check Human Tragedy First

Make a straightforward record of exactly what happened at the scene. The viewer doesn't know how the two cars hit, or where they landed on the street. The viewer wants to see the relationship of the cars to one another and to the highway.

Need Record of Accident

In some situations the accident story is better told with a symbolic rather than a literal picture. A bent wagon lying in the street carries its own silent message. There is no need to show the body of the dead child.

Symbolic Pictures Imply Rather than Tell

From the mangled wagon, the reader quickly realizes that a young child has been killed. Ralph Senne, 9, was hit by a rubbish truck as he stepped off the curb. (Bill Seaman, Minneapolis Star, dist. by Wide World Photos)

Photograph Cause

In many news events such as riots or murders, there is no way of capturing on film the cause of the disturbance. At an accident, however, you can sometimes show clearly what caused the collision. For instance, if a car failed to stop on a slippery street, you might show the wet pavement in the foreground and the damaged vehicle in the background. On a dry day you might photograph the skid marks left by the car as it screeched to a halt. Perhaps the accident was caused by the poor visibility of street signs. In that situation a picture that showed the confusing array of flashing lights and day-glo billboards that distracted the driver at the stop sign would be effective.

Look for Effect

Accidents affect more than the drivers of the involved vehicles. If a bridge collapses, look on both banks for long lines of blocked traffic and drivers slowing down to gaze as they pass the site.

Follow-up Story

If accidents keep occurring at one particular intersection, you might keep track to see if the highway department does anything to improve the hazard. A time exposure of the intersection at night, showing the traffic congestion, might help to spur the highway department into action.

Feature One Aspect

Notice how people adapt to their misfortune. Record the kinds of items people save from their wrecked vehicles. Note whether they get angry, sad, or frustrated. Catch the sorrow on the face of an owner of a new Corvette as she views for the first time her crumpled fender. See if an owner of a ten-year-old Volkswagen reacts the same way when he sees the damage inflicted on his "bug." Don't become hardened to accidents. No matter what the size of the mishap, the accident usually is still a major tragedy, or traumatic experience, to the individuals involved.

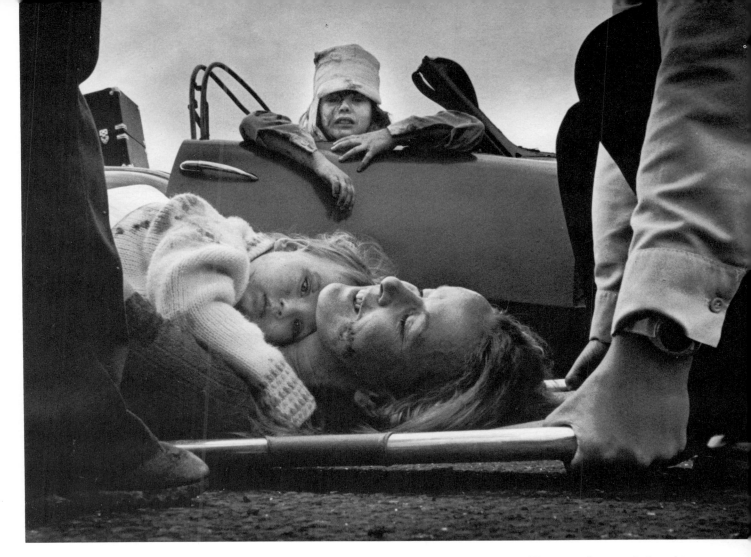

The Biggest Problem Is Getting There

Taking pictures at the scene of a spot-news event requires a photographer with a cool head, someone who can work under pressure and adverse conditions. You need no unusual equipment or techniques—just steel nerves and an unruffled disposition.

However, before you arrive at the accident scene, you must be prepared. Load your camera and charge up your electronic flash so you will be ready to start clicking the minute you get out of your car.

In fact, getting to the accident in time becomes the biggest challenge for the spot-news photographer. If you are stuck on the north loop and two cars crash on the south loop, by the time you get to the scene you might find only a few glass shards from a broken windshield. The ambulance has come and gone. Removed by the wrecker, even the smashed vehicles are on their way to the garage.

Consequently, a spot-news photographer's two most important pieces of equipment—after camera gear, of course—are a scanner radio and a city map. The radio provides the first report of the accident and the detailed map shows the quickest way to get to the scene of the collision. Stanley Forman, two-time Pulitzer Prize winner, attributes his success to the fact that he knows his city like the back of his hand.

A spot-news photographer finds the hardest story to cover one in which all forms of transportation have come to a halt. During a flood, hurricane, tornado, or blizzard, you often can't drive your personal car or ride public transportation.

Five people were injured in this accident but all lived. As the rescue team removed the passengers, the mother asked for her baby. Dan Poush concentrated on the human element of this tragedy. Camera reporters should never become indifferent to a victim's pain and grief. (Dan Poush, Statesman-Journal Newspapers, Salem, Oregon)

Faced with a major natural disaster, you can sometimes get assistance from one of the public agencies such as the police department, fire department, Red Cross, civil defense headquarters, or the National Guard. In case of disasters at sea, you can telephone the Coast Guard. Each of these agencies has a public information officer who is prepared to handle problems and requests from the media. When a major disaster occurs, many of these agencies will provide not only facts and figures, but transportation for the news photographer.

When the *Argo Merchant*, an oil tanker, ran aground, cracked in half, and sank off Nantucket Island, leaking thousands of barrels of oil into the sea, I contacted the U.S. Coast Guard on Cape Cod in Massachusetts. The Coast Guard arranged for me to fly in one of its planes over the site of the wreckage to take pictures. In another instance, during New England's 1978 blizzard, when the entire region, under four foot snow drifts, came to a stand-still, the National Guard provided photographers with a four-wheeled drive jeep and a driver so that they could shoot some of the outlying areas hit by the storm.

And as New England photo bureau chief of UPI, Dave Wurzel, said, "When a big storm breaks and everyone else heads for home, that's when the spot-news photographer goes to work."

An oil tanker, the Argo Merchant, *broke apart at sea. To cover the sinking of the tanker, the U.S. Coast Guard provided a press plane that flew over the wreck, enabling photographers to take pictures of the ship and the oil spill. (Ken Kobre, University of Houston)*

When a major storm or blizzard ties up all transportation, a public agency, such as the National Guard, can provide four-wheel-drive jeeps and trucks to help camera reporters cover the story.
(Tom Wolfe, *Exeter* [New Hampshire] *News-Letter*)

CRIME:
A National Problem

Photographing an Actual Crime in Progress

Irving Phillips, Jr., a photographer on the *Baltimore Sun,* was driving in the city when he swerved to miss several men scuffling in the street. He stopped his car, grabbed his motorized Nikon with its 200mm telephoto lens, and started back to the fight scene. He managed to click off sixteen frames of what turned out to be an attempted larceny in progress. John Mitchell, age 52, was attacked by two men after he cashed his paycheck at a local liquor store. Mitchell, who had a heart condition, fought off the muggers with a 6-inch knife, while Phillips photographed the chase and the fight. Phillip's photographs were used to identify the assailants who were later captured; the pictures were used as evidence in the trial.

The unexpected outcome for Phillips was that he received hate mail. Nine out of ten letters to the paper wanted to know why he had taken pictures instead of leaping in to stop the fight. One letter writer, however, noted that Phillips was doing exactly what he does best—informing the public by photos about what was happening: "If he dropped his camera to pitch in and 'help', we would never have the pictures that caused so much civic concern, and led to the arrest and conviction of the assailants."

Phillips's photos are rare. Unlike reporters who can reconstruct the details of a mugging from police reports and eye-witness accounts, the photographer has to be at the crime scene during the holdup to get action pictures. Criminals, however, rarely announce the time and place of their planned robbery!

Usually, kidnappers, rapists, and murderers shy away from the harsh glare of public exposure. However, a photographer with a good news sense can learn to predict some situations that might erupt into violence. For instance, a group called ROAR, Restore Our Alienated Rights, began organizing opposition to court-ordered busing the summer before South Boston's all-white high school was scheduled for desegregation. The press, tracking the growing size of the protest, evaluated the intensity of the local residents' feelings, and predicted chaos, perhaps even violence, on the first day of classes. Photographers and reporters representing both local and national media gathered early in the morn-

Spot News Pictures: Covering Fires, Accidents, and Crime

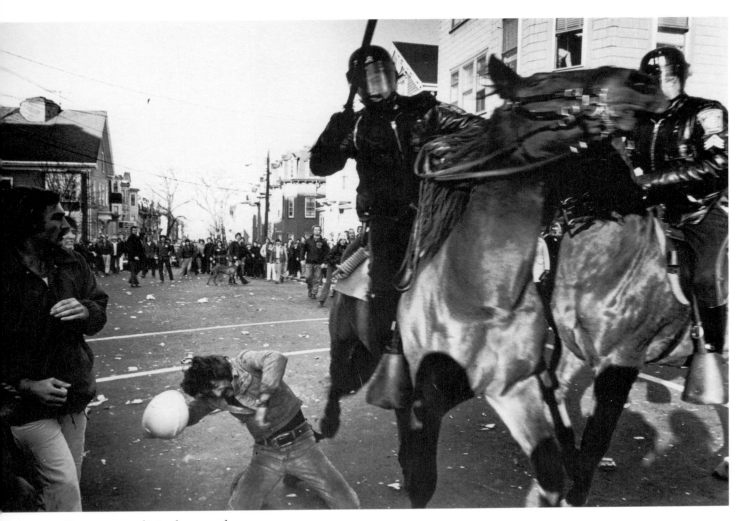

You can predict where and when some crime news will occur. Violence was likely on the first day of busing at South Boston High School. As school opened, mounted police, using billy clubs, broke up the rock-throwing, anti-busing demonstrators.

Vandals painted racial slurs on the doors and sidewalk of South Boston High School the night before the school was scheduled to begin desegregation. The epithets on the doors and sidewalk helped to explain the racial hatred underlying the violence that took place the next day.

Street Riots Follow First Day of Forced Busing in Boston

Photos by Ken Kobre,
University of Houston

The police arrested a teenager after he allegedly threw rocks at a bus carrying blacks to the previously all-white high school in South Boston, Massachusetts.

The first black student to enter South Boston High School was guarded by a large contingent of local and state police. While the police protected the black students, the police, unfortunately, did not provide security for the news photographers during the ensuing disturbance.

ing in front of the school. Hundreds of police, assigned to escort the blacks from bus to building, stood across the street from taunting white teenagers and their parents. When the buses carrying the blacks arrived, the crowd broke through the police lines. A full-scale riot started. Mounted police scattered the rock-throwing demonstrators.

During the ensuing violence, the crowd pelted the newspaper and T.V. photographers with rocks and bottles. The police provided no security for the working press; officers even tripped and pushed the photographers. Many demonstrators were arrested. Fortunately, no photographers were seriously injured. Caught between the police and the demonstrators, the media were hated by both. White residents of South Boston thought the press too liberal in its support of integration; the police believed the press had unfairly criticized them.

Crime Makes the Headlines

Crime, whether it's a burglary in Baltimore or a riot in Boston, is costly to society. It can be a deep human tragedy for criminals and their families as well as for the victims and their families.

Crime, almost any kind, makes a printable story in most newspaper offices throughout the country. The cub reporter soon learns that whether it is an atrocious murder, or a $100 hold-up of a gasoline station, the event is considered news in city rooms from coast to coast. Depending upon the degree of violence of the crime, the amount of money involved, the prominence of the people affected, or the humorous or unusual aspects of the crime, the news is featured with varying amounts of emphasis.

According to the latest figures available (1977) from the Federal Bureau of Investigation, in one year 19,120 murders, 63,020 rapes, and 404,850 robberies were committed in the U.S. In addition, over ten million burglaries and thefts were added to the record in that year. Crime, clearly, is a major problem.

Photos Bring the Crisis Home

Crime pictures rivet the attention of the viewer. The success of T.V. cop shows, dating back to "Highway Patrol" and followed by such shows as "Ironside," "Kojak," "The F.B.I.," and "Columbo," proves the solid unflagging public interest in crime viewing.

Actual news photos take the viewer from the fantasy realm of television to the real crisis in the streets. Crime photos in the paper remind the viewer that felonies don't stop at 11 P.M.; they can't be switched to another channel, or turned off at bedtime.

The news photo emphasizes the point that crime remains a major local problem. When readers recognize the street where a man was shot yesterday as the one they work on, when they realize the bank in the holdup is the one where they make a deposit, then the abstract crime figures—19,120 murders, 404,850 robberies last year—take on a personal meaning.

The public's insatiable curiosity about crime photos accounts also for editors' continued use of such photos. Few readers can resist inspecting a photo of a mugging in progress or a grocery store hold-up.

Perhaps readers' curiosity for crime pictures lies in a deep-seated belief that criminals look different from regular people. Even though psychologists have disproved the notion of "the criminal face," the reader checks to see if the convict has close-set eyes or a lowered brow—just as the reader suspected. But, to the unending surprise of the newspaper buyer, criminals appear quite normal.

Pictures of murder and mayhem not only excite readers' interest and satisfy their curiosity, but provide information hard to visualize from a written

description. Photographs of the drug bust indicate how big ten tons of marijuana really is. Photos of an ambush explain how near the sniper actually was to the victims. A portrait of the thief shows how frail-looking was the grandmother who robbed five banks. A newswriter would have to search long and hard for words that describe a crime scene with the clarity of a simple spot-news photo.

Evaluating a Crime Photo's News Appeal

Sometimes crime photos take on an importance beyond the news value of the story they report. Because photographers rarely record a crime in progress, or an actual arrest, editors play these rare photos on the front page regardless of the significance of the incident. Without the drama of Phillips's mugging photos, the *Baltimore Sun* editors would have buried this routine assault story with a few paragraphs on page 13; instead, the story received page 1 display. The value of the photo depends not only on the importance of the crime, but on the immediacy and freshness of the photos.

Besides action, the photo editor evaluates a crime picture on the basis of the severity of the incident. Were people injured or killed? Few papers failed to run pictures of the mass suicide of members of a religious group in Guyana in 1978. Both *Time* and *Newsweek* carried color photos on their covers. An editor also evaluates a crime photo based on the size of the property involved. Was a large amount of money stolen? The $2.8 million Brinks robbery in 1950, largest as of that date, produced banner headlines across the front pages of American newspapers.

A photo of Susan Saxe, accused of holding up a bank, contained news value beyond simple robbery. First, Saxe was a student at Brandeis, a private New England University; second, the holdup resulted in the death of a policeman; third, the crime appeared to have political as well as "revolutionary" overtones. This crime story, therefore, received extra media attention.
(George Rizer, courtesy Boston Globe)

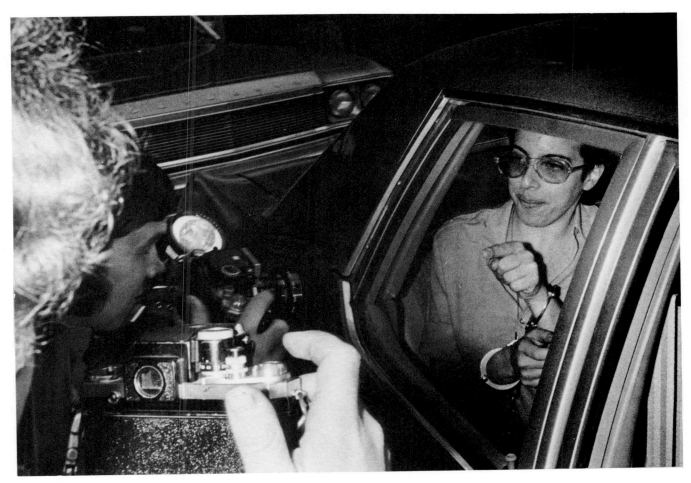

Spot News Pictures: Covering Fires, Accidents, and Crime

Crime Photographer Plays Sherlock Holmes

Crimes range from simple assault to kidnapping, rape, homicide, and murder. Crimes against property include larceny, robbery, embezzlement, forgery, and extortion. States have various laws against prostitution, obscenity, riots, and certain types of gambling.

In truth, the photographer rarely has the opportunity of photographing any of these crimes in progress. Most of the time the photojournalist arrives on the scene after the deed is done. Then comes the job of a Sherlock Holmes, with a camera instead of a magnifying glass. Like Holmes, the photojournalist must put the pieces of the crime together from the evidence that the criminal left behind.

Let's take one frequent event—a bank robbery—and see how the photo-sleuth might handle it.

The photographer gets a call from the assignment editor: "Head down to the First National; I think they've been robbed." The crime photographer begins to review mentally the list of possible pictures.

Start with the Victim

I will first need to check and see if anyone was injured or killed during the robbery. Since the injured victims are usually rushed to the hospital, I need to get these pictures as soon as I arrive at the bank.

Determine the Method

Did the robber blow the safe or pick the lock? Pictures of the vault door off its hinges will tell the reader which method the thief employed. Any tool of the trade, such as a crowbar, mask, or package of dynamite, left behind, will also help the reader understand the burglar's procedures. I'll check to see if the criminal used force. Were there overturned chairs, bullet holes in the wall, or guns on the floor?

Show the Loss

With the safe door open, I'll take a picture of the cash, checks, and securities scattered around the floor and shoot a photo of the pried-open, private bank boxes.

Police interviewing a young subject after a hold-up in a housing project.
(Ken Kobre, University of Houston)

As the police interview a witness, I'll take a photo. In a big robbery I'll need at least head shots of the primary investigating officer and the key witnesses. Other subjects I'll watch for will be the fingerprint and ballistics experts as they examine the scene.

Because of my friendship with the precinct desk sergeant, I might get a tip-off when the police arrest the suspect. If I miss the actual arrest, I might get pictures of the suspect entering or leaving the police station or later going in and out of the courtroom.

Almost no crime provides all the picture possibilities that this photographer has envisioned. In fact, at some crime scenes, the photographer has to search long and hard for one good photo to go with the story. But there are enough possibilities to provide some ideas for interesting photographs.

Track the Culprit

Cover the Arrest and Trial

Recap

Working with Uncooperative Subjects

George Reidy, photographer for the old *Boston Herald,* once said, "The true test of a news photographer is getting pictures of criminals entering or leaving police headquarters. The prisoner is moving quickly and trying to hide his face. The photographer has to follow the prisoner, sometimes moving backwards, focusing all the way and always trying to get a shot of the prisoner's face. If the cameraman succeeds at this we can call him a news photographer." To avoid taking the time to refocus, the photographer can walk backwards, keeping a constant distance between the camera and the subject. (See the section on zone focusing in chapter 7, "Capturing the Action in Sports.")

As Reidy points out, "It's hard enough to take a picture of a suspect if you know who he is, but how about the situation where you've never seen the suspect before?" When J. Walter Green, of the Associated Press, has to photograph an unfamiliar suspect at a trial, he will peer into the courtroom and carefully identify what the defendant is wearing. "You want to see how the person is dressed

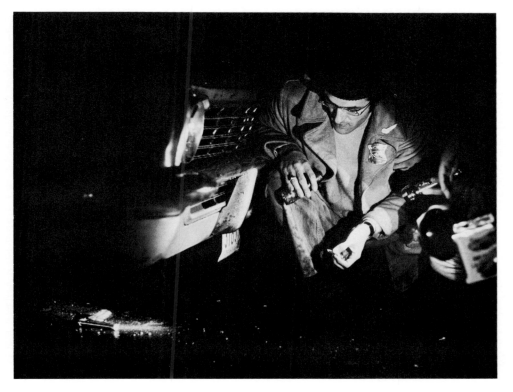

This gun was found after a tactical patrol force police officer shot and killed a suspect. Court testimony later revealed that the policeman illegally planted the "throw-down" gun at the scene of the shooting. The innocent victim was unarmed. This photo, used during the trial of the officers, added an important link in the chain of evidence demonstrating a cover-up by the police department.
(Ken Kobre, University of Houston)

Police arrested and photographed antinuclear protestors at the site of the Seabrook, N.H., reactor. The stuck-out tongue of the protestor introduced some humor to the otherwise solemn news event, giving the picture its unique flavor.
(Tom Sobolik, Concord [New Hampshire] Monitor)

and figure out what door he might come out of," says Green. By asking the sheriff which exit door will be used, the photographer can be positioned there ahead of time.

If defendants don't want to be photographed, they may hide their faces behind their hands. Green recalls the time that Raymond Patriarca, reputed Mafia boss of New England, was on trial. Speaking to Patriarca's lawyer after the first day of the trial, Green said, "We have great stuff of your client going into the courthouse. With his hands covering his face, your client looks like a real hard-bitten criminal. Why don't you do your client a favor and bring him downstairs, pose him outside. Then the photographers will leave him alone."

Patriarca's lawyer consented and persuaded his client to hold still for a picture. "Sure, Patriarca looked more like a criminal in my first set of pictures, but I made the second set because I thought the public wanted to see the Mafia boss's face," said Green. "I also knew that a picture of him covering up his face would not make the wires anyhow."

Sometimes photographers take surveillance pictures at night. Loaded with Kodak 2475 recording film, you can push the film with extended development to a nominal ASA of 4000 or 8000. You can get good detail in flat lighting situations and at least some record of the scene even in the contrasty lighting that is common at night when there is a great difference between brightly lit and dark shadowed areas. Producing grainy but recognizable pictures, you can shoot the action of the sleaziest underworld character handing over the payoff money or receiving the dope, even at night under poor lighting conditions.

Whether shooting a payoff at night with recording film or a plane crash during the day with Kodak Tri-X, the spot-news photographer must evaluate the situation quickly. Identify the newsworthy action immediately, and save the feature material for later. Usually taken under high-pressure conditions, spot news continues to be a major challenge for the photographer and an important ingredient of many newspapers and magazines.

4

GOVERNMENT AND ORGANIZATIONAL NEWS

Previous page: *President John F. Kennedy leaned on the table in his oval office during a moment of reflection. George Tames set his camera for a silhouette and snapped this graphic photo.* (George Tames, *New York Times*)

MEETINGS:
Tension and Resolution

Jim Atherton has faced the problems of shooting revealing political meeting pictures for twenty-five years, first for Acme News Pictures, then for United Press International (UPI), and most recently for the *Washington Post*. Located in Washington during his years in the picture business, he has covered some of the most momentous as well as some of the most trivial political conferences in the country. Today, as chief political photographer for the *Washington Post*, Capitol Hill is his beat.

Says Atherton, "A committee meeting is like a shooting gallery at the fair. You're there to shoot famous heads. You do not have to hunt down the lions of politics; they are captive on stage in front of you. You take careful aim and shoot with your camera." Atherton's prize shots are mounted on the front page of the *Washington Post*.

Meetings Generate News

Similarly, in other large cities and small towns photographers and reporters cover the news of governmental meetings, because they are important to readers. Meetings possess the same news value as do fires and accidents. Often, in fact, the results of a governmental meeting, especially those involving changes in the tax rate, for instance, directly bear on the lives of the reader, even more than yesterday's fender-bender on the expressway.

At each level of power, every governmental body—from city council and zoning board to state legislature to the United States House and Senate—forms public policy and takes action at meetings. The city council votes to add a new school to the district. The state legislature puts a ceiling on the mortgage rate. The Senate committee reviews a bill on national health insurance. All these meetings receive extensive coverage in newspapers and magazines, with written stories as well as accompanying pictures.

Other groups besides governmental bodies plan, decide, or announce decisions at meetings and awards banquets. The United Fund presents a plaque for the person donating the largest yearly gift to the organization's funding drive. The Committee for the Handicapped meets to review planned transportation facilities of the Transit Authority. The Chamber of Commerce announces a new advertising campaign to bring business to the city. Members of the Knights of Columbus elect new officers. Editors routinely assign photographers to cover these meetings, awards, and press conferences.

Spot news challenges the photographer to get to the breaking story in

Most photographs of meetings tend to look similar, because the meetings too often don't lend themselves to visually exciting or story-telling photos. To shoot eye-catching and different pictures requires a great deal of patience and thought by the photographer. (James K.W. Atherton, *Washington Post*)

time. Meetings and press conferences don't carry the same challenge. To cover these planned news events, the photographer has the advantage of knowing the time and place of the action.

With a yawn, this city councilman summarized the flavor of the long meeting.
(Peter G. Noble)

But the news of meetings and ceremonies does test the photographer's creativity. Unfortunately, a critical meeting of the Senate Armed Services Committee looks very much like an ordinary meeting of the local zoning board. If the pictures remained uncaptioned, readers could easily be confused. Press conferences as well as awards ceremonies all look homogenous after awhile.

A photographer's job, then, is to portray each planned news event in a way that features the event's uniqueness. The picture must be related to the news—a difficult assignment because planned news often takes place in evenly lit rooms, produces little action, and the participants display few props that would add clarity to the picture. Infrequently a panelist holds up a sign that tells the viewer clearly what the meeting is about. Few Senators carry placards that read "I think we should reduce farm supports." Sometimes, however, you can catch a city council member yawning, or a participant from the audience yelling, thereby summarizing the tone of the meeting.

Also, through the creative application of framing techniques, catching the moment, and using long lens and light, the photographer can help portray for the reader the excitement, the tension, the opposition, and the resolution of the meeting.

Face and Hands Give Emotion Away

When Jim Atherton raises his 80–200mm zoom lens at a committee hearing or press conference, he looks for expressive faces. A wrinkled brow, a grin, or a curled lip can add life to a routine meeting picture. Hands, also, reveal the emotion of the speaker, according to Atherton. The reader understands the meaning of a clenched fist or a jabbing finger.

Pictures of Senator Edward Kennedy speaking almost always get wide play in newspapers and magazines, regardless of the significance of the Senator's message.
(Phyllis Graber Jensen)

The *Post*'s political photographer watched both faces and hands when he was assigned to cover Senator Sam Ervin's Senate Select Committee investigating the Watergate break-in. In session for several weeks, the Committee was receiving top play in the nation's papers. The outcome of the Committee's investigation could lead to the first impeachment of a president. The daily sessions turned into a running nightmare for the assigned photographers. "There was

nothing worse than to cover the same damn speakers, with the same panel of Senators, sitting in front of the same green felt-covered table, day after day," lamented Atherton.

Excitement, however, peaked when John Dean, ex-counsel to President Richard Nixon, took the witness stand. Dean accused the President of the United States of breaking the law to cover up his involvement in Watergate. During the first day of his testimony, Dean read the lengthy text of his speech. The *Post's* photographer needed a unique approach to dramatize the speaker. "I had to make something with a little pizzazz," said Atherton. On that first day Atherton tried overall shots and close-up head shots, but on the second day of Dean's testimony the photojournalist concentrated on Dean's hands. Atherton produced a series of close-ups showing the ex-counsel's hands raised as he was sworn in, spread out as he listened to questions, drumming on the table as he read his text and fidgeting with his pencil as he waited during a recess. Sometimes Atherton would miss a characteristic mannerism the first time it occurred. But he noted, "I had patience; I knew Dean would repeat the quirk again; I just kept watching." Isolating one revealing element, Dean's hands, helped tell the bigger story of a young man seemingly cool, but really nervous underneath, who accused the President of the United States of lying. The poignant pictures were played on the front page in the next morning's *Washington Post.*

Revealing vs. Accidental Photos

Atherton warns that a speaker's facial expressions and hand gestures can be accidental and misleading. They might have nothing to do with the personality of the individual or the thrust of the message. Suppose during a luncheon, former Secretary of State Henry Kissinger is talking about détente with the Soviets. You take 100 to 200 frames. You might catch a shot while he is eating showing him with his mouth screwed up into a knot. This picture, although an actual shot, might not reflect anything about the nature of détente or even the speaker's character. The misleading picture, in fact, tends to distort the news rather than reveal it.

Richard Nixon's puckered expression tells the story of this press conference.
(James K.W. Atherton, UPI)

Photojournalism: The Professionals' Approach

For Jim Atherton, news means *politicians*. He describes himself as a head-hunter on "the hill." He shoots the faces of the famous. A Washington politician is news, whatever he does. If the president gets a cold, his press secretary calls a news conference to announce the medical details. This news causes the stock market to dip. Constituents want to read about the goings-on of their Senators and Congress members. Atherton notes that, "Washington is the only place in the country where you can take a simple snapshot of an elected official today and have it appear on the front page of every newspaper in the country tomorrow."

Translated into local coverage, this means that meetings, speeches, or press conferences in a town take on news value based on the personalities involved and on the importance of the subject debated. The photographer must

Personality Makes News

Depending on which photo you choose, former Secretary of State, Henry Kissinger, looks stable, important, and dignified . . .
(Arthur Rothstein, the *Look* Collection, Library of Congress)
. . . or awkward, funny-looking, and foolish. Pictures might not lie, but they can reflect many sides of truth about a person.
(Tom Kinder)

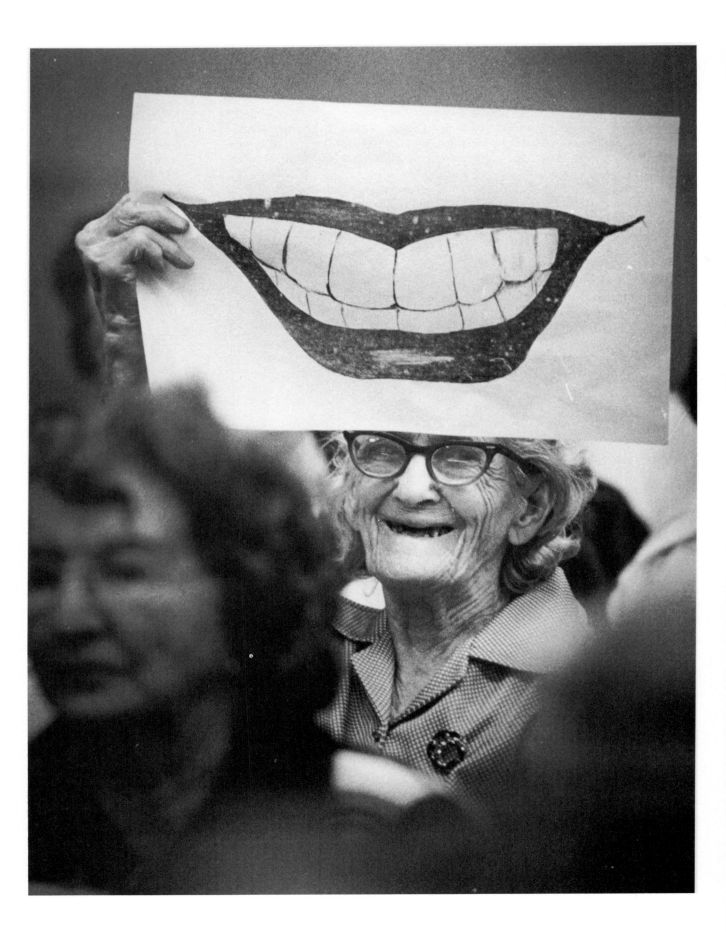

know or be able to recognize the players in the game without a score card. If you are not familiar with the participants in a meeting, you should ask someone for information about the speakers. What are their names? Which ones are elected officials? Who is best-known? With this information, you can zero in on the most newsworthy individuals.

Props can add a meaning to a routine meeting picture. If the speaker or member of the audience holds up a prop, the reader will have an easier time understanding the point of the photo. If the speaker who denounces the lack of gun control laws brings to the meeting a few Saturday Night Specials, the photographer can have the person examine or display the guns. Unfortunately, not all speakers have the camera-sophistication to bring along appropriate props when they talk at public meetings.

Props Communicate

Sometimes the photographer has to pose a picture after the meeting is over. Suppose two politicians start a debate during a committee meeting, but they are sitting at opposite ends of a long panel table. Even a long lens could not bring both of them together and in focus at the same time in one picture. At the close of the meeting, therefore, the photographer could arrange to have the two important participants together. Perhaps the two could continue to discuss the point at issue, and re-ignite the heat of their original debate.

When Posing Is Needed

Let the Sunshine in

Besides props and facial expressions, the quality of light and the choice of lens can also add impact to a simple meeting picture. When you walk into a meeting room, notice the quantity and quality of light in that room. Is the light sufficient? Is the room lit by natural light from the windows or fluorescent light from the ceiling? Check to see whether the light comes from in front of or behind the speaker's table. Note whether television lights will be turned on in the room during the hearing. If, after "casing" the room, you find the level of light too low, you might ask if you can open the window shades. If there is enough natural light streaming in through the windows you could ask if you could turn off the overhead lights.

If natural light is a photographer's best friend, then fluorescent light is his worst enemy. Fluorescent light is efficient, economical, cool, and saves energy. But for a photographer, fluorescent light is as exciting as white bread. Fluorescent bulbs emit light in all directions. The light bounces off ceiling and walls and even the floor. With enough fixtures, the light can illuminate every nook and cranny, leaving only dull highlights and faint shadows.

Fluorescent Light Is Bland

Some photographers, working in a room evenly lit by fluorescent light, will manipulate exposure and development to increase contrast. They underexpose their film, about ½ stop rating, for example, Kodak's Tri-X at E.I. (effective index) 600 instead of the normal ASA 400. Then they overdevelop the negatives about 25 percent, increasing the processing time with D76 (diluted 1 to 1), from 10 to 12½ minutes at 68 degrees. This underexposure/overdevelopment technique increases contrast of the negative.

Without the woman's sign in the picture, few readers would guess that this meeting focused on free dental care for the aged.
(Tom Strongman, *Kansas City Star*)

T.V. Adds Contrast

To add drama to a meeting picture, backlight a subject with the illumination from the television floods. This strong contrasty light helps to pop out the subject from the background.
(James K.W. Atherton, *Washington Post*)

Television lights not only brighten the room, but if used correctly can add contrast to the picture. The secret of using television light to add depth in a black-and-white picture lies in not shooting from the same position as the T.V. camera. If the main spot-light is located to the left of the T.V. camera, the still photographer benefits from cross-lighting by moving to the right of the T.V. equipment. The farther you move around the subject, and the greater the angle from the T.V. camera, the more the light crosses the subject's face. Cross-lighting means the brightest or main light is hitting the side of the subject's face farthest from the still photographer's camera. The side of the face nearest the lens is in the shadow. The contrast between the highlight on the far side and the shadow on the near side of the face brings out the texture of the subject's skin and adds roundness, which gives the whole picture an added sense of drama.

Separate the Subject from the Background

A photographer has to be conscious of not only ambient room light but also of the relationship between the tonal values of the subject and the background. How will the subject look on black-and-white film? A dark-suited Congress member can appear to fade into an oak-paneled wall when photographed with black-and-white film.

The contrast between the tone of the subject and the tone of the background takes on added importance if the picture is reproduced in a newspaper. Newsprint grays out the blacks and muddies the whites. If the original difference in contrast between the Congress member and the wall were slight, the tonal separation would be completely lost when the picture was reproduced on newsprint paper.

If you had to take a picture of a dark-suited city council member speaking at a meeting, you might circle the official, watching the background, looking for a light-colored wall or door that could offset the subject. If you can't find the correct background, then, after the speech has been concluded, you could ask the speaker to move to a different location in the building.

Sometimes, you still can't find a convenient background. Then you can shoot the pictures anyway and manipulate the tones of the background in the darkroom. In fact, some photographers claim that 50 percent of a picture's quality is created or destroyed in the darkroom. Burning and dodging can help separate the subject from the background, but the technique can produce a light halo around the subject's head if the photographer is not careful. Few politicians, however, deserve a halo. (See "Burning and Dodging Can Improve Print Reproduction," p. 198.)

Blow-up or Compression for Effect

When Jim Atherton covers an important committee meeting on Capitol Hill for the *Washington Post*, he slips over his shoulder three camera bodies: two Leicas, one with a 50mm and the other with a 35mm lens, and a Nikon with either a 24mm wide-angle or 80–200mm zoom. He bayonets the 24mm on the Nikon for "overalls" of the conference room, but saves the zoom for close-up portraits. The close-up, he notes, brings the viewer and the subject nearer than they would meet normally in public. Says Atherton, "A zoom is difficult to use because everything moves; the focus, the focal length, and the f-stops. Also the telephoto magnifies my hand movements. I'll lean on any sturdy object available; tabletop, chair, or doorpost to steady my aim." Atherton hand-holds the zoom lens for maximum flexibility and mobility. He often sets the shutter speed fairly slow (about 1/60 sec.) for this length lens in order to use a smaller aperture and get more depth of field. Atherton estimates that because he hand-holds the lens and shoots at a slow shutter speed he loses 60 percent to 70 percent of his frames

because of image blur. But, Atherton notes, 30 to 40 percent come out sharp. These rarer but striking pictures represent some of the photos that distinguish Atherton from the rest of the photo corps.

To avoid camera movement and to increase the percentage of sharp pictures, some photographers use extremely fast lenses and rate their film at higher-than-normal film speeds. With a fast lens that has a wide aperture, you can use higher shutter speeds to avoid the effects of camera-shake. The same result is produced when you use a higher effective film exposure index (E.I.). When you change the film index, you must give special development, such as using a high-energy developer like Acufine or Diafine. (See table on p. 198.)

Besides creating close-up portraits, the telephoto lens offers another advantage when you are covering a meeting or press conference. Often the important figures at a conference stretch out in a line down one side of a table or sit on

Shooting perpendicular to the line of speakers leaves large blank spaces between their heads.
(Jan Ragland)

When shooting these dignitaries, Jim Atherton moved to the side of the table with his telephoto, aimed down the line. Shooting from the side eliminated dead space between subjects. Photographing with a telephoto lens appeared to bring the subjects closer together.
(James K.W. Atherton, Washington Post)

a platform at the edge of a stage. If you stand in front of the line of panelists and take a picture, each participant's head will appear quite small on the final print. Gaping holes of unwanted space will lie between each speaker. If you move to one side or the other and shoot down the line of dignitaries, the panelists will appear in the picture to be quite close together with little space between them. The compression effect gets more noticeable as you use longer telephoto lenses and move farther from the subjects. However, the depth of field decreases as the length of the lens increases. So you may find it almost impossible to keep a long line of panelists in sharp focus when you shoot with an extreme telephoto. To achieve maximum depth of field, focus one-third the way down the row of dignitaries. You can put the camera on a tripod if you find you can't hand-hold the telephoto at slow speeds. With the aperture on a relatively small f-stop, all the subjects will appear sharp. Also, the panelists will look like they are sitting shoulder to shoulder without any dead space between them.

IN-DEPTH PHOTOJOURNALISM

Photograph the Subject of the Talk, Not the Talker

Even with the best lens technique, and keen sensitivity to light, photographers still have trouble distinguishing for the readers the difference between a city council meeting called to increase taxes and a meeting convened to decrease the number of district schools. The difference between these meetings lies in what

In Oregon a woman decided to test a local ordinance that permits topless sunbathing. The law, hammered out in a city council meeting, was translated into action— action that could be photographed. (Charlie Nye, *Eugene* [Oregon] *Register-Guard*)

Photojournalism: The Professionals' Approach

the council members said verbally, not what they did visually. The photojournalist must translate the words of the speakers into pictures that portray the underlying controversy.

Arthur Perfal, a former associate editor of *Newsday*, gave his view of the problem at a conference of editors conducted by Chuck Scott at Ohio State University. Perfal said, "Remember that people talking often supply material for good stories, but they seldom supply material for good pictures. Particularly when the same officials or the same chairman are doing the talking. Let the photographer go where the action is—*shoot what they're talking about.*"

If the Board of Education is having a hearing on a budget crisis, the reporter should cover the meeting. Then, if the crisis involves dropping the hot lunch program, the photographer should go into the school cafeteria and shoot pictures that will indicate what effects the budget cut will have. If the Board is contemplating eliminating school athletics, the photographer should go to the gym and the playing field, where a photograph can capture what the athletic program means to students. The photographer should go where the action is.

Investigative Photography Exposes Ghetto Conditions

One photographer, Michael O'Brien of the *Miami News,* left the meeting room behind and went where the action was to produce an impressive piece of advocacy journalism. In 1975 the city of Miami passed a $1.7 million bond issue to

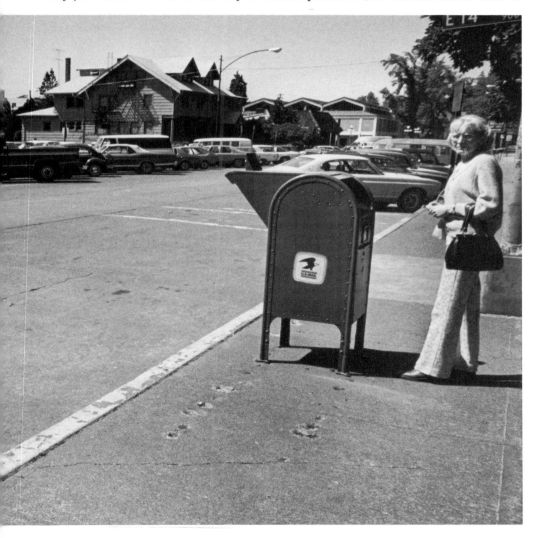

improve the parks of Culmer, a rundown black neighborhood in the inner city. The money never arrived. O'Brien had photographed individual stories about problems of Culmer, but the idea occurred to him that the paper needed to produce a documentary about life in this ghetto. O'Brien described the neighborhood as a place where, if you can't avoid it, you drive through with your windows rolled up and your doors locked.

Below is O'Brien's story-behind-the-story; it originally appeared in the magazine *News Photographer*, a publication of the National Press Photographers Association:

A Photographer Who Cares

Culmer is a 70-block area just west of downtown Miami. Its problems are not simple: Culmer is a ghetto. It has been torn by urban renewal, carved up by freeways and allowed to go to pot by various city and county administrations—and its residents. Neglected and abused for years, things weren't getting any better.

Who cares about a ghetto? It's just a place—somewhere to stick a jail or an auto pound without creating an uproar. Or spend only one-fourth of the money appropriated for parks and not even open the public pool. How can these people fight back when they have no voice?

But this is what the *Miami News* has tried to do—to give them a voice and let them have an opportunity to speak out about their problems and what they want to do about them. Culmer residents have a pride in their area, deteriorated as it is.

In early April when another assignment came in to photograph boarded up businesses in the area, I suggested that the reporter, Bill Gjebre, and myself, go into Culmer and do an extensive documentary. The thought was to run a story plus one page of pictures for five straight days.

Gjebre and I started. We spent two weeks in the area. Every day we got out of our car (our protection) and began to walk around. Initially, everyone was suspicious. The first day I was photographing in an apartment complex. A man around twenty came over and asked to see my camera; I had two around my neck. Without even looking at him, I continued photographing and handed him one of the cameras. Well, people say that was stupid—maybe so, but how can you expect someone to trust you if you don't trust him first. Remember, I was in his neighorhood. So I lost a camera.

Five minutes after this the police came screeching up to a building across the street. It was a domestic argument in which a woman had shot her husband right between the eyes, but the bullet bounced off his skull and he walked away from it. I thought to myself, "This is only the first day." I won't lie; I was scared.

There was only one other notably frightening experience: Gjebre and I were down at a ghetto store about 5 A.M. one day. There were a bunch of men around drinking wine, waiting for a bus to pick them up and take them to the field for a day of work. It was a group of around 20 men. I started making pictures when one came over and started screaming at me to leave. Well, I didn't say much but I didn't leave. He kept screaming until another man came over and told him to "cool it." The guy persisted and my benefactor pulled a knife on him and chased him down the street.

There were other physical problems in doing the story, but they were the exception. I found that if I was honest and direct with the people, most would be the same with me. I explained what we were trying to do . . . to show the way things were, to present a picture of the people and their neighborhood. I carried in my wallet copies of our editor's columns and had some of the people read them. On the whole

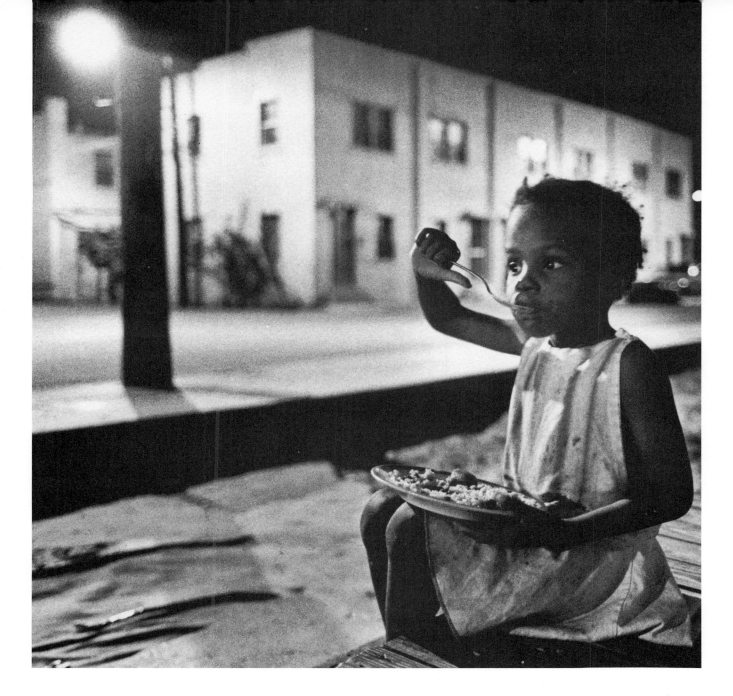

we were treated kindly. One family accepted us completely; we stayed two days reporting on their daily routine. It occurred to me that it would be a lot harder to do the same story in a suburb.

Calling the pictures good or bad is inappropriate. If the photographs convey with emphasis the plight of the people and their neighborhood, and show their problems in a way that affects thought in our readers, then they are successful. It's nothing fancy, it's just my attempt to say, "This is Culmer—take a look."

After directing attention for more than two months to Culmer and its problems we accomplished some things. For one, the pool reopened on May 20. An 11-member Chamber of Commerce committee has been named to spur redevelopment of the rundown downtown section with new homes, parks, and businesses. A black man, William Fair, the executive director of the Urban League, and Howard Kleinberg, editor of the *Miami News,* will serve as co-chairmen. The committee was formed

To go beyond the meeting rooms of Miami's Chamber of Commerce, Planning Board, and City Hall, Michael O'Brien, photographer for the Miami News, *went to Culmer, a poor black ghetto of the city, to investigate and shoot the real plight of the residents.* (Michael O'Brien, *Miami News*)

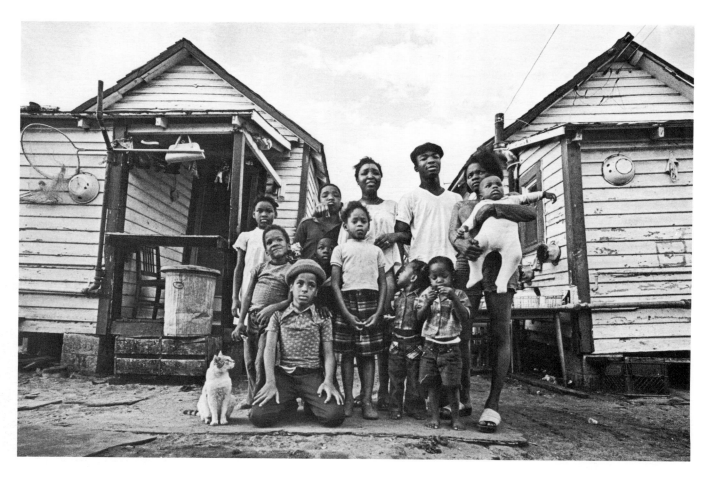

The Miami News's photographer spent two days with the Evans clan, taking pictures in their Crab Alley shack. O'Brien zeroed in on one typical family to personalize the problems of the whole community. (Michael O'Brien, *Miami News*)

In Culmer, O'Brien found the wigman who travels across Florida and Georgia, selling hairdos from the back of his station wagon. (Michael O'Brien, *Miami News*)

after Culmer residents told officials they did not want to be forced out of the predominantly black area but wanted to help develop it. The catalyst for this was the series of stories in the *Miami News*.

As a result of the story O'Brien and Gjebre worked on, Culmer received a half million dollar clean-up program as well as an urban renewal plan for a multi-million dollar project in the area.

Before O'Brien's photo story, the city had promised $1.7 million to improve the parks of Culmer, but no money ever arrived.
(Michael O'Brien, *Miami News*)

Many of Culmer's resident's, like Ben Thompson, didn't want to leave the area. Instead, with federal help, they wanted to improve the neighborhood. As a result of the Miami News's series on Culmer, the ghetto received $.5 million for clean-up and repairs. (Michael O'Brien, Miami News)

Ingredients for In-depth Coverage

What are the ingredients of good investigative photography?

O'Brien started with sound ideas. He knew the neighborhood and its problems because he shot several assignments there. His paper was located near the area. O'Brien wanted to go beyond the immediate news story of "Park Remains in Disrepair." He wanted to investigate the lives of those affected by this news. He wanted to transform a ghetto of statistics—number on welfare, number of muggings—into a neighborhood of individuals who were trying desperately to survive.

To give his story this personal feeling, the Miami photographer *zeroed in on the lives* of several residents who exemplified the area's problems. He and reporter Bill Gjebre told the story of Percy Bethel and P. A. Poitier, who make a living by reselling aluminum cans from the garbage dumps of Culmer. The two newsmen explored the problems of Eugene Taylor, a 27-year-old former Vietnam paratrooper, who sits in his room at night and hears rats running in between his ceiling and the floor above. The building's hot water works only sometimes and sewage often backs up in the rear alley. The photographer-reporter team presented the lives of the Evans family—ten people who live in two rundown shanties in Crab Alley. The news team spent two days with this family, documenting their household expenses and then showing the primitive housing the residents get for their money.

To tell the story of Culmer in any depth took time. In other photo stories for the *News,* O'Brien shot the photos between regular assignments or on his own time. For the Culmer series the *News* allotted him two weeks. Newspapers think nothing of assigning a reporter to an investigative story for a few weeks or even a month. But few editors extend this privilege to a photographer.

Of course, the photographer needed to make powerful images for the article and O'Brien's pictures were superb. Equally important, however, the images must have a showcase in the paper or magazine. On this point the *News*'s photographer extolled the help of his picture-sensitive editor, Howard Kleinberg, who ran the photos and story for five days. Each day the story opened on page one and then jumped to two pages, uncluttered by ads, on the inside of the paper. O'Brien called his editor innovative and daring. Kleinberg has devoted equivalent space to other projects like this.

O'Brien himself received personal recognition for the Culmer project. Florida's governor presented him with the Rubin Askew Black Awareness Award. He also received the Robert Kennedy Journalism Award and a Citation from the Picture of the Year committee for photos that most contributed to world understanding.

POLITICIANS AND ELECTIONS

Politicians seek interviews and photographs. Press aides dream up news events and organize news conferences to attract coverage. Astute politicians know that re-election depends on good media coverage. The monetary worth of a page-one photo cannot be estimated—most newspapers will not even sell front-page space.

A politician plans media events that attract the camera, even if the events themselves have little news value. Called "photo opportunities," press secretaries design these nonevents for the camera journalist. Here is one such event held by the White House during Jimmy Carter's presidency and reported by Anthony Lewis in the *New York Times* magazine.

"11 A.M. Photo Opportunity White House Tree House"

At 10:55 that morning 34 reporters and photographers lined up at the door of the White House press room. Then, led by Mary Hoyt (Mrs. Carter's press secretary), the group trooped across the broad green sweep of the south lawn toward a gigantic atlas cedar tree and the White House Tree House nestled in its lower branches. Squatting in the White House Tree House (WHTH) was the President's 9-year-old daughter Amy and his 3-month-old grandson, Jason. The cameras clicked, the mini-cams whirled and reporters fired questions at the two children huddled on the platform.

Ed Bradley, a White House correspondent for CBS, ruminated, "The White House grinds it out and we eat it up."

Don't assume that President Jimmy Carter invented the photo-opportunity. John F. Kennedy rarely missed a chance for full coverage. He knew that if he brought John-John, his young son, with him, the press was sure to be close behind.

The photographer directs a politician to stand this way, look that way, move closer and smile. To get a picture that the editor wants, the photographer will cajole a mayor or senator into wearing some sort of ethnic costume; a yarmulke when he lectures a Jewish group, a feather headdress when he pow-wows with an Indian tribe.

Ted Dully, a photographer with the *Boston Globe,* points out that if Jimmy Carter put on a stupid hat for a photo, the editor couldn't resist using the picture. As Dully say, "Politicians manipulate photographers and photographers manipulate politicians, both to their mutual benefit. Politicians look for free publicity and photographers want visual events. Editors think readers want to see elected officials in costume. The picture of the yarmulke-wearing senator is not wrong," he adds, "it's just not good journalism."

Behind the Scenes at Election Time

Politicians come alive at election time. The old "pol" gets out from behind his desk in his plush office and starts pressing the flesh at ward meetings, ethnic parades, and organizations for the elderly. The young challenger, by contrast,

Politicians like former Massachusetts Governor Michael Dukakis make themselves available to photographers during an election. But even after they win office, officials plan "photo opportunities" to keep up their media exposure.
(Ken Kobre, University of Houston)

walks the streets of the ghetto with his suit jacket thrown over his shoulder and his shirt collar casually open at the neck. Both candidates plaster stickers on cars, erect billboards, appear in "I Promise" T.V. ads, and attend massive rallies.

A photographer can take two sets of campaign pictures: one set shows the candidate's public life—shaking hands, giving speeches, and greeting party workers. The other photo set shows the candidate's private life—grabbing a few minutes alone with his or her family, planning strategy behind closed doors, trying to raise money, pepping up the staff, and collapsing in bed, exhausted at the end of a 14-hour day.

All too often newspapers present their readers with only a one-sided visual portrait of the candidate—the public side. The paper prints only up-beat, never down-beat, pictures; only happy, never sad, pictures. Photographers continue to churn out photos of the candidate shaking hands and smiling, photos that reveal little about the person who is going to run the city, state, or federal government.

Political scientists claim that the American public votes for a candidate based on personality. If that is true, the responsibility of the photo editor should be to present a complete picture of the candidate. This in-depth portrait must include the public as well as the private side.

In-depth Election Reporting

The public might vote its politician in or out of office on the basis of a pleasant smile or a firm handshake but, in the long run, progress in America depends on issues, not personalities. What has the incumbent mayor accomplished in office?

Almost all political issues of a campaign can be translated into pictures. If the mayoral candidate says city education is poor and should be improved, the photographer must search for supporting evidence of the mayor's claim. Are the schools overcrowded? Do the students hang around in the halls with nothing to do after class? If racial tension exists between black and white students, can the journalist photograph the hostility? A set of realistic photos will transform the rhetoric of a campaign into observable issues.

Photographers have to spend too much of their time shooting political mug shots and too little of their time digging up visuals that either confirm or deny the claims of these politicians.

When covering a campaign, election, or any other contested issue, the photographer has the same responsibilities to objectivity as does the reporter. The photographer, like the reporter, can directly distort a scene. A super wide-angle lens can make a small room look large. Strong lighting and harsh shadows can transform, in Jekyll and Hyde fashion, a mild-mannered speaker into a tyrannical orator. Even more damaging, the photographer, like the writer, can report one side of an issue and, intentionally or not, leave the other side uncovered. Because papers run only one or two pictures, such biased photo reporting creeps into the paper easily. The honest photographer, however, tries to select the lens, light, and camera angle as well as a representative moment or scene to present a fair view of a complicated topic.

Unfortunately, few staff photographers for newspapers, magazines or even television are given time for investigative political photography. An editor finds it easy to send a staffer to cover a press conference. The editor knows the time and place of the gathering and can guarantee that some usable "art" will result. But readers don't want to see another mayor-talking-picture. They already know what the mayor looks like. They want to determine if the mayor is telling the truth about the school system—pictures can supply part of the evidence for the mayor's assertions.

AWARDS:
Avoiding the "Grip-and-Grin"

After politicians' press conferences and meetings, the awards ceremony ranks as the most commonly photographed planned news event.

"I would like to present this check for $5,000 to your organization," says the president of the local bank as he passes a check to the head of a service organization. The cameras click and the strobes flash.

These awards pictures, all identical, do not give the reader any new insight into the individuals involved in the ceremony. Who are the individuals? Why did the group give the money? Who will benefit? The handshake—or "grip-and-grin" photo, as it's commonly known—doesn't answer these questions. The picture simply records that two people held a trophy or a check, or just shook hands.

Boston Globe's Ted Dully says that awards pictures should not be run in a newspaper. "They pander to the desires of people to feel important and they perform no newsworthy function." Many papers, however, especially in smaller communities, continue to publish such photos, perhaps for public relations reasons.

At Cornell University, Russ Hamilton, the university's photographer, has to take awards pictures almost every day. His attempts at giving impact to these awards pictures, making them different, has given him a national reputation. When asked how he approached an awards ceremony picture, Hamilton wrote: "I have never seen or ever taken an excellent awards ceremony or presentation picture. In the line of duty, I have tried my best, using every trick of the trade, wide-angle lenses, high-angle shots, massive foreground . . . and never have I been able to obscure the artificial, ridiculous atmosphere of an award presentation. Let us not overlook the fact that an awards presentation is a 'kiss-in-the-ass' to someone for doing something. In any case, many publications have dropped awards photos in favor of using the space for better purposes."

If you took a poll of professional photojournalists, they would probably share the sentiments of Ted Dully and Russ Hamilton by voting overwhelmingly to eliminate awards pictures from newspapers altogether. Some newspapers, in fact, have a policy that forbids awards pictures except under special circumstances. The *Boston Globe,* for instance, prints only one awards picture a year. The picture, however, happens to be the winner of the *Globe* Santa Contest, which the paper sponsors.

Most editors, however, continue to assign hand-shaking, check-passing pictures. Sometimes the events deserve coverage. When a citizen of a small town wins a million dollar lottery, that is clearly worth a picture. Other times the event is so close to home, a photographer had better not miss it. When the publisher of your newspaper wins the community man-of-the-year award, you will want to take several shots of his receiving the plaque.

Awards pictures, commonly called "Grip-and-Grins," rarely give the viewer any new information. Can you tell from this photo if the mayor is giving out a) money, b) a raise in rank, c) a citation, or d) just a greeting?
(Herbert Stier, *Herald* File, Print Division, Boston Public Library)

Taking Winning Awards Pix

To avoid the standard shot of two individuals standing stiffly against the wall looking at the camera in a pose reminiscent of a police line-up, try these approaches:

Natural Look

Any time that you can get your subjects to look natural, the picture will improve. Involve them in some kind of activity, and they will unbend. Get the bank president to talk to the check recipient, and before long both might forget that they are supposed to look proper and you will get a striking awards picture.

Lighting

Any lighting technique, other than flash-on camera, adds to an awards picture. Side-, back-, or even multiple-light, set-ups put spark into the standard cliché.

Get the Story Behind the Award

The real secret to an awards picture lies in searching out the reason for the ceremony and bringing out this fact in the photo. Sometimes the photographer only has to add a prop to the picture to point out the meaning of the event. If a man

Any prop, even a Saint Bernard dog, helps improve an awards ceremony picture.
(Ken Kobre, University of Houston)

wins an award for best marksman, his gun included in the picture cues the reader to the nature of the award. Other times the photographer has to arrange the picture to clarify the point of the award. If an employee gets a bonus for stitching more shirts than anyone else in the shirt factory, then the photographer needs to find a time to photograph the worker standing next to her tall stack of finished clothing.

Often the photographer needs to re-create an awards picture. If an employee has retired after twenty-five years of service to a watch repair company, then a photograph of him repairing his last watch carries more interest than a photo of him shaking the company president's hand. The retiree's face juxtaposed with the tiny watch gears certainly holds more potential for an eye-grabbing photo than another "grip-and-grin."

Governmental and organizational news, including meetings, elections, and awards, account for almost 80 percent of the national news sections of *Time* and *Newsweek,* according to Herbert Gans in his book *Deciding What Is News*. The president alone receives 20 percent of all national affairs coverage in these magazines. Local papers also devote an enormous amount of space to appointed and elected officials, and political campaigns. Therefore, developing visually interesting techniques for reporting these kinds of stories becomes mandatory for the professional photojournalist.

FINDING FEATURES

Previous page: *Feature photos give the newspaper reader a visual break from hard spot-news pictures.* (Donald A. Roese, *Akron* [Ohio] *Beacon Journal*)

WHAT IS A FEATURE?

"When I first entered the news-picture business in the 30s, papers would run a lot of gruesome, sensational photos of murders and accidents on their front pages. Today, editors print features," said Dave Wurzel in an interview.

Wurzel heads UPI's New England Photo Bureau. As he talked about feature pictures in his office, the sound of teletypes and scanner radios in the adjoining room nearly drowned out his voice. The place was alive with action, as photographers rushed in to process film for their wire service deadlines.

"Many editors argue that since readers receive so much depressing news in the paper's gray columns of type, subscribers deserve a break when they look at pictures," Wurzel explained. "For this reason, these editors tend to publish light feature pictures more often than straight news pictures."

Feature photos provide a visual dessert to subscribers who digest a daily diet of accident, fire, political, and economic news.

How Feature Photos and News Photos Differ

Timeless

Feature photos differ from news photos in several respects. A news picture portrays something new. News is timely. Therefore, news pictures get stale quickly. By comparison, feature photos published tomorrow, or a week after tomorrow, often still maintain their interest value. Many feature pictures are timeless. Feature pictures don't improve with time, as good wine does, but neither do they turn sour. Wire service photos showing Nixon giving his inaugural speech carry little interest today. Yet, pictures of a perfectly symmetrical water tower in Kuwait still retain their same holding power, even though the photos were shot some time ago. Gordon Converse, who has worked for the *Christian Science Monitor* for twenty years, described feature photography as the "search for moments in time that are worth preserving forever."

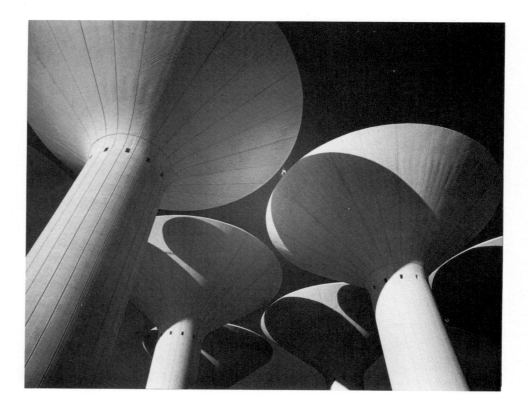

A good feature photo such as this picture of water towers in Kuwait is timeless. (Gordon Converse, *Christian Science Monitor*)

A news picture accrues value when (1) its subject is famous, (2) the event is of large magnitude, or (3) the outcome is tragic. A feature picture, by contrast, records the commonplace, the everyday, the slice of life. The feature photograph tells an old story in a new way, with a new slant. Two children playing games at a day-care center will not change the state of world politics, but the photo might provide the basis for a funny feature picture.

Slice of Life

A feature picture records the commonplace, an everyday happening, or a slice of life.
(Ken Kobre, University of Houston)

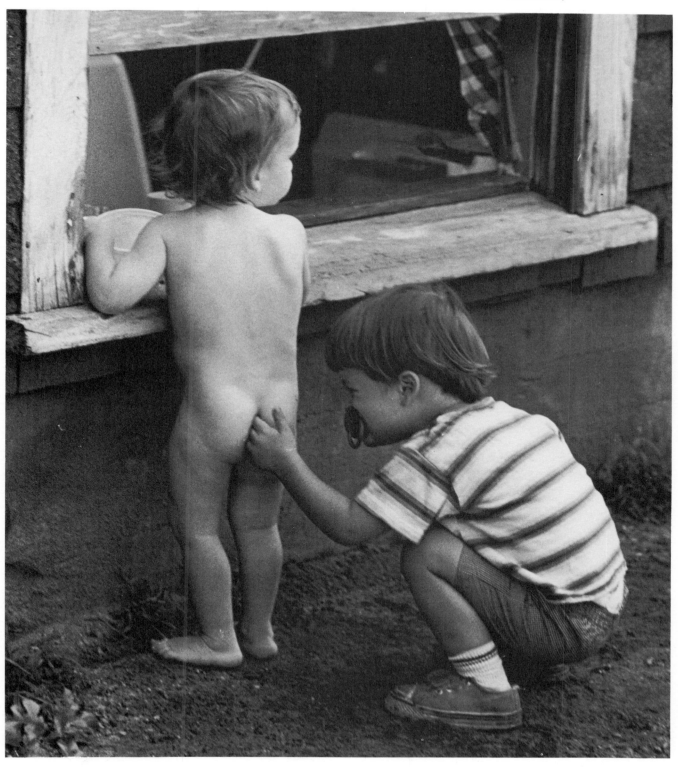

With hard news, the event controls the photographer. Photojournalists jump into action when their editor assigns them to cover a plane crash or a train wreck. When they reach the scene, they limit their involvement to *recording* the tragedy. They certainly would not rearrange the bodies and wreckage for a more artistic picture angle.

When shooting features, the photographer controls the event: the photographer chooses the subject, the time, the place, and the approach. As a feature photographer, you can can often generate your own feature assignments. In fact, many newspapers call features "enterprise pictures." You might arrange to spend the day shooting photos of a man who makes artificial limbs for the injured. Or you might head for the city park, looking for a pretty child playing ball with her parents. If you see such a scene at the park, you might ask the parents and child to repeat the action several times until you get just the right moment combined with just the right light. On a feature, as compared to a news assignment, you can have more influence on the outcome of the picture.

Featurizing the News

News does not stop with fires and accidents—features don't begin with parks and kids. The division between these two types of pictures is not that clear-cut. The sensitive photographer, for instance, could uncover features even at a major catastrophe. This is called "featurizing the news." The main story might describe a fire's damage to an apartment house, and give a list of the injured and dead. The news photo might show the firefighter rescuing the victims with the burning building in the background. For a news feature, the photographer might take a photo of a seven-year-old boy holding his pet cat, Gertrude. The boy had returned to his smoke-filled apartment to save Gertrude. This picture, along with a caption about the feline rescue, might be printed as a "side bar" in a box next to the main fire story. The side bar would feature the heroics of one child, while the main story and photos would concentrate on the resident's injuries and the general damage to the building.

Sometimes a news picture turns into a feature picture. This transformation can occur when an editor plays the news photo long after the date of the original event. While deplaning from Air Force One, President Gerald Ford slipped. Had the president received a concussion from the fall, the nation would certainly have worried. As it turned out, Ford survived unharmed. When, after the president's retirement, a series of photos appeared showing Ford stumbling in a variety of places, the pictures no longer had news value; Ford's health was no longer critical to the country's stability. Therefore, the news pictures of Ford's mishaps, published long after they took place, turned into feature pictures.

The term *feature picture* tends to serve as a catch-all category. In fact, some writers define features as "anything that's not news." Yet many pictures fit into neither the news nor the feature category. Snapshots from a family album, for example, don't really belong in either pigeon hole. How can the photographer learn to recognize a scene with good feature potential? By looking at feature pictures in newspapers, magazines, and books, you will begin to notice a consistent attribute that all features possess.

Great feature pictures—and there are few—*evoke a reaction* in the viewer. When viewers look at a powerful feature photo they might laugh, cry, stand back in amazement, or peer more closely for another inspection. The photo has succeeded.

Some features are even universal in their appeal. They will get a response no matter in what country they are shown. When individuals in Russia, China, Africa, or the United States respond to the same photo, then the photographer has tapped into the universally understood language of feature pictures.

GOOD FEATURE SUBJECTS

Each time a new photographer was hired by Florida's *St. Petersburg Times and Independent*, Norman Zeisloft, a staffer with at least twenty years experience in the business, drew the individual aside to explain the secret ingredients of the feature picture. "Friend," he said, "if you need a feature picture for today's edition, you can't go wrong by taking photos of kids, animals, or nuns." These were not bad words of advice, since a large percentage of published feature pictures includes kids, animals and sometimes nuns.

Kids Imitate Adults

Photographers find children relatively easy and willing subjects because they act in natural ways, play spontaneously, and look cute. Children do silly things without any encouragement. To grown-ups, children seem particularly funny when they imitate adult behavior. The child often acts as a mirror, showing the adult how grown-up behavior appears to the younger generation.

A specialist in photographing children for the *Boston Globe*, Ulrike Welsch always asks permission of parents before photographing youngsters. "That way the parent does not become suspicious and does not interrupt the shooting," says Welsch. If the parent is not around, Welsch will ask the child to lead the way to the adult, giving Welsch the opportunity to secure the permission. Although asking permission interrupts the child's activity, Welsch notes that as soon as the parent gives the go-ahead the child quickly goes back to his or her natural play.

When children imitate adults, the youngsters prove to be appealing feature subjects. This child washes his bicycle, just as his dad or mom cleans the family car.
(Ulrike Welsch, courtesy Boston Globe)

Some owners spare nothing to satisfy their pets. This animal-fancier knows that her snapping turtle loves vanilla ice cream cones. (Bruce Gilbert, Miami Herald)

Animals Seem to Act Like People

It is common for people to attribute human characteristics to animals. People respond to pictures in which pigs seem to smile and chimps look bored. Pet lovers often believe their animals exhibit human emotions, and treat their animals as if they were little human beings. Dog fanciers feed their pooches at the dinner table, dress them in sweaters for walks, and at night tuck them in velvet beds. One owner even taught her pet bird how to smoke; another fed her turtle ice cream. Such idiosyncrasies supply the material for good features.

Look for the Incongruous

A nun with a gun seems incongruous. The guns were actually donated presents for a camp the sisters administered. (Wide World Photos)

A photo of a nun holding a gun looks odd, because nuns and guns don't seem to go together. The gun seems incongruous in the situation.

This is just one example of persons or things which seem out of place or disjointed in time. A revolutionary soldier carrying a 35mm SLR would appear incongruous. A man stripping at a women's lib meeting would fascinate the viewer. Such photos provide eye-catching features.

People Like People

Clearly the feature does not restrict the photographer to picturing only kids, animals, and nuns, although whenever you can include these elements in a picture, the photo has a greater chance for publication. People of any age prove fascinating when they labor or learn, play or pray. One professional, Bob Kerns, professor of photojournalism at the University of South Florida and a seasoned feature photographer, estimates that 90 percent of the feature pictures in papers across the country center on people.

DISCOVERING THE FEATURE

I asked several well-known feature photographers where they looked for people features.

Ted Dully, of the *Boston Globe*, replied that when he has time he heads for the park or the zoo. "If you go where people collect, where things are happening, you have the deck loaded in your favor," he noted.

Author of *The World I Love To See*, a book of feature photos, Ulrike Welsch said her best human interest pictures are shot out of doors. "Taking features outside is easier than my having to go into a shop, introducing myself, and obtaining permission from the owner," explained Welsch.

Keeping A Fresh Eye

To keep a fresh eye for features, Welsch gets in her car and drives to an area she's never seen before. The experience is similar to traveling to a new country, even though the place might be only a few miles away. Whenever you live for a stretch of time in the same place and see the same things daily you grow accustomed to your surroundings. Psychologists call this phenomenon habituation. Feature photographers face this same problem of habituation. They come to accept as commonplace the unique aspects of the area they cover.

"Whenever I go to a new place, even if it's just a little way down the road, everything is novel," points out Welsch. She notices and photographs the differences between the new environment and her familiar territory. When she first arrives, her eye is sharpest. Those first impressions usually lead to her best photos. "I take pictures I might have overlooked if the subjects were in my backyard," she says.

When *Christian Science Monitor*'s Gordon Converse looks for feature photo possibilities, he shuns the car. Even if he is on his way to an assignment, he prefers to walk if he has the time. "If you are in a car, whizzing through a neighborhood, you miss seeing how the residents respond to one another. This interchange provides the basis for good features."

Readers like to look at pictures of people more than photos of any other subjects. The expression on this amateur clown's face has a universal appeal. (Robert Kerns, University of South Florida)

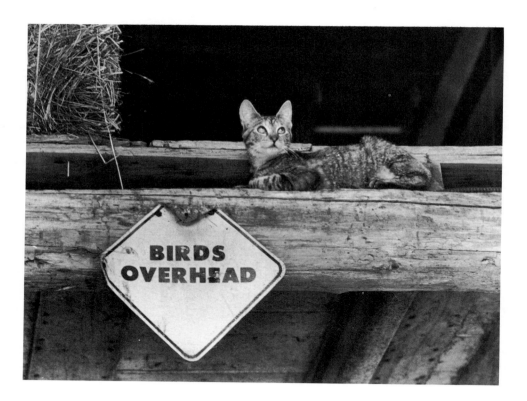

To find fresh features, Ulrike Welsch travels to places she has not explored before. (Ulrike Welsch, courtesy Boston Globe)

TO TAKE, MAKE, OR RE-CREATE A FEATURE

As a feature photographer, you can take enterprising pictures in three basic ways. First, you may pick a likely place such as a park or zoo, and then go out and search for candid features. Second, you may sit in your office, dreaming up ideas for feature pictures, then go out and translate the ideas into pictures. Third, as you travel around the city, you may see a feature situation but can't get there in time or, if you arrive in time, discover that the light is wrong for shooting. In this circumstance, you might re-create the scene, maintaining control of all the photographic elements to assure success.

Taking a Candid

Constantine Manos, an outstanding free-lance feature photographer for Magnum picture agency, looked for candid features during the year he spent taking 500 rolls of black-and-white and color for a forty-projector slide show called "Where's Boston?" He remarked that he never posed or arranged any of the pictures contained in the show. Manos says he explored each area of the city on foot, introducing himself to the residents. He explained, "If you sneak up on people, they have a right to resent you. Instead if you say 'Hello,' and talk a bit about what you are doing, people will let you continue with your work. All my subjects are aware of me." Yet Manos caught remarkably candid and uninhibited moments in these people's lives. One of Manos's photos shows the bassoon player in a small chamber quintet leading the group with complete abandon. Another photo shows a janitor nonchalantly erasing a blackboard containing a word so long and obscure that few Harvard professors would understand it.

Manos points out that photographers have the responsibility *not to offend by their presence.* "That is why appropriate clothing is important, and it is also the reason I seldom work with more than one camera at a time. It is especially bad when the second camera body has a big impressive, fierce-looking, telephoto

lens." Once while out shooting Manos saw an old woman fleeing from a bearded youth with a big tele lens on a menacing SLR. "Why shouldn't she have felt intimidated," Manos said.

Making a Picture

Converse, of the *Monitor,* said that he is happiest when he can capture a candid, but that's not always possible. "Sometimes you can just *take* a picture but other times you have *to make* a picture," he said.

"When there is nothing happening, I will create a situation to make something happen. For instance, while sitting in the office one slow day I decided to do a story about the window washer at the new all-glass John Hancock skyscraper. After I obtained permission I crawled out on the window washer's platform sixty stories above the city. But when I went to take the picture, I couldn't back up far enough on the platform to include the worker and the building's whole glass face in one shot. I previously noticed that when the platform was maneuvered around the corner of the building, the end of the support stood out about 20 feet from the face of the tower. I asked the window cleaner if he would mind jockeying the platform into position at the edge of the building. He obliged. As he proceeded to wash the windows on one end of the platform, I climbed out on the other end. I still needed more height so I gingerly stood on top of the protective scaffolding. A security guard held onto my legs for my protection. As I put my camera to me eye, I could see the window washer in one corner of the frame with the beautiful reflecting surface of the skyscraper sweeping down below. This was the picture I wanted."

Re-creating a Scene

Because of lack of time, or for technical reasons, sometimes a photographer can't get the desired shot. The photographer then might re-create the scene by posing the subject. Posing pictures range from asking a person to move left or right, to stage-managing the entire picture. The photographer can provide the props, find

Eighty-eight-year-old Catherine Turney nonchalantly waters her yard. To catch candids such as this, the photographer either shoots unannounced, or introduces himself or herself, and then asks the person to ignore the camera.
(David Rees, *Columbia* [Missouri] *Daily Tribune*)

When photographers can't find a feature, they sometimes make one. Gordon Converse crawled out on the window washer's platform, 60 stories above the ground, to shoot this photo of the John Hancock Insurance Building.
(Gordon Converse, Christian Science Monitor)

the location, select the subject and even direct the action. Ted Dully, of the *Boston Globe*, estimates that photographers pose, in some way, 50 percent of the feature pictures in his paper.

Ulrike Welsch once had two hours to photograph the influx of monarch butterflies on the North Shore of Massachusetts. After driving quickly to the spot where the monarchs had been sighted, she found butterflies—but no people. She caught a butterfly. Then, after carefully carrying the delicate insect to her car, she drove down the road until she found a young boy playing in the grass. Handing the butterfly to the child, Welsch positioned her youngster against a dark background. The light-colored butterfly thus would stand out in the black-and-white photo. As Welsch made a funny face, the boy released the butterfly. She snapped the picture at just that instant. The print, which she delivered to her editor's desk on time, received strong play in the next day's paper.

A photo of the butterfly alone would have carried little visual impact. Many children had caught butterflies during the day, but were not catching them when Welsch arrived on the scene. Welsch's posed butterfly picture was consistent with the reality of the original scene.

ILLUSTRATION PHOTOS FOR DIFFICULT-TO-PICTURE SUBJECTS

To illustrate stories on fashion and food, photographers create photos from scratch. Photographed soufflés look too perfect to eat. Photographed models wearing French designer originals appear sleek as race horses and even more perfectly groomed. Magazine and newspaper viewers have come to assume that

the photographer arranged these photos. The purpose of the photos is to illustrate the product, not to catch a slice-of-life facsimile.

Originally, illustration photography was confined to food and fashion. Today, news and feature editors choose illustration photography to portray editorial themes hard to photograph with the usual candid photo techniques. With stories about the economy, sociology, and psychology, the straightforward, realistic photos rarely capture these hard-to-define issues. The news photographer can do a good job covering an event such as a press conference, but might have trouble photographing a state of mind, such as mental depression. It is easier to record a fast-breaking story, such as a car accident, than to portray a sociological trend concerned with the declining birth rate.

At first, magazines and newspapers hired illustrators to render drawings in ink or water colors to provide artwork for stories about the behavioral sciences. Then *Esquire* magazine began assigning photographers to create illustrations for these stories. Today, many magazines have adopted editorial illustration photography, including *Psychology Today, Newsweek, Boston* magazine, *Philadelphia* magazine, and *Texas Monthly.*

Essentially, the illustration photo combines the limitless possibilities of the drawing with the realism of the photograph. The illustration photographer employs the same techniques as the advertising photographer—studio, lights, models, and props—to produce successful photos about editorial subjects.

During the Arab oil embargo *Newsweek* ran a cover showing a male model, dressed in a desert sheikh's robes, operating a gas pump at a filling station. *Psychology Today,* under the headline "The Quest for the Authentic Self," ran a cover photo of a woman appearing to unzip her outer skin, revealing an inner body.

To document the influx of monarch butterflies, Ulrike Welsch found she needed to pose this picture. She brought the butterfly and boy together, arranging them against a dark background. Just as she formed a funny face, the laughing child released the butterfly.
(Ulrike Welsch, courtesy *Boston Globe*)

Start with a Headline

Sometimes the illustration photographer, in consultation with the editor and designer, starts with a working headline for the story, then creates a picture to fit the words. For a cover of *Chomp* magazine, a dining-out monthly, I had to illustrate an article called "The Great Boston Ice Cream War." The story dealt with a Baskin-Robbins ice cream store manager who tried to burn down a competitor's store, which had recently opened across the street. The Baskin-Robbins manager started a fire in his competitor's basement. The fire did little damage to his opponent's store but cost the ice cream arsonist his own life. There were no pictures available.

I tried to think what items would suggest the headline, "Ice Cream Wars." I picked plastic toy soldiers to illustrate war. The difference in scale between the tiny toy soldiers and a seemingly gigantic ice cream cone gave the picture its needed impact, and fit the headline.

Start with a Concept

Sometimes the photographer starts with a concept, and later the headline writer formulates the words to fit the picture. I was once asked to illustrate a story about a bank president who embezzled thousands of dollars, then left for South America. The paper planned a major story about the theft, but obviously had no pictures of the crime. To illustrate the story, I dressed a man in a three-piece business suit and had him wear a burglar's mask. I photographed the model picking a lock on a large metal safe. No one would mistake the photo for a picture of an actual robbery. Rather, the picture symbolized the white-collar crime. After seeing the picture, the headline writer wrote, "How to Steal $8 Million the Easy Way."

Illustration photography can bring to life stories about the rise in inflation, the shortage of oil, or the changing family. As periodicals leave spot news

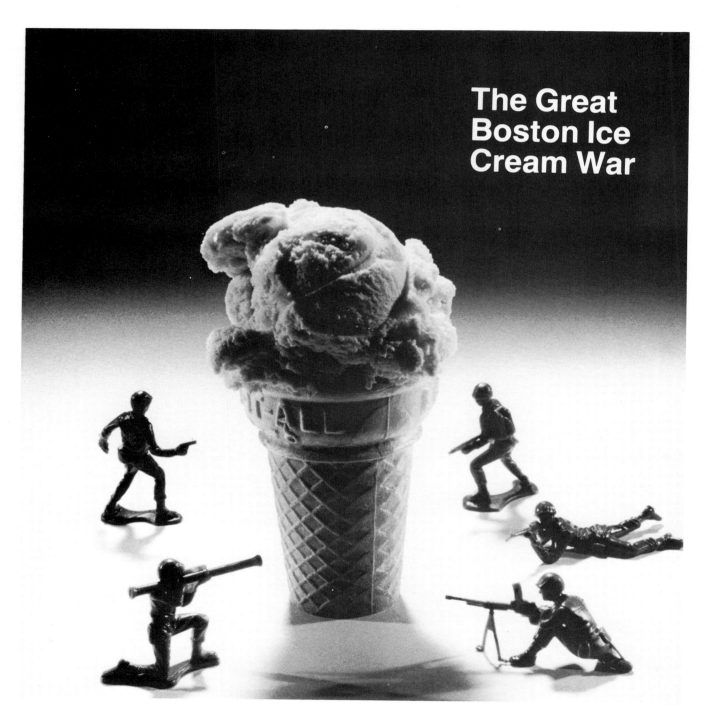

The Great Boston Ice Cream War

An ice cream store manager tried to burn down a competitor's store. The fire cost the arsonist his own life. To illustrate the story, the photographer and art director started with the headline, and then created the photo.
(Ken Kobre and David Krathwohl, *Chomp Magazine*)

to the more instantaneous medium of television, the press delves further into in-depth, background stories. In the future, editors will call on photographers more frequently to produce editorial illustration photos.

AVOIDING THE TRITE

Where Are the Substantial Features?

The bread-and butter feature in today's newspaper is still the pretty child playing in the park or the chimp clowning at the zoo. Photographers take pictures of kids and animals so often that these topics have become trite.

Robert Garvin in an article for *Journalism Quarterly* explained the genesis of the unsubstantial feature picture. "I have known picture editors (including myself up until ten years ago) who, on a dull afternoon, assign a photographer to walk around town and photograph anything he sees. What does he see? On an August day he sees a small boy in the spray of a fire hydrant, or a group of tenement dwellers sitting on a fire escape. These are so obvious that every passer-by has seen them in the newspaper for the last forty years. If there is no thought and preparation, one cannot expect striking pictures with more lasting merit."

When Arthur Goldsmith, an editor for *Popular Photography* magazine, judged the Picture-of-the-Year contest at Columbia, Missouri, in 1977, the contest that year included more than 9,000 entries. Goldsmith concluded that pictures in the feature category tended to be hackneyed. He wrote, "Feature pictures often mean space fillers for a slow news day. Here are the visual puns, the cornball, the humorous, the sentimental, the offbeat. (Greased pigs and belly dancers were especially big during this year's competition.)"

Goldsmith said editors divide the photo world into two camps. "Either an event is hard news, which usually means violence, death, horror, confrontation, etc., or the event is a 'feature,' meaning something that appeals to our warm furry sentimentality. . . . But between the two extremes, the agony of the spot-news disaster and the ecstasy of the feature picture, lies that great amorphous zone that is most of our life."

How can the photographer tackle that great amorphous zone outlined by Goldsmith?

Developing a Feature Beat

If photographers hope to produce more meaningful features, the answer lies in developing their own specialty area—their own beat.

For years writers have pried loose the city's news by covering a beat. Typical beats include police, hospital, and courts. Reporters on police beats check the precinct headquarters each day to see what is going on. They look over the police blotter and talk to the sergeant to find out if anyone reported a major or unusual crime during the night. Getting the inside track on current investigations, reporters find out about possible suspects. They know when the police plan to carry out a gambling raid or drug bust. They also get to know the personalities in the department—the seasoned police officer, on the force for twenty years as well as the new rookie, fresh from the police academy. From these contacts and observations, beat reporters don't just react to the news; instead they can interpret and predict it. If the police go on strike, they can explain why. If a cop dies in the line of duty, they can write a story based on personal knowledge of the officer.

Feature photographers could also cover a beat but rather than choosing the police, hospital or courts, they might select, as their beat, areas of education, science or religion.

Shriver Films the Religion Beat

The *Worcester* (Massachusetts) *Telegram and Evening Gazette*'s Sandy Shriver chose religion as her beat when she was a graduate student in photojournalism. To begin her research, Shriver phoned several ministers in the city to talk with them about old problems and new trends in theology. Some topics the religious leaders discussed were interesting, but not visual—a group of Catholics wanted to go back to the Latin Mass, whereas a group of Jews wanted more English in their services. As Shriver continued to interview the city's ministers and the university's religion teachers, she heard about one priest who held services in a hospital for the chronically ill. Because this subject piqued her interest, she lo-

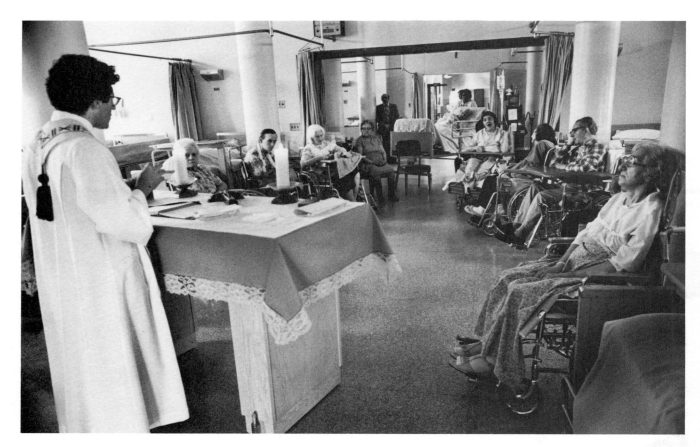

Sandy Shriver, working on a feature photo-beat, developed a feature story about Father Gregoli, a priest who serves the chronically ill.

To get an in-depth view of the priest's work, Shriver spent several days interviewing and photographing Father Gregoli. She took pictures of the pastor, as he offered comfort to a dying patient before giving the woman the sacrament of the sick.

Priest of the Dying

Photos by Sandra Shriver, *Worcester* (Massachusetts) *Telegram and Evening Gazette*

"I find it draining, more so than depressing," said Father Gregoli about working daily with the dying. Shriver was able to catch on film this personal moment of reflection, because she stayed with her subject long enough so that he felt relaxed.

Sandra Shriver recorded the effects of a faith healer on members of the Roxbury Mission Church. When the priest reached the peak of his oration, one of the church members fainted in the aisle.
(Sandra Shriver, *Worcester* [Massachusetts] *Telegram and Evening Gazette*

cated the name of Father Gregoli, a priest in the program and called him for an appointment. As Shriver learned more about the story, she realized that Father Gregoli worked each day with the terminally ill. Almost all his parishioners would soon die.

Finally, the day came for Shriver to go to Youville Hospital, in Cambridge, Massachusetts, and begin photographing. Shriver covered Father Gregoli as he gave Mass for patients who were restricted to wheelchairs. Shriver followed the priest as he made rounds of those too sick to get out of bed. She photographed haggard faces of the dying as they received communion.

After the young photographer returned to her darkroom and developed her film, she still was not satisfied. Although she had captured the pathos of the patients, her film didn't show the priest's emotional reactions to his job. What is it like to work with the dying every day, knowing you can't save anyone? When Shriver returned to the hospital the following day, she trained her camera on the clergyman. A picture showing Father Gregoli holding his forehead, the final portrait in the series, perhaps best captured the emotional drain of this man's job.

Shriver's initial story on the "Priest of the Dying" led her to other possible stories about religious activities. From her contacts, she heard about a Catholic priest, Father Edward McDonough, who was a faith-healer. People came to him from the entire region, claiming the man performed miracles. Shriver called the Mission Church in Roxbury (Mass.) to make photographic arrangements for the following Sunday. On that day she got to the church prior to the service so she could position herself in the balcony above the congregation. She attached her camera to her tripod because the low light level in the church required a slow shutter speed. The service began and as the priest reached the peak of his oration, one of the members of the congregation, with arms spread as on a cross, fainted in the aisle. Shriver snapped the shutter just at that moment. This overall appeared on the cover of *Healing* magazine. Carol Rivers, editor of *Healing*, commented that this cover, and an inside set of pictures about the priest, was the most moving feature series she had ever published. Shriver won the Fitzgerald photo essay contest with this series.

Informative Features Require Research

For more informative features, such as those taken by Shriver, you will need to perfect your skills as a reporter: (1) pick an area of specialization, (2) make contacts with experts in the field, and (3) become familiar with the issues and new trends on the subject. Once you hear about a story that sounds interesting, make arrangements to photograph it. Often you will need to return several times to secure complete coverage. After shooting the pictures, you can write the captions and submit the feature series. You might suggest to your editor that a more detailed story by a reporter would amplify your series of pictures. To assure more stories on the subject in the future, keep up your contact with your sources of information. These contacts will tell you when something new happens that might make striking pictures.

Few newspapers will release photographers to work full time on their beats. Therefore, the photographer must fit his or her special beat around routine assignments. Developing a feature area rarely produces great pictures on the first day. The photographer needs time to research information. Yet, in the long run, a photographer's beat will generate meaningful feature pictures that will remain permanently in the memory of the viewer.

THE STUDIO VERSUS THE
NEWS PORTRAIT

EVEN A MUG SHOT REVEALS
CHARACTER

ENVIRONMENTAL DETAILS
TELL A STORY

CAPTURING CANDIDS

USING A PORTRAIT TO
REPORT THE NEWS

PUTTING THE SUBJECT AT
EASE

PEOPLE PICTURES

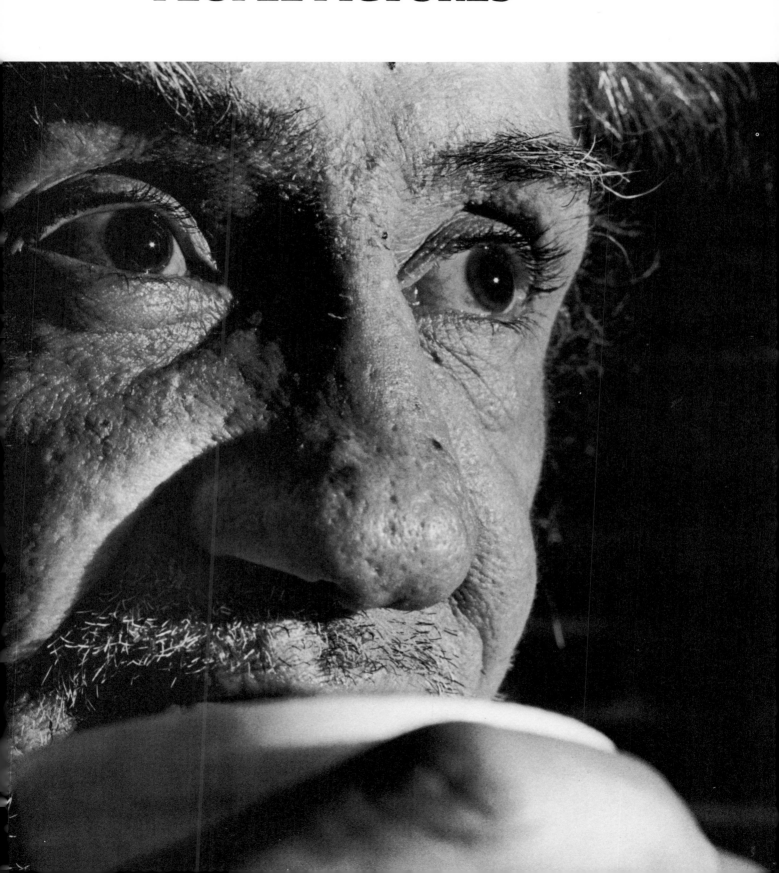

THE STUDIO VERSUS THE NEWS PORTRAIT

On the last day of March, 1974, Dr. Kenneth Edelin, obstetrician at Boston City Hospital, went to a fancy downtown studio for a formal self-portrait to give to his wife on their wedding anniversary. A few days later I took a picture of Dr. Edelin for a completely different reason. The district attorney of Suffolk County had charged Dr. Edelin with manslaughter for performing an illegal abortion. My paper wanted a front-page picture of the physician.

Both Dr. Edelin's studio portrait and my photojournalistic portrait contained a record of the doctor's features. The same face appeared in both pictures, but there the similarities stopped. First, Dr. Edelin chose to have his portrait made. Therefore, the studio photographer had to please one person—Edelin, the customer. I, however, went to Edelin's office to get a picture because he was in the news. I was imposing on the doctor's time and taking a picture that he certainly did not ask for and might even want to avoid. By telephone I had persuaded Edelin to let me come and take up 15 minutes of his day to shoot the news picture.

The studio portraitist took his time during the shooting session. He arranged the lights to flatter the subject, adjusting the main light to deemphasize a double chin, moving the fill light lower to strengthen the line of the cheekbone. The studio photographer tried to subdue any blemishes to idealize or even glamorize his subject. After all, the studio picture was designed to last Dr. Edelin for years. My photojournalist's portrait had a much shorter life expectancy—a few days at most.

The job of the news picture was not to glamorize Edelin but to show why he was in the news. Although I couldn't record Edelin performing an abortion, legal or otherwise, I could at least use enough props to indicate to the reader the doctor's profession. When I arrived at his office, Edelin was wearing a business suit. With the exception of his diplomas on the walls, the office gave little indication that it belonged to a doctor rather than to a lawyer or to an accountant. I noticed, hanging on the back of the door, a white lab coat. I asked Edelin if he ever wore the coat in the office and he replied that he had just taken it off before I came in. I asked the doctor to put on his lab coat, and after exposing a few

Previous page: This photo of a Salvation Army resident on Christmas Eve gained unusual intimacy, because people rarely come this close to anyone during normal conversation.
(Ken Kobre, University of Houston)

Below left: A studio portrait of Dr. Kenneth Edelin, a City Hospital obstetrician.

Below right: A journalistic portrait of Dr. Kenneth Edelin after the district attorney charged him with manslaughter for performing an illegal abortion. Note that the surgery cap, mask, and gown clue the reader as to Edelin's profession.
(Ken Kobre, University of Houston)

frames in his office, I suggested we go into his lab research room. There I made additional pictures of him surrounded by microscopes and other paraphernalia of his profession. With the right background, dress, and props appearing in the photo, I hoped my editor and, ultimately, our 100,000 readers, could immediately tell Edelin's type of work.

The studio photographer, on the other hand, had no interest in white lab coats and microscopes. His final portrait, with Edelin standing in front of a seamless roll of paper, would be seen only by Edelin's wife and their personal friends who needed little reminder of the physician's profession.

Which photo truly captured Edelin's personality—the studio portrait or the photojournalist portrait? The studio photographer tried to elicit a pleasing look from Edelin that seemed characteristic of the man. The photographer exposed six 4 x 5 sheets of film. By comparison, I took many more shots with my 35mm as I discussed with Edelin the political implications of the charges against him. When he became engrossed in his story, explaining to me the details of a grand jury investigation, I made exposure after exposure.

When Edelin paid for his studio portrait, it was printed on matted stock, handsomely mounted and framed. When he bought his photojournalistic portrait, it appeared on newsprint, on the cover of the *Boston Phoenix,* and later it was printed smaller but on glossier paper in *Newsweek.*

EVEN A MUG SHOT REVEALS CHARACTER

In the trade, newspeople call a single picture of a person's face "a mug shot" or "a head shot" or "a head and shoulders." The casual, slightly derogatory terms indicate that the photo usually runs only about two inches, or one column, wide, in the newspaper. The photo is not meant to be a revealing character study, but merely to identify the subject.

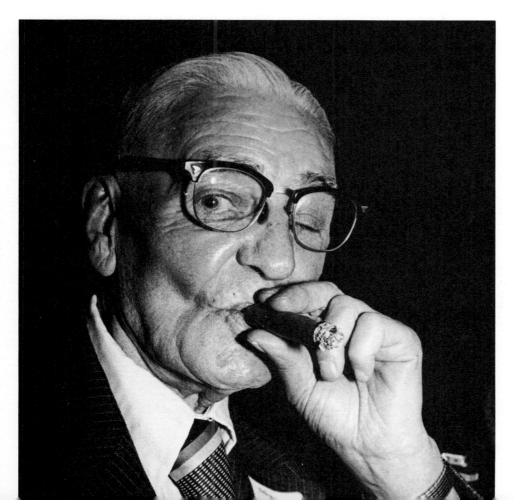

Even a "mug shot" can take on character when the photographer watches for the best moment. Michael Maher waited for this 80-year-old retired police officer to take a puff on his cigar.
(Michael Maher, *Lowell* [Massachusetts] *Sun*)

This head shot of Bob Gamere, a television sports announcer, was successful, because the photo is tight and well-timed, catching the "wry" expression on the sportscaster's face.
(Tom Sobolik, *Concord* [New Hampshire] *Monitor*)

You might ask why editors print these little postage-stamp sized pictures. Newspaper and magazine editors answer that their readers want to see what the subjects in the news look like. Whereas a one-column photo won't stand alone in the paper, with a caption the photo will tell the reader about the sex, age, and race of the subject. The mug shot also gives the reader an idea of the subject's personal characteristics, such as hair style, physical build, and general appearance.

Keep the Photo Tight and Simple

The purpose of the often used mug shot is to provide a clear, sharp, well-lighted record of a subject's face. Photographers find this type of portrait easy to take. With a 105mm lens on a 35mm camera, the photographer needs to get only about 4 or 5 feet away to fill the subject's face in the camera's viewfinder. A 200mm telephoto lens proves handy if the photographer's movements are restricted, and the photojournalist is relatively far from the subject as often happens at a speech or press conference. Most photographers avoid wide-angle lenses for mug shots, unless they want to exaggerate purposely a person's nose or forehead.

This portrait might capture the personality of Louise Day Hicks, former congresswoman and strong busing critic.
Unfortunately, when the photo was printed as a small head shot in the paper, few readers could recognize her from this side view.
(Ken Kobre, University of Houston)

George Tames, Washington photographer for the *New York Times*, shoots his subjects looking both left and right. "You never know which side of the newspaper page the editor will place the head shot, and editors like to have the subject facing into the page." In addition to a left and right shot, Tames provides his editors with a selection of photos showing different facial expressions. If the news story runs several days, such as in a murder trial, the editor will want to print for each issue slightly different head shots of the persons involved. Of course, if the outcome of the event is tragic, the picture editor will not want a smiling mug shot to go with the final day's story.

For the common mug shot, such as a picture of the mayor, the photojournalist must be careful to reserve any latent artistic abilities for other photos. Because the one-column photo of the politician runs so small in the paper, an overly dramatic lighting setup that shows only a sliver of the subject's face will not give the reader enough information. Nor will extreme camera angles that portray only the subject's profile reveal the subject's identity. The situation is different when the person is famous. Former President John F. Kennedy's face can be recognized under almost any light conditions and from almost any angle.

Side Lighting Brings Out Features

Arrange the subject so that the main light, whether it is flood, flash, or window, falls toward the side of his or her face. Side light, as compared to direct frontal light, adds a roundness and three-dimensional quality to the mini-portrait. Side light also emphasizes the textural details of the face—a technique especially suited for bringing out the character lines in an older person's features.

When shooting the mug shot, the photographer runs into the danger of sloppy technique and composition. The photographer takes a few quick shots, figuring that the photo will be small and mistakes won't be noticed. Too often, however, the head shot assignment winds up being played as large as a half page because no other picture is available. So keep in mind that the mug shot of today might appear on the front page of a newspaper or become the magazine cover of tomorrow.

ENVIRONMENTAL DETAILS TELL A STORY

From a mug shot alone, the viewer can't tell a banker from a bandit, a president from a prisoner. The wrinkles of a brow or the set of the eyes reveal little about a subject's past, profession, or newsworthiness.

An environmental portrait, however, supplies enough details with props and choice of background to let the reader know something about the lifestyle of the sitter. In an environmental portrait, the subject is photographed at home, at the office, or on location, whichever place best reflects the story's theme. As in a traditional studio portrait, the environmental photo generally has the subject look directly into the camera. But rather than sitting the subject before a plain seamless paper background as in a studio portrait, in the environmental photo the subject sits or stands amid the everyday objects of his or her life. For instance, you might shoot a butcher holding a side of beef inside his walk-in freezer.

I shoot environmental pictures whenever a portrait is needed, knowing the photo will probably play two columns or wider in the newspaper.

Background Adds Meaning

The background and the props become as important as the face of the sitter in an environmental portrait. The background details lend the photo portrait an extra dimension. The subject's face gives the portrait its primary force; the environmental details add depth and meaning.

No one would have any trouble recognizing what this man does for a living. Props and environmental details help to explain quickly the subject's job. (David Krathwohl, Chomp Magazine)

Side lighting adds drama to this portrait of a Tallahassee, Florida, artist. This type of directional lighting also tends to bring out the three-dimensional quality of the subject's face.
(Ken Kobre, University of Houston)

Arnold Newman, a master of the environmental portrait, who has taken the official photographs of many U.S. presidents, outstanding artists, and corporate executives, often arranges his portraits so the background predominates. The subject in the foreground is relatively small. In fact, one famous portrait of Professor Walter Rosenblith of the Massachusetts Institute of Technology shows him wearing headphones with an oscilloscope in the foreground and a maze-like baffle system in the background. His face takes up a small percentage of the picture with the lines of the experimental chamber occupying the remainder of the area.

Even more than Professor Walter Rosenblith's face, this portrait by Arnold Newman emphasizes the scientist's experimental chamber at the Massachusetts Institute of Technology.
(© Arnold Newman)

Newman says that the image of the subject is important, "but alone it is not enough. . . . We must also show the subject's relationship to the world." Newman goes on to say that "twentieth-century man must be thought of in terms of the houses he lives in, and places he works, in terms of the kind of light the windows in these places let through and by which we see him every day."

Symbols Reinforce Theme

The power of Newman's photos lies in his choice of symbolic environmental details that not only show the sitter's profession but the style of the sitter's work. For example, Newman photographed Igor Stravinsky sitting at the piano. The photograph told the viewer that Stravinsky was involved in the music. But the photo also included the lid of the grand piano, the black abstract shape of the lid suggesting the idea of discordant modern music, Stravinsky's trademark. For a portrait of Dr. Kurt Gödel of the Institute for Advanced Study, Newman arranged the sitter in front of an empty blackboard. The blackboard says to the reader, "Gödel—the academican"; the empty board says—"Gödel the high-level thinker."

Although Newman might not think of himself as a photojournalist, his approach to the portrait is reportorial. He goes beyond the lines in the subject's face to tell his audience something about the lines in his subject's work and life.

Wide-Angle Lens Brings in More Background

Technically, the environmental portrait does not differ from any other portrait. The photographer can use a normal or, if necessary, a wide-angle lens. Because the photographer wants to record the environmental background sharply, maximum depth of field is needed. You can increase the depth of field by stopping down the aperture to a smaller opening. This, however, requires a longer shutter speed. The camera on a tripod gives the photographer freedom to use longer exposures if the subject can hold still.

CAPTURING CANDIDS

A man strolled down a crowded street, his eyes darting left and right. As he stopped for an instant before an old woman draped in an American flag, he picked up his Leica and in one fluid motion focused and clicked off several frames. By the time the woman turned toward the photographer, he was already on his way. The "hit-and-run" cameraman who left the subject unaware of his presence was Henri Cartier-Bresson, the outstanding French candid photographer. Cartier-Bresson's candid portraits catch the subject unposed. Looking at his pictures, the viewer has the sense of peeping unnoticed into someone else's life.

Hints for Catching Candids

To nab candids like Cartier-Bresson's, photojournalists must be completely at ease with their equipment so that they can concentrate solely on their subjects. Here are a few hints about ways to improve your candid photography.

■ Unless the camera is automatic, set the aperture and shutter speed before you point the camera at the person. If you take time to fiddle with

With his Leica preset, Henri Cartier-Bresson frames and snaps so quickly that his subjects are almost unaware that he took their picture.
(Henri Cartier-Bresson, Magnum)

For this candid, the photographer preset the exposure and prefocused the lens. Then the camera operator merely framed and waited for the shot.
(Bruce Stockwell)

the camera's dials, you might catch the attention of the subject and lose the candid moment. To take your light meter reading without the subject being aware, point your camera toward an area that is receiving the same amount of light as the subject, then adjust your f-stop/shutter speed combination accordingly.

■ Select the appropriate lens before you bring the camera to your eye. A medium telephoto 105 or 200 is usually satisfactory for candids. The telephoto keeps you far enough away from your subject to decrease your visibility.

■ Swing the telephoto lens once by the subject, stopping just long enough to focus. As an alternative, you might focus on an object exactly the same distance away as your subject.

The telephoto requires critical focusing. For that reason, some photographers prefer the wide-angle lens for candids, even though the photographer must come closer to the subject. Prefocused at 10 feet with a small aperture of f/16, a photographer with a 28mm lens can snap away happily without ever touching the focusing ring.

■ Now, watch your subject. The camera is set, hence all you need to do is concentrate on the subject's expression, and when it's right, swing up the lens, frame, and snap away.

Creating the Candid Look

The photographer often faces the problem of creating a candid-looking picture, even though the subject is cognizant of the photographer's presence. "In most of the photo stories in *People* magazine, the subject knows ahead of time when we're coming, so the portraits are not truly candid," says John Dominis, who was the magazine's first picture editor. "If the subject has a trade like a blacksmith or fisherman, *People* photographers try to coax the subject to do what he normally does. When the worker goes back to his daily routine, he tends to get lost in his work, and the photographer can produce story-telling candids."

Sometimes, whether you are working on assignment for *People* or for your home-town newspaper, you will not have time to stand around and wait for the perfect candid to happen. Other times, even though you might have the time and patience, the subject freezes at the sight of the camera. Then you will have to set up a "candid-looking" picture.

I used the "setup" approach when I photographed an old wood carver. When I arrived at his shop, the carver was sitting at his roll-top desk. A wooden Indian lay on the workbench. Because I had other assignments to cover that day, I knew I would have to stage-manage a little to get my picture.

First, I spent a few minutes talking to the craftsman about how he became interested in wood carving and where he studied the art. I asked him about the kinds of objects he carves and the types of people who buy his sculptures. I then requested a guided tour of his quaint shop with its dust-covered tools and piles of aged wood. With unlimited time, I would have just watched him carve, following the progress of the piece as it developed; but, as it turned out, this day he hadn't even planned to chip wood. Instead, he was sending out bills!

Getting down to business, I asked the carver to describe the steps he goes through in carving a piece of sculpture. From his description, I selected several of the operations and asked him to demonstrate them for me—carving the eye socket, hammering the toe, etc. I positioned myself to catch the soft window light, which brought out the texture of the wooden Indian sculpture. As the subject repeated the action several times, I was able to vary the camera angle and lens, and take enough frames so that at least one picture had a natural "candid look."

Not all subjects are as natural and relaxed as the wood carver. Sometimes

I'm forced to tell a subject where to place his or her hands, how to stand and which direction to look in. But overly posed pictures look awkward and faked. Generally, I find that if I involve the subject in the photo session, explaining what I am doing, I elicit the natural "ham" that exists in most people. They relish the opportunity to act. As they get caught up in the mini-scene, with lights, camera, and action, they lose their self-consciousness and I nab a candid portrait.

Eye Contact Destroys Illusion

One element more than any other cues the viewer into the candidness of the photo. When anyone stares directly into the camera lens, the photo loses its

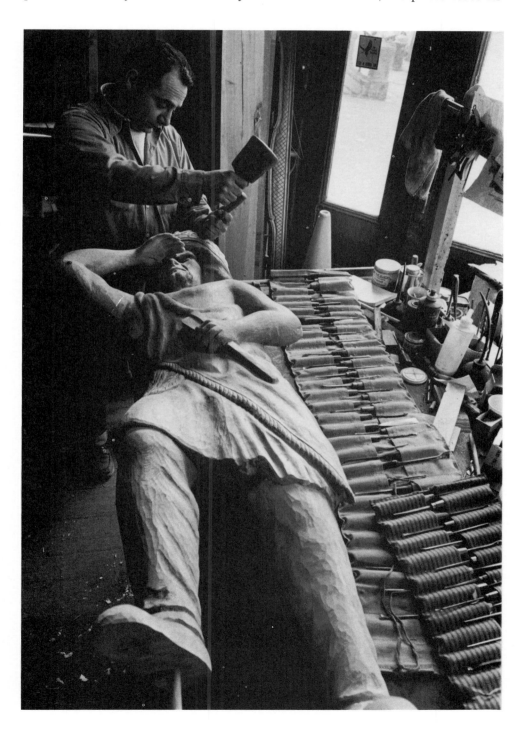

To set up this candid-looking shot, the photographer asked the sculptor for a wood-carving demonstration. Soon the woodworker was engrossed in his craft, and forgot about the camera.
(Ken Kobre, University of Houston)

candid flavor. The viewer assumes that the news personality saw the photographer's camera and was simply posing for the picture. Although eye contact between the person in the picture and the viewer adds intimacy to a head shot, the staring eye destroys the naturalness of a candid. However, pictures in which the subject's eyes are completely lost tend to deaden the effect of the photo. To solve this problem, I position the camera at an angle to catch part of the eye, without the individual looking directly into the lens. I watch to see the direction of the subject's glance. If the subject is talking to another person, I look for a moment when the two lock gazes. For a "created candid," I ask the subject to look at my shoulder. The resulting picture contains the person's eyes, without the subject seeming to peer directly at the camera.

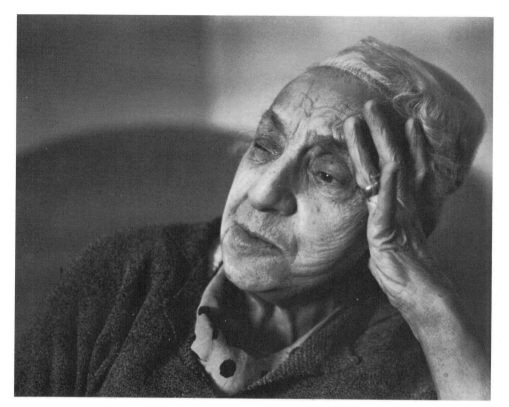

Ideally, the photographer wants to catch the eye of the subject without the person staring directly into the lens.
(Ken Kobre, University of Houston)

USING A PORTRAIT TO REPORT THE NEWS

By means of pictures the photojournalist tells a story about a subject. The portrait of a scientist shouldn't look like that of a steel worker. An aggressive personality deserves a different portrait from a shy and retiring type.

Three elements add to the story-telling nature of a portrait. First, a subject's face, hands, and body position reflect the psychological state of the sitter. Is the subject smiling or showing a grim face? Are his hands pulling at his beard or resting at his side? Is he standing awkwardly or comfortably? Second, the location of the picture and props held by the subject tell the viewer something about the profession, hobbies, and interests of the subject. A portrait taken in a dark factory, with the worker holding a wrench, says something different about the sitter than a portrait taken in a clean, well-lighted office with the accountant holding a pocket calculator. Third, an equally powerful message carried by the

photo depends on the light and composition of the picture. A heavily shadowed portrait, for instance, might look foreboding. An off-balanced composition could add tension to the picture.

Face and Body Provide Clues to the "Inner Person"

Of all the elements in a photo, the face still carries a disproportionate amount of psychological weight. Studies indicate that children, almost from birth, recognize the basic elements of a face, including the eyes, nose, and mouth.

Most people assume they can read something about a person's personality from his or her face. How often have you thought, "That man looks sneaky, I wouldn't trust him"? Or, "That person looks friendly, I'd like to meet her"—all reactions based on a glance at the person's face.

Whether true or not, people assume that the face is the "mirror of the soul." If the face is the soul's reflection, then the soul is multidimensional. Even the most sedate face reflects a surprising number of variations. Take a thirty-six exposure roll of film of one person's face as she talks about her favorite topic. Note the amount of distinctly different expressions the person exhibits. Is one frame of those thirty-six pictures true to the nature of the person? Have the others missed the essence of the underlying character of the subject? Arnold Newman says in his book *One Mind's Eye*, "I'm convinced that any photographic attempt to show the complete man is nonsense . . . we can only show what the man reveals."

The photojournalist usually selects an image of the subject talking, laughing, or frowning, an action coinciding with the thrust of the news story. When a recently appointed city manager expressed fear about his new job, the photo showed him with his hand massaging his wrinkled brow. A year later, a story in which the city manager talks about his accomplishments might require a picture of him talking and smiling. The photojournalist's portrait doesn't reveal a person's "true inner nature" as much as it reflects the subject's immediate response to his or her present success or predicament.

Hands help to tell the news in a nonverbal way. A news photographer covering a speech won't even bother to click the shutter until the lecturer raises a hand to make a point. When shooting a portrait, watch the individual's hands as she toys with her hair, holds her chin or pushes up her cheek. A person chewing his fingernails reveals a certain amount of tension about the situation in which he finds himself.

Desmond Morris wrote an excellent book, *Manwatching, A Field Guide to Human Behavior*, for those interested in improving their observational skills. Morris documented various types of gestures and signals that people use to express inner feelings. Studying ways people communicate nonverbally can sensitize the photographer to good picture possibilities.

George Tames of the *New York Times*, who's been a Washington photographer for thirty-seven years, says that when he shoots portraits, he watches for nonverbal mannerisms. If he catches a distinctive behavior pattern of the individual, such as pencil chewing, he won't hesitate to ask the person to repeat the action several times. Tames says, "I want to make sure the person does it right." What Tames really means is that he wants to guarantee that *he* gets the revealing mannerism on film.

The way an individual stands, whether as straight as a West Point cadet or as bow-legged as a cowboy, might clue the reader about the upbringing of the subject. Although the photographer does not control the facial expression, hands, or body position of the subject, the photographer is aware of these characteristics. When the body language speaks clearly the photographer grabs the shot. Later, when selecting the negative for enlargement, the photographer tries to correlate the visual images with the theme of the written story.

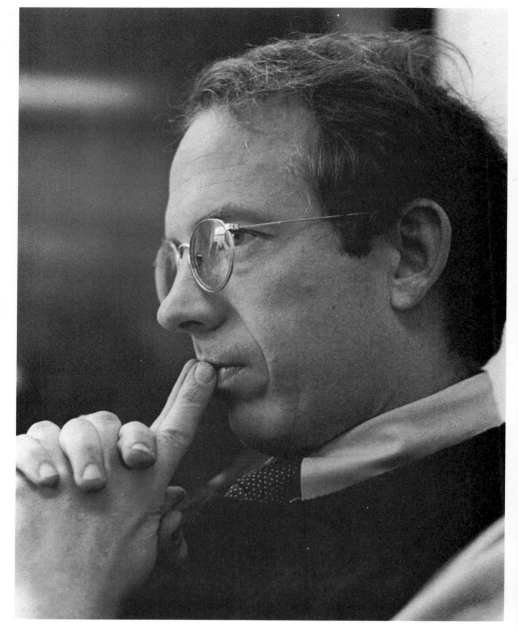

The hands of
Massachusetts' Secretary
of Human Services,
Jerald Stevens, reveal the
pressures and pleasures,
tension and relaxation,
experienced by this
powerful state official.
(Bill Collins)

Props Set the Scene

What photographers lack in control over the subject, they gain in control over the props they can have the subject hold. Photographers can also control the background against which they place the subject.

For example, I had to photograph Frank Perdue, the grower of a major line of roasting chickens sold in grocery stores. The feature was about new marketing strategies that Perdue was developing. The Perdue interview took place at an elegant restaurant. Unfortunately, Perdue ordered fish. Even though the dining room provided an attractive background, Perdue's plate of cod said little about his fame as a chicken marketeer or the reason he was in town.

After taking some mug shots of Perdue during lunch, I asked the headwaiter if the kitchen had any Perdue-brand chickens. He said that there were several in the refrigerator. Perdue and I went to the basement kitchen. After we entered the large walk-in refrigerator, Perdue picked up a plucked fowl with his label on it and held it aloft proudly. I popped off several flash shots. Now I had the right face with the right prop.

But, as I was taking the pictures, I noticed that all of the chefs had gathered around the walk-in refrigerator's window to watch Perdue. So I asked the chicken king if he would mind stepping into the kitchen and posing with the chefs. Surrounded by the men in their tall, starched white hats, Perdue proceeded to lecture the cooks on the finer points of chicken plucking. I fired away. The resulting pictures reflected Perdue's personality and business.

Not all props are as appropriate and readily available as the Perdue chicken. George Tames, of the *Times*, for instance, rarely photographs chicken magnates. His job is harder. He photographs Washington legislators. Since they deal mostly in words and paper, his story-telling props are less obvious. Tames says that when he walks into an office, the first thing he looks for are items that might help visually describe the politician. He checks for natural things the person might do—holding a pencil, handling the telephone, smoking a cigarette. He employs these common objects to help add variety to his pictures.

Tone of the Background Determines "Readability"

As with the selection of props, choice of background can transform an ordinary snapshot into a revealing portrait. Sometimes the subject knows just the right spot for a portrait. Other times the photographer must scout out the location. Tames says that based on his reading of the day's news and the particular assignment, he enters the senator's or representative's office with a "battle plan." By knowing his subject ahead of time, he says, "I can take control of the situation." Associated Press's Pulitzer Prize winner Eddie Adams said that sometimes he picks the background first and waits for the subject to move into the area. Eisenstaedt, of *Life*, wrote, "By now I've learned that the most important thing to do when you photograph somebody in a room or outside is not look at the subject but at the background."

Tames, Adams, and Eisenstaedt concentrate on the background behind the subject for two reasons. One, the background details help report the story. The rundown shack of the sharecropper tells us about the farmer's problems. The plush office of a new corporate executive indicates some of the advantages of the job. Two, the background affects the "readability" of a photo. Readability means that the subject must not get lost in the details of the environment. In a black-and-white photo, a dark subject can blend into a dark background, never to be seen again. You are about to photograph a black woman standing in front of a dark oak tree. When you shoot the picture the woman's face seems to disappear into the bark. To avoid this problem, place the woman in front of the white wall of her house and her face will stand out clearly.

Alone, a head shot of chicken producer Frank Perdue doesn't tell the viewer much about the man. . . .
(Ken Kobre, University of Houston)

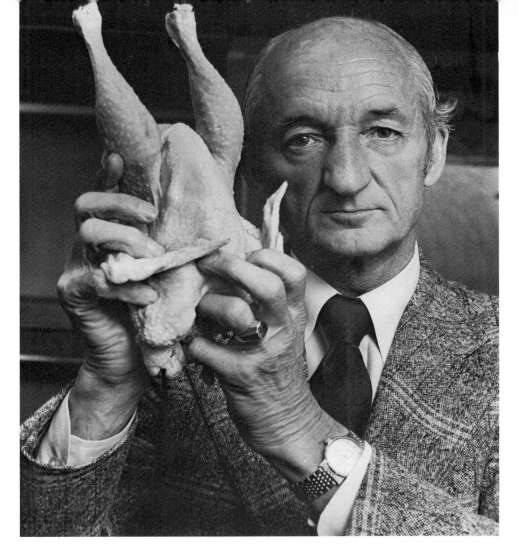

With Perdue holding one of his chickens, the readers get some idea of how the man made his fortune.
(Ken Kobre, University of Houston)

Below: A photo showing off one of Frank Perdue's specially raised and plucked chickens, and Perdue surrounded by a group of chefs, reflects Perdue's business specialty, as well as his engaging personality.
(Ken Kobre, University of Houston)

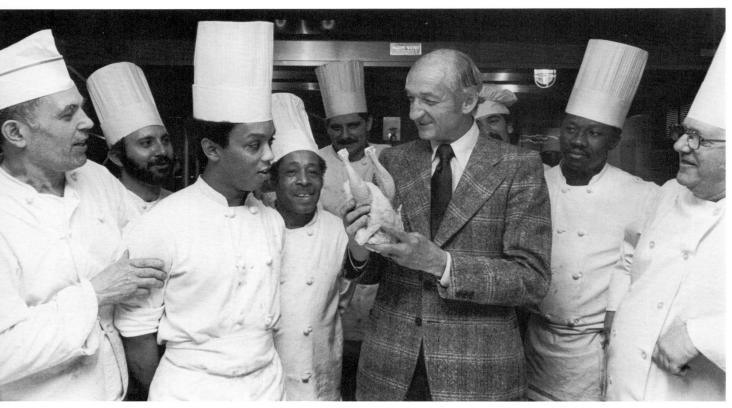

Because the world is colorful, the photographer might not remember that a red-shirted Santa Claus standing in front of a green Christmas tree background might blend together when photographed with black-and-white film. The reason for this is that red and green are different hues but can be of equal brightness; therefore, the film records them as nearly matching shades of gray. Santa Claus might look as if he were growing out of the tree in the black-and-white print. The photographer can improve readability by choosing a background setting with a tone that contrasts with the subject. You could place Santa Claus in front of a light-toned wall, for instance.

Light as well as background tone helps define the subject. If the person you are shooting has dark hair, the light hitting the back of the subject's head will create a highlight, thereby helping the subject stand out. If you could direct some light toward the back of Santa's head, the resulting hair light will help to separate Santa from the background.

A busy, multitoned background can clutter up any picture, distracting the viewer's attention from the main event. Keep in mind that a further complicating factor is that the subject-background tonal difference decreases when the photo is reproduced on coarse newsprint.

Lighting and Composition Add Atmosphere

Light can set the mood of a picture. When photographers shoot a picture that is lit brightly but has only a few shadows, the photo is called "high-key." In pictures of brides, photographers often employ high-key lighting because they want to give an upbeat mood to the photo.

When a somber effect is desired, however, the photographer chooses lighting that will leave large areas of the picture in shadow. The predominant tones of the photo are dark gray and black. At night, a tough police chief involved in a crime clean-up story might be photographed with the available light of a street corner. The moody character of the lighting in the photo coincides with the thrust of the story.

When the photographer placed this black woman from St. Petersburg, Florida, against a contrasting-light background, her face stood out clearly. (Ken Kobre, University of Houston)

A head shot of Natasia, "The Queen of Tremont Street," gave the viewer a hint about the street lady's attire but . . . (Greg Sorce)

. . . A full-length shot showed how truly unusual the woman's dress really was. The increased subject-to-camera distance also enabled the viewer to see the Queen's favorite possessions, her frying pan and her bottle of white port wine. (Abby Nash)

Photojournalism: The Professionals' Approach

Suppose your editor assigns you to photograph a banker. You size up the situation and decide to show the banker as a stable person in the community. You would want to position the person in the middle of the frame, lending balance and therefore dignity to the picture. You have used composition to help tell your picture story, conveying to the reader the point you wish to make about the banker.

Suppose, on another day, you are assigned to photograph the director of the Little Theater, an off-beat dramatic group. You want your picture of the director to be as exciting and tension-producing as a good Hitchcock thriller. By placing the director of the theater on the edge of your viewfinder and leaving the remaining area black, you can produce an off-balanced picture which gives added visual suspense to a photo.

The effect of the final picture changes, depending on whether the photographer fills the frame with the sitter's face or stands back for a full-length portrait. An extreme close-up, for instance, appears to bring the subject so near that the viewer gets the feeling of unusual intimacy with the sitter.

When I photographed a skid row wino on Christmas Eve at a Salvation Army party, I used a macro lens, which allowed me to bring my camera within a few inches of the old man's face. The resulting portrait of the alcoholic gained impact because I broke the unwritten but traditional space barrier, which is about 3 or 4 feet in normal conversation. With my camera, I had invaded the natural "psychological space" of the skid row resident to produce this personal portrait. The extreme close-up lent the portrait a unique perspective by concentrating the viewer's attention solely on the sitter's facial expressions and features. (See photo, pp. 116–117.)

Body language and choice of clothes can also reveal personality characteristics of the sitter. To capture these elements, the photographer must take a step backwards to include in the composition the full length of the subject. An overall photo can reveal more than a close-up showing only the face.

PUTTING THE SUBJECT AT EASE

If the subject doesn't feel comfortable in front of the camera, the best photojournalistic techniques in the world won't produce a revealing portrait. When a photographer disappears behind the camera, even if it is a relatively small 35mm, the photographer loses the eye contact with the subject. The subject is left alone to respond to a piece of coated glass and a black mechanical box, items not conducive to stimulating conversation.

To loosen up and relax the subject, even though the photographer-subject eye contact is lost, each photographer has developed his own technique. Keep in mind that an approach that works for one photographer might not work for you. Here are some choices to consider.

Stimulating a Reaction

Chip Maury, who works for the wire services and thus has little time to wait around for his photos uses the shock approach. When taking a head shot of a staid individual, he will ask the person to say his or her favorite four-letter word. The effect certainly works better than asking the person to say "cheese." Caught in the same time-pressure situation, I will ask the person to say the "ABCs" in a conversational tone. No subject thus far has reached "Z" without laughing.

Using Boredom Creatively

When you have time, the boredom technique works well; if you hang around long enough, often the subject gets tired of posing and forgets you are there.

Dr. Benjamin Spock ran on the People's Party ticket for President in 1972. Talking about politics with the photographer caused the baby-doctor-turned-presidential-hopeful to ignore the camera, as he outlined his platform for reform.
(Ken Kobre, University of Houston)

Then, as the subject becomes absorbed in his or her activities, you can shoot natural looking photos.

Arthur Grace, a frequent contributor to *Time* and *People* magazines, says that "once you put people in a location, you just wait and they will get lost in their own thoughts." Grace just sits there. "Maybe I'll take one frame to make them think that I've started but I haven't." Eventually, the subjects get so bored they forget they are having their picture taken and they relax. That's when Grace goes to work.

Conversation Relaxes Subjects

A most enjoyable aspect of photojournalism is meeting different kinds of people. Conversations with subjects often loosen them up. During a shooting session the talk usually turns to why the person is in the news. When they get engrossed in explaining to me how they became involved in the events, they forget about the camera.

Sometimes photographers need to research their subject. To photograph Jimmy Carter in 1976, when he was new to the Washington scene, George Tames read Carter's book, *Why Not the Best.* Tames says he tries to know enough about his subject for a preconceived notion of "what I'm going to get before I get there."

Tames says he calms his subject down with "strokes." He massages their egos—who can resist that? Tames puts subjects at ease because they sense he is their friend. "I have never deliberately made a bad picture of anyone," Tames said. His media-conscious subjects know his reputation for honesty. Tames never shoots a roll to the end because he finds that as soon as he puts his camera down, the conversation livens up. He needs those last frames to catch the subject—uninhibited and animated.

Photographer Takes Command

The difference between the veteran Tames and a shy young photographer is that the *New York Times*'s cameraman takes command of the situation rather than holding back. "You have to learn to influence politicians in a way that they will do what you want them to do," he says. He's frank with them. He tells a senator, "Look, this is only going to run one column, I need you to stand by the window and smoke your pipe." The senator responds because Tames exudes professionalism. Tames says, "Anytime I can control the situation I do. I shoot candids only when I have to." But Tames also knows when not to push his subjects too far. "I can tell immediately when enough is enough," he says.

Quit Hiding—Use a Tripod

One of *Life*'s original staff photographers, Alfred Eisenstaedt, emphasizes the psychological side of the portraitist. "You have to be able to sense very quickly when you meet someone whether you can back-slap him and call him by his first name right away, or whether you must be reserved and formal on your first meeting." Sensitive to his subject, Eisenstaedt avoids the disruption of picking up and putting down the camera, by using the tripod and cable release technique. He puts his camera on a tripod and focuses, freeing him to talk directly and keeping eye contact with his subject while snapping pictures. "For me," he says, "this method often gives the most relaxed pictures."

Another Interviewer Helps

Because it's often difficult to work the camera and carry on a meaningful conversation simultaneously, I have found it valuable to shoot pictures while the subject is being interviewed by a reporter. I took lively pictures of Marcel Mar-

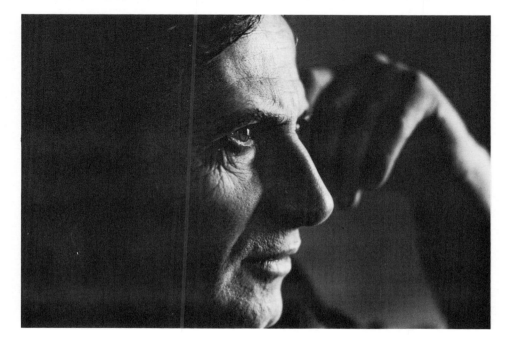

The camera essentially records the world in pantomine—actions without words. Marcel Marceau, therefore, is perhaps a photographer's perfect subject. A newspaper reporter involved Marceau in an interview. As the mime talked, the photographer was left free to catch candids.
(Ken Kobre, University of Houston)

ceau, the French mime, as he was busy talking to a reporter from my paper. The Frenchman was far too engrossed in the conversation to care about me or my camera. Before the interview started, I carefully placed Marceau so that he would be side-lit. Then when I sat side by side with the reporter, I could take unobstructed candids. Also, without disturbing the interview, I changed lenses and moved around the room to capture Marceau from a variety of positions and angles.

If an interviewer does not accompany me on a story, I often will take a friend along on the assignment. When no outsider is available, I will look for someone on location, like the subject's colleague, to whom the subject might enjoy talking. As the subject becomes involved in conversation, he unfreezes and his face becomes animated, producing a better picture.

The "Just-One-More" School

Finally, knowing the location of the door is just as important as knowing the location of the shutter. With a few frames left at the end of the roll, just in case, you should pack your gear before you wear out your welcome. Photographers have a bad reputation for asking for just-one-more picture. Leave in good standing with your subjects because you never know when they will be in the news again and you will need to make a new portrait.

"Bones" Kah, an Indiana motorcycle gang member, holds up his son, Harley Davidson. The direct approach sometimes works well with portrait photography.
(Rob Goebel, Sydney [Ohio] Daily News)

SPORTS AS NEWS

SPORTS AS FEATURES

TECHNIQUES OF THE SPORTS PHOTOGRAPHER

A SPORTS PHOTOGRAPHER CARRIES A BAG OF SOLUTIONS

ANTICIPATION:
Knowing Where the Ball Will Be Before It Gets There

PHOTOGRAPHING BASEBALL REQUIRES WAITING—UNTIL "ALL HELL BREAKS LOOSE"

FINDING THE FOOTBALL

SOCCER, A LIGHTNING FAST SPORT TO SHOOT

DON'T BE "FAKED-OUT" IN BASKETBALL

7
CAPTURING THE ACTION IN SPORTS

Previous page: *While some photographers zone-focus on an area a few feet from the basket, others prefer to keep the ball in focus as much of the time as possible.*
(George Rizer, courtesy *Boston Globe*)

Bill Rodgers made news as he won the 82nd Boston Marathon for the second time.
(Michael Grecco, Wide World Photos)

Sports photographers are like athletes. They have to have the aim of a football quarterback, the reflexes of a basketball guard, and the concentration of a tennis player.

The sports photographers' eye-hand coordination must activate the camera's trigger at the peak of the action. Their marksmanship must be excellent. Minute after minute, they have to aim and critically focus their telephoto lens, otherwise the image will be a useless blur.

Just as the players on the field cannot lose their concentration, so the photographers on the sidelines must be aware of every subtle movement of the game. In an interview for this book, Frank O'Brien, sports photographer with the *Boston Globe* for ten years, says he doesn't even talk with his fellow photographers during a game because conversation breaks his concentration. Pam Schuyler, who photographed for the Associated Press and wrote a book about the Celtics basketball team, commented that she won't even sit next to other photographers when she is shooting basketball pictures because the other photographers distract her too much.

The strategy of football is to "fake-out" the opposition by keeping the pigskin hidden for as long as possible. The photographer might as well be the twelfth player on the opposition team, because the photographer, too, is getting faked-out by the quarterback along with the defense tackles. Once the ball has been hiked, the photographer, like the opposing players, has to read the quarterback's motion, determining whether the quarterback will pass, hand off, or run through the line himself. A misread play for the defending football player could mean that the pass receiver was uncovered and "wide open" to catch the winning touchdown. A misread play for the photographer could mean that he or she took a meaningless picture of the halfback pretending to carry the ball while missing the end-zone shot of a newsworthy touchdown.

Sports photographers talk about getting in slumps just as baseball players who are having trouble at the plate get into ruts. Frank O'Brien said, "Sometimes I will go about 12 days without getting a good picture, then I will have a good streak and my stuff is fresh and exciting." O'Brien warns photographers not to get uptight when they're in a slump, because the extra tension will make their eye-hand coordination even worse.

In addition to these mental demands, sports photography is physically taxing. You need to carry bulky motorized cameras, long telephoto lenses, and a bag filled with extra film and supplies. After shouldering this awkward load, you must chase up and down the field to stay with the action and, at the same time, dodge 250-pound linemen crashing out of bounds.

Athletes try to jump higher, throw farther, run faster than anyone else; in other words, they strive to break a record. Sports photographers have the same goal. They use a longer lens to get closer to the action than their fellow photographers; they climb higher to get a new perspective, and they push their film faster to freeze motion. Sports photographers strive to create an image on film that captures in a unique way fast-paced action and drama of competition.

SPORTS AS NEWS

A good sports photo and a well-written news story have similar qualifications: both are timely and both have high reader interest.

Timeliness in a sports picture is essential. Nobody cares about a week-old game score but millions of viewers stay up to see the sports results on the eleven o'clock newscast. Interest is so high in sports it is estimated that 50 million people watch the World Series on television, and even more see the summer and winter Olympics.

Sports is big business, and the financial side of football or baseball rates as much attention as any other business story. Players are bought, sold, and

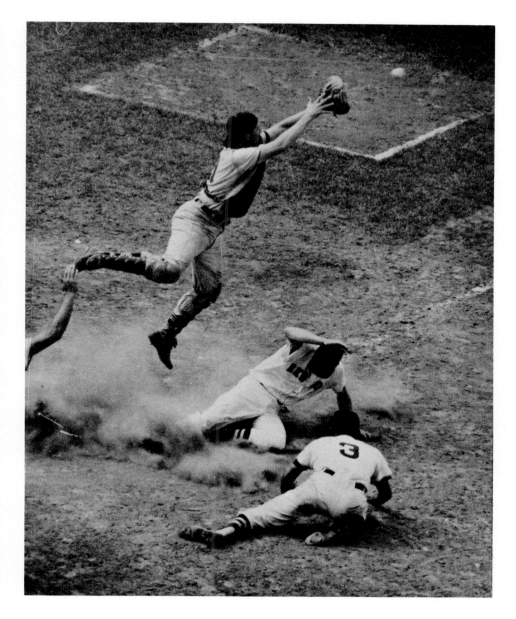

A sports news picture catches a critical moment of the game's action, such as this slide into home plate. The picture gains even more news value if the play proves to be a turning point in the game, or if the action involves an important star.
(Don Robinson, UPI)

traded for thousands of dollars: clubs approach the bidding block, ready to spend millions for promising superstars. Readers want to see pictures of these superstars sinking a basket, knocking a home run, or winning a marathon. Editors are aware of this star-gazing. During my interview with George Riley, sports photographer for UPI, he commented "a paper is more likely to run a picture of a top star hitting a home run than a lesser player doing the same thing, even if the pictures are equally good."

So sports photographers have to become sports fans; they must read faithfully the sports section of the paper, to learn who the top stars are, and what newsy things have happened to them lately. O'Brien says he combs the sports pages every day to pick up information on a player he might have to cover. He looks for lists of injured players, major trades, fights and feuds among the players and between players and coaches, records, and disputes over money. O'Brien also checks the paper to see if a player is having a hot streak that week. This news angle adds an extra dimension to a sports photo. If a player has made news on the side lines, readers will want to see what that player will do on the court or the field.

When Hank Aaron hit his 715th home run to break Babe Ruth's career

record, every camera in the stands clicked because the event was big news. When a record is broken, history is made. As sportswriter George Sullivan told this author, "One job of the newspaper is to record history." In baseball, especially, there seems to be an almost endless array of records to break. Surely the record book has listed the lefthander who had the most hits during an out-of-town night game pitched by a southpaw. Photographers can't memorize the record book, so they should check with the statistician before every game, to see if any new records are likely to be broken. A record-breaking home run or free throw might be the most newsworthy moment of the game, and an editor will want to see a picture of the event.

Summarizing the Game in One Photo

The lead of a sports story, written by a reporter, usually contains the names of both teams or players and the outcome of the game. It also describes the highlights of the game, the turning point or winning goal, the star of the game, and injuries to important players. Knowledgeable sports photographers follow the

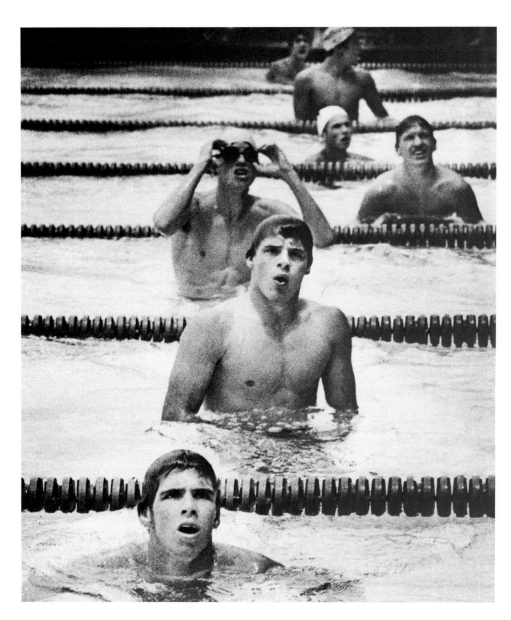

Good sports photographers keep their concentration up even after the contest ends. The expressions on these swimmers' faces at the AAU Junior Olympics, as the athletes watch the electric timer, reflect the intensity of their competition.
(Gary S. Wolfson, *Gainesville* [Florida] *Sun*)

game closely enough so that their pictures complement the lead of the news story. "I always try to develop the lead picture that will parallel the thrust of our wire story," explains George Riley. "UPI will often play up the top scorer in the game, so I will need a picture of him in action." If a particular play changes the course of the game, the photographer should have a shot of this play on film.

A good sports photographer watches all the action, but doesn't stop when the final gun goes off. Sometimes the expression on the athletes' faces *after* a tense meet tells the story better than a "play action" shot. O'Brien said that at the end of the game he looks for the elation in the crowd or anything else that will characterize the emotional flavor of the game. "Sometimes" he said, "these post-game photos are more revealing and have more story-telling value than a crisply focused action photograph of the critical play."

Captions Needed

Whether the picture shows the critical action on the field or the reactions off the field, the photographer must have complete caption information. The caption, as it is called in a magazine, or *cutline*, as it is known in a newspaper, is the explanatory line of type directly below the printed photograph. After many years on the *Boston Globe*, O'Brien is resigned to the fact that "editors will not run your stuff if you don't have caption information. Without captions, your pictures are useless."

If it is not obvious from the picture, a caption should answer the five W's

A photograph can tell a lot—but not everything. From glancing at this picture, the reader knows by the upturned arms of the referee that the play produced a successful touchdown. But the reader doesn't know which teams played, who made the touchdown, or what the final score was. For this information the reader needs a caption with the photograph.
(E. Joseph Deering, Houston Chronicle)

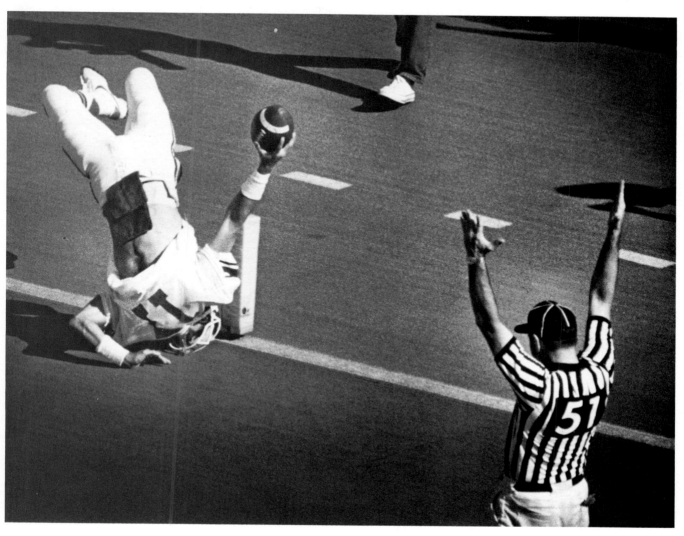

plus the *H*: Who? What? When? Why? Where? and How? Readers will know that the photo depicts a basketball game if a basketball is in the picture. But they might not know whether the picture was taken in the first or last quarter of the game, or the identity of the players, or the significance of the play.

A photographer's nightmare is to bring back 200 shots of a game, develop the negatives and select one frame with excellent action, then not know the names of the players, what happened, or when the action took place. Fortunately for the photographer, players wear large numbers on their uniforms. If the numbers are visible in the print, the player can be identified by matching the number against the roster list in the program. To determine when the play occurred, one old trick is to take a picture of the scoreboard after each major play or at the end of each quarter. By working backwards on the roll from the scoreboard frame, the photographer can determine when each shot was taken and which play led to which scores. The play-by-play statistics sheets, given out to the press at the end of the game by officials, also help photographers to write accurate captions.

Besides shooting frames of the scoreboard, sophisticated sports photographers usually take notes during the game. In baseball, there is time to record each play if you use a shorthand notation (for example FB = first base, HR = home run). In football, jot down a short description after each play. UPI's George Riley comments, "Keeping track of the plays can get tricky at times. This is where newcomers usually have the most trouble in sports photography."

On many weeklies, small dailies, and even the wire services, the photographer usually writes the caption as it will appear in the newspaper. (See chapter 10.) On large newspapers the desk editor or photo editor rewrites all the captions. Whether sports photographers dash off a sketchy list of notes or write a polished paragraph, they must provide enough accurate information for the reader to recognize the importance of the picture.

SPORTS AS FEATURES

Sports might be as timely and commands as much reader interest as any story in the newspaper. But sports events aren't hard news—they're entertainment and, therefore, they should be treated as features. A football game, no matter who wins or loses, is still *a game*. You might have a side bet resting on the World Series, but the outcome of the game will not affect your life beyond giving a moment of elation or depression (unless, of course, you staked your life savings on your favorite team).

Catching Reactions On and Off the Field

Opposite page: Sports is entertainment, and, therefore, provides good feature material. Chicago White Sox outfielder, Al Smith, watched a homerun ball fly over his head. Just as he looked up, a fan in the stands, trying to catch the fly ball for a souvenir, accidentally knocked his beer into the outfielder's face.
(Ray Gora, Chicago Tribune)

Because sports is entertainment, the sports photographer may treat the subject as a feature and look for the interesting, the unusual, the emotional, the unexpected, both on and off the field. What's happening on the bench can be as interesting as what's happening on the field. "Whenever I shoot sports I simultaneously watch the field and the sidelines," said the *Boston Globe*'s Frank O'Brien. "I lose some action plays sometimes but I get great emotional story-telling pictures this way." Coaches are under tremendous pressure, because their jobs are on the line every time the team takes the field. A picture of a coach pacing the sidelines, yelling at the referees, or jamming his finger at other coaches can reveal his underlying tension. Players feel that same pressure. The clenched jaw of a player sitting on the sidelines, or the wince of a player wearing a cast could also tell the story for the night.

George Sullivan, who has been handling sports pictures on newspapers for two decades, reminisced about one feature shot that summarized the whole game. Two football teams had been fighting it out on a field covered with eight

inches of water. "It wasn't a matter of winning or losing, just surviving," Sullivan recounted. "A photographer knelt behind the bench and focused his camera on one of the player's mud-encrusted boots. This photo captured the drudgery of that game."

Gaining an Impression of Movement in a Still Photo

The news approach to sports usually involves getting sharp, freezed-frame action shots of players hanging suspended in mid-air, grasping for the ball. Sometimes this literal approach robs the sports photo of its most vital element—the illusion of motion. A more impressionistic feature approach can add drama and reinforce motion in a still photograph. Certain camera techniques can heighten the effect. A sports photographer might pan the action of a bicyclist by setting the camera on a slow shutter speed and following the subject with the lens, intentionally blurring the background while keeping the subject sharp. (See page 153.) Such a picture can have more impact than would a traditional news photo of the winner of the bicycle race, in razor-sharp detail, crossing the finish line.

In a sports feature photo, the photographer ignores the critical winning moment in favor of capturing the atmosphere of the whole event. Impressionistic pictures of this kind transcend the actual event and become a universal statement about the grace and beauty of human movement. A bone-crushing tackle made by a football player may resemble a delicate pirouette when captured by a skilled photographer. Horst Baumann, an outstanding sports photographer, said in *Man and Sports*, a photo exhibit produced by the Baltimore Art Museum, that there is an increasing appreciation for the impressionistic nonfactual, but visually elegant, portrayal of sports.

Even though you might watch a game on television, the first section you turn to in your morning newspaper may be sports. Why? Television provides a fleeting image of the game-winning play. A good winning maneuver in gymnastics might last only one second. Even the instant replay is too fast for the viewer to note everything that went on during the tumble. The still camera with its multi-element glass eye, however, is very observant. The camera sees and records permanently more than the human eye notices at one glance, and the camera produces a picture that can be reviewed again and again.

TECHNIQUES OF THE SPORTS PHOTOGRAPHER

Freezing Action

Sports photography requires specialized technical skills because of the speed at which the athletes move and because of the limitations of position imposed on the photographer. Freezing the action in a sport requires a selection of a fast shutter speed, but how fast? Four factors affect the apparent speed of a subject, and therefore determine the shutter speed:

1. The actual speed of the subject.
2. The apparent distance between the subject and the camera.
3. The angle of movement relative to the camera's axis.
4. The focal length of the lens.

You will need a faster shutter speed to stop or freeze the action of a track star running a 100-yard dash than you will to stop the action of a Sunday afternoon jogger. To freeze a sprinter, the shutter must open and close before the image of the runner perceptibly changes position on the film. Therefore, the faster the subject runs, the faster shutter speeds you must use to stop the action and avoid a blur or double image on the film.

The second factor affecting the image on the film is the camera-to-subject distance. If you stand by the highway watching speeding cars go by, you may observe them zoom rapidly past you; but when you move back from the edge of the highway 100 feet or so, the apparent speed of the cars is considerably less. Speeding cars on the horizon may appear to be almost motionless. Translated into shutter settings, a general guideline for this effect is that the closer the camera is to the moving subject, the faster the shutter setting needed to stop or freeze its movement.

SHUTTER SPEEDS REQUIRED TO FREEZE ACTION

Speed of car (mph)		SPEED OF CAR			DISTANCE TO CAR			DIRECTION OF CAR			FOCAL LENGTH OF LENS			
		25 mph	50 mph	100 mph	50 mph	50 mph	50 mph	50 mph	50 mph	50 mph	50 mph	50 mph	50 mph	
Distance from camera to car	100 feet													
	50 feet													
	25 feet											wide	normal	tele
Shutter speed		1/250	1/500	1/1000	1/250	1/500	1/1000	1/500	1/250	1/125	1/250	1/500	1/1000	

Photojournalism: The Professionals' Approach

SHUTTER SPEEDS FOR ACTION PARALLEL TO FILM PLANE

| | | Camera-to-Subject Distance | | |
Type of Motion		25 Feet	50 Feet	100 Feet
Very fast walker	(5 mph)	1/125	1/60	1/30
Children running	(10 mph)	1/250	1/125	1/60
Good sprinter	(20 mph)	1/500	1/250	1/125
Speeding cars	(50 mph)	1/1000	1/500	1/250
Airplanes		—	—	1/500

Third, whether you get the camera closer by physically moving it towards the subject or remaining stationary and attaching a telephoto lens, thereby bringing the subject apparently closer, you must increase your shutter setting to freeze the action. Suppose you are 50 feet away from the track with a 55mm lens. A shutter speed of 1/500 sec. would be adequate to get a sharp picture of the car at 50 mph. However, if you keep the same lens, but move forward to within 25 feet of the railing, you must set the shutter at 1/1000 sec. to freeze the movement of the car. If you change from a 55mm to a 105mm lens but still remain at the 50-foot distance, you would still have to use 1/1000 sec. shutter speed (see diagram on p. 150). The rule is *when you halve the apparent camera-to-subject distance you need twice the shutter speed to get the same representation of motion.*

Fourth, the angle of the subject's movement relative to the axis of the camera also affects the choices of shutter speed. A car moving directly toward you may appear to be nearly stopped, because its image moves very little on the film. Yet the same car moving at the same speed, but this time moving across your line of vision, may appear to be traveling quite rapidly. This phenomenon means that if you position yourself to photograph a car 50 feet away going 50 mph moving directly toward you, you would need only 1/125 sec. shutter speed to stop the action. The same car, from the same distance, moving across your line of vision, would require 1/500 sec. to stop the motion.

With some movements, it is possible to stop the action at a relatively slow shutter speed by timing the shot to coincide with a momentary pause in the motion of the subject. At certain points, athletes come to almost a complete stop at the peak of their action. Consequently, the photographer can use a relatively slow shutter speed and still get a sharp picture. For instance, in track, when a high jumper reaches the apex of his leap directly above the bar, his vertical motion is over, he can't go any higher, and, for a split second, he will pause before gravity pulls him back to earth. A basketball player shooting a jump shot follows in the same pattern: he leaps into the air, reaches his peak, hesitates, and then shoots the ball before he begins dropping back to the floor. A pole vaulter's leap is another example of this type of motion. A sports photographer can use a slow shutter speed to stop action at the peak of the vault by anticipating where the peak will occur and *wait* for the athlete to reach the apex of the arc.

Panning

At times a fast shutter speed gives the photographer a chance to catch the action of the play, but lose the essence of the sport. Freezing a player in mid-air can rob the photo of any illusion of movement. To solve this problem you can use a technique known as *panning;* use a slow shutter speed and follow the subject. This technique produces a picture with a relatively sharp subject but a blurred and streaked background. A pan shot is dramatic and can make even the proverbial "Old Gray Mare" look like a triple-crown winner running at breakneck speed.

1/30 sec.—The direction a subject is moving in relation to the camera can affect the sharpness of the picture. At a slow shutter speed, a jogger moving from left to right is not sharp.
(Donald Dietz and Elizabeth Hamlin)

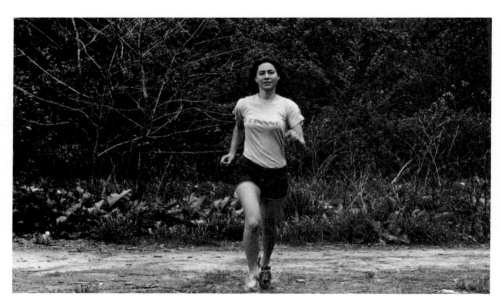

1/30 sec.—Here the jogger is sharp, even though photographed at the slow shutter speed that recorded blur in the first picture. Because the jogger was moving directly toward the camera, her image did not cross enough of the film to blur.
(Donald Dietz and Elizabeth Hamlin)

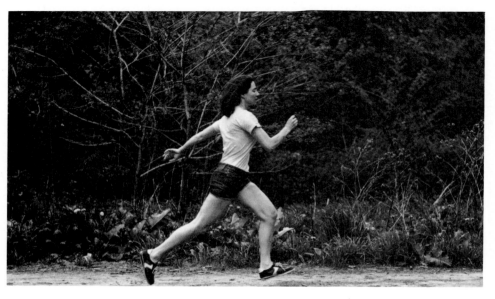

1/125 sec.—Photographed at a faster shutter speed, the same jogger, moving in the same direction, right to left, is sharp. During the shorter exposure, her image did not cross enough of the film to cause a blur.
(Donald Dietz and Elizabeth Hamlin)

On sports assignments for *Life* magazine and *Sports Illustrated*, Mark Kauffman has tried the panning technique on several different events. Kauffman in *Photographing Sports*, a book about his work, said, "Panning is something like shooting in the dark. It's practically impossible to predict the final result. Background colors will move and blend together giving shades and tones and creating hues which we cannot predict." If the photographer doesn't follow the subject smoothly, the image won't be sharp enough. Many photographers can't afford to risk a pan shot, because the editor counts on having at least one tack-sharp photo of the principals in the event. Therefore, the photographer never gambles on a pan shot for an important news assignment. "When on assignment," Kauffman cautions, "get the picture the editor needs first—then, if you have time, experiment with a pan."

The choice of lens is critical in panning. Kauffman selects the longest lens possible. A long lens allows the photographer to back off from the subject. The farther the camera is from the subject, the slower the photographer can pan resulting in more control. The lens, however, must allow a field of view that is wide enough to accommodate the anticipated action.

In panning, you use your eye-level viewfinder to spot the subject as it moves into view. Pivot your head and shoulders so that you keep the subject in the viewfinder at all times. When your subject is in view, release the shutter without interrupting your pivot. Be sure to follow through after you snap the shutter. The trick is to have the camera moving at the same speed and in the same direction as the subject.

Kauffman, who became the picture editor of *Playboy* magazine, explains his panning technique this way:

> You must start to track well before you actually trip the shutter in order
> to get a flow that harmonizes the movement of camera and subject. I

To retain a sense of movement in this still photograph of an antique tricycle, the photographer panned the camera with movement of the vehicle exposing the film for 1/15 sec.
(Ken Kobre, University of Houston)

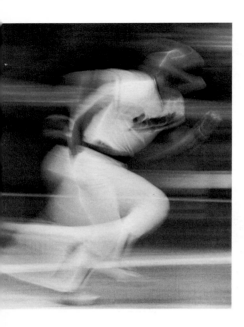

favor shutter speeds of 1/15 to 1/8 sec. You should shoot somewhere in the middle of the pan, and remember to continue to swing the camera in a follow-through motion even after you've taken the picture. Most cameras have in their viewfinders a cross hatch or center ring. I liken this to a gunsight and keep my game right in the crosshairs all the time. At the midpoint of my arc, I squeeze off the shot and continue the motion even after the mirror returns to view.

A smooth pan can be achieved with a subject that moves at a constant speed, such as a bicycle. But human motion is much less efficient. A runner slows down for an instant every time one foot hits the ground. Also, a runner's body moves horizontally while his legs and arms move up and down. Panned pictures of runners show their torsos as solid images, but their legs and arms look like fans in motion.

Critical and Zone Focusing—Two Ways to Achieve Sharp Images

Whether you use a slow shutter speed and a pan, or a fast shutter speed and freeze the action, the subject will not be sharp unless the lens is critically focused. Focusing a lens on a rapidly moving subject takes considerable practice. In some sports, like auto or motorcycle racing, it is nearly impossible to follow the subject and keep it in focus. To shoot such pictures, sports photographers use a method called zone focusing.

To zone focus, prefocus the lens for the point at which you expect the action to take place, such as the finish line in a race, or the basket in a basketball game, and let the depth of field of your lens do the rest. As the subject crosses the predetermined mark, frame and shoot your picture. Your picture will be sharp not only at the point at which you have focused but for several feet in front of and behind that point. The distance before and after the point in focus is called depth of field and is controlled by your choice of (1) lens, (2) f-stop, and (3) camera-to-subject distance.

At a given distance, the wider the angle of the lens, the greater the depth

The photographer panned the camera with the base runner. The University of Houston player's torso appeared relatively sharp, because he was traveling horizontally and the camera was panned horizontally in the same direction. But because the players' arms and legs were moving up and down, they came out streaked and indistinct.
(Ben DeSoto, Pasadena [Texas] Citizen)

For this pan shot, the photographer coordinated the swing of the camera with the runner in black in the lower right of the picture. The other marathoners were moving at slightly different speeds and at different angles to the camera's direction of movement; consequently, these other runners tended to blur on the film.
(Patti Gold)

Photojournalism: The Professionals' Approach

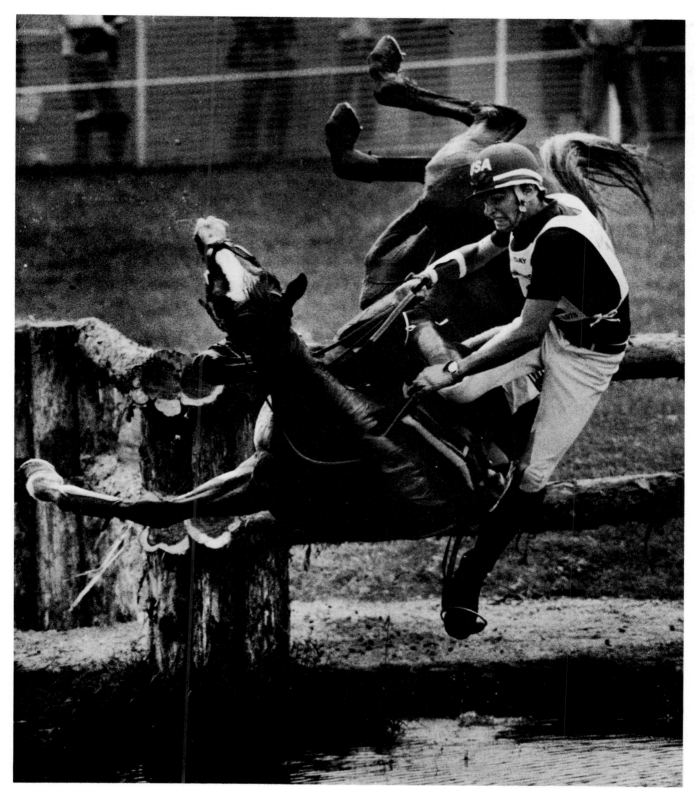

For a sharp picture of a fast-moving subject such as this horse and rider, the photographer can either focus on the top of the hurdle and wait for the animal to jump or, continuously adjusting the lens' focus, tracking the horse as it runs down the course. Melissa Farlow used the tracking method, also called follow-focusing or critical focusing, to catch this jumping accident.
(Melissa Farlow, The Courier-Journal and Louisville Times)

of field. For instance, with a 200mm telephoto lens focused at 15 feet and set at f/16, a depth of field will be about 1 foot in front and 1½ feet behind the subject. With a 20mm wide-angle lens focused at the same distance and set at the same f-stop, the depth of field will extend 12½ feet in front of the subject, and would be sharp to infinity behind the subject. Consequently, if you prefocus a telephoto lens your subjects will be sharp only if they stay within a 2½ foot band, but if you use a wide-angle lens, the subject can move almost anywhere in the playing field and you will get sharp negatives. There is a trade-off, however: your telephoto lens will give you a much larger image size on the negative than will the wide-angle lens.

Depth of field increases for both lenses as you back away from the subject and as you use smaller apertures. On most lenses, depth of field is marked on the lens barrel for each f-stop. Also, some single-lens reflex cameras have a depth-of-field preview button.

Once you have prefocused and determined your depth of field, you know the zone in which you can shoot without refocusing. When the subject speeds into the framed area, you can take several shots as long as the subject is within the zone. For example, at an equestrian event, the sports photographer can prefocus on the hurdle and wait for the horse and rider to jump. In some sports, such as baseball, the action occurs in definite places, such as first, second, and third bases and home plate. Baseball is ideal for zone focusing, and some baseball photographers even label the base positions on their lenses. First, they sit in a fixed position between home plate and first base. Then, they put a strip of white tape around the lens barrel next to the footage scale. They focus on each base, home plate, the pitcher's mound, and the dugout, and mark on the tape labeling each point. When a runner breaks to steal second, the photographer can quickly rotate the lens to the "2" position, and the lens will be in sharp focus to catch the player sliding into second base. If the action suddenly switches to third base, a short twist of the lens to position "3" and the photographer is ready for the new action. The photographer does not have to peer through the lens, spending time to find the optimum focus.

This technique, of course, works only if the photographer remains in the original spot. At the beginning, it's difficult to move the lens to the designated marks, raise the camera, and shoot. But after awhile the photographer becomes accustomed to rotating the barrel and knows each position just by feel.

A SPORTS PHOTOGRAPHER CARRIES A BAG OF SOLUTIONS

Adding Drama to Drama—The Telephoto and Zoom Lens

A sports photographer cannot run onto the playing field with a wide-angle 20mm lens and snap a picture of the action. To get an image size large enough to print, the sports specialist usually has to use long telephoto lenses. The telephoto adds drama to the drama, and heightens the impact. With these long lenses you magnify what you want to show by eliminating all other distractions.

Unfortunately, telephoto lenses are not the sports photographer's panacea. The telephoto lens itself has inherent problems. For instance, the longer the lens the less depth of field; therefore, focusing becomes even more critical. With extreme telephoto lenses, like the 500mm and 1000mm, there is no margin of error. The focus has to be perfect or the shot is lost.

Critical focusing is just one challenge when you use a telephoto lens. Another is the exaggerated effect of camera movement on the sharpness of the picture. The length of the lens magnifies any camera movement and thus adds

Photojournalism: The Professionals' Approach

to blur in the final image. A 200mm telephoto, compared to a normal 50mm lens, magnifies the image four times, but also magnifies camera-shake by the same amount. With any very long lens, it is sometimes necessary to use a tripod or, more conveniently, a monopod, a one-legged support. A shoulder pod can also help steady a long lens.

Another problem is that if your eye is not perfectly aligned with the optics of the lens, one-half of the split-image focusing circle will tend to go dark when you use a long telephoto lens. If you can't change to a focusing screen without a split image circle, you can look through the ground glass surrounding the circle to focus the picture.

Even though telephoto lenses are difficult to use, they do put the viewer right in the middle of the action. These lenses can be a creative tool because they pull things together in a way the human eye never sees. A telephoto lens appears to compress space. This compression makes objects seem much closer together in depth than they really are. Also, because of its shallow depth of field, the telephoto lens has the effect of blurring distracting backgrounds, such as crowds in the stands or chain link fences around the field.

Rather than carry a satchel of different lenses, some sports photographers prefer to use zoom lenses. With the zoom you can continually change the focal length of the lens, so that one lens is doing the work of several. Because you can zoom to any millimeter within the range of the lens, your framing can be exact. Sports photographers also like the zoom because it lets them follow the action as a player is running towards the camera and keep the player's image size constant in the viewfinder. Another advantage is that with the zoom lens you can get several shots from a single vantage point without moving. For instance, you can zoom back and catch all the horses at the starting line of a race; then, after the horses leave the gate, you can zoom in to isolate the leader of the pack—all this by just a twist of the lens.

But even this versatile lens has some drawbacks. A zoom is usually heavier than a single-length telephoto lens. This extra weight and bulk may make the

Photographing with a telephoto lens gives viewers the feeling that they are on the ice with these two hockey players as they trade punches. (Frank O'Brien, *Boston Globe*)

zoom harder to hand-hold steadily. Second, the zoom lens's widest apertures are usually smaller than the maximum aperture on a fixed focal length lens, so the zoom is less useful in low light situations, such as indoor arenas or night games. Third, focusing and zooming simultaneously as the subject moves can be difficult to coordinate. You can develop this skill with practice, but it does take time. The fourth and certainly the most controversial drawback is the alleged lack of crispness of the image shot through a zoom lens. Some photographers feel that the zoom lens is not as sharp as a single fixed-focus lens at wide apertures, whereas others believe that any difference is not significant. This last point will always produce a debate among photographers. However, depending on the sport, zoom lenses used creatively can be invaluable.

Automating the Finger—The Motorized Camera

A motor-drive attachment allows you to fire a series of frames without manually advancing the film between each shot. (See photo on p. 163.) Every sports photographer interviewed for this book used a motor-drive, but several mentioned that in some instances a motor-drive caused them to miss the peak action of the play.

George Riley of UPI points out that "motors can throw your timing off and sometimes the best pictures come between the frame." However, Riley quickly pointed out that on a controversial play the photographer needs the motor-drive to fire off a sequence and show how the play developed. Pam Schuyler, who worked for the AP, commented that a motor-drive is not absolutely necessary. For three years she worked without one, although she does use one now, because the motor-drive increases the probability of "getting the perfect frame."

The motor-drive fires the shutter, advances the film, and cocks the shutter again for the next picture faster than you can blink an eye. If you use the motor-drive semi-automatically—one frame at a time—you need not remove the camera from your eye to advance the film. Or you can shoot rapid sequence pictures at a rate of 2 to 5 frames per second, depending on the make of the camera, without taking your finger off the shutter. This rapid-fire pace increases your chances of capturing peak action.

As in working with all photographic equipment, you must learn the technique of using motor-drive. You should begin shooting before the action starts and continue holding down the shutter release until after the action stops. This will expose a series of frames that encompasses the complete play. From the sequence, you can choose the best frame, one you might have missed if you had advanced the film manually.

A motor-driven camera may also be placed in a remote location such as on the inside of a hockey goal or behind the plastic of a backboard. Because no sane photographer wants to be subjected to a barrage of speeding hockey pucks or powerful slam dunks, the camera can be activated either by an electrical wire or by a radio control. Firing the camera remotely can give the photographer a unique vantage point, right in the middle of the melee.

The motorized camera can be an expensive piece of equipment, and because it advances film so quickly the extra film adds to the cost of the job, a particular concern of the free-lance photographer. The rapid winder, a battery-powered motor attachment that will not advance the film as fast (about 2 frames per second) as a motor-drive (up to 5 frames per second) but is lighter and less expensive, provides a viable alternative.

The ultimate motor-drive camera, the Hulcher 35, is out of the price range of even most professionals. The Hulcher sequence camera offers rapid-fire capabilities; it may be adjusted to operate as fast as 20 frames per second at shutter speeds up to 1/4000 of a second. The custom-built camera, operated by heavy-duty batteries, uses bulk-loaded 35mm film.

Developing the Film for Dimly Lit Sports

Outdoor sporting events present few lighting difficulties, but indoor and night sports can be trickly to shoot because of low light. A photographer must compensate for this low light. First, poor light means that you must set your lens on its widest aperture. Unfortunately, this narrows the depth of field, and reduces the chances for a sharp picture. Second, you might have to turn your shutter dial to a slower speed to compensate for the low light conditions, but again, this may blur the image in the final picture.

To get sharp pictures under minimal light conditions, such as a football stadium at night, you can overrate your film, thus allowing you to use a higher shutter speed and/or a smaller aperture. For instance, with a Kodak Tri-X Film normally rated at ASA 400, the exposure might be 1/125 sec. at f/2.8. You could rate the film at ASA 1600, reset your light meter accordingly, and get a new metering of 1/250 sec. shutter speed with an aperture of f/4.

To compensate for overrating the film, you would have to use high-energy developers in the darkroom. Simply giving the film longer development in a standard developer, such as Kodak's D-76, is not satisfactory if the film was shot under normal or contrasty lighting conditions; the overdevelopment will produce more contrast without a true gain in sensitivity. Overdevelopment will build up the dense highlight areas of the negative, but will not provide more detail in the film's shadow areas. Overdeveloping the negatives works satisfactorily if the film was taken under flat lighting conditions such as an overcast day. For normal and contrasty lighting conditions high-energy developers, such as Acufine, Diafine, and Ethol UFG, specifically compensate for shadow detail when you increase the normal ASA ratings and consequently provide a negative with a fairly complete tonal range. Every photographer who has to shoot black-and-white pictures in dingy gyms or poorly flood-lit stadiums has settled on one or another of the high-energy developers. Some photographers have even concocted their own formulas. Pam Schuyler, for instance, uses one part HC-110 replenisher to 15 parts water at 75° for 6 minutes. She claims she can rate Tri-X as high as 2400 and still get good results with this solution. (See table on p. 198.)

Regardless of which alchemist you listen to, you pay a price when you rate your black-and-white film above normal. The price is enlarged grain. Grain tends to become more pronounced and to clump at higher ratings. Although unattractive for display prints, enlarged grain rarely shows up in newspaper halftone reproduction. But because of the higher E.I. (exposure index) rating, you do get sharp pictures. These inflated ratings enable you to shoot sports, unencumbered by strobes, cords, batteries, and delayed recycle time, and still get sharp, clear action pictures.

Don't Hock Your Strobe Yet!

Some sport situations demand electronic flash, whereas others merely benefit from the use of this lighting source. If the light level in the hockey arena is too low, you will have to resort to a strobe to stop the action on film. The electronic flash from a strobe begins and ends so fast that the flash will stop just about any action you might encounter. Although the lighting effect from a single strobe looks unnatural, the resulting print will be sharper than a blurred shot taken with more natural available light.

Sometimes, direct flash can enhance a sports picture. Direct flash on the camera used in a gymnasium will illuminate a foreground subject and the background will go black, creating a dramatic light-on-dark effect that separates the athlete from the crowd. This result is particularly helpful when the background is visually busy; the strobe eliminates the distracting background elements and makes the subject pop out. Some photographers like to set up two or more strobes

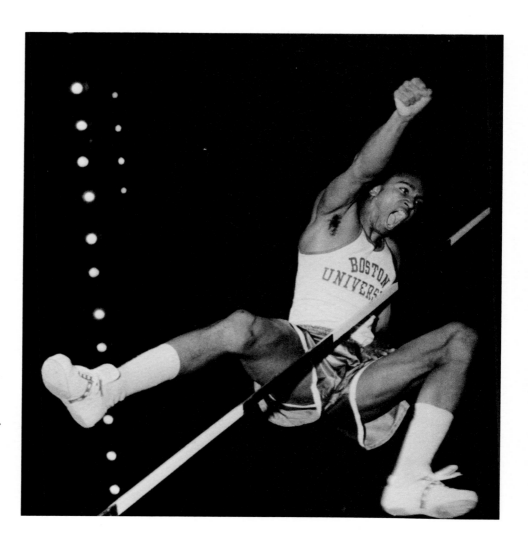

for a spectacular multi-light photo at indoor and night sports events. Two lights can be synchronized with a connecting wire or photoelectric slave cell that fires both units simultaneously.

Major magazines, such as *Sports Illustrated*, will light an entire sports arena with a battery of huge strobes; photographers can shoot with slow, fine-grain color film, and still get outstanding picture results. Note, however, that the elaborate multi-light installations require a great deal of money and time. (See chapter 8 for more details on strobe use.)

ANTICIPATION:
Knowing Where the Ball Will Be Before It Gets There

At one time photographers were allowed to work on the field of major league baseball games, but this freedom was curtailed because of the antics of photographers like Hy Peskin. An outstanding photographer, Peskin was covering a close game between the Giants and the Dodgers from a spot behind first base when he saw a ball hit into right field. He realized there would be a close play at third base. With the volatile Leo Durocher coaching at third, Peskin knew there would be a scene. As the right-fielder chased down the ball, Peskin took the shortest route to third base—over the pitcher's mound and across the infield. Peskin, the runner, and the ball all arrived at third base at the same moment.

Peskin got his pictures, but after similar incidents photographers were barred from the playing field of the major league games.

If Hy Peskin had anticipated third-base action before the play began, he could have positioned himself near that baseline, or he could have focused with a long lens on the bag at third.

"In fact, the key to getting great sports photographs is anticipation," claims Pam Schuyler. Anticipation means predicting not only what's going to happen but where it's going to happen. You must base these predictions on knowledge of the game, the players, and the coaches. For instance, anticipation in football means that you must know the kind of play to expect—run, pass, or kick. Then you must predict who will be involved in the play—quarterback, running back, or pass-receiver. And finally, you must guess where the play will take place—at the line of scrimmage, behind the line, or downfield. Basing your position on these predictions, you would station yourself along the sidelines, usually at the point nearest the expected action. Choose the appropriate milli-meter lens and prefocus that lens on the area where you expect the play to take place. Then wait and hope the action will follow the course you have predicted.

Counteracting Reaction Time

Besides anticipating the place of the action, you must also press the shutter button before that play reaches its peak. In baseball, for instance, if you hit the trigger of your camera when you hear the crack of the bat against the ball, your final picture will show the ball already headed for left field. You would swear that you squeezed the shutter at the same instant the bat met the ball, yet the picture clearly demonstrates the shutter was delayed. Why?

A lag-time occurred between the moment you heard the crack of the bat and the moment you pressed the shutter. Psychologists have termed this lag period "reaction time," and they are able to measure precisely its duration. The delayed reaction is caused by the amount of time it takes you first, to recognize that an important play is in progress; second, to decide if a picture should be taken; third, to send a positive signal to the muscle group needed for the move-

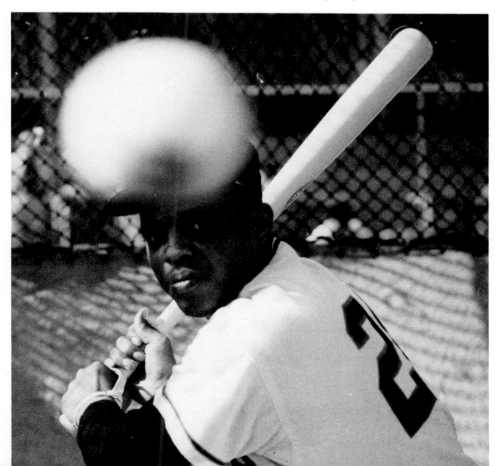

Willie Mays watches a pitch. A sports photographer must anticipate a player's next response to overcome the photographer's own reaction time. If the camera operator waits to release the shutter until hearing the sound of the bat hitting the ball, it will be too late. (Bob Vose, *Look* Collection, Library of Congress)

ment, in this case the index finger; and fourth, to contract the muscles in the forefinger, thereby releasing the camera shutter. Even after the shutter trigger is depressed, there's another delay while the camera itself responds. Even the most sensitive shutter still takes time to function. This shutter reaction time is the fifth step. All five steps added together account for the reaction time between seeing the action and taking the picture. You run through these same steps every time you take any picture, but the cumulative length of reaction time becomes critical when the subject is a baseball moving at 90 mph.

If you peer through your viewfinder and wait to see the play reach its peak, and then decide to take a picture, the action will be over by the time the shutter opens. The sound of the crowd's reaction is like the final gun; it's too late to change the outcome. By the time the crowd begins to cry or cheer, the play is finished and you might as well save your film for the next play or the next season.

PHOTOGRAPHING BASEBALL REQUIRES WAITING—UNTIL "ALL HELL BREAKS LOOSE"

Pam Schuyler describes baseball as a "Zen sport." She says that baseball requires infinite patience to photograph because the action erupts in spurts and instant response is needed. "You wait and wait and nothing happens. Then, all of a sudden, all hell breaks loose," says Shuyler. "I get bored easily at a baseball game and then I lose my concentration. That's when the big action always seems to occur!"

It does appear sometimes that nothing ever happens in baseball, and, in fact, the perfect game from the standpoint of a baseball aficionado is a "no-hitter." Sports writers still refer to the game in the 1956 World Series when Don Larsen of the Yankees pitched a no-hitter. Not only were there no hits, but also no walks, and no errors either. Twenty-seven Dodgers went from the dugout to the plate and back again without reaching first base. There was no action for the photographer to shoot in this perfect baseball game. The picture that is remembered shows Larsen pitching his last ball, with a row of Dodger zeroes on the scoreboard in the background.

Sliding Second

Fortunately for the photographer, a no-hitter is rare. Most games have at least some action at the bases, and baseball, like all sports, has its standard or classic action photo. In baseball, the standard photo is the second-base slide. Learning to anticipate when a second-base slide is likely to occur is not hard. When a player reaches first base in the early part of an inning, keep your lens trained on second base. First, the runner on first base might try to steal second base. Some runners have a long record of stolen bases. If the man on first is a proven "base thief," the photographer, like the pitcher, should watch his every move and keep the lens sharply focused on second base. Second, if the batter hits a ground ball the fielder will try to force the lead runner out at second base. Third, if the batter knocks a high fly ball (a sacrifice fly) the runner will tag up at first and try to beat the throw at second. Whether the runner steals, runs on a ground ball, or tags up and runs after a fly ball is hit, the slide will be at second base. When the play is going to take place at second base, train your telephoto lens on the base, focus, and wait for the action. With a single-frame camera, try to snap the shutter either just as the runner touches the base or just as the baseman tags the runner. With a motor-drive, the timing does not have to be so exact because the camera fires between 2 to 5 frames per second; if you press the release as the slide begins, and hold it until the umpire makes the call, one frame is likely to coincide with the

peak of the action. Often a good series of pictures results. If any of the photos in the series shows the intense expressions on the player's face, these pictures will have added human interest.

Stealing Base

When the key play is a second-base slide, the photographer simply zeroes in on the base and concentrates. A more difficult situation occurs when a notorious base-stealer ventures into no-man's-land between first and second. The pitcher could try to pick off the runner at first if he feels the runner has too daring a lead-off, or the catcher could peg the runner if he breaks for second. Frank O'Brien covers this split action by prefocusing one camera on second base and setting this camera aside; then he focuses another camera on first base and keeps this camera to his eye. O'Brien can snap a picture of the pick-off on first or, if the runner heads for second base, O'Brien has time to raise his other prefocused camera and catch the slide at second.

When a runner gets to second base and is officially "in scoring position," you should prefocus on home plate. On the next fair play, the runner might try to score.

One general rule is to follow the runner, not the ball, with your lens. A routine catch in the outfield makes a routine picture. "Except with a short fly, when either the infielder has to catch the ball in back of him, or the outfielder

To catch a photo of this slide, Michael Maher shot with a motorized camera prefocused on second base. He triggered the camera as the play began, firing until after Jerry Remy of the Red Sox threw the ball to first, forcing out the runner for a double-play. After inspecting the film in the darkroom, Maher chose one key frame to enlarge. (Michael Maher, Lowell [Massachusetts] Sun)

has to dive for it, I keep my camera focused on the base path runners,'' says O'Brien.

Photographers position themselves several yards back from the base path between home and first base, or home and third base, or in the press gallery. From these positions, especially when shooting high school, college, and professional baseball, sports photographers prefer a 200mm or 300mm lens to cover the infield and a 400-600mm to cover the outfield. A sandlot or Little League playing field measures a shorter distance, hence a 135mm lens covers the infield easily. A shutter speed of 1/500 sec. stops movement of the little leaguer or the professional and results in sharp pictures. Zone focus the lens (see "Critical and Zone Focusing," p. 154) and wait for the action.

Looking Out for the Unusual

Baseball is a team sport played by individuals. Each player has his own strengths and his own repertoire of favorite stunts. One ballplayer might hold the season's record in stolen bases, while a pitcher might lead the league in pick-offs at first. With this combination, the smart photographer has the camera lens focused and aimed squarely at first! One batter might be a consistent bunter; another might consider a bunt below his dignity under any circumstances. The more you know about the idiosyncrasies of the players the better your forecasting—therefore, the better your pictures.

Although the dust-swirling second-base slide is a sports photographer's "bread-and-butter" shot, because the action is guaranteed, sometimes the shot can be overworked. "You can almost take the slide shot out of the files, the situation starts to look so similar," says UPI's Riley. Other standard "must" pictures for the baseball photographer are photos of the pitchers and photos of

An unusual catch like this lets the reader empathetically strain with the fielder as he tries to reach over the fence to snatch this fly.
(Duane Hamamura,
Auburn *[Washington]*
Globe-News*)*

any batters who are either long-hitters or are on a hitting streak. If the pitcher has thrown a particularly good game with few runs and multiple strike-outs, the sports reporter may develop the lead around him. That means the photographer should deliver shots of the pitcher and his pitching style. Although all batting photos tend to look similar, if a particular hitter knocks many runs in one day, the batter's feat will lead the next day's news story and will require an accompanying picture. Coordinating the photographer's coverage with the writer's lead helps to produce a solidly illustrated story. The antics of the team manager may provide another rich source of photographic material. When he strides onto the field, you can bet sparks will fly whether he harangues the umpire or yanks out the losing pitcher.

A photographer can shoot baseball without being a Zen master. Just remember that you will never go hungry if you consistently catch your bread-and-butter action picture, the second-base slide. But you are more likely to be eating steak and lobster if you cover *all* the important action on the field.

FINDING THE FOOTBALL

When you cover a football game you face some of the same problems as does a 250-pound defensive tackle. Before each down, you and the football player have to predict which way the quarterback will move on the next play. Then, after the center hikes the ball, you and the tackle must react quickly and make adjustments as the play unfolds. Will the quarterback hand off to a speedster for an end run or to a powerful halfback for a bruising plunge through the center? Or will the quarterback throw a quick spike, for short yardage or a long bomb to the end zone? As the defensive player considers the options, the sports photographer likewise anticipates the call and prepares for the play. You must be in the right place at the right time, with the right equipment, ready and waiting for the action.

For the opening kick-off, Frank O'Brien stands at the receiving team's 20-yard line. He estimates that 75 percent of the time the ball will wind up on this yard line by the end of the first down, and he will be there to cover the action.

Watching for the Run

After the kickoff, you must watch out and plan for three basic kinds of plays: runs, passes, and punts. On a run, track the football as it is snapped by the center and either carried by the quarterback or handed to another backfield player.

Most teams tend to run the ball on the first down because a run is generally considered a safer play than a pass, or, as former Ohio State coach Woody Hayes put it, "Only three things can happen when you pass and two of them are bad." Therefore, cautious quarterbacks like to keep the ball on the ground on the first down. Caution also dictates the use of a running play on the third down when the team is just one or two yards shy of a first down. Some teams, particularly the Big Ten power squads, with their strong running backs and blockers, carry the football not only on the first and third down, but are very likely to run on the second down as well.

Shooting the "Bomb"

The photographer can anticipate a pass on the first down instead of a run only if the team is behind on the scoreboard, needs long yardage on the play, and wants to stop the clock. A quarterback might go to the air on the second down if the team is just a few yards short of first down; he knows he still has two more downs to pick up the necessary ground. The photographer can bet with good odds on a third down pass if the team has lost ground or failed to advance the ball on the first two downs.

To photograph a long pass, the photographer should swing the lens toward the receiver, in this situation, Billy Johnson of the Houston Oilers. Then the photographer should wait for the ball to arrive. (George Honeycutt, Houston Chronicle)

Knowing the idiosyncrasies of a team will help the photographer predict when the team will call for an aerial play. Frank O'Brien was once going to cover a home game between the New England Patriots, his local team, and the Baltimore Colts. He began watching the Colt's games on television, and noticed that 90 percent of the time when the Colts used a "split back" formation they went to a pass play. This bit of knowledge gave O'Brien an edge on his photographic competition when he covered the Colts-Patriots battle on the home field.

But not all pass-plays are alike. The photographer must be prepared to cover the action of a short-screen-pass or a long bomb. The coach usually calls for the "Big Bomb" when his team, trying to come from behind, wants to put fast points on the scoreboard. A photographer can predict the "Big Bomb" by noting the score and watching the body language of the quarterback. If the quarterback drops back far behind the line of scrimmage, firmly plants his feet, pumps the ball a few times, and then cocks his arm way back behind his head, the player is very likely winding up for a long throw. Once you read these cues and see a "bomb" in the making, you should immediately swing the barrel of your telephoto lens downfield, focus on the expected receiver, and follow his pass pattern. Do *not* try to track the ball as it flies through the air; you couldn't follow the focus fast enough to keep the ball sharp. O'Brien says he always notes the direction of the quarterback's gaze for a tipoff on which downfield receiver will get the ball. O'Brien points out that "even the best quarterback has to look where he's throwing the ball."

Adjusting Your Position as the Game Progresses

Most teams punt on the fourth down, unless they are within a few yards of the goal line. Photographing a blocked punt results in a more exciting picture than does photographing a downfield receiver, especially if he signals for a "fair catch." So remain on the scrimmage line and keep your camera focused on the kicker and the attacking defensemen. Even if the punt is not blocked and the receiver returns the ball for long yardage, you will be in a good position to snap the runner as he fakes and dodges his way up the field.

At each down, station yourself a few yards ahead of the scrimmage line. Then, when the play begins, wait for a clear, unobstructed view of the ball carrier before you depress the shutter button. At most stadiums, photographers are permitted to roam freely from the end zone up to the 35 yard line on either side of the field. To avoid distracting the coaches and sidelined players, photographers are prohibited from moving in front of the benches at the center of the field. Photographers must stay behind the sideline boundary strip at all times and never get between the player on the field and the yardage marker poles. If you had to jump back quickly, as the thundering pack of players heads towards the sidelines, you could trip on the marking chain and get trampled—a high price to pay for even the most dramatic play-action shot.

You can also shoot from high up in the stands to get a refreshing angle on the game. Sometimes a long shot from this vantage point produces a photo that resembles a chalkboard diagram of the play.

All fifty thousand pairs of eyes in the stadium are searching for the pigskin. The ball itself is the center of interest because everyone wants to know who has the ball and what's happening to it. Therefore, you have an obligation to get the brown leather ball in your picture as often as you can. The players, however, trained by their coaches to protect the ball at all times, will make your task difficult.

But not every picture must involve the ball-carrier. After all, when one 250-pounder, with an indestructible frame and shoulder pads, meets another human impasse capped by an impact-resistant helmet, something has to give. The confrontation scene might be spectacular—even if it occurs 10 yards away from the ball.

A 200mm lens will cover the action on a high school or college football field, but for the professional game, because the layout of the field is a little different, a 300mm lens is recommended. If you have only a short telephoto lens, such as a 105mm or 135mm, wait for the ball to be carried toward the sidelines. If you try to cover midfield action with a short lens, the image size on the negative will be too small for a high-quality blow-up. With a versatile 80-200mm

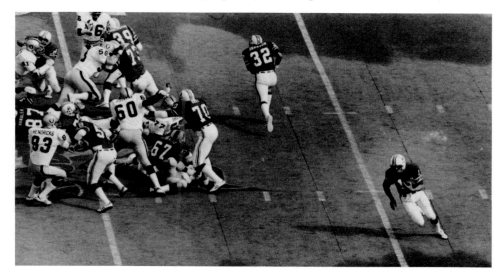

For a refreshing angle, the photographer can shoot from high in the stands. Sometimes an overall shot from this vantage point produces a photo that resembles a chalkboard diagram of the play. (George Rizer, courtesy Boston Globe)

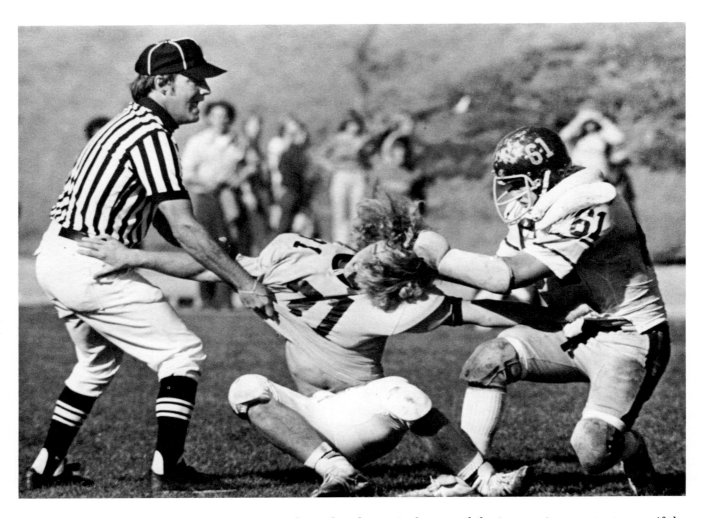

zoom you can keep the players in focus and the image-size constant, even if the play runs right off the sidelines. To ensure freezing the action, set the shutter speed at 1/500 sec. or faster.

Avoiding the "Standard Stuff"

When Pam Schuyler covered a football game for the AP, she looked for dramatic catches, fumbles, collisions, and flagrant penalties, such as face masking or illegal holdings. She is always searching for the unusual football picture. "You get only a half-dozen super pictures a year if you are lucky," she says. "The remainder are standard stuff."

George Riley of UPI once got a football picture that was anything but "standard stuff." Football, unlike other sports, is not called off because of bad weather. The day of a Dolphins-Patriots game, the sky let loose with a downpour. Sheets of rain pounded the players and drenched the field. Riley grew tired of plodding along the muddy sidelines and envied the dry reporters and television crews in the covered press box high above the stadium. Riley climbed the stairs to the press box. From that height he could barely make out the lines of the end-zone, buried under three feet of water. "I knew that eventually some guy was going to have to go down there and I just waited 'til he did."

A player jumped into the water in the end-zone, creating a big splash just as Riley snapped the shutter. A little later another player was tackled in the end-zone and only his helmet could be seen above the water line. "I really got excited about those shots," said Riley. And for good reason. Both local dailies gave the pictures a play, not only on the sports page, but on the front page as well.

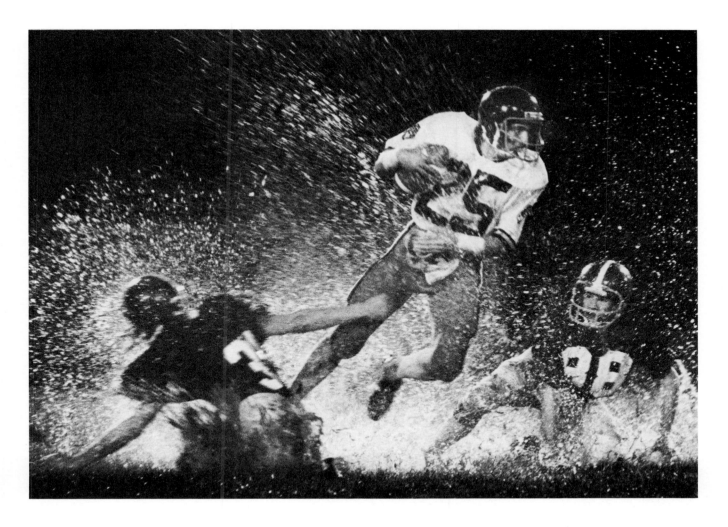

SOCCER, A LIGHTNING FAST SPORT TO SHOOT

Football is one of the few sports that referees don't call because of rain. (George Olson, Kansas City Star)

Soccer is the world's most popular spectator sport. It is also one of the most difficult sports to photograph, according to George Tiedemann, who shoots the game on assignment for *Sports Illustrated* and *Time* magazine. The playing area in soccer is larger than a football field, the game flows almost continually, and the action is lightning fast.

Because the playing field is so large a photographer needs a long lens. Tiedemann shoots with a 300mm f/2.8 telephoto. When he needs an even longer lens, the soccer photographer adds to his basic lens one of two teleconverters. These devices convert his 300mm into a 420mm with a Nikon TC 14 teleconverter or a 600mm lens with a Nikon TC 300 teleconverter. He uses a primary lens plus one of his teleconverters rather than three individual lenses because it saves him from carrying the added weight of the extra telephotos.

With the teleconverter in place the light reaching the film is reduced, so the lens effectively loses one stop with the TC 14 or two stops with the TC 300. Tiedemann doesn't find this loss particularly significant, because his basic lens has a relatively fast maximum aperture of f/2.8.

To support the heavy weight of the lens and to reduce camera movement, the soccer specialist rests the 300mm lens on a monopod. When he converts the lens to a 600mm tele, he uses a tripod.

Players score about 95 percent of their goals within 18 yards of the net.

Generally, soccer is a low scoring game; a 1-0 on the scoreboard is not unusual. Therefore, a photographer tries to get a shot of the scorer as he kicks the ball into the net. Editors almost always want a picture of a successful play, especially if it is the winning goal.

Besides free-lancing with *Sports Illustrated* and *Time*, Tiedemann is also under contract with the North American Soccer League. I asked him what he looks for when the game gets under way. He said that as he stands on the goal line between the corner flag and the net post, he picks up the action in his lens about 25 yards out. He follows the play down the side lines until it gets so close to his camera that he can't include the whole player. Then he swings his lens toward the goal and looks for a forward receiver in the clear. He keeps his lens trained on this player rather than trying to follow the ball; the ball travels too quickly to keep in focus. When he looks through his telephoto and watches the forward's eyes, Tiedemann can often anticipate what is going to happen next. If the player looks up, the photographer can expect the ball to come sailing through the air; the forward is likely to hit it with his head. If the player looks down, the pass is usually on the ground; the player will likely try to maneuver for a clear kick toward the goal.

The movement of the goal tender also indicates, to the observant photographer, on which side of the field the play is likely to develop. If the goalie moves to the right, look toward the right side of the field for an offensive play. If the goalie shifts left, swing your lens in this direction.

The goal tender also makes for an interesting picture as he sways and bobs in his attempt to keep the ball out of his 8-yard-wide net. For goalie pictures, stand on the side-lines about 25 to 35 yards from the corner flag and use a long telephoto lens. Again, concentrate on the goalie, not the ball. Watch the goalie's eyes and head to determine in which direction the defense player is likely to go.

For photos of the goalie in action watch his eyes and head to determine in which direction he is likely to move.
(George Rizer, courtesy *Boston Globe*)

Plays occur with incredible speed. The ball flies toward the net as the goalie leaps up for a save. The action only lasts long enough for one or two frames even with a 5 frames per second (fps) motor drive. By the time the goalie catches the ball and lands on his feet the excitement of the play has ended. Thrilling pictures also occur when the goal tender collides with an incoming player or dives at a forward's feet to block a kick.

To shoot soccer consistently, start with a 200mm and work up to the longer telephotos. The shorter lenses are easier to frame and focus. Use a wide aperture (about f/5.6, if possible) even in bright light on a sunny day, a neutral density filter or slower film in the camera will enable you to use the wider aperture. At smaller apertures, the resulting pictures tend to include the key players as well as the rest of the team, the fans, and the stadium. With the shallow depth of field that you get with a wide aperture and long telephoto, the primary player pops out from the distracting background. With shallow depth of field and a telephoto, however, you have no margin for focusing error.

DON'T BE FAKED-OUT IN BASKETBALL

The ball travels so lightning-fast in basketball that following the ball is like keeping your eye on the pea in the old shell game. Unlike football with its discreet downs, and baseball with its clearly defined plays, the basketball game rolls on at full speed until a point has been scored, a foul called, or the ball goes out of bounds. The basketball might be bigger than a baseball or a football, but keeping track of a basketball can be just as tough.

Pam Schuyler, who spent two intensive years covering the world-champion Celtics for a picture book she photographed and wrote called *Through The Hoop: A Season With the Celtics,* formed some valuable theories about anticipating basketball action. Schuyler says that the key problem in photographing basketball is learning to read the "fake," the quick twisting and jerking movements that players use to "fake out" their opponents and get a clear shot at the basket. As Schuyler points out, "They often fake-out the photographer as well."

Schuyler points out that a pro basketball player can fake not only with his hands and arms, but also with his legs and feet. Therefore, Schuyler has discovered that watching the player's stomach muscles provides the best clue to the timing and direction of the player's movement. "A player cannot fake with his stomach, so where the stomach of the player goes, his arms, legs, and head will soon follow," says Schuyler. Basketball players wear tight, thin jerseys that cling to their ribs like surgeon's gloves. "You can easily see a basketball player's stomach muscles contract through his jersey, just before he breaks for the hoop." However, Schuyler also points out that you can't constantly stare at the abdomens of all the players on the court during the game, because you have to spend most of your time and attention tracking the path of the basketball. "But if you watch the player's torso muscles and catch a glimpse of them tightening, you will have a good tip-off an instant before the player begins his moves for the basket," she says.

Sideline Positions

Many basketball photographers sit on small stools or kneel on the floor behind and a little to either side of the basket. Then they prefocus their 50mm or 85mm lens about 10 to 15 feet into the court and wait. Schuyler, however, prefers to gamble on more unusual shots. Instead of prefocusing and thereby snapping off sharp pictures only of the action under the basket, she follow-focuses on the ball as it is tossed around the court. She rotates the lens barrel as fast as she can, trying to to keep the ball in sharp focus as the ball flies from one player to an-

other. Follow-focusing the ball is tough. "You get more bad, out-of-focus shots when you follow-focus, but your good shots are usually worth it," said Schuyler.

After the first few minutes of the game, Schuyler identifies the key players and notes where they execute most of their plays—under the backboard, to the right of the foul line, and so on. She then positions herself as near as possible to this focal spot. If the action spot changes as the game progresses, she shifts her sideline position.

With her two favorite basketball lenses, the 85mm and the 180mm, Schuyler covers the entire court. From a vantage point under the basket, she shoots with the 85mm; from mid-court, she works with the 180mm. She always sets the shutter speed at 1/500 sec. to freeze movement. "At slower speeds, I've found the players' hands move so fast they tend to blur."

The "Arm-Pit" Shot

The standard bread-and-butter basketball photo, nicknamed the "arm-pit" shot, shows the lanky basketball player jumping off the floor with arms extended over his head, pumping the ball toward the basket. Pro players use the jump shot so often that the conscientious photographer actually has to work hard to avoid taking this standard photo.

Skipping the Cliché

Photographers who cover basketball regularly try to find alternatives for the arm-pit shot, figuring that readers will consider the shot a somewhat boring photographic cliché. For example, Frank O'Brien goes after tight shots highlighting facial expressions. In basketball, the players don't wear headgear such as protective helmets and sun-shading caps; they look up at the basket rather than down

An "armpit" shot gets taken so often that most photographers try to avoid returning to the office with just this standard pose. (Michael Maher, Lowell [Massachusetts] Sun)

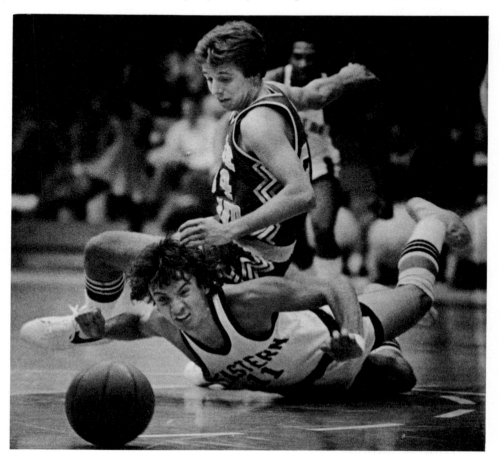

A loose ball on the court breaks the rhythm of the game. The unmanned ball often produces a scramble, which can result in an out-of-the-ordinary picture. (Harold Hanka, Willimantic [Connecticut] Chronicle)

at the floor as in hockey, enabling the photographer to see the emotions on the players' faces. Sometimes, a close-up showing the tension on a player's face during a tight game or a strained grimace as he struggles for a rebound can summarize the mood of the whole contest.

For unique basketball pictures Schuyler is always on the lookout for loose basketballs on the court. "You can bet when a ball's free there will be a scramble for it and then a fight to gain possession of it," notes Schuyler. "Players fouling one another always look funny on film and these seem to be the pictures people remember longest. When a ball bounces loose on the court or a foul is committed, the rhythm of the game is broken. A mistake was made. The game gets interesting and so do the pictures."

When you can't attend the practice sessions of a team or when you don't have time to learn the team's basic patterns, concentrate your coverage on the player with the star reputation. Stars tend to score the most points and snag the majority of rebounds. Also stars don't just sink baskets like regular folk; they exhibit individual styles and almost choreographed moves. Kareem Abdul-Jabbar shoots with his famous "sky hook." Julius Irving, known as Dr. J, is famous for his seemingly effortless dunk. A good sports photographer tries to capture on film the style of the star.

Once you have clicked off a few standard "arm-pit" shots and caught the superstar in action, you should feel free to search for a unique, or at least unusual, picture.

Shooting, when possible, from the rafters of the gymnasium offers a unique angle on the game of basketball.
(Michael Murphy, *Houston Chronicle*)

SPECIAL EQUIPMENT AND TECHNIQUES OF THE PHOTOJOURNALIST

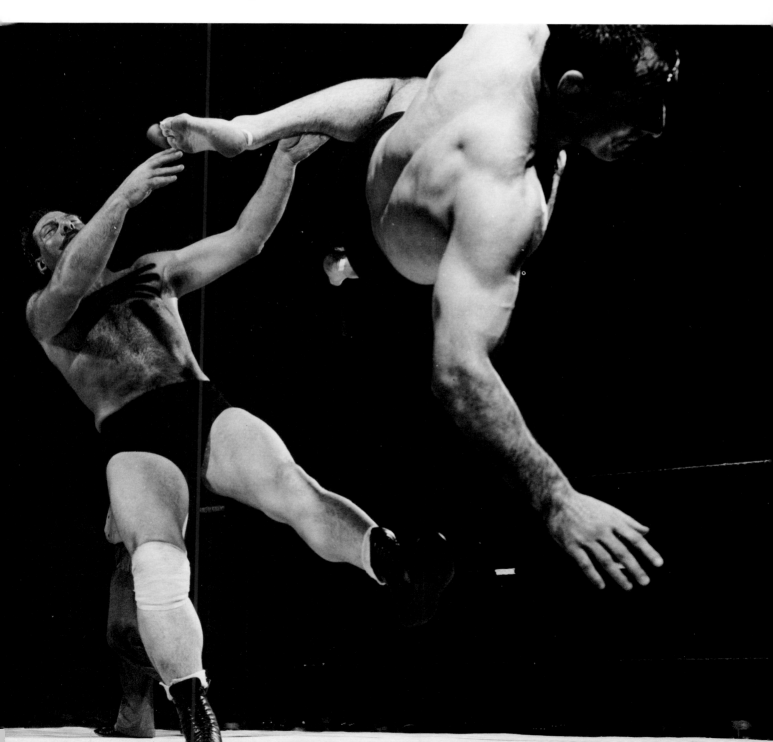

Previous page: *Lasting less than 1/1000 sec., the light from a strobe freezes the flying wrestler in mid-air, eliminating any blur resulting from the subject's movement.*
(Phillip Harrington, *Look* Collection, Library of Congress)

BUYING A JOURNALIST'S CAMERA

A news photographer's bag is like a doctor's bag—both contain the essentials for handling any emergency the owner might face.

Each photographer, as each doctor, carries different equipment, depending on personal taste. Some photographers prefer extra-long lenses, whereas others like motorized cameras. But all news photographers pack enough gear to handle any assignment, whether the event they cover takes place in the brilliant light of day or the pitch black of night. A news photographer must have a sturdy camera, a variety of lenses, a strobe, and, of course, film—lots of film.

The Need for Rugged Equipment

The most expensive piece of equipment you will buy will be your camera system. Purchasing cameras and lenses can cost from hundreds to thousands of dollars. In the past, some cameras, because of their ruggedness, gained popularity among news photographers. In previous years photojournalists chose the Graflex and later the 4 x 5 Speed Graphic. The twin-lens reflex Rollieflex and the rangefinder Leica became popular after World War II. During the 1960s the single-lens reflex Nikon and Canon dominated. Today, with miniaturization and automation, no single camera controls the photojournalist's field.

Camera journalists still face the same problems that the Graflex user did. They want a camera that is sturdy enough to take the bangs and bashes of the business; they need a camera that can be subjected to freezing weather one day and melting temperatures the next. Yet, they want that camera to continue to function perfectly, frame after frame.

A camera system is the most expensive piece of equipment the photo-journalist buys. You want a versatile system which, without breaking, takes the knocks of the business.
(Nikon Inc.)

To find out which cameras hold up the best and operate under extreme, repeated adverse conditions, I turned to Marty Forscher, president of the Professional Camera Repair Service (37 West 47 Street, New York City). Forscher, a veteran of the repair business for over thirty-five years, said the photojournalist's ideal camera should be built "as strong as a hockey puck." Forscher pointed out that some professionals put 400 rolls of film a month through their cameras. The repairman lamented, "Nowadays manufacturers produce cameras for amateurs. The companies keep their fingers crossed, hoping that professionals also will buy the equipment. No company is building the Rolls Royce or the Checker Cab of cameras anymore." Also, as he pointed out, "35mm photojournalism is one of the few fields in which there are no professional tools." Forscher, who repairs

equipment originally designed to shoot pictures on Sunday afternoon in the park but used instead to cover riots and wars, says, "People who risk their lives taking photos have a right to have their cameras work properly."

Asked about the trend toward electronic cameras, Forscher said, "I'm not convinced about the reliability factor of the new equipment. The new sophisticated technology is exciting, but the manufacturers have to find some kind of reasonable compromise between the quality standards of the old and the performance standards of the new."

The newly designed cameras are lighter and more automated. Photographers using the new cameras constantly will be able to determine if these pieces of equipment hold up as well as their predecessors.
Top, left: Nikon FE.
Top, right: Canon AE-1.
Bottom, left: Pentax ME.
Bottom, right: Olympus OM-10.

How to Keep the Camera Dry

In addition to recommending regular camera maintenance, Forscher warned photographers "to keep your camera dry." This is particularly important with newer cameras that have electronic circuitry. The electrical contacts can corrode on exposure to moisture, especially salty moisture at the beach. Forscher mentioned that when David Douglas Duncan, a well-known war photographer, shot pictures in Korea under the worst rain and mud conditions possible, Duncan used a simple underwater camera and got wonderful results. Forscher suggested that if you don't have an underwater camera or a waterproof housing and need to shoot in the rain, wrap your regular lens and camera body in a plastic bag sealed with a rubber band. Cut one hole in the front of the bag to let the lens stick out, and another in the back of the bag to enable you to see through the viewfinder. Put the lens and eye-piece through the holes and secure them with rubber bands. Now you can operate the camera through the bag, but you shoot and view through a clear area. Remember to keep the front element of the lens dry because drops of water on this element will distort the image on the film.

Contents of a Photographer's Camera Bag

To find out what one typical news photographer assembled for an average assignment, I asked Chip Maury to list the items he put in his leather bag. Maury has shouldered his bag, 27 lbs. when full, around the world taking pictures first for the United States Navy and later for the Associated Press.

Bag	Hand-made	All leather for heavy-duty wear. Strap runs continuously under the bag to avoid being broken at a hinge connection.
Cameras	Nikon F2	Rugged, variety of lenses and attachments available.
	Motor drive	Fires up to 5 frames per second.
	Nikon F2S	Light meter conveniently built-in.
Lenses	24mm f/2.8	Great depth of field, good for zone focusing (on camera).
	35mm f/2.8	General purpose (on camera).
	85mm f/1.8	Especially for portraits and basketball photos.
	180mm f/2.8	Good for night and indoor work. f/2.8 extra fast for this focal length.
	300mm f/5.6	Needed for major league stadiums.
Filters	Polarizer	Cuts glare from reflective surfaces like windows and water.
	Cross-screen	Creates star effect when lights are in the scene.
	Close-up	Magnifies small objects.
	Yellow	Darkens blue sky moderately.
	Red	Darkens blue sky dramatically.
Tissues	One pack	Keep lenses clean.

Strobes	Vivitar 283	Automatic exposure, lightweight, versatile, and powerful.
	Vivitar 292	Slave eye attached. Used for multiple-light set-up or emergency backup.
Strobe attachments	Wide angle	Spreads strobe's light to cover view of 24mm lenses.
	Telephoto	Concentrates strobe's light to illuminate subjects that are far away.
	Neutral density	Cuts the light output of the strobe without changing the color characteristics of the strobe's light.
Light meter	Zeiss Ikon	Backup for built-in camera meter. Wide sensitivity range for readings in low-light.
Tripods	C clamp	Clamp will attach to door jam, chair, or post. Good for getting sharp pictures under low light at slow shutter speeds or with long lenses.
	Tabletop	Can rest on any flat surface.
Film	Black-and-white	Kodak Tri-X, fast (ASA 400) can be pushed up to E.I. 1600. Kodak 2475 Recording film, extremely fast (E.I. 1000 to 4000). Grainy but acceptable in an emergency.
	Color	Kodak Ektachrome 400, fast (ASA 400), can be rated at E.I. 800 with special processing. With E6 kit, film can be developed quickly in any darkroom.
Batteries	Spare	For strobes, light meters, and cameras
P.C. cord	Spare	Standard cord breaks frequently.
Tape	Electrical	On spot repairs. Also used to attach items to wall or light stand.
Reflector	Space blanket	Lightweight, highly reflective, large silver surface; use tape to attach it to a wall.
Credentials	Press passes	Issued by the State Police.
	Dog tags	Identification in case of an accident.
Taxi credit	Preaddressed	For sending film back to the office while remaining at the scene of the event.
Pad, pencil	Notes	For writing captions.
Car keys	Spare	In case of loss.
Glasses	Spare	Prescription

Maury has chosen carefully to pack back-up pieces of equipment in case his primary hardware breaks down. As you can see from the list, he totes two cameras, two strobes, extra batteries, a spare pair of glasses, and a double set of keys. Maury can't afford to miss an assignment because he loses his glasses or his strobe fails to work.

(*Author's note:* For every assignment the photographer doesn't have to lug every piece of equipment. You won't need long lenses, for instance, when photographing in a small room. Also to reduce the load, manufacturers are building lightweight, compact-designed lenses. For a complete description of lenses—which ones to use and what effects they have, see chapter 2, "Covering an Assignment," chapter 6, "People Pictures," and chapter 7, "Capturing the Action in Sports.")

STROBE:
Sunshine at Your Finger Tips

The Search for Portable Light

Originally, photographers were limited to picture-taking only when the sun was out. Not all news, however, happened in the light of day. From flash powder through flash bulbs to electronic flash, photojournalists have searched for a convenient light source that would enable them to take pictures under any circumstances. Today, possessing a compact strobe is similar to having a pocketful of sunshine at your finger tips.

In the 1970s manufacturers brought out the modern miniaturized, small, lightweight and high-powered strobe. With a thyristor (energy-saving) circuit, the new sophisticated strobes can fire in synchronization with motorized film advance. With the advent of strobes with automatic exposure control, over- or underexposed negatives are almost eliminated. The photographer no longer has to estimate the flash-to-subject distance, then calculate the f-stop. The strobe's automatic eye, coupled with an internal computer, releases just enough light from the strobe to produce perfectly exposed pictures each time.

Pros and Cons of Strobe Light

Even though the designers have engineered a compact and convenient strobe, flash detractors still point out that the strobe's light looks artificial in photos. These purists note that the strobe throws an unnatural black shadow behind the subject's body—producing pictures with the look of a police line-up. True: flash pictures can look stark. In the old days, photographers, who kept their flash guns mounted to the sides of their Speed Graphics, churned out these unnatural, stylized pictures.

The cause of these harshly lit pictures did not lie with the flash but rather with the flash photographer. When the photographer uses techniques like bounce, bare tube, and multiple-flash, almost any lighting effect that occurs naturally can be created. The light from a strobe, when used creatively, can give a photo the even feeling of fluorescent light, or the strong dramatic feeling of window light. But when the flash photographer leaves the strobe mounted on the camera and aimed straight ahead, the lighting effect does look unmistakable.

Flash-haters argue one persuasive point. Initially, when a flash goes off, it does tend to draw attention to the photographer. The burst of light can throw cold water on a hot discussion. However, just as the mayor becomes accustomed to a photographer following him around, clicking off pictures, most subjects will eventually pay little attention to the firing of the flash.

Strobe supporters point out the advantages of the portable light source for the photojournalist. They note that a strobe can boost the overall quantity of light in a room, thereby enabling the photographer to set a smaller aperture for greater depth of field, which is needed, for instance, when shooting an overall picture of a political meeting in progress. Also, the strobe light lasts for only a brief instant, usually 1/1000 of a second or shorter. The photographer, therefore, takes a picture at an effective speed of 1/1000 of a second. You should note that on a single-lens reflex camera, the focal plane shutter is usually set at 1/60 sec. (with some cameras "X" or flash synch is a slightly faster 1/90 sec. or 1/125 sec.). This enables the shutter to synchronize with the strobe. Even though the lens is open for 1/60 sec. the flash lasts for only a fraction of this time, and the picture is made during the brief flash period. This super short flash duration means that the photographer can stop a subject's movement, no matter how fast the person is traveling. The strobe freezes the gymnast as she leaps in mid-air, the motorcyclist as he bends into a turn, or the wrestler as he hangs suspended above the mat.

Today's strobes are small, lightweight, relatively high-powered, and they recycle quickly.
(Vivitar Corporation)

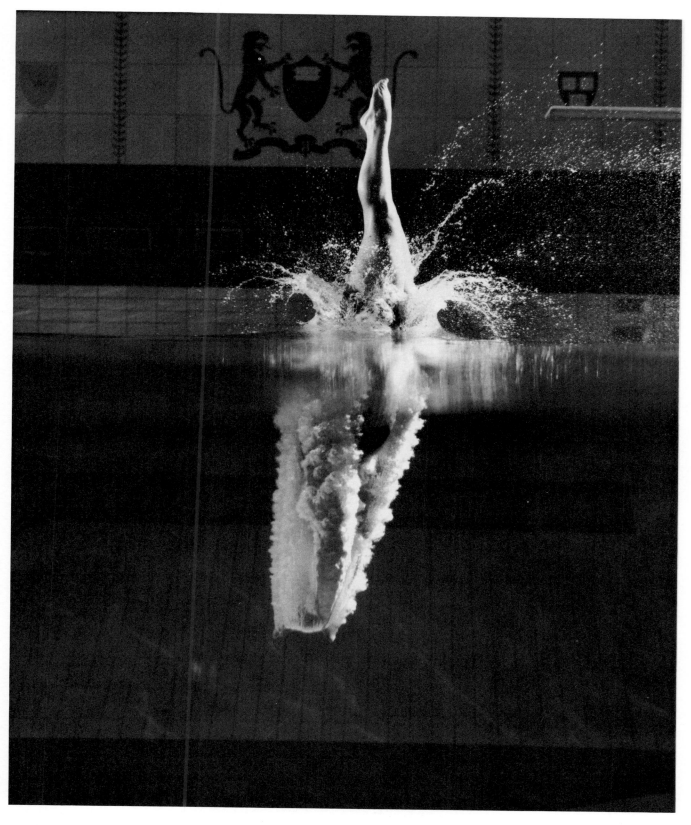

To photograph this perfect entry, George Silk used an electronic strobe to stop
the action of the diver. He also employed Polaroid film to determine the quality
of each photo instantly.
(George Silk, *Life Magazine*, © 1962 Time Inc.)

Because the light of the flash is almost instantaneous, you avoid blurry pictures because of camera movement. Even if you are clicking pictures as you chase a council member up the stairs of city hall, your pictures will come out sharp if you shoot with a strobe.

As a photojournalist, you must weigh the strobe's advantages against its disadvantages. In many circumstances, you would not be able to get any picture without your strobe. In other situations, you can produce a technically improved or visually more interesting picture when you fire a portable light source. Sometimes the strobe, especially in a sensitive situation such as a funeral, can be disruptive. However, few spot news, general assignment, feature, or sports photographers would leave their offices without their electronic flash equipment in their camera bags.

When Does the Strobe Light Dominate Existing Light?

You can use a strobe any time. Outside, when the sun is bright, the strobe can help fill in harsh shadows. Inside or at night, the strobe light usually will predominate over the existing light.

You can check to see which is greater, the strobe light or the natural light, by taking a standard reading with your light meter. Note the f-stop you would use at 1/60 sec. shutter speed. Then compare this reading with the f-stop you would use if you were to fire your strobe. If the strobe aperture is smaller than the available light aperture, the strobe light will override the natural light in the situation. For example, if the subject is standing at 10 feet, suppose the light in the room reads f/2.8 at 1/60 sec. with ASA 400 film. The strobe dial, set on ASA 400, indicates an aperture of f/8 for a flash-to-subject distance of 10 feet. You will set the camera at f/8 to expose for the brighter source. Because f/8 is a smaller aperture than f/2.8, the strobe light will overpower the natural room light in this case.

When the strobe is brighter than the available light, its output will freeze motion, stop camera movement, and, most importantly, determine the quality of light in the final photo. Generally, the strobe's light will be brighter than the existing light inside a building, or outside at dusk, or at night.

For this photo the photographer set up both a strobe and a floodlight. During a single exposure of 1/30 sec., as the subject roller skated, the flood plus long exposure contributed the light for the ghost image while the strobe exposed the subject for the sharp image.
(Ken Kobre, University of Houston)

AIMING THE STROBE FOR DIFFERENT LIGHTING EFFECTS

Direct Strobe-On-Camera Leaves Harsh Shadows

The strobe mounted on top or side of the camera produces a direct light aimed at the subject. At night, outside, or in a big room, direct strobe-on-camera works well. Direct strobe-on-camera, however, in a normal-sized, white-walled room creates a harsh shadow behind the subject.

To get around the lurking black shadow problem, move the subject in front of a dark wall if you can. Now the black shadow created by the strobe will blend somewhat with the dark wall and be less prominent. Or, move the subject away from the wall. If you and the subject move away from the wall, keeping the same distance between the two of you, the subject will receive the same amount of light, but the wall behind will get less. Again, the wall will darken and the obtrusive shadow will merge with the darkened wall and disappear.

Sometimes you must photograph a group of people with direct strobe. Flash-on-camera may overexpose group members nearest the light, and underexpose members farthest from the light source. To avoid this problem you can arrange the participants so they stand approximately in a line equidistant from the strobe light. When all the group's members are the same distance from the strobe, they will get the same amount of light and, therefore, be equally exposed.

Direct strobe-on-camera worked well for this rescue scene; at night the harsh shadows, produced by the flash, disappeared in the black background.
(Michael Grecco, Boston Phoenix)

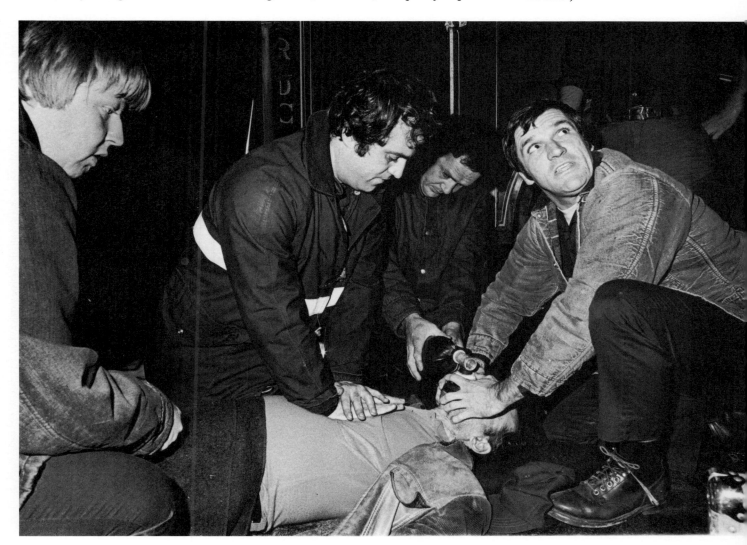

Special Equipment and Techniques of the Photojournalist

Direct Strobe-Off-Camera Can Produce Variety of Lighting Effects

A photographer can avoid the ugly shadows thrown off by direct strobe, even in a white-walled room, by removing the flash from the camera. The photographer aims the flash at the subject, but holds the strobe at arm's length above the lens. A 3-foot to 5-foot coiled extension cord connects the strobe with the camera. As the photographer holds or places the light higher and higher, the shadows drop behind the subject's back and disappear out of view of the lens.

Try this experiment: to see the effect of holding the strobe in different places, ask a friend to stand in front of you, then manipulate the head of a regular lamp, as if it were a strobe. Watch what happens to the shadows behind the subject, and see what happens to the light striking the subject as you move the lamp. Don't miss the ghoulish effect resulting from holding the lamp at a low angle. Horror films often employ this lighting technique for scary scenes.

As you move the lamp higher and higher, the light on the subject appears more natural, because we are used to seeing people lit from above, as with sunlight or ceiling light. When you extend the lamp to arm's length, above and a little to the side of the camera, the light adds a three-dimensional quality to the subject's face. Photographers call this position, with one arm high, holding the strobe, "Statue of Liberty,"

As you move the light toward the side of the person's face, one side of the profile becomes highlighted, while the other side recedes into shadow. To continue the experiment, place the lamp on a light stand, still aiming it at the subject.

The photographer used side lighting to achieve a dramatic effect and to avoid the problems of harsh background shadows.
(Ken Kobre, University of Houston)

Front lighting (left)—*Here the main light is placed close to the lens. Forms seem flattened, and textures appear less pronounced.*

Side lighting (right)—*A main light with about a 90° angle to the camera will light the subject brightly on one side and will cast long shadows across the other side.*

Top lighting (left)—*With the light directly overhead, long, dark shadows are cast into eye sockets and under nose and chin, producing an effect that is seldom appealing in portraits.*

High 45° lighting (right)—*If the main light is moved high and to the side of the camera, not precisely at 45°, but somewhere in that vicinity, shadows model the face to a rounded shape and accent textures more than front lighting does.*

Back lighting (left)—*Here the light is moved around farther to the back of the subject. If the light were directly behind the subject, the entire face would be in shadow, with the hair outlined by a rim of light.*

Bottom lighting (right)—*Lighting coming from below looks distinctly odd in a portrait; light on people outdoors or indoors almost never comes from this direction.*
(Photos by Donald Dietz and Elizabeth Hamlin)

Now you are free to walk around the person. The light and subject remain constant but you and the camera move. As you circle the subject and observe the light you will notice that at one point the light is on the side of the subject, resulting in a side lighting effect, and as you move around still further, the light is directly behind the subject, producing a back lighting effect. As you proceed a few more inches, the subject completely blocks the light and you get a silhouette effect.

You can create these lamp effects with your strobe by attaching your electronic flash to a light stand and connecting the flash to the camera with a long P.C. to P.C. extension cord. You can ask an assistant to hold the strobe if you don't have a light stand available. Remember what the effects looked like with the lamp light. To get the same effects, say side lighting, with your strobe, visualize where you stood in relationship to the lamp and the subject. If you were to the left of the subject, the lamp was to the right; then arrange the camera, the strobe, and subject in the same relative pattern. The effect you get with the strobe light will look just like the one you saw with the lamp light. Removing the strobe from the camera and placing it on a light stand frees you up. You can now change your position relative to your subject and light source. You can walk around the subject, looking for a dramatic lighting arrangement that will add interest to a potentially mundane photo.

Determining Exposure with Direct Strobe

Strobe manufacturers build their strobes in different ways, hence a brief check of your instruction book will indicate how to operate your particular strobe.

Manual

To take into account all the variables that affect the amount of light your flash unit will throw on the subject, a system of guide numbers has been developed to simplify calculating exposure settings when the strobe is set on manual. The guide number takes into account the speed of the film you are using. The guide number also considers the amount of light put out by the flash unit, and indicates the effectiveness of the flash reflector in concentrating the light on the subject. Packed with strobes are guide numbers for your combination of flash source, reflector, and film speed.

Typical Strobe Guide Numbers

ASA	25	50	100	200	400	800	1600
Guide Number	40	56	80	110	160	220	320

The guide number helps you calculate your aperture setting for any given flash-to-subject distance, which is the factor most likely to vary from shot to shot. The basic principle of using the guide number is: *as the subject-to-flash distance increases, the amount of light reaching the subject decreases.*

To determine the lens opening, divide the flash-to-subject distance (in feet) into the guide number. The quotient is your correct f-stop. The general formula is:

$$\frac{\text{Guide number}}{\text{Distance}} = \text{f-stop}$$

Using the table above as if it came with your strobe, and shooting with ASA 100 film, your working guide number would be 80. Now let's assume that the distance between your subject and the flash unit is 10 feet. 80 ÷ 10 equals 8, so you would set your camera aperture at f/8. Sometimes, of course, the result of the division, or quotient, does not turn out to be a full f-stop. In that case, set

your aperture a little over or under the closest whole stop; for instance, if the guide number divided by the distance works out to be f/10, then set the aperture just a little shy of f/11. Usually, on back of the strobe head, the manufacturer builds in either a footage vs. f-stop scale, or a simple circular slide rule that performs the division for you. You set the ASA, then look up the subject's distance. The slide rule tells you the f-stop to use. If you want to use a smaller aperture, just get the strobe closer to the subject. The nearer the strobe, the more light will reach the subject. The reverse is also true. If you want to use a wider aperture, just move the strobe away from the subject. Many strobes show a guide number for the flash-to-subject distance measured in meters as well as feet. You can use either, just be sure not to divide the distance in feet if you are using the guide number for distance in meters (or vice versa).

Most portable strobes today come with a built-in automatic feature, controlling exposure. The automatic sensor eye on a strobe works a little like a thermostat on a heater. You set the thermostat for the correct temperature. The heater turns on. Then the thermostat turns off the heater when the room reaches the desired temperature. On the strobe, the photographer sets the ASA, thereby telling the strobe how much light will be needed for a particular film. The photographer adjusts the aperture on the lens to the f-stop specified by the manufacturer for the range of distances that the strobe can light. Then the photographer fires the strobe. The light hits the subject, quickly bouncing back to the sensor eye in the strobe. When enough light returns to the eye for a perfectly exposed picture, the internal computer shuts the strobe off. This whole cycle takes less than a 1/1000 sec. If the subject moves anywhere within the range of the strobe, and if the sensor eye is pointed toward the subject, the exposure should be fairly accurate without requiring any further adjustments.

A prisoner uses a mirror to see what is happening down the cell block. The photographer took the picture with strobe.
(Don Robinson, UPI)

Automatic

For example, suppose you are using ASA 400 film. The manufacturer recommends an aperture of f/5.6 for this speed film. You would then dial ASA 400 into the strobe, set the lens aperture on the camera at f/5.6, and note that your automatic range runs from 3 to 40 feet at this aperture. Once the lens is set, you are free, within the 3- to 40-foot range, to move toward or away from your subject, firing off pictures without changing anything on the strobe or the camera except the focus.

Some automatic strobes even allow you a choice of f-stops for a given film, enabling you to control depth of field. Each f-stop, however, is associated with a different minimum and maximum distance range for the automatic feature of the strobe.

The automatic sensor works well as long as the subject is neither exceptionally dark nor exceptionally light. The sensor adjusts the strobe's light as if the subject were of a neutral gray tone (18 percent reflectance). The light meter in the camera functions in the same way. Both the strobe's sensor and the camera's light meter give correct readings most of the time, because the majority of subjects are approximately equivalent to 18 percent neutral gray. However, to compensate for the exceptionally light or dark subject, the photographer using a strobe must adjust the f-stop on the lens. For instance, for a subject wearing very dark clothes, standing in front of a black background, *close down* the lens' aperture one or two stops to avoid overexposed negatives. For a subject wearing very light clothes, standing in front of a white background, *open up* one or two stops to avoid underexposed negatives.

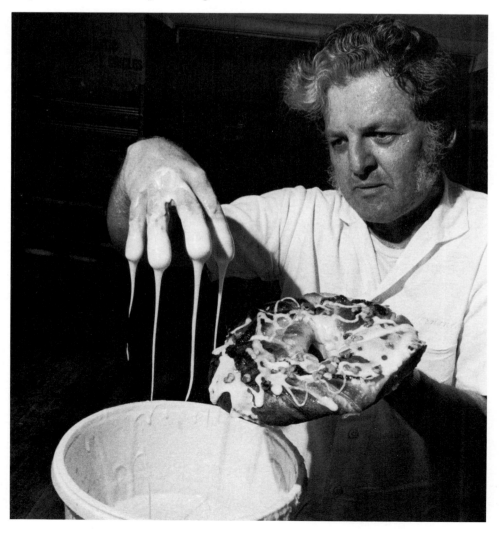

To determine the correct exposure for this shot of a baker decorating a pastry, the photographer dialed in the film's ASA, set the strobe on automatic and moved the lens to the f-stop recommended by the manufacturer.
(Ken Kobre, University of Houston)

Bounce Strobe Gives Soft, Even Light

To avoid the harsh effects of direct strobe, a photographer can bounce the strobe's light off a room's ceiling. When the light leaves the strobe, it comes out in a bundle of rays the size of the strobe face, about 2 to 5 inches in diameter, depending on the size of the flash. The rays spread out as they head toward the ceiling. By the time they reach a ceiling of normal height, the rays cover an area about 5 to 10 feet across. Because the surface of the ceiling is rough, the rays bounce off it in all directions, evenly lighting a much larger area below and leaving few shadow areas.

Bounce light has at least two advantages over direct strobe: bounce light eliminates the subject's black shadow and helps light a group of people evenly, removing the danger of burning out those in front or letting those in back go dark.

Not only can you bounce light off the ceiling, but you can also bounce light off a wall, partition, or any other large opaque object. Light bounced off the ceiling results in a soft, relatively shadowless effect similar to that produced by fluorescent bulbs found in ceilings of most modern buildings. Light bounced off a wall or partition gives a more directional effect, such as the light that comes from a window; the directional effect becomes more prominent the closer the subject and the flash are to the wall.

To bounce some strobes, all you have to do is tilt the strobe head toward the ceiling or wall, then fire. With other strobes, you must attach a cord between the camera and strobe so that you can remove the flash from the camera. Then aim the strobe toward the reflecting surface. When you point the strobe, pick a spot on the wall or ceiling midway between yourself and the subject. Light reflects from a surface at the same angle but opposite direction the light hits the surface. Think of the light as if it were a pool ball you are going to bounce off a cushion into a pocket. Be careful, however, not to let any light from the strobe head hit the subject directly.

Several factors determine how much light will eventually bounce back from the wall or ceiling and strike the subject. First, the farther the reflective surface is from the strobe, the greater the spread of light. The greater the spread,

To bounce some strobes, you tilt the strobe head toward the ceiling, or wall, and fire.
(Vivitar Corporation)

Bouncing the strobe light off the ceiling for this photo of an acupuncture patient resulted in a practically shadowless picture.
(Ken Kobre, University of Houston)

By bouncing the strobe off the wall, outside the picture area, the light appears to come from the candles. Mimicking the available light with the strobe increases the overall illumination, without losing the natural feel. (Ken Kobre, University of Houston)

the less light will return to strike an individual subject. A low-ceiling room, for example, will return more light to the subject, thus needing less exposure than a high-ceiling room. In an auditorium or gymnasium, the ceilings are so far away that almost no light ever gets back to the subject after a bounce shot. Second, darker surfaces absorb light more than do lighter surfaces. If a photographer tries to bounce light off a black ceiling, the ceiling itself will absorb the light and return none to the subject. Third, the size of the strobe unit also limits bounce potential. Small cigarette pack sized strobes don't put out enough power to produce an efficient bounce light. In a normal sized room, the light of a miniature strobe leaves the head and travels to the ceiling. Some rays soak into the surface, others scatter, and finally some return to the subject; not much is left for the exposure. Fourth, if the photographer stands a long way from the subject, the strobe light will have to travel an extra long distance. The light has to go first to the ceiling and then back to the subject. Because light spreads out more the farther it travels, little light will be left finally to illuminate the subject.

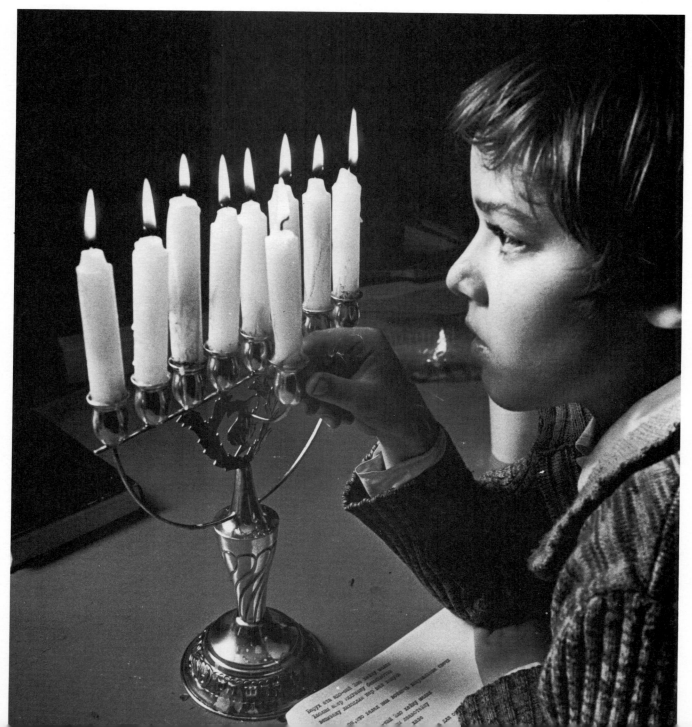

Bounce works perfectly with a medium to large sized strobe, in a normal room with white ceilings and a subject standing within 10 to 20 feet of the photographer.

Determining Exposure with Bounce Strobe

Manual

You can calculate the correct exposure for bounce flash, even if your strobe has only a manual setting. *Method one:* Estimate the distance from the strobe to the ceiling and the ceiling to the subject. Divide the total distance the light travels into the guide number, then open about three stops to allow for the absorption of the surface of the ceiling. For example, if you are 5 feet from the spot you are aiming at on the ceiling, and the subject is 10 feet from that ceiling point, then the total distance the strobe's light travels will be 15 feet. Say the guide number is 165 for Tri-X film with your flash. Then 165/15 equals f/11. Now open about three more stops for absorption from the white ceiling and you would expose the film at approximately f/4. *Method two:* Divide the guide number by 40. The resulting f-stop will be reasonably accurate when you are working in an average sized living-room with about a 10-foot high white ceiling, if the subjects are 5 to 15 feet away. Dividing your guide number, 320 in this example, by 40 (320/40), you get 8. At f/8, your bounce exposures will produce correctly exposed film in a normal room.

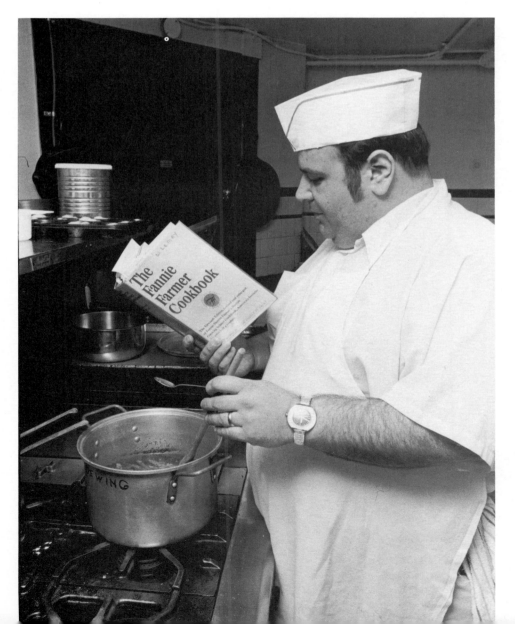

A student prepares lunch at the Fannie Farmer Cooking School. To calculate the f-stop for this bounce shot, the photographer divided the strobe's guide number by 40. The resulting f-stop was correct for a medium-sized room with white ceilings and walls.
(Ken Kobre, University of Houston)

Working in conditions other than a normal room with this method, estimate the exposure based on the color and height of the ceiling and the distance you are standing from the subject. Essentially, you would open the aperture if the room is large, the ceilings are dark, or the subject is standing at a distance from the camera. Close down the aperture when you work in a small room. Surprisingly, this guide-number-divided-by-40 method works well under most circumstances. With a little practice, you can learn to size up a room, taking into account its dimensions and tone, and accurately estimate the correct exposure.

Suppose after you've divided your guide number by 40, you find your base exposure is f/8 for a normal room. If you take a picture in a small white bathroom, you would cut the exposure down to f/11 or f/16. If you had to shoot in a normal-sized room with a dark ceiling, you would open the aperture to f/5.6 or f/4. With the latitude of black-and-white film, estimating the exposure within a stop is usually adequate.

Automatic

For the correct exposure on this bounce shot, the photographer put the camera on automatic, then adjusted the lens to the manufacturer's recommended f-stop. (David Aronson)

When you bounce a strobe with an autoflash, the exposure, as long as the sensor eye points toward the subject, will be correct. As in direct strobe, the photographer dials the ASA of the film and reads off the correct aperture setting for the lens. The automatic feature of the strobe then controls the output of light to give perfectly exposed negatives almost every time regardless of the color or height of the ceiling or the distance of the subject. (Note exceptions, as mentioned earlier, when the subject is dressed in exceptionally light or dark clothes.)

Sometimes with automatic strobe the sensor eye is not sensitive enough to measure the small amounts of light coming back on a bounce shot. Several strobe models provide a warning light that tells you whether there is sufficient light for the shot. If your warning light indicates you do not have enough light or your strobe has no warning signal, just put the strobe on manual and calculate

Photojournalism: The Professionals' Approach

the correct exposure with one of the methods suggested above. With the strobe on manual, a fast lens and high-speed film, you can often bounce light in large rooms and get perfectly exposed pictures even with very small strobes.

Bare Bulb Strobe

Bare bulb light combines the effects of direct and bounce strobe. Basically, a bare bulb is a flash tube without a reflector. The light travels out from the tube in all directions. Some light hits the subject directly and some light bounces off the walls and the ceiling before it strikes the subject. The bare tube produces a light that is less harsh than direct strobe, but has more interesting shadows and highlights than bounce strobe. Because the light from the bare tube is evenly distributed over a 360° range, you can use your widest angle lens and you will not get any dark edges at the corners of your pictures caused by fall-off of the strobe light.

Engineers have designed some strobes solely for bare tube use; other strobes can be converted to bare tube by simply removing the reflector. Still other strobes can be modified with an external socket to accept a bare tube attachment.

The bare tube effect works only in a normal-sized room with about a 10-foot high ceiling. In a large auditorium or gym, the light from the tube strikes the subject directly but none of the light bounces off the ceiling and walls to fill the shadows. With no surfaces for the light to bounce off of, the bare tube functions essentially like a direct strobe, even though the reflector is removed. When holding the bare tube strobe, extend your arm toward the ceiling for maximum bounce light, then aim the tube toward the subject. To determine the exposure, use the same method as if you were using direct strobe with the reflector still on. Then open the aperture two additional stops. The resulting picture will have the zip of direct strobe, yet have the open shadows and clean highlights of a bounce light.

Multiple Strobe Used for More Complicated Situations

Sometimes you may want more control of a scene than the light from one strobe can produce. Perhaps you seek to add a highlight to a person's hair, or you want to feature one member of a group more than the rest, or you want to use a light on either side of a dancer to emphasize the person's form. To handle these photo situations, you might set up several strobes on light stands and fire all of them simultaneously. The camera's cord can be connected to a three-way plug, and cords from strobes can be attached to this plug. Then, when you trip the camera's shutter, all three strobes fire at once.

To eliminate the need for a long cord running from each strobe, only one strobe needs to be connected directly to the camera; the other strobes can be fired remotely. You can hook up a slave-eye on each remote strobe. The slave-eye detects the light from the primary strobe attached to the camera, and, in turn, triggers the remote strobes. Because the speed of light is so fast, all the strobes in effect flash simultaneously. The slave-eye reacts only to the onset of a strobe light, and is not affected by room light. To function properly, the slave-eye, however, has to be close enough and pointed directly at the main strobe light.

The slave-eye can be tricked. If any other strobe or flash bulb in the area goes off, the slave-eye will fire the remote strobes. Thus if you are working at a basketball game or a boxing match and you have two lights set up, one main and the other remotely fired, the second light might go off if anyone in the auditorium pops off an instamatic flash. Then you need to wait until your units have recycled and are ready to fire before making your exposure. Sometimes you can tape a tubular hood in front of the photo-eye to reduce the likelihood of a stray flash causing your strobe to fire.

With large studio strobes, a modeling light is built into the strobe head,

A bare bulb strobe throws light in all directions. (Graflex, Inc.)

To handle the exposure for a complicated multiple strobe set-up, the photographer can take a reading with an electronic flash meter. (Minolta Corp.)

Two strobes on either side of the dancer stopped the performer in mid-air. Coming from the side, the strobe lights isolated the dancer from the background, allowing him to leap in a seemingly weightless black void. (Ken Kobre, University of Houston)

giving the photographer the opportunity to see exactly where the light will fall. Small portable strobes don't have this feature. You can't see the lighting effects until you have developed the film, hours or sometimes days later. To overcome this problem when using multiple strobes, you can visualize the effect of the light by placing a regular lamp, aimed at the subject, next to each strobe. The lamps' light will give you an indication of how the strobe light will look in the picture. You can use this modeling light to adjust the shadows, or to bring up highlights. The final picture is still taken with the light of the strobe, but the lamp or modeling light helps you previsualize the results.

In a multiple light setup, if all the strobes are of equal power, the photographer, in general, bases the exposure on the shortest strobe-to-subject distance. The nearest strobe throws the most light on the subject, leaving the others to fill in the shadows. For a complicated light setup, or with setups involving units of different power, the photographer may need to take a light-meter reading with a specially built strobe meter.

Photojournalism: The Professionals' Approach

Five strobes, one fired with each dance step, helped create this multiple exposure of modern dancer, Sharon Beckenheimer.
(Ken Kobre, University of Houston)

DEVELOPING AND PRINTING TO MEET A DEADLINE

Once you have your pictures of the train wreck or car accident on film, you'll want to develop your negatives and make prints as quickly as possible. A delayed print could mean that the photo wouldn't reach the editor's desk on time and would miss the paper altogether.

Short-cuts to Film Processing

The list on p. 198 contains the standard and special developers used by newspaper and wire service photographers. You will find included in the list short-cuts to the procedures recommended by the manufacturer, such as reduced fix and wash times. You can use these short-cuts when you are under deadline; then, when you have free time, you can return to the darkroom and refix and rewash the negative, without any permanent damage to the film.

A photojournalist, operating under tight deadlines, doesn't always have the perfect facilities for processing film and printing negatives. (Chip Maury)

Sometimes, because of deadline pressure, photojournalists have to print negatives while they are still wet. This procedure is not desirable because the soft emulsion of the wet negative is easy to scratch and readily attracts dust. Also, as the film dries in the negative carrier of the enlarger, the emulsion tends to contract and buckle, because of the heat of the enlarging light. As the negative changes shape, it requires constant refocusing in the enlarger. With the glassless negative carrier of the Beseler and Omega enlargers, you can print a wet negative; but with the glass negative carrier of the Leitz enlarger, you must wait for the negative to dry.

Many newspapers have installed machines such as the Kodak Versamat to process, fix, wash, and dry the film automatically. Some of the machines produce a finished, printable negative in 5½ minutes.

When development, whether with the Kodak Versamat or by hand, is speeded up, the photographer saves time but loses quality in the prints. Speed processing tends to increase the apparent grain of the negative. This grain increase, however, gets lost anyway when the photo is reproduced on newsprint. In the end, a grainy photo that makes the deadline carries more value than a less grainy photo that reaches the editor's desk too late.

Special Equipment and Techniques of the Photojournalist

Normal and High-Speed Film Developing Procedures

(All times based on Kodak Tri-X film developed at 68 degrees.)

		Standard	Normal	Emergency
1. Develop		(Normal—ASA 400)		
	a.	D-76 1:1	10 min.	
	b.	D-76 straight	8 min.	
	c.	HC-110 (dilution A)		3¾ min.
	d.	UFG	5¾ min.	
		High Energy		
	a.	Acufine (ASA 1000)	5¼ min.	
	b.	Diafine (ASA 1600)	4 min. + 4 min.	
	c.	Dektol 1:2 (ASA 400)		1½ min.
2. Stop bath		Water	15 sec.	5 sec.
3. Fixer	a.	Normal	5–10 min.	
	b.	Rapid fix	2–4 min.	1 min. (or until clear)
4. Wash	a.	Water	30 min.	5 sec.
	b.	Water	1 min.	30 sec.
		Perma Wash	1 min.	30 sec.
		Water	1 min.	30 sec.
	c.	Hurricane washer	5 min.	
5. Wetting Agent		Photo flo	30 sec.	5 sec.
6. Dry	a.	Air	1 hr. (depending on humidity)	
	b.	Forced hot air	2 min.	
	c.	Yankee film dryer (or alcohol)		2 min.

Note: Each lower case letter represents an alternative procedure for this step in the developing process.

Burning and Dodging Can Improve Print Reproduction

If you are printing pictures for a paper or magazine, sometimes you have to dodge and burn a print more than you might if you were preparing the picture for an exhibition. For reproduction, you must bring out the tonal separation between the subject and background. Reproduction, especially letterpress reproduction on newsprint, tends to decrease the number of tonal values in the final halftone. The press can never reproduce the black blacks or the clean whites of the original print. The number of discernible gray steps between black and white is also limited. This limited tonal range becomes especially detrimental to the picture when a subject has roughly the same tonal value as the background. This occurs, for instance, when a bride in white is posed in front of a white clapboard church, or when the groom, wearing dark gray flannel, sits in front of a paneled mahogany pew. The bride and groom will blend into their respective backgrounds. By burning in the background—that is, adding additional light to the area while the negative is still in the enlarger, and the print is still on the

easel—the background will darken. With the darker background, the bride and groom will each stand out from their environments in the final pictures.

This burning-in technique also proves valuable when the subject moves in front of a busy, distracting background. For instance, when a football player jumps to catch a pass, the ball often appears to get lost in the crowd. By darkening the crowd, the player and the football will stand out and the picture will read easily.

You can burn in an area of the print by letting light strike the section you want to darken, but blocking light from other parts of the print. After you complete the original exposure of the paper, hold between the lens and the print a piece of cardboard with a hole in it. Now, while holding the hole in the cardboard over the section you want to darken, turn on the enlarging light again for an additional exposure of that one area.

This straight print of a fishing boat returning to port with a load of cod looks dull and didn't reflect the day's somber atmosphere.

The photographer burned in the area around the trawler. The dark background took on the mood of the overcast gray day. Darkening an area of a picture often helps to eliminate distracting elements in the background.
(Ken Kobre, University of Houston)

Ideally, the reader should never notice that a section of the print was purposely darkened in the darkroom. The secret of producing a natural effect lies in keeping the cardboard constantly moving both sideways and up and down. As you agitate the cardboard, the burned area of the print gradually fades into the unburned area and looks natural.

Burning in the background doesn't work for all prints. For some photographs, the technique looks artificial. But when the subject tends to bleed into the background, even an artificial look is preferable to losing the main element of the picture.

Sometimes the photographer needs to dodge a negative, especially when a shadow crosses the face of an important subject. Subtle details in the shadow area that show up easily in a glossy print might get lost when the photo is reproduced on rough newspaper. During the exposure of the print, with a small piece of cardboard attached to a wire the darkroom technician jiggles the dodging tool, blocking the light coming through the subject's face just long enough to slightly lighten the face on the print. In the next day's newspaper the face will still appear shadowed but all the details of the facial expression can be seen easily.

Developing the Print Quickly

Many papers have turned to the Kodak Ektamatic Processor to increase the speed of printing. The processor develops and partially fixes a print in 15 seconds. The developed print comes out of the machine somewhat sticky but usable. For permanency, the special Kodak Ektamatic paper can be fixed and washed following the processing time for normal bromide paper.

A larger machine, the Kodak Royal Print Processor, develops resin-coated (RC) paper in a little longer time, but the print comes out of the machine completely fixed and dried.

Tray Processing

	Kodak RC (Resin Coated) Type II	Kodak Bromide
1. Developer	½–1 min.	1–2 min.
2. Acid stop bath	10–15 sec.	10–15 sec.
3. Rapid fixer	2 min.	5–10 min.
4. Wash a. Water*	4 min.	30 min.
b. Water		2 min.
Perma Wash		2 min.
Water		2 min.
5. Dry a. Air	Minutes	Hours
b. Dryer**	Seconds	Depends on dryer

 * Hot water can speed up wash times.
 ** Dries RC prints quickly.

Press photographers usually use off-the-shelf cameras, lenses, and strobes along with stock film, paper, and chemicals to shoot, develop, and print their assignments. What separates the working picture journalists from the Sunday-in-the-park snap-shooters is the intense wear working pros give their equip-

ment. The pros work hard under adverse physical conditions. Finally, photojournalists operate under constant pressure to meet deadlines. They must use the standard chemicals and paper to do a job in much less than the standard time. The amazing fact about news and magazine photographers is that they can produce consistently excellent technical photos under these adverse conditions.

THE JOB OF THE PHOTO
EDITOR

STRATEGIES FOR SELECTING
NEWS PICTURES

MORAL DILEMMAS OF A
PICTURE EDITOR

9
THE ART
OF PICTURE EDITING

THE JOB OF THE PHOTO EDITOR

Photo editing takes strong eyes, a sharp grease pencil, and the psychological strength to reject thousands of pictures as you seek to find the one frame or part of a frame that tells the story and has visual impact. Technically poor negatives that are out of focus, underexposed or overexposed are easily rejected. After squinting through a magnifying glass at page after page of contacts, each containing up to thirty-six frames, the experienced editor only *glances* at static, routine, outdated, duplicate, or clichéd photos. But when a unique image catches the editor's eye, the picture is like a red traffic light forcing the editor to stop. "There are so few good pictures in any proof sheet that the good ones jump right out at you," says John Dominis, ex-*Life* photographer, who became picture editor of *People* magazine, and then picture editor of *Sports Illustrated*. When the editor sees a unique photo, he circles it with his red grease pencil, indicating to the lab that the negative should be blown up. Then, with the enlargements spread out in front of them, the picture editor, layout editor, and managing editor select the final images to appear in the magazine or newspaper.

Editing Pictures Professionally

Some newspapers do not have a picture editor, and many of those who do fail to give that person enough authority. As a result, unqualified and uninterested people may be involved in the handling of pictures.

Effective photojournalism begins with the photo editor, not the photojournalist. Striking pictures result from sound assignments. The picture editor runs down the list of news stories on the day's log to determine which lend themselves to pictorial reporting, which need an inked illustration, and which need no accompanying artwork at all. With limited staff and resources, the editor must choose to cover the stories that have a certain amount of intrinsic visual interest.

Bruce Bauman, photo editor for the *San Jose* (California) *Mercury*, warns that the photo department should not become a "service station." He points out that a photographer's job is not just to provide the service of illustrating a writer's story.

Therefore, the enlightened photo editor not only assigns the listed news stories of the day, but generates pictorial story-ideas. The photo editor might ask a photographer to cover the background or sidelights of a news story in addition to the breaking event itself. Say a news conference is called to announce a million-dollar grant to cancer research. Although a picture of the press conference may be necessary, it has little chance of producing exciting photos and less opportunity for providing readers with any valuable information about cancer. The story is concerned basically with the statistics—percentage increase in cancer—and with the number of dollars spent on research. The photo editor might try to interpret these statistics visually by instructing the photographer to spend a half day at a cancer research laboratory. The laboratory photos would help to translate the dull, itemized costs of research into more human terms; the reader would see the size of the sophisticated equipment and the number of specially trained personnel working in the research facility. Finally, photos showing dying patients in a cancer ward can bring the dollars-and-cents issue home to the reader.

The person on the picture desk must be able to predict the world's future news events and thus commissions photojournalists to get coverage on stories that might break. When he was picture editor of *Time* magazine, John Durniak knew by closely following the international scene that a Middle East story was soon to hit the front pages of the papers. He assigned photographer David Hume Kennerly to shoot candid portraits of the heads of state of Israel and Egypt

Ray Lussier of the Boston Herald American *needs only one glance to reject static, routine, outdated, duplicate, or cliché shots.* (Ken Glass)

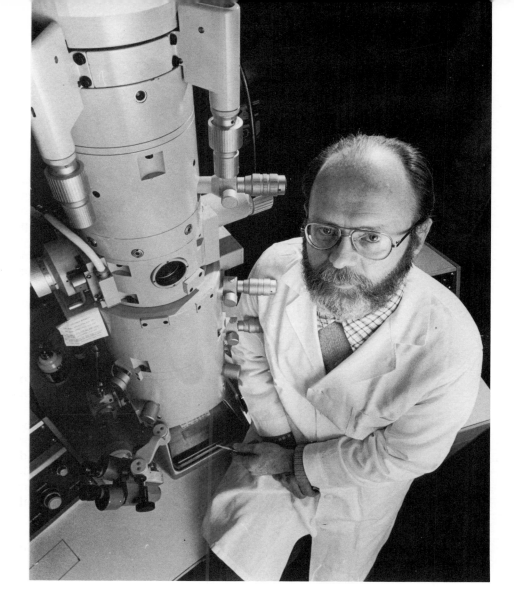

Just the size of the electron microscope helps explain to the reader why research is so expensive. Progressive editors assign photos like this to translate dull numbers into concrete items, whose price the reader can appreciate. (Chip Maury, Providence Journal)

months before Egyptian President Anwar Sadat's precedent-setting 1977 trip to Israel. When the peace story broke in the newspapers, *Time* already had a backlog of recent color photos. A tight head shot of Sadat appeared on the magazine cover within a few days of the peace offer.

Sometimes the picture editor develops photo essay ideas that might not have a news-peg, but will produce informative, lively picture stories. Such stories can include a day in the life of a politician, an essay about the environment, or a story about how to build your own house in ten easy steps. Once the photo editor has developed a sound idea, he or she must set aside scheduled time for a photographer to cover the story.

The sensitive, perceptive photo editor realizes the strengths and weaknesses of the available staff and free-lance photographers. All photographers do not like sports; only a few take funny pictures. Some photographers notice subtle shadings of light and shade, whereas others have an eye for action. Matching the correct photographer with the appropriate assignment can be a complex task for the photo editor.

The photo editor should provide the photographer with all the available information on the upcoming story. The more a photographer knows about an assignment, the better he or she will cover it. The desk person should give the photojournalist clips of previous and related stories to fill in the background and

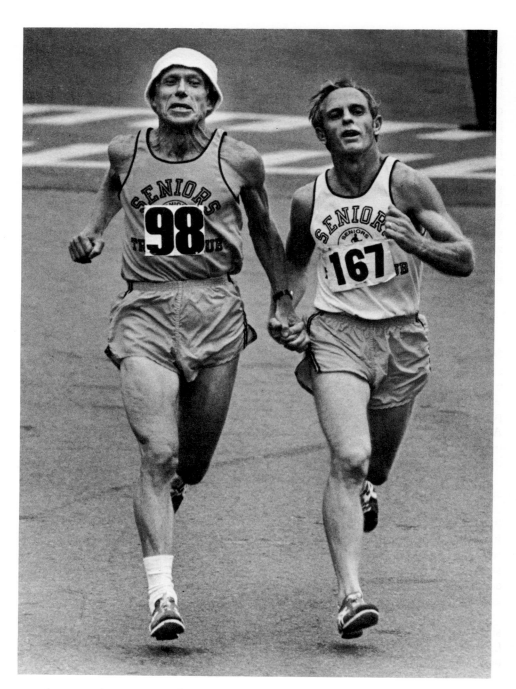

Some photographers specialize in sensitive personal features. Other photographers concentrate on sports, hard news, illustrations or fashion. On a small paper, one photographer supplies the photo expertise for every department.
(Ulrike Welsch, courtesy Boston Globe)

put the story in context. The editor should suggest possible contacts to talk to for further information. If the story is expected to run with a photo layout rather than a single picture, then the editor should forewarn the photographer about the number of pictures that will be needed.

Ideally, after the film has been shot and processed, the photo editor reviews the contacts with the photographer, selecting the frames that best fit the story. Then begins the behind-the-scenes job for the photo editor, who battles for adequate space for the photographer's pictures. The city editor, wire editor, feature editor, and sports editor each try to hoard sections of the paper for their stories; consequently, the photo editor must be just as possessive and aggressive as the other editors in fighting for picture space. Great pictures never seen by the readers are just as worthless as great pictures never assigned or taken.

Surprisingly, one skill that is not necessary to be an outstanding photo editor is the ability to take pictures. Many of the best-known photo editors never learned to use a camera; others, although they know the basic techniques, never practiced photojournalism. Robert Wahls, of the *New York Daily News*, says he is better off not knowing about the mechanics of a camera: "It just bogs you down," he says. "What you need to edit pictures is in you—not the camera." John Durniak, formerly of *Time* and *Look,* and Tom Smith, *Geographic*'s illustrations editor, both have spent most of their lives handling pictures, not lenses. In fact, Roy Stryker of the Farm Security Administration, who produced probably the most complete and lasting still-photo documentary of an era, never took pictures himself. The most famous example, however, is Wilson Hicks, executive editor of *Life* magazine. He sent photographers to every point on the globe; he hired and fired the best photojournalists, and set the direction of the field for years to come. Yet he never took a picture that was published in his own magazine. No one has proved that photographers do not make good photo editors, but camera knowledge is not a prerequisite for becoming a successful picture desk executive.

The Hazards of Do-It-Yourself Picture Editing

Should photographers edit their own work? *Life* and *Look* magazines represented diametrically opposed positions in this controversy. Wilson Hicks, executive editor of *Life,* said that photographers are too emotionally involved when taking pictures to evaluate the pictures objectively during the editing process. Former *Look* art director Will Hopkins argued the opposite philosophy. At *Look,* the photographer and photo editor, as well as the writer and art director, operated as a closely knit group, each contributing to the final story, without letting job titles limit each participant's input.

Life staffers received assignments, covered the story, turned in the film, and waited until the following week when the magazine appeared to see how their pictures were selected and played. *Life* photographers had almost no control over stories after shooting them. Specialists in picture research, picture editing, caption writing, text block writing, and layout took the photographer's raw material and produced a finished photo essay. W. Eugene Smith, an outstanding photo essayist and co-author of *Minamata,* quit the staff of *Life* twice, essentially over this arbitrary division of responsibility between photographer and editor. (See Interview with W. Eugene Smith, chapter 12.)

By comparison, at *Look* magazine, each photojournalist stayed with the story from conception through shooting to editing and paste-up. Tim Cohane, *Look*'s sports editor from 1944 to 1965, remembers that in the initial stages of each assignment he sounded out the ideas of photographers and layout people. "If you can use their enthusiasm and combine your ideas with theirs, you will come up with imaginative picture stories," said Cohane. "The photographer voiced his opinions at each stage of the story's development."

Over at the Time-Life building, Hicks used to argue that photographers evaluated their own pictures on a different basis from their editors. The photographer, who might have dangled from the top of a mountain in subzero weather to get a particularly evocative picture, attached more significance to the resulting image than did the editor, who evaluated the picture's merits impartially, without considering the trials and tribulations under which the photo was taken. The photographer's familiarity with the difficulties of the assignment might affect personal objectivity.

Your ego should not prevent you from realizing that, even if you have the opportunity to edit your own contacts, you should seek impartial outside counsel to confirm or reject your personal selections. On many small newspapers, a

photojournalist shoots an assignment, develops the film, scans the negatives, chooses the frames, prints the pictures, and delivers the finished glossies to the editor's desk; no one else inspects the original negatives. What this system gains in efficiency, it loses in objectivity. The editor or managing editor does not have to view the negatives; the photographer, however, should find someone who was not present at the news scene to offer an impartial opinion. The neutral observer can tell the photographer which pictures illustrate the story best and which photos, even though they might have been difficult to get, do not add to the visual report.

Photographers, however, should try to avoid the "shoot and ship system," in which the photojournalist shoots the pictures and ships them to the newspaper or magazine, along with a few sketchy cutline notes, never even catching a glimpse of the negatives before the pictures are published. The photographer, like the reporter, participated in the news event and therefore has a better idea of what actually occurred than does the editor in an executive office. Photojournalists should be involved, if possible, in the picture editing process at all stages.

STRATEGIES FOR SELECTING NEWS PICTURES

Theories of Picture Selection

Laura Vitray, John Millis, Jr., and Roscoe Ellard, in *Pictorial Journalism*, an early book (1939) on news photography, tried to develop a mathematical formula for determining reader interest in pictures. The researchers assigned points for the degree of news value of the event, the notoriety of the subject, and the amount of action in the picture. But many newspaper editors did not adopt the formula because it did not define the word *news*, nor did it provide a yardstick for measuring notoriety of the subject or a system to quantify the degree of action in the picture. Also, editors felt limited when required to judge all pictures on only three scales.

Stanley Kalish and Clifton Edom, in their book *Picture Editing* (1951), added several new factors to consider when selecting pictures. They advised editors to look for pictures that not only had news, notoriety, and action, but also eye-stopping appeal. By "eye-stoppers" the authors meant pictures that contained interesting patterns, strong contrasts in tonal value, or that could be uniquely cropped (like extra-wide horizontals or slim verticals). Then, after the readers' attention was engaged, the pictures should also hold interest. What galvanized readers' attention depended on the subject matter, they said. A picture about love or war was more likely to maintain attention than was a picture about farming or economics. Some topics are intrinsically more interesting than others, regardless of the quality of the photo, the researchers concluded.

Tom Hardin, director of photography for the Pulitzer Prize winning *Louisville* (Kentucky) *Courier-Journal and Times*, argues that pictures are no longer good just because they are "eye stoppers." "Pictures must report something about the community. These pictures might not win photo contests but they serve to tell the local reader a visual story about the events in his city," says Hardin. "One of our photographers took a picture of the mayor and the judge helping each other cross the heavily trafficked street. The picture to an outsider might seem dull and routine. But, to the readers of our paper who recognized that this act of cooperation was the first time the mayor and judge had worked together constructively, the picture carried importance," explained Hardin.

"We don't have room for a day-in-the-life-of-a-stone-mason type photo essay anymore." As space grows tighter in metro papers, Hardin says, the editors must continually apply the yardstick of community-worth to each picture.

Found on an art museum lawn, this sculpture possessed visual values other than news content. With exciting patterns and strong contrasts in tone, the photo of the sculpture stops the eye and intrigues the mind of the reader. (Ulrike Welsch, courtesy Boston Globe)

Surveys Indicate Readers' Preferences

Researchers have conducted several surveys over the years to determine subjects that have intrinsic interest to readers. In 1939 the Advertising Research Foundation began a survey of readership of 130 daily newspapers, varying in size, circulation, and locality. *The Continuing Study of Newspaper Reading* com-

pleted eleven years later was statistically analyzed by Charles Swanson to determine what categories of pictures were the most read. From the 3,353 photos in the study, Swanson reported in *Journalism Quarterly* that fire, disaster, and human interest were among the top-read categories. Least-read picture categories included sports, fine arts, and the family.

In 1977 Joseph Ungaro, Chairman of the Associated Press Managing Editors (APME) photo committee, with the assistance of Hal Buell, AP's assistant general manager for news photos, polled 500 readers to find out what type of pictures they liked. The AP survey reported that readers liked human interest and feature pictures most. Readers found general news and sports least interesting. Out of the many photos presented in the AP picture survey, readers selected as their favorite a photo of a big fluffy Saint Bernard kissing a little child.

Surveys indicated that all readers do not have the same taste in pictures. Based on the 1940s data of the *Continuing Study of Newspaper Reading*, Swanson found that women are more picture-minded than men. He concluded that women have a greater interest in a larger number of picture categories than men do, and they also differed from men in their preference of specific categories. In a survey conducted in the 1960s Randall Harrison found that men tend to prefer photographs of events, whereas women prefer pictures of people. Both sexes looked at pictures of women more than pictures of men.

One category that men and women differ on is sports. Although the overall statistics of the picture surveys indicate that sports is a low-preference category, this finding results from the fact that women look at baseball, basketball, and football pictures only half as much as men, according to Swanson's analysis.

With so few studies available, and the studies themselves differing in their sampling and survey techniques, generalizations have to be limited. Several conclusions, however, do seem justified: from 1939 to 1977, human interest pictures received high ratings from readers. Not surprisingly, the public liked to look at pictures of people engaged in funny or unusual activities. Sports appeared at the bottom of the surveys. This finding coincided with a 1978 Lou Harris survey that found that newspaper editors overestimate the general public's interest in sport stories.

Although women express a lower preference for sports pictures, these pictures should not be eliminated from the newspaper. A newspaper's inherent advantage over its nearest competitor, television, is that newspapers can display an array of items simultaneously, letting individual readers pick the news articles they are interested in pursuing and disregarding those that do not pique their curiosity. Women can look at people pictures while men can review sports photos. Television, by contrast, is linear. It can display only one item at a time. Therefore, it presents only items that have mass viewer appeal. Television selects its subjects based on what the station managers think will have the broadest common pulling power for all sexes and ages. Newspapers do not have to be edited this way. A newspaper can present a variety of items, each of which will appeal to a select group of interested readers.

Can Professional Editors Predict Readers' Preferences?

Who knows what kinds of pictures people like? Logically, you might assume that photo editors know their audiences, but a study by Malcolm S. MacLean and Anne Li Kao reported in *Journalism Quarterly* suggested that editors are just guessing when they predict reader response to pictures. The researchers asked average newspaper readers to sort through pictures, and to arrange them in order from most favorite to least favorite photos. Then the researchers asked a group of experienced photo editors and a group of untrained students to sort through

the same photos. The editors and the students arranged the photos in the order they thought the readers had organized the photos. The editors and the students based their predictions on statistical information they had about the readers. MacLean and Kao hypothesized that the more information such as age, sex, and occupation the editors and the students had, the more accurately they could predict the likes and dislikes of readers.

Surprisingly, the researchers' hypothesis was wrong. Professional photo editors did barely better than even chance when given minimal or even detailed information about their readers. Furthermore, photo editors did no better at predicting than had the students. The researchers did find, however, that once the professional editors had seen how their readers sorted one set of photos, the editors could anticipate how the readers would sort a second set of photos. These predictions were even better if the editors knew more about the reader, including the person's age, hobbies, and lifestyle.

Until the editors had seen the picture selections of the readers, they could not predict an individual reader's preferences. Clearly, more editors should find out what pictures their readers are actually looking at rather than basing editorial decisions on their own biases.

Robert Gilka, director of photography for the *National Geographic*, tells a story about Charlie Haun, a picture editor in Detroit who used to make his own surveys. "Every couple of days Haun would ride the bus in Detroit and look over the shoulders of the bus riders who were reading the paper. He would note which picture their eyes stopped at, how long they dwelt on each photo, and see if they read captions." Gilka points out that although Haun's method was primitive, "Charlie probably knows more about pictures than most of us today." Haun, from his bus rides, came to the same conclusion that MacLean and Kao did from their research: identifying what pictures people have picked in the past is the best determinant of what pictures they will choose in the future.

To discover if editors and readers agree on what constitutes interesting and newsworthy photos, the Associated Press Managing Editors photo survey, mentioned earlier, was designed to determine which kinds of pictures readers liked as well as which type editors preferred, and whether readers and editors had the same taste. The results indicated a surprisingly close agreement between readers and editors. Both selected the same photos in the sports, general news, and feature categories. Editors' and readers' opinions, however, differed radically on the use of dramatic news pictures. By a two-to-one margin over readers, editors chose action-packed, often violent, and sometimes gruesome news pictures. A majority of the readers not only disliked such pictures, but thought that violent pictures should never be published. As the pictures became successively more gruesome, fewer readers voted for photos in this category.

As MacLean and Kao discovered, editors cannot predict an individual's photo preferences. Yet, as the AP survey indicated, except for spot news, editors' and readers' tastes are generally similar. When it came to picking a favorite picture, however, the two groups, editors and readers, diverged. Readers chose the St. Bernard-kissing-child picture. Editors, by comparison, chose as most interesting the photo of the lifeless body of a hanged Bangkok student being beaten by a right-wing opponent.

When I interviewed Hal Buell, he tried to draw some conclusions from his picture survey:

> Newspapers have to be all things to a lot of different people. The editors must print what people want and also what the editors think is significant. I guess a paper in the end has to publish both some dogs kissing kids and some violent Bangkok student pictures in order to present a complete picture of the world.

MORAL DILEMMAS OF A PICTURE EDITOR

The Gruesome Picture—Seen or Suppressed?

A photographer at the scene of an accident or disaster does not have the leisure to determine if a particular picture is too gruesome or horrible to appear on the paper's front page. Only when the film has been contacted can the photographer and the editor study the images with an impartial eye toward deciding if the photos are too indecent, obscene, or repulsive for publication. The subscriber of the *Republican-Democrat* might have trouble digesting, with morning cereal and coffee, a gory accident picture on the front page of the paper. Yet newspaper managers must not whitewash the world. Accidents do happen. Murders do take place. People do commit suicide. Eliminating all pictures of violence presents readers with a false view of the city and the world.

Curtis MacDougall, author of *News Pictures Fit to Print . . . Or Are They?* recalls that when he was a reporter on the *St. Louis Star Times*, the managing editor once spent a full hour soliciting the opinions of everyone in the newsroom regarding the propriety of using a picture of a lynching. The picture showed a dead man in a heap at the bottom of a tree on which he had been hanged. MacDougall remembers the photo and the incident: "No facial expression was visible; nevertheless the decision was made to black out the body and substitute an artist's drawn 'X' to mark the spot." This conservatism was typical of editors through a century of brutal torture and murder of blacks. According to MacDougall, plenty of photographs were available that showed this inhuman treatment of blacks; however, even if they reached the newsroom, they were relegated to the paper's file.

Opposite, top: In the Associated Press picture survey readers chose this St. Bernard and child photo as their favorite. (Wide World Photos)

Opposite, bottom: By comparison, in the same survey, editors chose this hard news shot of a rightist striking the lifeless body of a hanged student in Bangkok, Thailand. (Neal Ulevich, Wide World Photos)

If the photographer had waited to click the shutter, this photo of a man jumping from a building would have been lost. Later, in the news room, under less stressful conditions, editors can decide if the picture should or should not be printed. (Joseph B. Young, III, Indianapolis News)

213
The Art of Picture Editing

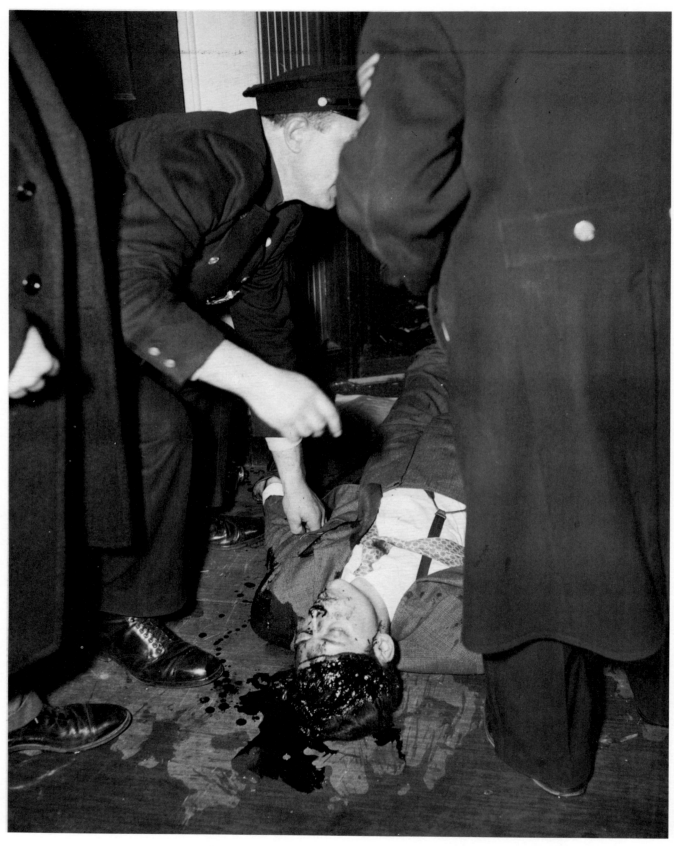

The man fired first at the police, then took his own life. Would you print this news picture?
(Warren Patriquin, *Herald* File, Print Division, Boston Public Library)

Should the squeamish be protected from gruesome pictures? Another lynching picture was described as "shocking and unnecessary." "So was the crime," wrote Ernest Meyer in the *Madison* (Wisconsin) *Capital Times*. "The grim butchery deserved a grim record. And those photographs were more eloquent than any word picture of the event."

Usually, newspaper editors did not print lynching pictures because of the argument that they were too grisly. However, at the same time, editors did play up pictures of horrible, blood-soaked, maimed car-accident victims. Editors rationalized that accident pictures served as a warning to careless drivers and thus improved highway safety. At the time, no one thought to add that lynching pictures might also have a positive benefit by stirring up moral outrage against mob rule.

Today, the number of accident photos has decreased; because accidents have become so common, they are less newsworthy. Accident photos often also are more difficult to get because the police's removal of the bodies is prompt. But the underlying moral question remains: Does the sight of mutilated victims in a mangled car scare readers into caution when they drive their cars? And should this type of picture be published?

The Akron Beacon Journal said in an editorial:

> The suddenness and finality of death, the tremendous force of impact are vividly depicted in crushed, twisted bodies and smashed vehicles. The picture implants in the minds of all who see it a safety lesson that could not be equally well conveyed in words alone. How long the shock value of such a picture persists, varies. But one can be sure that a majority of those who see photographs of traffic accidents are more concerned with their safety than they had been before seeing the picture. "This can happen to you!" is the unwritten message of every picture of an accident.

Stanley Forman's photo showing the sudden collapse of an ironwork balcony during a fire, plunging a woman to her death, with a child surviving miraculously, was printed on more than a hundred front pages across the country. Later, telephone calls and letters to newspapers charged sensationalism, invasion of privacy, insensitivity, and tasteless display of human tragedy to sell papers.

Hal Buell, AP's assistant general manager for news photos, says he received more reaction to the Forman picture than to any other news photo. Buell wagers that if the woman had survived, there would have been very little reaction. "The pictures would not have changed but the fact of death reached into the minds and feelings of the readers," he said. Most of the nation's editors published Forman's picture on their front pages. Yet, in a survey taken by the *Orange County Daily Pilot* in Costa Mesa, California, 40 percent of their readers did not approve of that paper's publishing the photo. Wilson Sims, editor of the *Battle Creek* (Michigan) *Enquirer and News*, defended publishing the picture: "The essential purpose of journalism, including both print and photojournalism, is not to make the reader feel pain or to bring the reader happiness. It is to help the reader understand what is happening in the world. Therefore we ran the picture."

Forman's photo of the falling woman and child won a Pulitzer Prize and eventually led to a change in fire safety laws in Boston. Forman's editor, Sam Bornstein, said, "Without the picture, the word-story would have been 'page 16.' Only pictures of this magnitude would have resulted in something being done by the safety agencies."

This fire escape balcony collapsed, plunging a woman to her death; the child miraculously lived. After the picture appeared on hundreds of front pages across the country, telephone calls and letters came into newspapers, charging sensationalism, invasion of privacy, insensitivity, and tasteless display of human tragedy—all to sell newspapers. Would you have printed this picture? (Stanley Forman, *Boston Herald American*)

BIBLIOGRAPHY

N. Abrams, Associated Press, Inc., 1976. The Instant It Happened. New York: Harry

Malcolm F. Mallette, director of the American Press Institute in Reston, Virginia, discussing ethics in news pictures at a seminar for picture editors and graphics directors, rhetorically asked the attending members, "Do we print the gruesome picture of the Buddhist monk who has set himself afire? Yes, of course. And do we print the horrifying pictures of the South Vietnamese military officer firing his pistol point blank in the brain of a captive? Startling. But, yes again. Life is often startling and horrible but only by knowing can readers seek a better existence for all." But, Mallette pointed out, a fine judgment must be made: "The fact that one shocking picture is printed does not mean that all should be."

Flames enveloped Reverend Quang Duc, an aged Buddhist priest, as he burned himself to protest the Diem government in South Vietnam. Startling— yes. But life is sometimes shocking. Would you have published the picture? (Malcolm Browne, Wide World Photos)

Covering Up Nudity

Nudity in pictures generates more disagreement among editors than does any other controversial type of picture. With the advent of *Hustler* and other maga-

Nudity made the news. Stripper Fanne Foxe was the paramour of Wilbur Mills, a powerful United States member of Congress. Because of the ensuing scandal and political implications, this photo had news value.
(Ken Kobre, University of Houston)

zines, almost no part of the human anatomy has been reserved for the imagination. Yet many newspapers, both weekly and daily, and magazines that consider themselves family fare refrain from printing nudity on their pages. Speaking for the Associated Press, Buell said that he will not carry full frontal views of nude men or women except in most extreme cases. "Such a story has yet to occur," he commented.

Critics of *National Geographic* claim the magazine will print pictures of bare-breasted black women but not of bare-breasted white women. Tom Smith, illustration editor of the *Geographic*, replies that the magazine has guidelines of good taste. "I would say that we are not prudes in any way, but that at the same time we are not going to show any explicit nudity except when there is some real reason for it." Smith gave as an example a *National Geographic* story in which the magazine sent a team of photographers to the Philippines to cover the

Tasaday, a recently discovered primitive tribe. The natives were completely naked, and that is the way they were presented in the magazine. "We wouldn't go out of our way to hide nudity," the illustration editor said.

Robert Wahls, photo editor of the *New York Daily News*, avoids running nudes except under unusual circumstances. Despite the *Daily News*'s reputation as a genuine tabloid, Wahls feels that although nudity is acceptable in film and theater, "It is inappropriate when you can sit and study it." The photo editor made an exception when there was an overriding news value to a picture. The photos from Woodstock, a 1969 massive outdoor rock concert, showed members of the audience frolicking in the muddy field without their clothes on. The sheer size of the audience, 300,000, gave the activities news value. Wahls points out that even if nude pictures help push up the circulation of a newspaper, the gain might be a useless one if advertisers start to consider the paper pornographic. "A newspaper's job is to inform, not to titillate," says Wahls.

On the other hand, Wahls had no reservations about printing pictures of Siamese twins. He felt that the pictures and the X-rays of this unusual abnormality provided news information in a pictorial way without titillating the readers.

Pictures of Fanne Foxe stripping in a Boston burlesque house might have aroused some readers; however, the photos possessed overriding news value because the "Argentine bombshell" was the consort of Wilbur Mills, a powerful member of Congress. Both clothed and unclothed, Fanne Foxe was covered in words and pictures.

Readers also might disapprove of photos showing obscene gestures. However, with the exception of the *New York Times*, few news desk editors refrained from printing the picture of Vice President Nelson Rockefeller "giving the finger" back to a crowd of hecklers at an airport. News value overruled matters of good taste in this situation also.

MacDougall, in his book *News Pictures Fit to Print . . . Or Are They?*, struggled to find a common rule to help editors decide when to splash a controversial picture on the front page or when to file the picture in the bottom desk drawer. "My yardstick is the public interest," says MacDougall. "I would run any picture calculated to increase the public's understanding of an issue about which the public is able to act."

Each editor will use his or her own yardstick of public interest.

Some papers would not publish this photo of a two-headed and four-armed baby girl. Other papers would not hesitate to print the photo, arguing that this picture provides information.
(Mangkorn Khamreongwong, Wide World Photos)

Few editors passed up the opportunity of showing former Vice President Nelson Rockefeller "giving the finger" back to a crowd of hecklers at the Binghamton, New York, airport.
(Don Black, Binghamton [New York] Sun-Bulletin and Press

Fair and Balanced Photo Reporting

The experienced professional reporter continues to dig up the facts of a news story until he or she feels it is possible to write an unbiased, balanced report of the event. News reporters might write articles in which several paragraphs explain the position of each conflicting party. Many stories have no clear good guys and bad guys; hence the reporter devotes additional copy to explaining the complexities of the situation. The writer not only has several paragraphs to tell the story but employs the flexibility of the English language, with its great store of adjectives and adverbs. These modifiers enable the writer to emphasize an

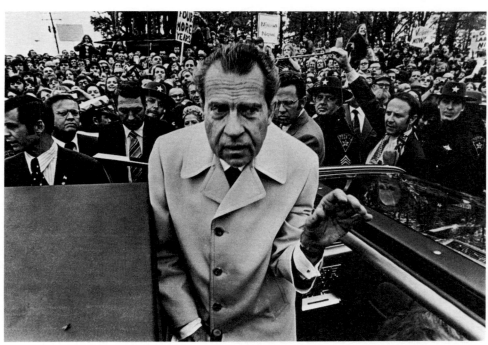

Former President Richard M. Nixon squeezed through the top of his limousine on the campaign trail in 1972. Could any photographer take a completely neutral picture of President Nixon? (Charlie Nye)

idea or soften a phrase. Listen to the difference between "the criminal stared" and "the criminal quietly stared."

The photographer has no adjectives or adverbs. The picture captures only one moment in time, one set of circumstances, one expression or action. If the newspaper's managing editor has allotted space for just one picture illustrating a complicated story, then the photo editor is faced with a task as difficult as if the writer had to tell a multifaceted story in one sentence. Of the two hundred or so exposed frames shot on a story, which single picture tells the whole story?

When former President Richard M. Nixon once gave a speech to 10,000 listeners, ten hecklers in the back of the hall tried to interrupt him. AP's Hal Buell remembers the difficult decision whether to run a photo showing the large enthusiastic supportive crowd, or the small but newsworthy band of dissenters. Although the AP photowire could carry both pictures, newspaper editors with space limitations often had to choose between the two photos. Did either the crowd picture or the heckler picture reflect the complete truth about the event?

The Vietnam war presented a constant challenge for photo editors. Each day they had to sum up a complicated, tragic event in a few pictures. Eddie

The body of a dead Viet Cong soldier was dragged by a United States tank to a burial site. Liberals said the photo showed the horrors perpetrated by the American Armed Forces. Conservatives said that the media was biased, and that editors, with pictures like this, tried to downgrade the American soldier. Who was right?
(Kyoichi Sawada, UPI)

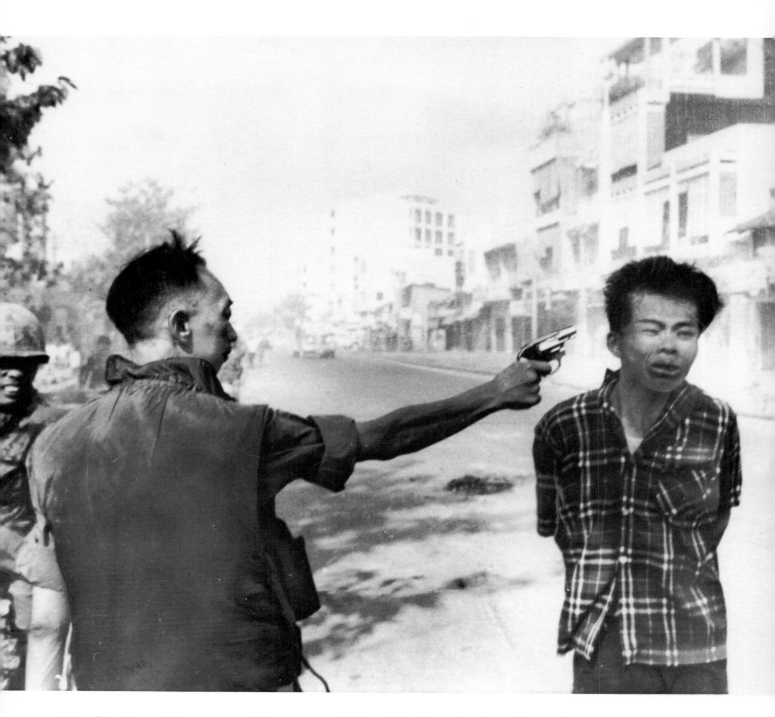

Brigadier General Nguyen Ngoc Loan, Police Chief of Saigon, assassinates a Viet Cong suspect.
(Eddie Adams, Wide World Photos)

Adams won a Pulitzer Prize for a shocking photo of a Vietnamese colonel executing a suspected Viet Cong on a Saigon street. The overwhelming message of the picture spoke of the cruelty of the South Vietnamese army officer. To balance out this view of the war, many editors chose to run on the same day another picture portraying the terrorism of the Viet Cong. The photo, although not as dramatic as the Eddie Adams picture, showed a soldier leaving a house recently bombed by the Viet Cong. Do the two photos really explain both sides of the conflict? Can any two pictures be balanced?

In 1966 United Press International editors had to decide whether to use a vivid picture by Kyoichi Sawada. The picture showed a dead Viet Cong soldier being dragged by an American armored vehicle to a burial site. UPI used the picture, says Ted Majeski, the wire service's picture editor. "We knew it would bring criticism. And it did." According to Majeski, liberals said the picture was

Photojournalism: The Professionals' Approach

typical of horrors American forces were inflicting upon the Vietnamese; the far right saw the photo as an effort by the biased news media to downgrade the role of the American soldier.

When the deadline looms near, whether the photo is apparently innocuous or loaded with emotional impact, the editor must decide which picture to run. Knowing that no picture is immune from interpretation by the reader, the editor, in the end, must still make an attempt at fair and balanced photo reporting.

CROPPING:
Cutting Out the Fat

SIZING:
When Bigger Is Better

CAPTIONS:
The Stepchild of the Business

WRITING CLEAR CAPTIONS

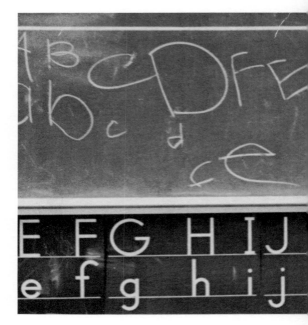

CROPPING AND SIZING FOR IMPACT—CAPTIONING FOR MEANING

*Previous page: Cropping
the picture down to this
long horizontal gained
additional reader interest
for the photo.*
*(Jim Clark, Springfield
[Oregon] News)*

CROPPING:
Cutting Out the Fat

Regardless of how good the original is, if a photo is butchered on the cropping table, or buried in a back corner of the paper, or reduced to the size of a postage stamp, no one will see the picture. Newspapers commit all of the above sins. Says Roy Paul Nelson, author of *Publication Design,* "The typical daily or weekly newspaper is not designed, really; its parts are merely fitted together to fill all the available space, sort of like a jigsaw puzzle." To try and save their photographs, more and more camera journalists are getting involved in layout. These photographers want to have a say in how their pictures are cropped and sized.

Perfect Framing Is Rare

When you take a picture, you must decide what to include in the viewfinder and what to leave out. The impact of a picture often depends on this decision. By including too much in a picture, you run the risk of distracting the viewer from the main subject. By framing too tightly, on the other hand, you might leave out important storytelling elements. Photographers carry a variety of lenses to enable them to zoom in or draw back to include only the important pictorial elements.

Every photo cannot be perfectly framed in the camera, however. For instance, the photographer sometimes puts the wrong lens on the camera. With a wide-angle rather than a telephoto lens, for example, the camera reporter is shooting an awards ceremony. Just then a little child walks on the stage to visit her father, who is the key speaker. Because the wide-angle lens takes in too much of the scene, unwanted elements intrude. The other guests on the platform don't add to the picture's action. These unneeded details distract the viewer's attention from the central focus of the picture. To save the shot, the photographer must enlarge the negative in the darkroom and crop the print with the adjustable

*The crop marks tell the
printer the new dimensions
of the picture. Always put
the marks on the border of
the print with grease
pencil, so the marks can be
rubbed out easily, and, if
necessary, changed.*
*(W. Peter Monsees, Bergen
[Hackensack, N.J.] Evening
Record)*

borders of the printing easel. The final glossy represents only a portion of the original negative.

If, however, the photographer did not crop the picture in the darkroom, then the layout editor provides a second line of defense. Looking at the 8 x 10 print, with all of its distractions, the layout editor can cut out the extraneous area of the photo by putting *crop marks* on the white border of the picture. These marginal marks indicate to the printer the area that should be left in the final reproduced halftone. The editor can cut out as much of the picture as he or she wants from the top, sides, or bottom of the print by merely drawing a short line with a grease pencil where the new border of the picture should be.

Even with tight framing in the camera to eliminate the distracting elements, every subject does not fit neatly into the 1 x 1½ format of the 35mm negative. For that matter, all subjects do not fit naturally into a 2¼ x 2¼ square or a 4 x 5 rectangle—some subjects are low and wide, as is a modern racing car whereas other subjects are tall and skinny, like the Washington Monument. Consequently, no matter how carefully you compose the picture in a 35mm viewfinder, the image from the real world may not completely fill the frame. In these situations, all you can do is shoot, and crop the negative in the darkroom, or crop the picture on the layout table later.

*Creative cropping
improved this picture.
(George Rizer, courtesy
Boston Globe)*

By cropping the photo, the layout editor kept the reader's attention on the relevant section of the picture.
(Frank Hoy, Washington Post)

Crop the Excess

Like a writer editing copy, the layout person should emphasize the significant elements in the picture by eliminating extraneous material that carries little meaning. If a person's expression gives the picture sparkle, zero in on the face and cut out the peripheral material. If the action occurs in one corner of the picture, focus in on that area. The layout editor should have a reason for leaving in each area of the picture. No corner of the picture should remain just because it happened to be in the original negative. The rule is: *Save the meat of the photo by cutting out the fat.*

"Crop ruthlessly," advised Edmond Arnold, head of the Graphic Arts Department of Syracuse University and one of the leading experts on newspaper design. "Cut out anything that's not essential to the picture, so that the reader's attention won't be distracted or wasted. Ruthless cropping leads to stronger images."

But Don't Cut Out the Mood

The editor's red grease pencil can save a picture or destroy it. Cropping can improve a picture by eliminating irritating details. But mindless cropping can ruin the intent of the picture by slicing off areas of the photo that give the image its mood and atmosphere. The sensitive editor preserves the ingredients that give the picture an arresting look, leaving in the brooding gray sky in the scenic picture, or including the messy bookshelves in the shot of the college professor.

Sometimes a blank area in the picture balances the action area. Leaving a little room on the print in front of a runner helps create the illusion that the

Cropping doesn't help all
pictures. Eliminating the
tall columns from this
picture leaves only a
routine shot of a woman
reading.
(George Rizer, courtesy
Boston Globe)

athlete is moving across the picture. Similarly, some blank space in front of a
profile portrait keeps the subject from looking as if he or she is peering off the
edge of the print.

The editor's most perceptive skills come into play when cropping a pic-
ture containing a person. The editor must be careful to operate, not amputate.
Parts of the body can be cropped off, but usually the crop-mark should not fall
on a joint like an elbow or knee. If the editor divides the head from the neck in a
photo, some of the shoulder might be left so that the head will have a platform to
sit on. The layout person can crop into the face of a person, but should not leave
half an eye or just part of a mouth. Look at the pictures on page 230 and decide
which crops seem natural and which crops seem arbitrary and absurd.

Which cropped photos seem natural? Which choices seem arbitrary and even absurd?
(Ken Kobre, University of Houston)

Photojournalism: The Professionals' Approach

There was once an insensitive layout artist who used to dream up designs before he even saw photos for the spread. When he received the glossies, he squeezed, sliced, and diced them into the preplanned shapes of his layout, regardless of the photo's content. If his design called for a thin vertical running down the right-hand side of the page, he did not care if he had to chop up a perfectly composed horizontal shot, leaving in only one eye and the tip of a nose, as long as the picture filled the predetermined space. The thoughtless layout editor cropped pictures for design purposes, not storytelling reasons.

Of course, sometimes a picture has to be cropped, even though this step does not enhance the photo's qualities. On a newspaper or magazine with rigid, predetermined columns, pictures must fit into fixed spaces. When an editor crops a picture for space rather than for compositional reasons, the photographer must hope that the operation does not destroy the meaning of the picture.

Reduced Quality: The Price of Cropping

A perceptive editor can improve the impact of a photo using thoughtful cropping, but sometimes only at a price. Enlarging only a very small portion of the original negative, or blowing up only a part of the final glossy, magnifies any defect in the original picture. If the original negative lacked perfect sharpness, then the final published picture will look soft and indistinct. Even if the original is sharp, enlarging only a portion of the negative expands each grain of the film, thereby decreasing the resolution of the photo. The more the image is enlarged, the more the grain is visible. Enlarged grain means the detail of the photo may be obscured to the point where the print takes on the texture of rough sandpaper.

Blowing up just the face of Mick Jagger means that the resulting halftone exhibited increased grain and decreased resolution. Rarely is such an extreme enlargement called for. (Ken Kobre, University of Houston)

The photographer faces a dilemma then. While the technical quality of the picture decreases when a photo is drastically cropped and enlarged, the visual impact of the photo is often improved. Cropping, therefore, involves a trade-off between poorer quality but better composition. Taking a 1-inch square segment of an 8 x 10 photo and publishing it as a half-page spread in the newspaper might produce a perfectly composed picture that is too blurry for the viewer to appreciate.

Few situations merit an extreme blow-up from such a tiny portion of a picture. Generally, however, a good photo editor will opt for a dramatic image at the expense of some sharpness and grain. The layout editor reasons that it is better to catch the reader's attention with an exciting photo than lose the reader with a technically sharp but dull image.

SIZING:
When Bigger Is Better

Sizing Up for Impact

A battle rages in many newsrooms everyday between the wordsmith—the reporter or feature writer—and the photographer. The outcome of the battle determines the size of the pictures in the next day's paper. The wordsmith, backed up by the copy and managing editors, fights for small pictures to leave room for type. Reinforced by the photo editor, the photographer demands that the pictures be printed large enough so that readers will not miss them.

The camera contingent argues that the larger the picture, the more powerful its impact. Ample evidence supports this claim. In his article entitled "Reader Interest in Newspaper Pictures," published in *Journalism Quarterly*, Bert Woodburn concluded that as the size of a photo increases, the number of readers grows at a similar rate. For instance, 42 percent of all the readers looked at a one-column picture, but the audience grew to 55 percent when the photo ran across two columns. A four-column-wide picture caught the attention of about 70 percent of the readers. Seith Spaulding in his paper for *Audio Visual Communication Review*, entitled "Research on Pictorial Illustration," verified Woodburn's findings.

The axiom, according to Edmund Arnold, champion of improved newspaper design, reads, "A picture should be run one column wider than you first think." Arnold claims that as a photo is enlarged, its impact on each reader increases geometrically. A 2 x 10 picture, for example, is more than twice as powerful as a 2 x 5 picture.

Size Helps Both the Head Shot and the Aerial

Armed with Woodburn's finding and Arnold's axioms, the photographer fights for larger photos, so that the audience can easily see the textural detail that the original glossy contained. A one-column head shot is so small that it communicates almost nothing, and the person is barely recognizable. With a four-column head shot, the reader can examine the two-day-old whiskers on the mayor's face, or the tear in a little girl's eye.

A long shot, such as an aerial, also demands newsprint space. Compressed into one column, all the details blend together, losing the bits of information such as houses, trees, and landmarks that give the picture meaning.

"Exquisite," remarks the reader who sees a larger-than-life, oversized photo. A common object, like a pencil or pen, or even a media-worn face, becomes fresh and exciting when magnified beyond its natural size.

If the editors played the photo small (above), all the detail would be lost in this picture of apartment-dwellers in Fort Lee, New Jersey, watching "Operation Sail." (See opposite picture for comparison.) (Eddie Adams, Wide World Photos)

If the photo is striking, the photographer should fight for space. Bad photos, of course, should not appear in the paper, but if they must be printed, play them small. Oversizing a technically poor photo calls attention to its deficiencies.

Printing some pictures small and others big heightens the contrast between them, adding to the interest of the page. Publishing all pictures in a 3 x 5 size produces a deadening effect: no individual photo predominates, therefore the readers think the editor could not decide which pictures were the most important. Just as the newswriter emphasizes certain points of an article by putting them in the lead, the layout editor spotlights certain pictures by playing them larger than the others.

The never-ending battle between the word and visual camps continues, but the photographer can gain newsprint space if he or she is willing to sacrifice a few weaker pictures so that stronger pictures can be printed larger.

The reporter also gains when a large picture accompanies a story. William Baxter, Rebecca Quarles, and Hermann Kosak in a study presented at the Association for Education in Journalism (AEJ) in 1978, found that while a small two-column-wide picture associated with a story does not help the reader remember the details of that story, a large picture, six-columns wide, does measurably improve readers' recall of details in the associated article. Big pictures, therefore, attract readers' attention, lure them into the accompanying article, and help them remember the facts of the story.

CAPTIONS:
The Stepchild of the Business

Some pictures—such as Norman Rockwell's cover illustrations for the *Saturday Evening Post*—need no words. The idea portrayed is so simple, or its emotional content is so powerful, that the illustration tells the story clearly and immediately without any captions.

But most photos do need words. The old Chinese proverb relates that a picture is worth a thousand words, but the corollary to the proverb is that a picture without words is not worth much. A picture raises as many questions as it answers. Look at the picture on page 235 and ask yourself if you know who is in the picture, what is happening, when and where it took place, and why the action occurred. Pictures usually answer these questions only partially. A picture that can stand completely alone is rare. The point is not whether photographs can survive without words or words without pictures, but whether pictures and words can perform better when they are combined.

Words Influence Picture Meaning

When Jean Kerrick was assistant professor of journalism at the University of California, Berkeley, she conducted research to determine the influence that captions had on readers' interpretations of pictures. Captions, Kerrick found, can at least modify and sometimes change the meaning of a picture, especially when the picture itself is ambiguous. A caption can change from one extreme to another the viewer's interpretation of the same picture.

Kerrick presented a profile shot of a well-dressed man sitting on a park bench to two groups of subjects and asked the groups to rate the picture on several subjective scales. The scales ranged from "good to bad," "happy to sad," "pleasant to unpleasant," and so forth. Then, the first group was shown the same picture with this caption: "A quiet minute alone is grabbed by Governor-elect Star. After a landslide victory there is much work to be done before taking office." The second group was shown the *same* picture with a *different* caption: "Exiled communist recently deported by the U.S. broods in the Tuileries Garden

alone in Paris on his way back to Yugoslavia.'' Both groups were again asked to rate the picture on the evaluative scales.

Kerrick found that after the first group read the positive caption, they rated the picture ''happier,'' ''better,'' and ''more pleasant'' than they had originally judged it. The second group of viewers, who read the caption about the exiled communist, changed their rating of the picture in the opposite direction—the photo now seemed ''sad'' and ''unpleasant.'' In this example the caption completely reversed the impression given by the picture.

Pictures serve as a primitive means of communication, but carry out their task instantly. Words function as a sophisticated means of communication, but lack the impact of the visual message. Pictures transmit the message immediately, but words shape and give focus to that message.

Pictures Draw Attention to Words

Pictures need words, but words also need pictures. A picture serves a story as an exclamation point does a sentence. Regardless of its content, the photo says to the audience ''READ THIS STORY—IT'S IMPORTANT!'' By adding a picture related to the news, an editor brings more significance to the story. Functioning as a banner headline, the picture flags down the readers' attention to a given spot on the newsprint page.

Practically every day on page one of many American newspapers the President's picture appears, accompanying a story about the U.S. budget, the Middle East negotiations, or some other equally weighty news event. The articles carry significant information on these important topics, yet the companion picture of the President looks remarkably similar from day to day. The chief executive's picture itself does not have much news value, but if the written story

Although a few pictures can stand alone, most of them benefit from having captions. From this photo, the reader can tell that cattle were shot, but the reader can't tell why. Midwest ranchers slaughtered their cattle, because the wholesale price of beef dropped so low that raising their herds became unprofitable. (Ernest W. Anheuser, Milwaukee Journal)

Published daily, pictures of President Jimmy Carter tend to look similar, but without these photos in the newspaper, fewer readers would notice the accompanying stories on politics or critical economic issues. (Ken Kobre, University of Houston)

were published without any halftone, most readers would tend to pass right over the article on their way to another news item that was associated with a photo.

A study by Bert Woodburn points up the advantages of pairing print with pictures. In analyzing the data from the Advertising Council's Continuing Readership study, Woodburn discovered that while only 10 percent of the audience read the average story, 33 percent looked at and remembered the average picture. *One-third more* of the public viewed the picture page than read *any* story on the front page. The conclusion from these data is that even the most important news profits by adding illustrations.

WRITING CLEAR CAPTIONS

The need for clear and concise caption-writing is obvious. Readers often determine whether they are going to read an entire article based on what they gleaned from a picture and caption. If you glance through some newspapers, however, you may get the impression that the first person to walk into the city room wrote the captions in the paper that day. Writers polish their story leads, and photographers polish their lenses, but no one shines up the captions. Writers claim that caption-writing is beneath them, while photographers always find an important blazing fire to cover when the time comes to compose captions. The caption—the stepchild of the newspaper business—is the most read but least carefully written text in the paper.

Poor captions sometimes result when photographers fail to get adequate information at the time they take the pictures or forget to include the information when they write the captions. John Dominis tells the story of holding up the production of *People* magazine because a photographer did not send in one needed identification. Lights in the New York headquarters burned past midnight as the editors carried out a desperate search by telephone for the forgetful photographer. Not only editors, but writers, layout artists, designers, and production staff waited hour after hour for the missing caption, costing *People* magazine thousands of dollars in overtime.

Types of Captions

"A caption is a verbal finger pointing at the picture," wrote John Whiting in his book, *Photography Is a Language.* Captions, like fingers, come in many sizes and shapes. Here are explanations and examples of some standard types of captions:

Label Caption

The label caption merely identifies in the picture the person along with his or her title. Periodicals reserve the label caption usually for simple single person shots.

Label Caption: *Father Robert Drinan, member of Congress from Massachusetts.*

Limited Caption

Running no longer than the width of the printed picture, the limited caption serves as a teaser, giving only enough information to lure readers into the story. *Time* magazine often writes this type of caption.

Limited Caption: *Untangling America.* (See photo p. 237.)

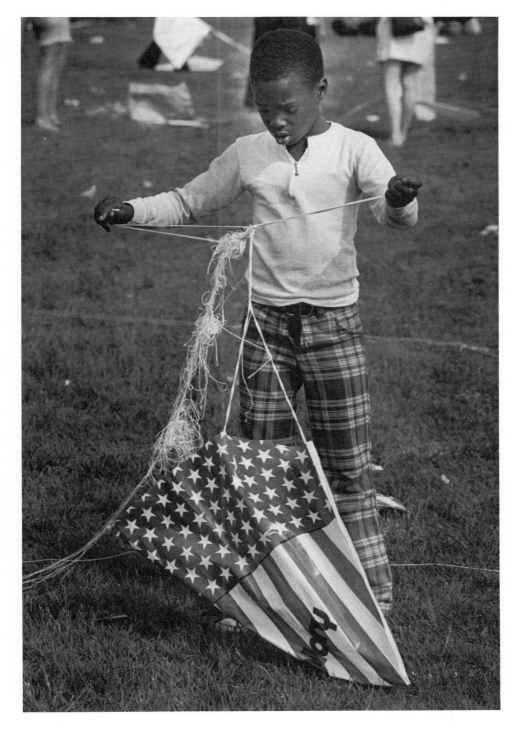

Untangling America.
(Ken Kobre, University of Houston)

Though brief, the traditional caption still presents a satisfyingly complete story. This form of caption answers the basic questions the picture might raise. Readers would not have to read the accompanying story to understand what the photo shows.

Traditional Caption

Traditional Caption: *The Italian liner* Andrea Doria, *her screws showing, sank 45 miles south of Nantucket Island today, after she collided with the Swedish liner* Stockholm *late last night in a thick fog. (See photo p. 238.)*

The Italian liner Andrea Doria, her screws showing, sank 45 miles south of Nantucket Island today, after she collided with the Swedish liner Stockholm late last night in a thick fog. (Harry Trask, Boston Traveler, distributed by Wide World Photos)

Deep Caption

When the picture tells a story but does not require a long accompanying text, a deep caption suits the situation. The deep caption can go beyond the five W's (who, what, where, when, and why) to include descriptive detail and even quotes.

> Deep Caption: *Losing its footing on the slippery course, Limerick, ridden by Lisa Mangione from Hutchison Paris, Kentucky, did not make one of the demanding jumps at the Ledyard Farm Horse Trials yesterday. The ground was soaked from three days of continuous rain. After help from the jump crew, Mangione's horse was freed and the horse and rider finished the course. A passerby commented, "The horse seemed to keep its regal bearing even in this awkward position." (See photo p. 239.)*

Putting the Five W's in a Caption

The opening words of a caption must capture the reader's attention just as do the lead words of a news story or feature. The caption writer starts off the sentence with the most newsworthy, interesting, or unusual facts. Copy desks have developed several varieties of captions, each emphasizing a different element of the story.

The "What"

The reader wants an explanation of what is happening in the picture; hence, the first words of the cutline should explain the action. Unless the situation in the picture is obvious, the cutline must describe what is going on.

> Example: *At a fashion show, staged by the husbands and boyfriends of the National Organization for Women members, an all female audience chants "We want more."(See photo p. 240.)*

The vital element in this picture is not when or where it happened, but the fact

that the show happened at all. The readers want to know quickly what the people in the picture are doing. Why does the man have his pants down? Why are the women yelling? Further down in the cutline the writer can "flesh out" the other details of the story by giving the remaining five W's.

The *who* may be emphasized in the caption when the person in the news is featured.

> Example: *President Carter said yesterday that the budget will be slashed.*

In this situation, the newsworthy aspect of the picture was the person, Jimmy Carter. The fact that the President was speaking outweighed even what he said about the budget and other details, such as that the speech was given at a news conference in the Rose Garden.

A person's name should lead the caption only when that person is well-known to the readers of the magazine or newspaper. Do not start the caption, "John Doe said yesterday that the budget should be slashed." No one knows John Doe, so placing his name prominently in the cutline neither adds to the interest of the picture nor explains the news value of it. However, if John Doe's face is recognizable in the photo, he should be mentioned somewhere in the caption. A person's name is usually included in the caption even if he is not famous, because someone—spouse, parents, friends—certainly will recognize him or her.

> Example: *To teach deaf children how to read lips, Lucille Turner used flash cards.* (See photo p. 241.)

Also, readers can misidentify the person in the photo if the name is left out of

Limerick, ridden by Lisa Mangione, lost footing on the slippery course. (Debra Kerkorian)

The "Who"

Cropping and Sizing For Impact — Captioning For Meaning

the caption. Often you may hear, "That woman in the upper left of the picture in the paper today looks just like"

Many editors will not run a picture unless the photographer has included in the caption the names of all the recognizable people in the picture. The wire services, which send their pictures around the world, write in the person's first and last name, regardless of the individual's national prominence.

If a child is pictured, the news photographer should get the name and the age of the youngster. This information often adds additional human interest to the picture.

> Example: *The collie pup would have drowned if the Selleck girls (left to right) Debbie, age 3, Heidi, age 5, and Becky, age 7, had not pulled their dog Sam from the stream in time.*

Note that readers are given clear directions about which girl is which with the phrase "left to right." Sometimes the words "top row," "wearing the tie," or other identifying feature will help readers match the faces in the photo with the names in the cutlines.

The "When" and "Where"

Photos rarely tell the reader exactly *when* or *where* the pictures were taken. If this information helps the reader understand the picture, supply the location and the time of the news event. Use the day of the week, not the calendar date.

> Example: *Carl Yastrzemski hit the home run yesterday that gave the Red Sox their win over the Yankees. (Not "Carl Yastrzemski hit the home run July 6.")*

To teach deaf children how to read lips, Lucille Turner used flash cards.
(Darrell Davidson, *Houston Chronicle*)

Example: *A representative of the National Fisheries measures the heads of giant tuna on the docks of Gloucester, Massachusetts. The bodies of the super-fish are flown to Japan where the bellies are removed and eaten raw as a delicacy. (See photo p. 242.)*

The writer should begin the cutline with time or place only when that fact is significant or unusual.

Example: *At 3 A.M., the mayor, Ted Stanton, finally signed the zoning bill.*

Example: *Standing in the sewer, the water commissioner, Steven Gangelhoff, explained the new drainage system.*

The "Why"

Some caption writers claim that explaining *why* the action occurred in a picture takes away the reason for reading the story, thus causing readers to skip to the adjoining article. Other news photographers and editors argue that extensive captions pique reader interest for the main body of the story. I think telling readers why the action occurred will not spoil their desire to read the main article.

Example: *Because of the transit strike, highways leading into the city were jammed at the early morning rush hour today.*

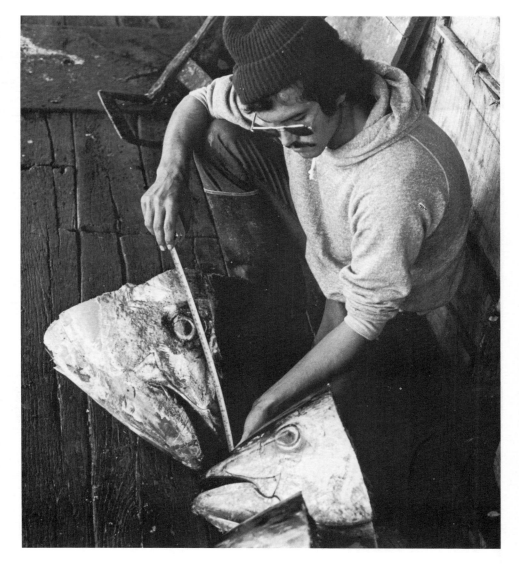

Opposite page: This Ritz Hotel waiter was fired from his job, and in exclusive interview he told what it's really like to work for the prestigious hotel. The photo is a montage made from several individual pictures.
(Ken Kobre, University of Houston)

A representative of the National Fisheries measures the heads of giant tuna on the docks of Gloucester, Massachusetts. The bodies of the super-fish are flown to Japan where the bellies are removed and eaten raw as a delicacy.
(Ken Kobre, University of Houston)

Filling Out the Detail

Posed or Manipulated

The caption is the place to tell readers if the subject in the picture was posed. If the photographer took the picture with a special lens, or manipulated the print in the darkroom, this fact should be noted. In fact, anything about the scene in the picture that differs significantly from the actual event and, therefore, might distort the facts should be explained in the caption.

> Example: *This Ritz Hotel waiter was fired from his job, and in an exclusive interview he told what it's really like to work for the prestigious hotel. The photo is a montage made from several individual pictures.* (See photo p. 243.)

Subtlety and Emphasis

Casually glancing at a photo, readers might miss an important but small detail. The cutlines can focus attention on various parts of the picture, emphasizing the elements the photographer thinks are important.

> Example: *Waving his hand to rescuers, this man was almost lost following a chemical plant explosion.* (See photo p. 244.)

242
Photojournalism: The Professionals' Approach

THE RITZ-CARLTON

Confessions of a Waiter

Waving his hand to rescuers, this man was almost lost following a chemical plant explosion. (J. Walter Green, Wide World Photos)

Feel, Taste, Smell, Hear

Trying to climb a slippery, greasy pole can scare the most adventurous souls. (Jim McNay, Houston Post)

The cutlines can supply details about the four senses—hearing, tasting, smelling, feeling—that the picture does not convey.

Sometimes this purpose can be accomplished by telling what the subject said with a catchy quote.

Example: *"Some days I feel more like a plumber than a surgeon," said Dr. Steven Pettibone, noted heart specialist.*

How something tastes might explain a subject's reaction in a picture. Without an explanatory phrase in the caption, the picture might not make sense.

Example: *The sour taste of the pickle caused Ellen deSchweinitz's mouth to pucker as she attempted to break the Guinness Book pickle-eating record.*

Smells are hard to describe, but the caption writer might add this detail if it helps to set a mood for the pictured scene.

Example: *The smells of the fresh-baked bread came blasting out as the baker opened the heavy, metal, black doors of the oven.*

The caption writer can also use words describing how something feels to bring to readers an additional perceptual level of the picture.

Example: *Trying to climb a slippery, greasy pole can scare the most adventurous souls. (See photo at left.)*

Even though black-and-white photos record the world in almost infinite detail, one visual element is left out: color. When color is an important aspect of the scene, the cutline must supply this missing dimension.

Example: *The Franklin High Majorettes, dressed in bright pink outfits and pink tennis shoes, marched and twirled in front of the county court house yesterday.*

A camera shutter, open 1/500 sec., results in a photo that accurately describes what happens in that brief span of time. But the photo does not inform the readers about what happened before or after that split second; the cause of the event and its effect are absent. Cutlines must supply the befores and the afters.

Example: *During a disturbance last night at the South Gate Mall, Dean LeCoe was struck by a policeman. Later, at St. Mary's Hospital, he was described as being in satisfactory condition by the hospital spokesperson.*

Caption Writing Styles

Write short, declarative sentences with as few words as possible. Avoid complex sentences. Do not put unrelated facts in the same sentence. Keep facts separated with periods, not commas or other punctuation.

Two schools of thought differ on the question of the tense of verbs in captions. The first group advises putting everything in the cutline in the present tense, because the words in the caption are describing a photo immediately in front of the reader. The present tense also involves the reader more than does the past tense.

Example: *John Brown* tags *the runner to make the last out in yesterday's game.*

The opposing view advocates using the past tense, because all the action in the picture has already taken place.

Example: *John Brown* tagged *the runner to make the last out in yesterday's game.*

Each paper or magazine has its own caption style and the photographer should follow the format of the publication.

Phrases like ''firefighter fighting blaze'' or ''basketball player going for hoop'' are unnecessary, because readers can see that, in the first picture, the people are firefighters, and in the second photo, the athlete is a basketball player. Phrases like ''pictured above'' also add no new information. Basically captions should avoid telling readers what they can find out for themselves by looking at the picture.

Final Advice

Caption writers—both neophytes and old hands—must always remember to start with the picture. If the writer looks at the picture, at least he or she will avoid the mistake that one caption-writer made. The caption read, ''Police seized a quantity of opium.'' But in the picture, there were no police and there was no opium.

The head copyeditor and caption-writer of *Life* magazine, Joseph Kastner, said that the discipline of caption writing is of an order that no other kind of journalism requires. ''And when this discipline is exerted it produces writing that is as taut, as spare, as evocative, and as cogent as any writing in journalism today.''

11
PLANNING
THE PICTURE PAGE

Realer
Than Real:
The Mannequin
Factory

Photos by Ken Glass
and Carol Dobson

Previous page: Photo by
Ken Glass.

The unworldly nature of the
mannequin factory gave this
set of photos a consistent
theme. To further carry out
the surreal theme the lead
picture (see previous page),
originally a color slide, was
printed onto black-and-
white photographic paper.
This photo needs no cap-
tion.

(Ken Glass)

(Ken Glass)

(Carol Dobson)

(Ken Glass)

(Left, Ken Glass)

DIFFERENT APPROACHES FOR THE SAME ASSIGNMENT

Suppose a newspaper or magazine editor assigned you to photograph a town's major industry, the Walk Right Shoe factory. You can approach the story in several different ways.

Single Photo Stands Alone

You could call the company's president to ask what events that will have *news* value are expected to take place at the factory. Perhaps the one-millionth pair of shoes is scheduled to come off the assembly line that day. You could take a picture of this historic moment with all the planned festivities. Upon visiting the plant, you are surprised by the number of employees required to manufacture one shoe. You decide to set up a picture that *summarizes* this point. You assemble all the employees on the lawn of the factory. In front of the group you place the president of the company, holding a sample of the latest footwear in the Walk Right Shoe line.

While touring the plant during the lunch-break, you notice a man and a woman sitting, holding hands, behind a huge pressing machine. This unexpected romantic scene, incongruous in a shoe factory, strikes you as having excellent *feature* photo possibilities. You shoot the picture of the two employees.

Now that you've taken a news picture, a summary picture, and a feature picture, you feel confident that you can select from these a photo that can stand alone, without requiring other photos to carry the message. With some explanatory caption material, the single picture tells a complete story.

For Comparisons You Might Need Two Pictures

Walking through the factory and observing the many employees and the various machines, you realize how modern the shoe-making business has become. You shoot a few pictures of the sophisticated, high-speed machinery, but discover that the viewers of the photos will see only the gears, wheels, and pulleys. To visualize the advanced state of shoe manufacturing, you need to compare the differences in constructing a shoe by hand—the old-fashioned way—and manufacturing a shoe with high-speed machines—the modern way. Because you can't make the comparison in one photo, you need two. In the first photo you show an old-time cobbler in his shop, using a sharp knife, hand-cutting the cowhide, a process that requires 10 minutes per shoe. Then in the comparison photo, you picture one worker on the Walk Right assembly line, using a pre-shaped die to cut the material for 10 shoes at once. Laid out side by side on the printed page, the set of pictures will demonstrate the technological change in the shoe industry.

Sequence Implies an Order

Watching the Walk Right Shoe worker cutting the leather, you become intrigued with the methods for constructing a shoe. You decide to photograph a "how-to" sequence of pictures by tracking one shoe as it progresses down the assembly line. You shoot a picture as the cutting machine stamps the shoe shapes out of the leather. You photograph the stitching machine as it sews the uppers. Then, as the molding machine forms the arches, you click your camera shutter. Now you follow the shoe down the line as the workers fasten on the sole and heel. Finally, you record the polishing, pairing, and boxing operations. In the actual layout, you might not use pictures from every station on the assembly line; you might want to show only the key steps in the process. But at the time of shooting,

you should record the whole operation, showing as much detail as you can. Just as the shoes proceeded down the assembly line in a fixed order, the pictures should be presented on the printed page in that same order. This how-to picture sequence is time-locked. The orderly time progression of shoe-making, from the original cutting of the leather to the final sewing, should be reflected in the final page layout.

Illustrating Points of an Article

Impressed by your how-to sequence, your editor may ask you to return to the Walk Right Shoe factory, this time with a reporter working on a story about the shoe industry. After interviewing the plant manager and the workers, the reporter decides to feature in her article two points: the dynamic young president and the fact that the factory emits few pollutants.

The reporter asks you to illustrate these points for her article. You photograph the 35-year-old president with the plant foreman looking over a blueprint. You shoot the modern glass and steel building standing against a clean, clear sky. On the printed page, your pictures appear near the paragraphs in the story telling about the two key points the reporter wants to make. The pictures, however, have no relationship to one another. No matter how much eye-stopping power each picture has, their purpose is to illustrate a written point rather than carry their own message.

A Photo Story Needs a Theme

For a more complete visual look at this important town industry, you might spend a whole day at the factory, snapping pictures of the president at his desk and photographing a worker on the assembly line. You shoot an overall of the building and a close-up of a new shoe. Your final group of pictures describes the operation of the plant better than the two illustration pictures accompanying the reporter's story. However, your four pictures still have no theme to hold them together. A viewer would perceive the pictures as four independent elements, rather than one story-telling unit.

While you were in the factory you kept noticing that even though the factory was modern, clean, and sterile, some employees added a few of their own individual touches. One employee brought in a padded easy chair with arm rests and sat down comfortably while she operated her folding machine. Another employee had lovingly painted "Old Clunker" on the base plate of her stitching machine. A casual investigation of the factory and the offices of Walk Right revealed other personal touches that stood out against the efficient look of the shoe manufacturing hardware and the ultra-modern building. You decide to take a series of photographs showing these individual variations. Rather than having random shots of (1) the factory, (2) the employees, and (3) the shoes, your group of pictures holds together now because the series has a unified theme. In taking the photos, you can demonstrate how the Walk Right Shoe factory employees adapt their mechanized environment to their human needs.

Organize a Picture Story Around a Day-in-the-Life

While shooting this picture group, you keep observing the woman employee operating "Old Clunker." She seems to have a photographic quality that sets her apart. You ask her if you could do a picture story about her. She gives her permission. Because Walk Right Shoe is the major employer in the town, and therefore interests a large number of the paper's readers, your editor approves more release time for the project.

The woman's name, you learn, is Sally Cane. Divorced and supporting one child Ms. Cane has worked at the Walk Right Shoe plant for five years. Impressed by her leadership and enthusiasm, her fellow-workers elected her shop

steward, representing the plant union. To make the story come alive, you just about glue yourself to Ms. Cane. You follow her through each hour of her day. She gets used to you and your camera. She begins to relax, and you get even better, more natural photos.

Your final pictures, organized like a story, open with a shot of Sally Cane, wearing her Walk Right overalls, tossing her hair back and laughing as she operates her two-ton stitching machine. She sews four shoes at a time. This opening shot introduces the reader to the main character of your picture story, catches the employee's personality, and tells about her job. This opener, you believe, will lure the reader into the story, so that the reader will look at the other photos.

The photo of Ms. Cane at the stitching machine was not the first frame on your roll. Actually, you took this particular photo somewhere in the middle of the shooting session. In a picture story, the layout is not necessarily time-locked; therefore, any picture can lead the sequence if the photo meets the necessary qualification for an opener—an "eye catcher" with a message.

The second picture in the layout shows Ms. Cane hurriedly delivering her 4-year-old son to the day-care center. Although the picture might not be exceptional graphically, the layout needs the photo to make the points about Ms. Cane's outside pressures and responsibilities. Another point pictured in the essay shows Ms. Cane as the union steward, meeting with the company foreman to discuss problems of employees in the plant. In the final layout, these point pictures are played smaller than the key photos; however, these explanatory shots cement the story, broadening its depth and meaning.

The essay peaks with a photo showing all the employees on the floor stopping their work to watch Ms. Cane and her boss argue over a policy dispute. With the final picture, the story resolves itself. The photo shows Ms. Cane, her boss, and a few fellow workers, after the factory whistle blows, going out for a drink at the neighborhood bar.

As in a written short story, this photo story has a narrative or plot line. With a lead picture, this day-in-the-life of a Walk Right shoe stitcher introduces the reader to the main character, explaining some of the action with point pictures. The photos bring the story to a head with a climax picture, and then resolves the story with an end picture. The reader thus sees the story of the factory through one person's eyes—Ms. Cane's. Becoming interested in this worker, the reader wants to know what happens to her. Ms. Cane's ordinary life catches the reader's attention, because the photograph isolates one worker from the crowd, showing her joys and frustrations, her conflicts and successes—moments with which the reader can empathize.

Single pictures, comparison pictures, sequence pictures, illustration pictures, along with picture groups organized into a theme or a story, represent a few of the ways a photographer might handle the Walk Right Shoe assignment. (See photo essays in this chapter for examples of these different ways of linking pictures together.) For an extended photo essay about the factory, a photographer might combine several of the approaches.

Life Formula for the Photo Essay

For a typical assignment at *Life* magazine, the editors expected the photographer on location to shoot at least eight basic types of photos to ensure complete coverage of the situation and to guarantee enough good pictures for a layout.

1. Introductory or overall: Usually a wide angle or aerial shot that establishes the scene
2. Medium: Focuses in on one activity or one group
3. Close-up: Zeroes in on one element, like a person's hands or an intricate detail of a building
4. Portrait: Usually either a dramatic, tight head shot or a person in his or her environmental setting

5. Interaction: People conversing or in action
6. Signature: Summarizes the situation getting all the key story-telling elements in one photo—often called the decisive moment
7. Sequence: A how-to, before and after, or a series with a beginning, middle, and end (the sequence gives the essay a sense of action)
8. Clincher: A closer that would end the story

Life photographers who took all eight types of photos for a story had a high probability of bringing back to the office a printable set of pictures. This picture set provided the designer with many layout options. When the *Life* photographers had run through the list of picture possibilities, the photojournalists could feel confident they had covered the story completely and in depth. Then the photographers were free to look for unusual or unexpected situations that would set their essay apart from the standard photo story. *Life* editors didn't use all the photos from an assignment. But they knew that whether the photographers were shooting in Hollywood or Haifa, they would bring back a viable array of pictures that could be formed into a *Life* essay. (See W. Eugene Smith's "Midwife" essay, pp. 290–301.)

Not many newspaper photographers would have the time to shoot the entire list of combinations described above. Most photojournalists would evaluate the time they can spend on the assignment against other stories they have to cover. Photographers working for dailies often have to shoot more than five assignments a day. Magazine photographers usually can take more time on a story than their newspaper counterparts can. An article for *National Geographic* magazine might take several months to complete. But even the photographers employed by the national glossy magazines must limit the time they spend on an assignment. Only on major stories of vital interest will some progressive newspapers, such as the *Miami News,* and a few large magazines, such as the *National Geographic,* release a photographer for long time periods to produce in-depth picture coverage.

DEVELOPING IDEAS FOR PICTURE STORIES

Staff photographers or free-lancers cannot depend on editor-originated assignments. Photojournalists must generate their own story ideas. Most photographers have good ideas, but sometimes find it difficult to formulate ideas into concrete picture story subjects.

Brainstorming Produces Concepts

Alex Osborn, a partner in Batten, Barton, Durstine & Osborn (BBD&O), a large New York advertising firm, formulated one method for bringing workable, productive ideas to the surface. He called his method *brainstorming.* Essentially, he recommends getting a group of people in a small room, where everyone can voice his/her ideas, no matter how foolish-sounding the suggestions. Each suggestion stimulates and generates the birth of another suggestion. A brainstorming session can produce more than a thousand ideas, Osborn claims.

Brainstorming works even if you just talk over your ideas with another person. In his book, *Halsman On the Creation of Photographic Ideas,* Philippe Halsman, who produced more than one hundred *Life* covers, explains why he uses the brainstorming technique. "You are not alone, you face someone who serves you as a sounding board, who prods you and who expects you to answer . . . Your system is stimulated by the challenge of the discussion. There is more adrenalin in your blood, more blood flows through your brain and, like an engine that gets more gas, your brain becomes more productive."

A student in the class for the partially deaf learns to hand sign his name while also listening to his teacher with his over-sized hearing aid called a "phonic ear."

With Aid the Deaf Learn to Talk

Photos by Sandy Goldsmith, *Haverhill* (Massachusetts) *Gazette*

Billy Brissenden learned to talk by holding one hand against his vocal cords, and the other hand against his teacher's throat.

The pictures in this story are threaded together both by the repeating identity element of the hearing aid worn by the partially deaf students and by the consistent upbeat mood of the children.

The handicapped children spent part of their day with Ms. Holstein and part of their day in a normal class, integrated with other students.

Billy Brissenden writes a word using the overhead projector.

Talking with other people, even when you are not brainstorming, alerts you to good picture-story ideas. Someone's description of an 80-year-old man who plows the field every day, or a tip about a women's motorcycle gang called the "Fantastic Foxes," might provide the catalyst for a story. Perhaps a book or movie that is a hot topic of discussion will stimulate your interest to investigate the subject with your camera. The conversation might turn to a national trend like improved care of the elderly. This trend story can be localized for your area with a picture sequence about the old-age home in your town.

Study the Classics

Current and back issues of *Life* and *Look* magazines, which you can find at the local library, provide excellent sources of ideas for picture sequences. Using the magazines' stories as formats, you can update the articles, focusing on your own locality as the setting. *Life*, for instance, did a story about Victor Sabatino, head of a chain of foam-rubber stores, which he started on a shoestring bank account. The pictures showed Sabatino's all-consuming desire for success. Shot by Grey Villet, the story, called the "Lash of Success," appeared in the November 16, 1962, issue of *Life*. Perhaps there is a similar individual in your town. Another story, photographed by Eliot Elisofon, called "Fight Trainer," was published in *Life* on February 12, 1951. In the pictures, the essay described the life of Charlie Goldman, who trained boxers at New York's Stillman Gym. For a local twist the story could have been about your town's high school football coach or swimming coach. You don't have to imitate the old stories. Rather, you can use those articles as inspiration, adapting them to new situations.

Many photo essayists who worked for *Life* and other magazines merit the attention of the beginning photojournalist. *Great Photographic Essays from Life* by Maitland Edey has brought together an impressive array of photo stories from the back issues of that magazine, including works by John Loengard, W. Eugene Smith, Leonard McCombe, Cornell Capa, and others.

Another photographer worth studying is Paul Fusco. His essay, "Beyond Survival: A Chance to Begin the Highest Human Adventure," published in the January 13, 1970, issue of *Look*, captures the sense of excitement that children exhibit when they explore the wilderness. Rather than covering all topics, some essayists specialize in one subject. Lennart Nilsson, for instance, photographed the drama of life before birth. He worked for many years on a series of photos showing the development of the embryo inside the womb (*Life*, April 30, 1965). Since 1961, Dean Conger, photographing for the *National Geographic*, has taken twenty-six trips to Russia, producing several articles and a book, *Journey Across Russia: The Soviet Union Today*.

Other photographers have also produced important book-length photo stories. Jill Krementz has photographed and written several books in which she has followed the life of a young girl learning to ride a show horse, dance ballet, or do gymnastics. Mary Ellen Mark, a free-lancer, photographed *Ward 81*, about a mental hospital for women. In their book *Gramps*, Mark and Dan Jury traced over a two-year period their grandfather's decline into senility and finally his death. This brief list represents only a few of the many outstanding photo essays.

Perhaps you might follow the example of Eliot Elisofon, who wanted to become a *Life* photographer. Recounted in Maitland Edey's book, the story goes that Elisofon locked himself in a room for two weeks with every issue of the magazine he could get his hands on. He analyzed the photo essays not only for technique but for the thinking that had made them succeed. He then photographed some essays. *Life* liked his pictures so much that they hired him.

Find a Newspeg

Whether you are an employee or a free-lancer of a newspaper or magazine, an editor is more likely to use your picture sequence if it has a *newspeg*. A newspeg

tells the reader why the story is being seen now instead of six months ago. If you can tie your picture story into a front-page news item, then your story will take on a more immediate and timely quality.

Suppose your story revolves around the life of a family doctor. You might peg your picture sequence on a recent study showing that the number of general practitioners is decreasing in the nation. Or suppose your story concerns the town emergency accident squad. If an emergency squad member died last month while trying to save a child's life, your timeless story about the unit's general operations can be pegged to this recent news event.

Magazines commission and buy many picture stories that the editors hold until a related news event breaks. The news sections of the daily newspaper, therefore, provide excellent sources for story ideas, because the news leads are timely.

Identifying a Trend Story

Surprisingly enough, the *Wall Street Journal* is an excellent source for picture story ideas. Although the national business newspaper does not print any half-tones itself—for technical reasons—the *Journal* does report on interesting trends in the business world: trends that the photographer can translate into highly visual photo stories.

Whereas a news story has a specific time peg, a trend story identifies a gradual but demonstrably real change in the public's buying preferences, life styles, or a technological shift in an industry. For example, a news story might read, "The First National Bank went bankrupt yesterday." By comparison a trend story might say, "The number of two-income families increased dramatically during the past ten years." A trend doesn't start one day; it happens gradually over time.

Often the *Wall Street Journal* is the first to spot a trend in the buying habits of the American public. Not only are the *Journal* stories first to pinpoint a new trend, the stories are usually well-researched. For major trend stories, which appear on the left, middle, and right-hand columns of the front page, staff members of the *Journal* spend over a month researching and gathering data before they begin to write.

After reading the *Wall Street Journal*'s story, the photographer should find visual verification of the trend. The camera reporter must transform the economic charts and abstract statistics from the *Journal*'s article into photographable subjects that will result in eye-catching pictures.

When disco became the new dance craze, for instance, the *Wall Street Journal* noted the shift in the record industry profits. When small cars began replacing larger ones, the *Journal* pointed out the trend in the sales figures of the car manufacturers. Each of these articles could have lent itself to a photo story.

On the disco story, for example, the photographer could have produced a photo essay comparing how people danced to old rock-and-roll music versus how they are gyrating to the new disco sound. A few pictures of couples dancing do not constitute a trend story, but when the reader knows that millions across the country are moving to this new beat and this trend represents a multi-million dollar shift in the music business, the photo story takes on added impact.

A Case Study—The Double Life of the Hare Krishna

I began my picture essay on the International Society for Krishna Consciousness when my paper, the *Boston Phoenix*, assigned me to cover a story about a Krishna member kidnapped by his own parents. The parents claimed that the International Society brainwashed their son, Ed Shapiro. The parents abducted their son, so that they could deprogram him. Ed escaped, returned to the temple and then sued his parents.

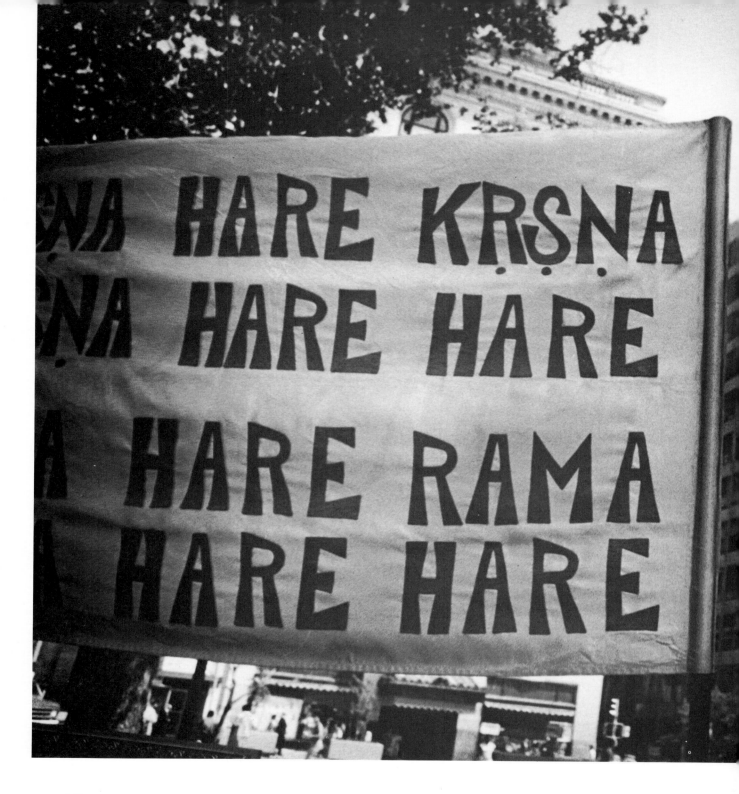

The Double Life of
The Hare Krishna

Gandolf, a member of the International Society for Krishna Consciousness, chants in the Boston Common. He, like all members of the religion, repeats the words "Hare Krishna, Hare Rama" over 20,000 times a day. Gandolf was an advertising executive in New York before joining the movement.

Photos by Ken Kobre

When they are dressed in their robes, members of the International Society for Krishna Consciousness movement are usually unmistakable. They wear saffron garments called **dotis** and the men shave their heads.

However, when the Krishnas shift into their double life by putting on wigs, suits, ties, and button-down shirts on their way to the city's airports, they look like normal passengers. But their mission is not to travel; rather, they go to the airport to collect money. From selling religious magazines and books and soliciting donations, they have accumulated, nationwide, over $7 million a year.

Few passengers in the airline terminals realize that the young men and women in hip clothes are actually the same Krishnas who wear the shaved heads and saffron robes. But many travelers are bothered by the intense solicitation methods of these religious devotees. In fact, Senator Robert Morgan of North Carolina introduced legislation in Congress to limit such fundraising in public places such as airport terminals.

When members join the Krishnas, they renounce their worldly possessions and usually turn over all of their money to the temple. All members of the group swear to eat no meat, fish, or eggs; they also agree to drink no liquor. Their code also prohibits gambling or sex, which is allowed only in marriage and then just for procreation. Many members join the Krishna temple for a period of time but leave because of the monk-like existence.

The Krishna devotees are intensely spiritual, and have a missionary's zeal for converting the world to their beliefs. Leaders of the Krishna movement believe that raising money for this missionary work requires their members to live the double life of ascetic monk and aggressive fund raiser.

Members of the Krishna movement rise before 4:00 A.M. to begin praying. They feel that for prayer, certain hours are better than others. Their temple and living quarters are both located in this brownstone house.

Left: Each Krishna puts in about two hours of individual chanting, called Japa, every day. Some members pace around the temple room as they repeat the "Hare Krishna." They count the number of chants on beads carried in a small sack.

Below: During the daily, four-hour morning prayer members worship their Guru, the founder of the movement, His Divine Grace A.C. Bhaktivedanta Swami. His picture rests on the seat reserved for him.

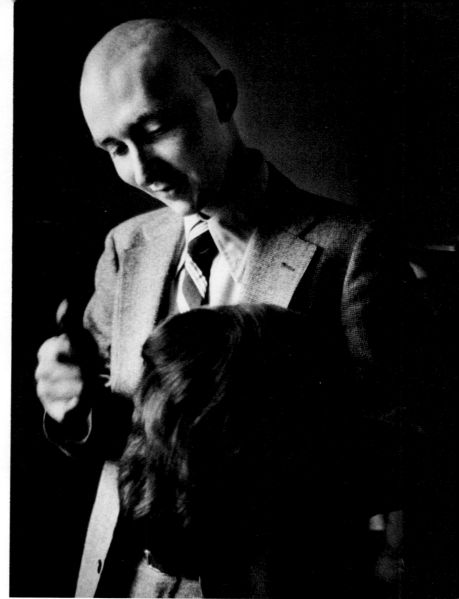

Above: A Krishna member, wearing street clothes and a wig, solicits money at Logan Airport.

Right: A Krishna member combs his wig.

Below: Although they cleanly shave most of their heads, the Krishnas leave a pigtail, called a sikha, to distinguish themselves from Buddhists.

On Sunday evening, the temple opens to guests who come to observe the ceremony and take prusada, a vegetarian feast. The members of the temple try to convert the newcomers to Krishna consciousness through intense discussions about the faith.

Right: Judy Schimmel waves to her son, Govinda das.

Below left: Katherin Mathews is one of only six women in the Boston temple.

Below right: Richard, her husband, holds their son Kancabla. The religion dictates that married men and women can have sex only once a month. Single men and women must remain celibate.

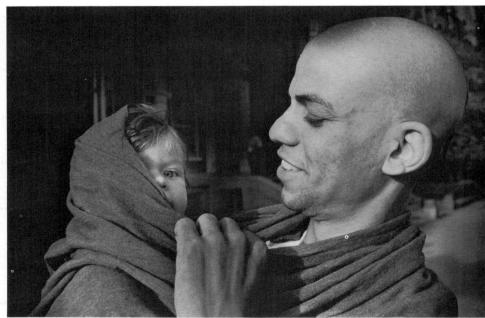

A Krishna member holds the Ghee lamp during the evening worship. During religious services and meals, men and women are usually separated so that the devotees will not be distracted from prayer. The structured life of the Krishnas, beginning at 4 A.M. each morning and ending at 10 P.M. each evening, attracts members but few can handle the discipline. The woman dancing on the right remained with the movement for only two months.

At the time, I photographed Ed Shapiro and took some pictures around the temple for a cover story about the kidnapping. Ed Shapiro's situation got more involved as the kidnapping incident became a test case for determining if the Krishnas were a legitimate religion. The court ruled that the International Society for Krishna Consciousness was a bona fide religious organization.

After my initial exposure to the Hare Krishna movement I got interested in exploring why young people in the 1970s would subject themselves to the strict requirements of the sect. I wanted to broaden the story from the original news event. I contacted the assistant president of the temple about the possibility of doing a picture article on the group. I promised to show the religious official my contact sheets so that he could voice any objections he might have to my pictures, but I reserved the right to make the final decisions about what photographs would run in the article. He agreed because the Krishnas need publicity to attract new members since the turnover rate of followers is so high. Few individuals can withstand the rigorous, highly structured life of a sect member.

I had a vague idea that this transplanted Eastern religious group would provide material for an interesting picture essay, but I didn't have a focus for the project yet. As I worked on the story over several weeks, I discovered that many members of the International Society led double lives. They began each day at 4 A.M. as shaved-headed, saffron-robed religious devotees, chanting and praying. Then at about 9 A.M. several of the bald-headed monks disappeared to their rooms, emerging a few minutes later wearing modishly tailored sports jackets, white collared shirts, Ivy League ties and, most surprising of all, full heads of hair—from wigs.

The Krishnas, in jackets, ties, and hair, got into the temple's trucks for the drive to the city's main airport or a suburban shopping center. At these busy public places the Krishnas hawked their religious books, magazines, and even gave out flowers in exchange for donations. Sometimes they approached potential donors with a simple question like, "Where are you from?" Other times the street-clothed Krishnas tried straight-out flattery, such as, "You are the prettiest girl I've seen today." The Krishnas themselves say that nation-wide they collect over $7 million from these solicitations. According to NBC reporter Chris Wallace, outside observers of the movement estimate the figure even higher—from $25 million to $50 million.

Senator Robert Morgan of North Carolina introduced legislation in Congress that would restrict the Krishnas' fundraising in public places such as airports. This recent congressional interest in the issue provided me with a timely newspeg for my story about the dual life of the Krishnas.

SUBJECT MATTER FOR THE PICTURE PAGE

Viewers Relate to People Stories

Maitland Edey, an editor on the staff of the old *Life* magazine, concluded that, "Great photo essays have to do with people: With human dilemmas, with human challenges, with human suffering." People's lives, even if they are not in a crisis situation, still provide the basis for most of the best photo stories. (See Finding Features, chapter 5.)

Photo stories about people usually break down into three categories: the well-known, the little-known but interesting, and the little-known who serve as an example of a trend.

The photo story of a well-known personality provides the primary content for several larger circulation magazines. The best-read section of *Time* magazine, called "People," gave the Time Inc. editors the idea for a picture magazine with personalities as the sole subject. Naturally, the editors called the magazine *People*. With the phenomenal success of *People*, the New York Times Inc. issued a similar magazine, called *Us*. Both weeklies publish a steady diet of photos showing the lives of the famous and the infamous.

Well-Known

Besides the famous, both *People* and *Us* magazines print photo stories about little-known people who either do something interesting or exhibit eccentric characteristics. Hero or not, the person must do something to fascinate readers. George Willis, the man who climbed the outside of the World Trade Center, or Edwin Land, the inventor of the Polaroid camera, are examples of unusual personalities. A photo story by Sam Math (see pp. 268–269) traced a typical day of an untypical Massachusetts Institute of Technology student, who rode a unicycle everywhere he went.

Little-Known but Interesting

Another type of personality story investigates the life of a little-known person who is an example of a new trend or a growing style. Perhaps John Jones, a divorced single-parent father, represents a new trend in men taking over traditional female roles. How Jones handles the combination of wage-earner, home-cleaner, baby-sitter, chauffeur, and cook represents the way many other males are coping with the same problems. John Jones thus typifies a larger group of single-parent fathers.

Little-Known Who Exemplifies Trend

With a picture story, the camera, like a microscope, magnifies the subject's daily routine. The results of the visual probe depend on the subject's accessibility and cooperativeness. The photographer shadows the subject as long as the subject does not object, and the paper, or magazine, will finance the effort. In the heydays of the big picture magazines, when the glossies had lavish photo budgets, photographers were given considerably longer time to shoot personality stories than they are today. When John Dominis was on the staff of *Life* magazine, he worked on his "day-in-the-life" of Frank Sinatra for four months before the story was finished. Later as picture editor of *People* magazine, which had a relatively smaller photo budget, Dominis had to send photographers out on personality profiles and expect the job done in a half day.

Personify an Abstract Topic

At times, the photographer wants to explain an abstract topic. But here again personifying a topic helps readers relate to the subject. Zeroing in on one person affected by atomic radiation, or focusing on one person out of work, dramatizes the general problems of nuclear energy or unemployment. The readers identify with the woes of a little-known individual much more than with the problems of a political group or a sociological class. For photographers, converting the topic into human terms provides a visual clothesline on which to hang the individual points of the picture story.

Generally, photo stories that personalize important social issues remain in the reader's memory longer than stories about neutral topics. A picture story about a child dying of cancer, such as the one photographed by George Wedding of the *Palm Beach* (Florida) *Post*, will probably be remembered longer than a story about day-in-the-life of the town's blacksmith. A story concerning abortion will cause more conversation than one pertaining to street beautification.

Some issues require a comparison approach rather than a personality profile. Suppose you want to examine the problem of city waste-disposal. In your essay you could contrast pictorially the raw sewage dumped in the local river with the treated sewage emitted by a modern facility. With photos you could

Rolling Through Life On One Wheel

Photos by Sam Math

Loren Schmid is not famous. Rather, he is eccentric. His unique mode of transportation piques the reader's interest. Schmid's one-wheeler, repeated in each picture, helps hold the story together visually.

Right: On his way to the bathroom to brush his teeth, Loren Schmid overcomes the obstacle of the three stairs while still riding his unicycle.

Below: Riders get so adept at balancing they can even play games while peddling their unicycles. The Massachusetts Institute of Technology unicycle club has a lifetime membership of approximately 150.

Schmid pedals to class each day on his one-wheeler. "Once you start riding a unicycle you become utterly addicted to it," Schmid said.

Schmid's engineering background helps him repair his unicycle.

contrast soot emitted by a plant without antipollution facilities with a smoke-free sky above a plant that has installed the new environmental devices. With a series of one-on-one contrast photos you could argue visually your case for better environmental protection devices. The point of your story would not be to narrate the life of one sanitation worker; rather, you want to dramatize the problems and solutions of the sanitation crisis.

THREADING PICTURES INTO A UNIFIED STORY

Whatever the subject of the individual photos, the pictures themselves take on an additional quality when an editor places them together on a printed page. When the layout is successful, the photos interact with one another, forming an eye-catching, compelling picture-story. When the layout is unsuccessful, the pictures remain separate units only co-existing on the page.

What clues the reader that a group of pictures interacts as a story rather than functions independently as individual images, such as the ones you see on a gallery wall? In the earlier example of the Walk Right Shoe factory the photographer took a group of pictures including the president, the factory, a worker, and a shoe. Except for the fact that all four pictures would appear on the spread side-by-side, the reader would have no way of knowing that the photos belonged to the same story.

To link pictures together visually, photographers use a pictorial device. With a visually unified essay, the viewer sees in almost every picture, either the same (1) person, (2) object, (3) mood, (4) theme, (5) perspective, or (6) camera technique.

Repeat Identity of One Person

The easiest way to tie pictures together into a photo story is to concentrate on one person. Restricting the scope to one individual helps to define the focus of the series. The person's identity, repeated in each of the photos, threads the story together, giving the layout continuity. (See "Midwife" by W. Eugene Smith, pp 290–301.) Sam Math's sequence (pp. 268–269) on the M.I.T. unicyclist held together easily beause the series followed the activities of just one student.

Repeat Objects in Each Picture

Besides having the repeated identity of one person, the M.I.T. story also interlocked because the same object, a unicycle, appeared in each shot. Sandy Goldsmith's sequence on the class for the partially deaf achieved photo-bonding through this same device. (See pp. 254–255.) Goldsmith, now a photographer on the *Haverhill* (Massachusetts) *Gazette*, compressed her photo story into a few pictures representing the activities in each part of the children's day. Her opener showed a partially deaf child, wearing a hearing-aid called the phonic ear, while the youngster used hand signs to spell his name. The child thus could communicate visually with his hands as well as hear, with his powerful hearing aid, some of the teacher's voice when she talked. This keystone photo established both the content and the mood for the remainder of the photo series. In the following pictures in the sequence, the reader saw each child in the class wearing an oversized hearing-aid. With this element, the hearing aid, repeated in each picture, the reader could tell easily that the children in each photo belonged in the same class.

Keep Mood Consistent

The story about the partially deaf children also projected a consistent mood. Excitement in the children's faces gave each picture an up-beat flavor. This positive feeling permeated the whole essay.

Using a different connecting device, the story about a mannequin factory tied its pictures together with a unified theme (see pp. 248–249). The pictures concentrated on the mannequins themselves, rather than on the factory's employees. The theme, running through the pictures, was the surreal atmosphere of the plant. The viewer saw a bizarre box of hands and arms in one photo, a group of bald-headed torsos in the next. Even though two photographers, Ken Glass and Carol Dobson, worked on the project, the photo story retained its cohesive theme.

A uniform camera perspective can also add a coherent atmosphere to a picture story. If, for instance, the photojournalist takes all the pictures in the essay from a helicopter, the reader perceives a view of the world from a consistent vantage point. For another story involving a child's perception of his surroundings, the photographer, looking up, might shoot the pictures from two feet above the ground. Again, the same perspective in each picture interlocks the images.

When another cementing device is needed, the photographer might choose a unique camera technique to take all the pictures. To photograph the U.S. Olympic trials in 1960, George Silk used a "strip camera" with an extremely narrow slit for a shutter past which the film ran. The camera was operated by a motor. Against a streaked background, the bodies of the athletes looked stretched out or compressed. The final layout, "The Spirit and Frenzy of Olympian Efforts," which appeared in the July 18, 1960, issue of *Life,* was held together visually with this uniform graphic identity.

Identify Theme

Stick to Uniform Camera Perspective

Employ Unique Camera Technique Throughout

LAYING OUT THE PICTURE PAGE

After the photojournalist constructs the units for the page, including photos, captions, and copy, the designer lays out the interior arrangement of the display, spot-lighting some images and down-playing others. The layout editor follows a set of visual rules when designing a picture page.

As grammar performs an important job in writing—unifying the parts of speech, relating noun and verb, adjective and noun, adverb and verb—the rules for structuring the page layout hold together the elements of picture and copy in an organized and pleasing way. Readers do not stop ordinarily to analyze the grammar of a sentence or the structure of the layout of pictures. The effect is subtle, but nevertheless it is there.

The design editor must deal with different elements when he or she lays out a picture page for a newspaper as compared to a magazine. For instance, although a single page of both a newspaper and a magazine is usually vertical, magazines often arrange picture stories on two-page spreads, producing a horizontally shaped format. Also, a full-sized newspaper usually confines its picture stories to one large page, whereas a magazine might use several double pages to present their picture sequence. This means that a newspaper viewer can hold the paper at arm's length to see all the photos at once. A magazine reader can never do this.

In a newspaper, the photos in a story with a built-in time sequence are usually laid out from top to bottom, the way people naturally read a page. In magazines, a time sequence photo story appears from left to right across a spread. (See "Up Up and Away," pp. 274–275.)

Each two-page magazine spread tells a small but unified part of the overall picture story. Pictures are grouped into common topics for each of the spreads. After five or ten double-page spreads, the viewer has a cohesive idea about the story's subject. (See pp. 258–265.) In a newspaper, the whole story is usually contained on one full-sized page. Therefore, the newspaper page has to tell the story with fewer pictures and cannot present as many sidelights to the central theme.

SEEING SOUND

Each picture individually shows one way of depicting sound. Together, the photos take on an added dimension.

The saxophonist, Anthony Braxton, swayed during a long exposure, creating this blur effect. Notice the microphone is still sharp.
(Michael Grecco)

Double exposure of Bruce Wilkerson, bass player of the "Atlantics."
(Pamela E. Chipman)

For this photo of a folk singer, the photographer held the camera steady for ½ sec. and then moved the camera in an arc before closing the shutter. (Ken Kobre, University of Houston)

A straightforward photo of a child listening to music through earphones. (Greg Schneider, *San Bernardino* [California] *Sun Telegram*)

A balloon holds 77,000 cubic feet of hot air.

Away

and

Up Up

The balloon filling with hot air stood out as the obvious BIG picture in this sequence. The sequence has a logical time-locked order that needs to be followed in the layout.

Professional balloonist Dana Hardy makes final adjustments to his rig during a test flight.

The balloons prepare to
land in a pasture.

Photos by Bob McWade

All things that go up must
come down.

Even though these inherent differences do exist between a picture story in a magazine and a picture page in a newspaper, the general rules of design that organize together photos, type, and white space apply in both situations. The rest of this section will deal with these general principles.

Start with a Dummy

The layout person on a magazine or newspaper goes through several steps to produce an effective design. First, the person spreads out the dummy page. The dummy is proportionately the same size as the printed newspaper or magazine page. Full-sized newspaper pages are designed one at a time, because readers deal with large sheets singly. Tabloids, however, are often opened and read in two-page sections, and should be laid out with a double-folio type dummy. Two-page dummies also work when you lay out a magazine.

On the dummy, margins are marked off, with the widest border at the bottom of the page. Outside, top, and gutter margins get progressively smaller. Positioning the widest margin at the bottom of the page creates the effect of supporting the layout. If the widest margins were at the top the reader would feel the design slipping off the page.

Type, headlines, and cutlines stay within the prescribed margins of a newspaper page, but in magazines, pictures can be run to the edge of the page to give them more emphasis. With this technique, called *bleeding*, the picture continues right off the top, bottom or outside of the page, leaving no white space on the edge of the sheet. (See examples, pp. 272–273.)

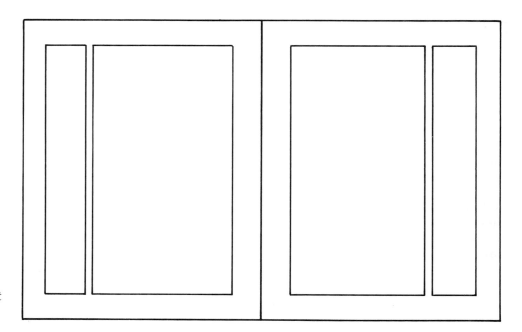

Start with a page dummy. The designer of this book used this dummy to lay out the pages you are reading.

Select the Big Picture

Before cropping or sizing a picture, the make-up person first gathers all the enlargements pertaining to the story, then either lays them out on a table or pins them to a corkboard wall. Next the designer sorts, arranges, accepts, or rejects the array of pictures, narrowing the field to the best storytelling ones. From this final selection, the make-up person chooses the strongest pictures that interrelate, while moving forward the plot of the story.

The dominant picture should be printed large enough in the layout, and

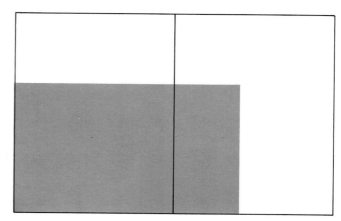

be positioned on the page in such a way as to grab the reader's attention. The layout person should do something drastic:

- Splash the dominant picture across a whole page.
- Create tension by placing a horizontal picture on the lower-left or upper-right side of the layout.
- Position a tall, skinny vertical right down the middle of the spread.
- Extend a square picture across the gutter onto the second page.

Clever positioning of the dominant picture makes it stand out. (See p. 254, pp. 258–259, and p. 260, for example.) For a two-page spread in a tabloid or magazine, accurate positioning of the main picture enables the layout person to tie together the two adjoining pages. Marrying the two pages visually clues the reader to deal with the spread as a unit. (See pp. 248–249.)

Vary Size and Content

If the photographer did a complete job of covering the assignment, then the photo editor faces the difficult task of weeding through the many good pictures to find the few great ones. The photo editor must resist the temptation to use too many pictures in a layout. Fewer pictures per page means the photos that are used can be displayed larger, and the final layout will look cleaner.

After positioning the dominant picture, the editor selects two or three additional photos to complete the story. These pictures are made smaller so that they will not interfere with the main photo. The shape of the smaller pictures usually follows the shape of the dominant picture. The editors of *Look* and *Life* designed their photo spreads to fit into three basic layout patterns: the square,

Above left: Grab the reader's attention by placing the dominant picture down the center of the page as a strong vertical.

Above right: Create tension by placing the dominant picture horizontally on the lower left of the layout.

Below left: Avoid placing the dominant picture in the middle of a page. Published this way, the photo seems statically framed by the margins, therefore uninteresting to the reader.

Below right: The predominant shape of the picture in this layout is vertical.

Above left: This layout emphasizes the square.

Above right: The most common layout in the original Life *and* Look *magazines reinforced the horizontal pattern of the pictures.*

Below left: This picture arrangement leaves awkward, inside white space.

Below right: Filling the center of the layout puts the white space on the outside, avoiding the Swiss cheese look. Aligning the edge of each picture with the border of one other picture helps to lock the layout together.

the vertical, and the horizontal. If the dominant picture, for instance, is square, most of the smaller pictures were cropped to squares. Because most pictures lend themselves to the horizontal format, this pattern was most frequently used in the layouts of the magazines. To avoid monotony, though, the art directors tried to work several vertical and square layout patterns into each issue of their magazine.

Variety in layout patterns gives the magazine a quality called *read through*—the reader keeps turning the pages to see what comes next. If each spread were built around only horizontal formats, or every page had a full-bleed picture, the reader would quickly catch onto the unchanging format and lose interest.

Varying not only the shape of the picture but the perspective from which the pictures were taken, increases reader interest and attention. The close-up, the overall, and the more typical medium shot introduce diversity into the layout. The overall shot sets the scene for the story; the close-up adds drama; and the medium shot carries forward the theme.

Sometimes the layout artist believes that running an additional picture adds more variety. Although the two pictures might appear different, they should be carefully scrutinized to see if they actually convey the exact same message. Information transmits better in one large picture than in two small pictures.

Cluster Design Elements Together

To achieve unity in the layout, hold together each of its four basic design elements: pictures, type, headlines, and white space. Grouping the pictures together forms a cohesive design unit, and, in turn, leaves a larger area of contin-

Photojournalism: The Professionals' Approach

uous white space. This white space, called *negative space* or *air*, imparts a light, clean feel to the layout.

Misuse of the white space gives the layout the Swiss cheese look: the layout appears to be riddled with holes. (See diagram, p. 278, lower left.) Too much white space also leaves readers with the impression that the designer did not have enough type and pictures to fill the blank spaces. Generally, keep the white space on the outside of the layout. Pack the inside solidly with type and photographs. (See diagram, p. 278, lower right.) James Magmer and David Falconer, authors of *Photographs and Printed Word*, did an extensive analysis of picture spreads from *Look* and *Life*, and found that in these magazines the center of each two-page layout, except for the narrow columns of white space between pictures and type, was loaded completely with text and artwork. Sometimes pictures filled the gutter and most margins. The corners, though, were opened with white space.

Cutlines generally remain within the margins of the page, without extending longer than the width of the picture. Except when pictures are bled, the cutline usually starts flush with the left-hand margin of the photo. Cutlines do not always have to be placed under the pictures: instead, they can be set in blocks and placed to the right, left, or above the halftone. Care should be taken, though, to place the cutline and picture close enough together to enable the readers to see at a glance which cutline explains which photo.

Along with the picture, the headline, and the white space, the columns of text also form a design element. Holding the type together in a block enables the layout person to play off this graphic element against the rectangular shapes of the photos and against the openness of the white space.

In most magazines the designer arranges the pictures, headlines, and text block so they line up with one another. The viewer should look at the layout and know the designer locked each element in the page together (see diagrams p. 278, lower right and left). For instance, the designer might position the headline evenly with the left-hand border of the picture. This keeps the headline from looking as if it is floating in space. Anchoring the head in line with a border of the picture indicates to the reader that the designer purposely located the type in this particular location. (See p. 248) If the layout has several pictures, the designer will make sure that each photo is lined up with the border of another photo in either the horizontal or vertical direction. This type of ordered placement also helps to give the layout a defined logic. The designer puts the text block in line with either the top or bottom edge of a photo, so that it will fit in this organized relationship. The layout artist keeps the distance between all the elements even by holding the same margins between all the pictures. By keeping consistent margins and aligning pictures with one another, the layout exhibits a preplanned, organized look.

Direct the Imaginary Lines of Force

The successful layout has a dynamic quality that draws the reader's eye into and around the page. The reader starts off with the dominant picture, then reads the headline before examining the smaller photos. Interest in the pictures will lead the reader next to the cutlines and finally to the text.

To keep the flow going and the readers' attention on the page, the layout artist has to pay attention to the lines of force, which are created either by implied motion of the subject or strong directional elements in the picture. A runner headed from left to right across the picture draws the readers' eyes along in the same direction. If nothing stops the readers, their gaze continues right off the page. Even the runner crouched at the starting line gives the picture a sense of forceful direction across the page, affecting the readers' attention. Seeing a profile view of a person, readers unconsciously follow the direction of the sitter's line of vision—off the side of the picture into space. Two rails converging on a

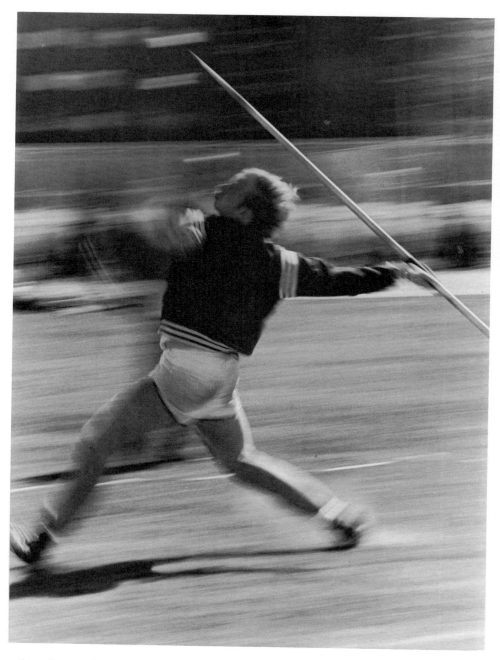

railroad track form an arrow, directing the reader's view out of the picture.

Keeping in mind these subconscious lines of force in the picture, the layout person should put them to work to keep the readers' attention fenced within the borders of the printed page. Whenever possible, keep the lines of force directed toward the copy or related pictures, and hold on to the viewers' curiosity until they see the spread's final photo.

A Step-by-Step Outline for Laying Out the Photo Page

Rich Shulman, of the *Everett* (Washington) *Herald*, has won the Picture Editor of the Year award twice. To win this prestigious award, Shulman applied the principles of magazine layout to newspaper design. He noted, during an interview, that when newspapers went from linotype to computer-set type, the layout editor's options were suddenly opened up. "Now the picture page doesn't have

to look like the rest of the paper," Shulman pointed out. The *Herald* editor even puts picture-page headlines in display type. Traditionally, designers reserved display type only for ads. A designer chooses display type that complements the context of the story. For the Krishna story, pp. 258–265, a type called Legend, which looked Eastern and Oriental, was chosen.

Below are the procedures that Shulman follows when he designs a picture-page.

1. Select good pictures. All the photos in the layout must communicate.
2. Choose each picture to tell a different aspect of the story.
3. Pick photos that show the event from different perspectives, wide-angle to telephoto.
4. Blow-up or reduce pictures so that the final layout presents images of different size.
5. Crop out all unessential areas from the photos.
6. Look for photos you can crop into strong horizontal or vertical shapes.
7. Identify one dominant photo and play it large.
8. On a dummy sheet, with the margins drawn in, locate the best position for a dominant picture, enabling it to stand out.
9. Arrange the subordinate pictures. Keep even spaces between all photos.
10. Sketch in the headline, cutlines, and text block.
11. Intentionally place each picture, headline caption, and text block so they line up.
12. Keep the white space to the outside of the layout.

Shulman tries for a synthesis of good design and content. He places pictures and text so that they are in logical order, and therefore readable. This sensitivity for strong, graphic design and the use of sound news judgment have given Shulman's layouts their award-winning appeal.

Closing Look

Layout is less rigid than a science but more organized than mere chance. The rule is to let the pictures and story dictate the design; the resulting layout will communicate your facts and ideas successfully.

BIOGRAPHY OF W. EUGENE SMITH

THE SMITH INTERVIEW

AN INTERVIEW WITH
W. EUGENE SMITH
ON THE PHOTO ESSAY

BIOGRAPHY OF W. EUGENE SMITH

When I went to interview W. Eugene Smith in his New York loft on Twenty-third Street, he greeted me at the door wearing all black: black shoes, black socks, black pants, black belt, and a black tee shirt. His hair was snow white. He looked like one of his own high-contrast black-and-white photos. His only point of color was his two bright blue eyes. He opened the steel door to his studio loft. Light streamed into the studio from the floor-to-ceiling window at one end of the large room. The light fell on stacks, boxes, and single prints, covering every available flat surface in the studio. Tables, couches, chairs, and floor were completely hidden under the piles of portfolio cases and prints. Pinned casually on the wall were images like "Spinner" from Smith's Spanish Village essay, and "Walk to Paradise Garden" from the "Family of Man" exhibit.

No single photographer can speak for the photo essay. Yet, most times when the topic turns to the picture story, W. Eugene Smith's name comes up in the conversation. Therefore I interviewed Smith on this subject.

Popular Photography magazine in 1962 described Smith, then forty-two, as the world's greatest photographer and called him "the youngest living legend in photography." *Life* magazine described his essays as "the most memorable we have ever published." The executive editor of *Life*, Wilson Hicks, said that Smith made "the camera a part of himself, primarily emotionally, also aesthetically, intellectually, and, of course, physically. He had a way of forcing himself into the machine and through it into his photographs."

First Job Is on a Newspaper

Smith first worked for the *Wichita Eagle* and the *Wichita Beacon*. He joined *Newsweek* magazine in 1937, but was fired the following year because he used what was considered a miniature camera, a 2¼" format twin-lens reflex. He signed a contract with *Life* magazine in 1939, and subsequently shot many photos and photo essays for *Life*. Smith resigned in 1941 because he felt he was in an assignment rut at *Life*. He covered World War II at first for Ziff-Davis Publishing Company and later for *Life* magazine. Obsessed with the gap between the reality of war and the comfortable headlines of war the people back home saw, the twenty-four-year-old correspondent hurled himself into the front lines in the Pacific and Europe, trying to catch on film the horror of killing. Smith followed thirteen invasions, taking memorable pictures of the war—a tiny, fly covered, half-dead baby held up by a soldier after being rescued from a cave in Saipan; a wounded soldier, hideously bandaged, stretched out in Leyte Cathedral; a decaying Japanese body on an Iwo Jima beach. Then, on a ridge along the coast of Okinawa, Smith was hit by a shell fragment that ripped through his left hand, his face, and his mouth, critically wounding him. Two years of painful convalescence followed.

Smith Rejoins *Life*

In 1947 Smith resumed his work for *Life* magazine. During the next seven years, he produced his best-known set of photo essays: the exhausting dedication of a country doctor; the poverty and faith in a Spanish village; the pain of birth, life, and death being eased by a nurse midwife.

In the country doctor essay, Smith followed the life of one physician, Dr. Ceriani, who lived in the Colorado town of Kremmling. One of Smith's photos showed the burden and responsibility clearly on Dr. Ceriani's face as he stitched up a young child's head. The final photo in the essay showed the physician exhausted, drinking a cup of coffee in the kitchen of one of his patients.

The Spanish village essay was an assignment that was supposed to re-

Previous page: W. Eugene Smith and his wife Aileen recorded the effects of mercury poisoning on the residents of Minamata, Japan. Mrs. Vemura bathes her daughter Tomoko, who was crippled from birth by the mercury poisoning. (W. Eugene Smith, Center for Creative Photography)

Photojournalism: The Professionals' Approach

quire six weeks but took six months. After searching throughout Spain for the right village, Smith chose Deleitosa, a town of 2,300 residents that had changed little since medieval times. Smith's essay following the life of a town opens with a child taking her first communion and closes on the deathbed of one of the town's patriarchs. Smith's camera caught the common everyday activities: a young woman baking bread, an old woman spinning thread.

Smith's own favorite among all his essays featured a black midwife in the back country of North Carolina. "In many ways shooting these photos was the most rewarding experience photography has allowed me." (See pp. 290–301.)

In 1954, Smith photographed an essay, "Man of Mercy," about Dr. Albert Schweitzer's leper colony in Africa. Smith found Schweitzer's relationship to the Africans more complex than the typical view of the doctor as a grandfatherly savior.

After carrying the Schweitzer essay back to America, Smith quarreled with the *Life* editors about the photo essay. Smith resigned from *Life* in an attempt to affect the use of pictures and captions, and to expand the Schweitzer layout. Smith believed that he should do his own developing and printing whenever he could, and that he should have a hand in the layout of his pictures and have a voice about the captions. What the writer wrote, Smith held, was the writer's entirely. Why, then, should not the picture story be completely the photographer's?

By most accounts Smith himself was not an easy photographer to work with. Most *Life* staffers shot their assignments and shipped the film back to New York. Smith developed his own negatives and then held on to them. With control of his negatives Smith could threaten to withdraw a story if he felt the editors were not going to play the photos accurately.

After leaving *Life,* Smith began his most ambitious photo essay. He wanted to capture a whole city, Pittsburgh, on film. With the help of a Guggenheim grant, Smith finished the Pittsburgh essay; eighty-nine of his photos were published in *Photography Annual* in 1959. Smith had difficulty editing this essay even though the publication gave him the opportunity. John Durniak, who worked for *Popular Photography* at the time, remembers that Smith had not written the text and captions for his Pittsburgh essay 24 hours before it was due at the printers. The magazine finally sent a team of writers to help Smith meet the fast-approaching deadline.

Exposing Mercury Poisoning in Minamata

In 1971, along with his wife, Aileen, Smith went to Japan to produce a story on Minamata, the town afflicted with mercury poisoning. A company, Chisso, had systematically dumped mercury-laden waste into the bay of Minamata, poisoning the fish, and thus in turn poisoning the townspeople who ate the fish. Smith described the effects of the poisoning of the people: "The nervous system degenerates—first a growing numbness of limbs and lips. Motor functions may become severely disturbed, the vision constricts, the speech slurs. In early, extreme cases, victims lapse into unconsciousness and become agitated by involuntary movements, by uncontrollable shouting. Autopsies show that the brain becomes spongelike, the cells eaten away." His photos show the physical effects on the victims and he documented through his photos the fight of the victims to receive restitution payments from the company. (See chapter opening photo.)

Smith almost lost his eyesight covering the story. He and his wife, armed with camera and tape-recorder, accompanied a group of patients to record a meeting the group expected to have with an official of the company. The official failed to show up. "But," Smith related, "suddenly, a group of about 100 men, on orders from the company, crowded into the room. They hit me first. They grabbed me and kicked me in the crotch and snatched the cameras, then hit me in the stomach. Then they dragged me out and picked me up and slammed my

head on the concrete.'' Smith survived, but with limited vision in one eye. The photo essay about the town was finally published in a book, *Minamata*.

The following interview, which took place in the fall of 1977, is one of the last Smith gave before his death in Tucson, Arizona, in 1978.

THE SMITH INTERVIEW

During the interview, Smith would listen to each question, pause, answer, then pause again. He talked about following through with his essays from creation to layout. Few editors allowed him this freedom, and Smith remembers every battle.

"The Essay Is Relationships Between Photos"

KEN KOBRE (KK): Your work in the early 1950s at *Life*, when you shot the photos about Spanish village, midwife, and country doctor, is known as the turning point in the photo essay. Would you describe what the photo essay was like before that period, say in the 1930s when *Life* first started?

W. EUGENE SMITH (WES): The difference between the early period and the later period was mainly that photographers in the beginning went out and made many pictures, and edited them. The picture did not have the same coherence as the work I did later.

KK: Where does the coherence come from? Is it in the planning?

WES: No. Just photographing with an awareness of the relationships, instead of taking pictures that were just interesting. You can go out and take pictures forever, and still never pull together an integrated photographic sequence, unless you have thought about the entire story or essay.

A collection of pictures so often is nothing more than a portfolio that you bring together, a group of photos that do not have the interrelationship that pictures of a photographic essay should have.

KK: Can you explain the phrase "the relationships between the pictures." Can you tell me what you mean by this relationship?

WES: I can best describe the relationship as something that is optical and mental at once. One photograph says something about the subject. The next photograph may amplify on that subject, or the picture may add its own dimension to the subject. When you have two photographs or perhaps three—together they establish a special point that gives three different viewpoints. Sometimes the relationship of the pictures can be contradictory; sometimes the connection can be complementary; but sometimes I've taken three entirely different pictures, and made them work together, because each picture stated a different point, yet together had a relationship that invited many thoughts instead of a single one.

KK: Are there examples from some of the stories you shot that summarize this kind of interrelationship between pictures, where we can see the second picture build on the first picture?

The Pittsburgh Essay

WES: Yes, I know that in the Pittsburgh essay, I started out with a photograph of a worker with the flare of a vesper furnace in his face. I specifically took this photo for the lead picture in the essay because I wanted to show industry in Pittsburgh as "the arsenal to the world"; that is what they used to call the city. I wanted to show that the worker was fairly well submerged beneath the weight of industry; the anonymity of the worker's goggles and the factory behind him told the story. Still, I did not want the worker to be entirely lost as a human

being. A second picture, which I used on the opening spread of the layout in *Popular Photography,* showed the ROTC students training on the campus of the University of Pittsburgh. As the officers were giving commands, the trainees just stared into the trees. So here we have two pictures of the "arsenal of the world." First, we have a shot of the workers in the steel factory. Then, we have another photo of people preparing to use the arsenal while being educated. I was beginning to set up a feeling for the city and its complexity.

The third picture in the spread was simply a rather moody street sign which said, "Love." This selection was probably subjective, because I wanted to get the feeling of love in the arsenal, in the training field, and in education. Love was also an important element even though it was represented by a shadowy street sign. In my mind, these three pictures set up the three themes as a counterpoint for the remainder of the picture essay.

That picture essay was unlike most of my other essays before, where the individuals were the leading persons. The city was the leading "person" in this instance, and the job I had set for myself was to project the city as hero or villain, and have everything else give credence to this feeling about the city. There have been many essays on Pittsburgh, but I think, in my pictorial layout, you had the feeling of people, and of the city; and you felt that you could recognize the city from my pictures. The layout was rather complex, and many people felt I wasted pictures by printing many of them too small, but it was not my purpose to show what a great photographer I was, but give a person the feeling of Pittsburgh, and the experience of the city. My pictures had been rejected by the *National Geographic.* [The *National Geographic* published their own story on Pittsburgh in March, 1965, pp. 342–371.] One of the criticisms leveled at my story by the *Geographic* editors was that it had too much emotion, and was not pictorial enough. I tried to take a *point of view* and *interpret* the city and its moods. I ended up using thirty-eight different pictures of the city. *Popular Photography* published this Pittsburgh essay. Although both magazines, *Popular Photography* and *National Geographic,* had thirty-eight pictures, you had a feeling of the city in my pictures, but I believe the reader received in the *National Geographic* layout far less understanding of Pittsburgh.

KK: Did you take the same subjects as the *Geographic*'s cameramen?

WES: In many instances, yes.

KK: Did you view the same subjects differently from the *Geographic* cameramen?

WES: We both took pictures of the University of Pittsburgh. The *Geographic* photographers simply made the point that the university was located in the city. My photos tried to link the educational institution with the other important aspects of Pittsburgh—the manufacturing of armaments. My picture showed the university on a hill, isolated, standing against the swirling smokestacks from the factories down below. I tried to transcend the editorial point I was making and sought also to produce a fine photograph. *National Geographic* used each picture in its essay to make a single point. The magazine photos did not look for any relationship between the segments of the city, and the photos rarely transcended their informative level to become fine photos.

KK: Before you shoot a picture, do you know what you want to state in it? Did you have, for example, an understanding of where the university stood in relation to the town, both physically and emotionally, and that you wanted to show the relationship?

WES: Well, yes. I drove through the streets of the city often, and I also walked through them. Sometimes I passed the same scenes a hundred times. But the scenes did not appear to me to make a striking photograph. Then one day, I saw the elements of a great shot, and so I worked on that scene and shot it. I always carried a map with me and a compass. Sometimes I would discover a scene that I would want to shoot to show a certain light—for example, a U.S. Steel plant. And I would say to myself, "This is a good place to photograph, but

the light is wrong, the situation is bad." And I would mark that place on the map and determine what time of day I thought the light would be right for the situation. Then I would come back and shoot the photo.

Smith Avoided a Shooting Script

KK: How did you organize your approach to a photo essay for *Life* magazine?

WES: *Life* often prepared complete shooting scripts. The magazine designated time and place and lighting conditions. The aim of these scripts was to make sure that a photographer would narrow his focus and would cover all the points.

KK: Did you ever use a shooting script?

WES: No. I made my own as I went along, writing down those points that I felt were important to cover, but my subjects grew out of the situation. The writing kept the subject fresh in my mind. I would write questions that had to be answered. This made for a busy schedule since I had to photograph, write, and develop the film at night.

KK: When you were in Africa, or in other foreign places, did you develop your own film on the spot?

WES: Always.

KK: Would you print pictures at that point?

WES: No. I would not even make contacts. I would just look at the negatives.

KK: Where did the ideas come from for your photo essays?

WES: Often editors of magazines originated the ideas, and I developed them along the lines I thought suitable. "Country Doctor" was suggested by *Life* editors but was done much differently than they expected. The midwife story was my idea. "Spanish Village" came from the suggestion of a story on food. As much as possible, I tried to suggest to the editors the subject of my essays, because this way I could be sure of working on something I wanted to do.

My ideas also come from a chance remark in a bar, or in any other place. The Minamata essay came directly from a Japanese who suggested that I photograph Minamata. I knew nothing about the mercury poisoning. I had never even heard of the incident before, but when I learned a little bit about it, I decided to photograph the story.

The best way to find ideas for photo essays is to be immersed in enough activities and different people so that you keep your mind stimulated. You should think not only of photography but what is going on in the world.

KK: Are there certain subjects that don't make good photo essays?

WES: I'm sure of this. For instance, an essay on the city as a whole would be a mistake. There is no beginning; there is no end. The subject is too vast and endless. There is no way you can bring coherence to the subject in a few pages. It is much better to photograph individuals in their limited relationship to life. The grave mistake that *Life* used to make was that the editors would do an issue called "Americans in Europe," or something like that. The photographers could never get close enough to anybody, so that cameramen ended up by making editorial-point pictures, covering lots of space, lots of territory. The photos showed very little that had insight and were rarely memorable.

KK: Do you ever have the problem of having to take a typical subject or stereotyped subject to represent a more general theme?

WES: I don't think the man in "Country Doctor" is typical. He is absolutely unique.

KK: Is this true of all your subjects? They are all basically unique?

WES: I think so. I don't think there is anything that is typical.

Once at *Life*, the editors wanted to do an essay about teenagers. [*Life*, Dec. 20, 1948, vol. 25, pp. 67-75] The editors wanted to produce the essay to represent

all teenagers. This was ridiculous. First, the editors had decided that seventeen was the crisis year in a teenager's life. But there is no such year that is the crisis point for everyone. The magazine lined up a whole group of candidates for the typical American teenager. The one thing they all had in common was that each owned a car. That is one reason why the editors ruled out New York as the scene for the photos, because few teenagers who live in the city have their own cars. Of course, the auto requirements would rule out also families that were too poor.

I had said that I would do the essay if the editors ruled out the phrase "typical teenager." We went around and interviewed several people and finally found someone in New Orleans who was a good subject. He did not happen to have his own car. He had some problem as to where he was going to college, a goal which most of the other youngsters were set on. And he was going to have to work for his tuition that summer on a steamer. His life had some of the elements of drama, and he had some character. Then the editors and I had a meeting about the essay, and I said I thought I could do a good essay about this young man. I pointed out, however, that he didn't have his own car. But above all, he was not typical. Finally, however, I concluded, I could not do the story, because the editors had a preconceived notion of what they wanted.

Researching a Subject

KK: Tell me about the research that you carried out before shooting a story, such as "Spanish Village."

WES: I read much about Spain before I went there, as I was interested in that country for many years.

KK: Did you look at pictures that had been taken of the place?

WES: Sure, I looked at pictures, just as I had read widely about the country.

KK: Did this cause a problem when you arrived? Did you already have a bias resulting from your reading about what others had said and the pictures they had taken?

WES: No, because I immediately started all over. I mean, I had some knowledge, but I found the people and the place different from what I expected.

KK: I suppose you researched Albert Schweitzer when you expected to do a photo essay on him. Did you have a bias before you started?

WES: I had read all his books, and thought it would be easy to strike up a rapport with him. When I went to meet him, I found that he was vastly different from what I had expected.

KK: Why?

WES: Those who had written about him had especially idealized him, and left him not quite mortal. I found, however, he had to make compromises.

KK: Like what?

WES: In the leper village, for instance, Schweitzer would let a clean child remain with leprous parents. He would not say, "Take the clean child away." Instead, Schweitzer would say, "If I take the clean child away, there will be no place for him to go to. His parents will leave also, and they will be in the forest where I cannot watch them, and they will spread the disease."

When Schweitzer first reached the village, his European training called for the amputation of a native's leg that was badly crushed. But if Schweitzer amputated, he would have become known as "the butcher doctor." He didn't amputate. He lost some lives but saved many more in the long run because natives kept coming to him for help.

KK: None of this is revealed in the final *Life* magazine photo story on Schweitzer.

WES: No; this was one of the reasons that led me to resign over the story.

KK: Did you resign after the story was printed?

WES: No, I resigned before it was printed, trying to force the editors to give some consideration and space necessary to tell the story right.

W. Eugene Smith originated and photographed the following essay, "Nurse Midwife," for Life *magazine. Smith felt this was his best work and asked that it appear with this interview. Because of Smith's story, Maude Callen, the nurse, got a permanent clinic. (Reproduced by special permission from* Life *magazine, December 3, 1951 © 1951 Time Inc.)*

An Interview with W. Eugene Smith on the Photo Essay

WAITING, the young mother leans forlornly against the window, ignoring sympathy and looking for Maude's car.

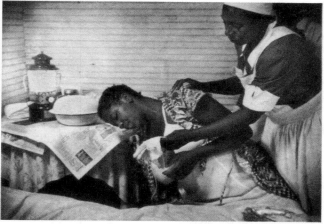

FRIGHTENED AND SICK, the nervous mother is helped by Phoebe Gadsden, the first midwife she called. Mrs. Gadsden, a practicing midwife who attended Maude's classes (*pp. 144, 145*), has helped at several deliveries but felt that this one needed special attention and so decided to ask Maude to come and supervise.

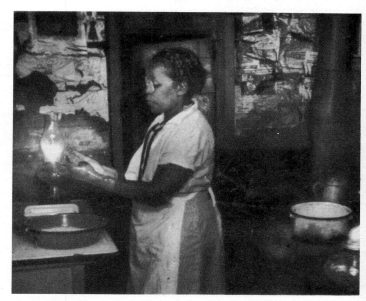

MAUDE GETS READY in the kitchen by lamplight. In addition to the stethoscope and gloves, her equipment consists of about $5 worth of such items as clean cloths, bits of cotton, scissors, cord ties, Lysol, surgical gown and mask and a blood-pressure gauge. Her deliveries are always made under aseptic conditions.

IN DEEP PAIN, the 17-year-old mother writhes, mumbling prayers while Mrs. Gadsden holds her hand. She could do little to relieve pain because she is not permitted to administer any drugs. The mother was worn out and weak even at the beginning of her ordeal, having previously gone through a period of false labor.

Nurse Midwife

MAUDE CALLEN EASES PAIN OF BIRTH, LIFE AND DEATH

PHOTOGRAPHED FOR LIFE BY W. EUGENE SMITH

Some weeks ago in the South Carolina village of Pineville, in Berkeley County on the edge of Hell Hole Swamp, the time arrived for Alice Cooper to have a baby and she sent for the midwife. At first it seemed that everything was all right, but soon the midwife noticed signs of trouble. Hastily she sent for a woman named Maude Callen to come and take over.

After Maude Callen arrived at 6 p.m., Alice Cooper's labor grew more severe. It lasted through the night until dawn. But at the end (*next page*) she was safely delivered of a healthy son. The new midwife had succeeded in a situation where the fast-disappearing "granny" midwife of the South, armed with superstition and a pair of rusty scissors, might have killed both mother and child.

Maude Callen is a member of a unique group, the nurse midwife. Although there are perhaps 20,000 common midwives practicing, trained nurse midwives are rare. There are only nine in South Carolina, 300 in the nation. Their education includes the full course required of all registered nurses, training in public health and at least six months' classes in obstetrics. As professionals they are far ahead of the common midwife, and as far removed from the granny as aureomycin is from asafetida.

Maude Callen has delivered countless babies in her career, but obstetrics is only part of her work. To 10,000 people in a thickly populated rural area of some 400 square miles veined with muddy roads, she must try to be "doctor," dietician, psychologist, bail-goer and friend (*pp. 140, 141*). To those who think that a middle-aged Negro without a medical degree has no business meddling in affairs such as these, Dr. William Fishburne, director of the Berkeley County health department, has a ready answer. When he was asked whether he thought Maude Callen could be spared to do some teaching for the state board of health, he replied, "If you have to take her, I can only ask you to join me in prayer for the people left here."

◄ **WEARY BUT WATCHFUL, MAUDE SITS BY AS MOTHER DOZES**

CONTINUED ON NEXT PAGE

4 A.M. As hard labor begins, the face of Alice Cooper seems to sum up all the suffering of every woman who has ever borne a child.

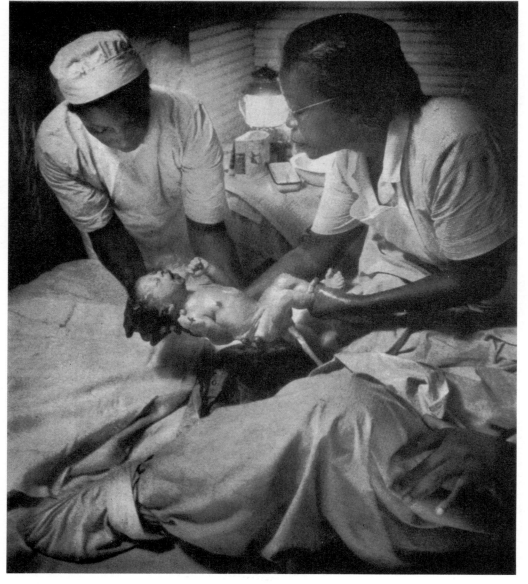

5:30 A.M. A few seconds after the normal delivery, Maude Callen holds the healthy child as he fills his lungs and begins to cry.

5:45 A.M. The mother's → aunt, Catherine Prileau, tries to soothe her so that she will go to sleep and begin to forget her misery.

Nurse Midwife CONTINUED

5:40 A.M. The long suffering over, the mother first sees her son. She had no name for him, but a week later she chose Harris Lee.

6:20 A.M. Her work over at last, Nurse Midwife Callen quietly takes the first nourishment that she has had for more than 27 hours.

CONTINUED ON NEXT PAGE

MAUDE AT 51 has a thoughtful, weary face that reflects the fury of her life. Orphaned at 7, she was brought up by an uncle in Florida, studied at Georgia Infirmary in Savannah, became a nurse at 21.

HEALTHY TWINS, who were delivered a day apart last year by Maude, get a quick once-over when she stops in to see them and to pump herself a drink of water. Only about 2% of her patients are white.

MAUDE'S 16-HOUR DAY

Maude's duties as midwife are no more important than those as nurse. On her daily rounds she sees dozens of patients suffering from countless diseases and injuries. She visits the nine schools in her district to check vaccinations, eyes and teeth. She tries to keep birth records straight, patiently coping with parents who say, "We name him John Herbert but we gonna call him Louie." She tries to keep diseases isolated and when she locates a case of contagious illness like tuberculosis she must comb through her territory like a detective, tracking down all the people with whom the patient may have been in contact. She arranges for seriously ill men like Leon Snipe (right) to go to state hospitals, and she keeps an eye on currently healthy

babies to see that they remain that way. Whenever she is home—she is childless and her husband, a retired custom-house employe, sees her only at odd hours—she throws open a clinic in her house to take care of anyone who wanders in. And sometimes patients like Annabelle Mc-Cray Fuller (below, right) will travel all the way from Charleston, 50 miles away.

Maude drives 36,000 miles within the county each year, is reimbursed for part of this by the state and must buy her own cars, which last her 18 months. Her work day is often as long as 16 hours, her salary $225 a month. She has taken only two vacations and has now become so vital to the people of the community that it is almost impossible for her to take another.

TUBERCULOSIS CASE, 33-year-old Leon Snipe, sits morosely on bed while Maude arranges with his sister for him to go to state sanatorium. Maude had met him on road, noticed he was thin, wan and sickly.

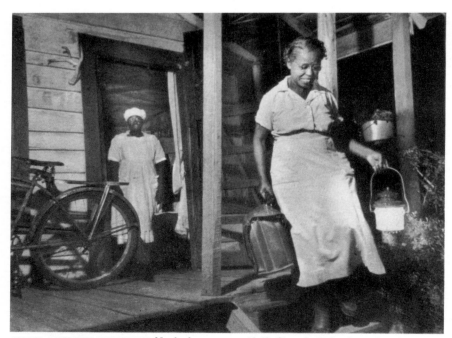

AFTER ANOTHER DELIVERY Maude departs at 4:30 a.m., leaving the case in charge of another midwife. Since she is already up, she is likely not to go to bed but to continue through rest of morning.

ACCIDENT CASE is brought to Maude's door one night. Annabelle Fuller was seriously cut in an auto accident and Maude had given her first aid. Now the girl returns to have her dressings changed.

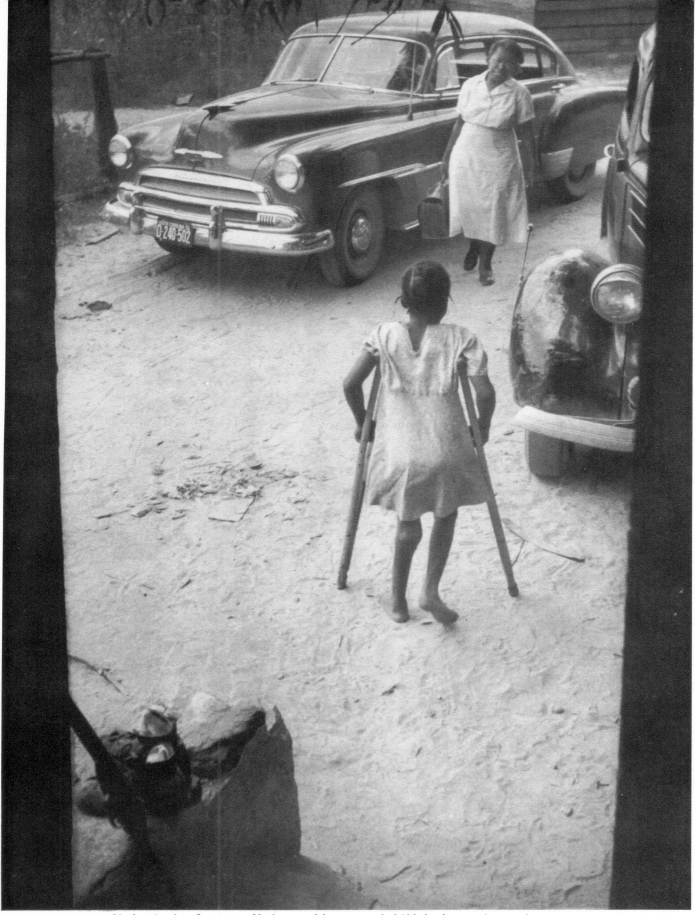

CRIPPLED GIRL greets Maude at her door. Last summer Maude arranged for her to go to a state camp for crippled children which had strict entrance requirements —each child had to have two dresses and one pair of pajamas. The girl could not meet these, but after Maude got her one dress and one pair of pajamas, she could.

CONTINUED ON NEXT PAGE

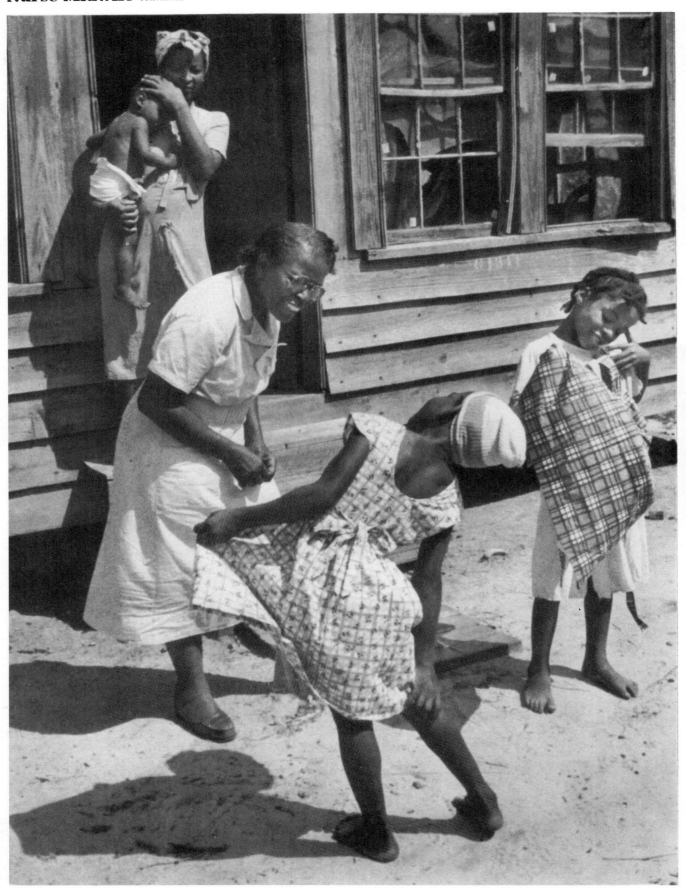

NEW DRESSES for 9-year-old Carrie (*right*) and 8-year-old Mary Jane Covington were dropped off by Maude on her way to a patient. Occasionally, as in this case, she gets clothing from friends or charitable organizations and distributes it where she thinks it is most needed. But sometimes she buys the clothes herself.

SIMPLE KINDNESS overwhelms an old man. Frank McCray had a headache one day in 1927, soon was paralyzed, and has been in this chair ever since. He broke down and wept when Maude stopped in.

EXTRA DUTY assumed by Maude includes cashing of relief checks and dealing with storekeepers for several people who are mentally incompetent or, like this man, blind. She paid his bills for him and counted out change so he could buy some tobacco.

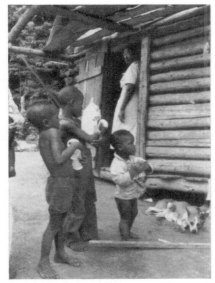

STORE-BOUGHT FOOD donated by Maude fascinates youngsters outside log cabin. She frequently finds families with only two or three items on their diet, recently found this one living entirely on corn.

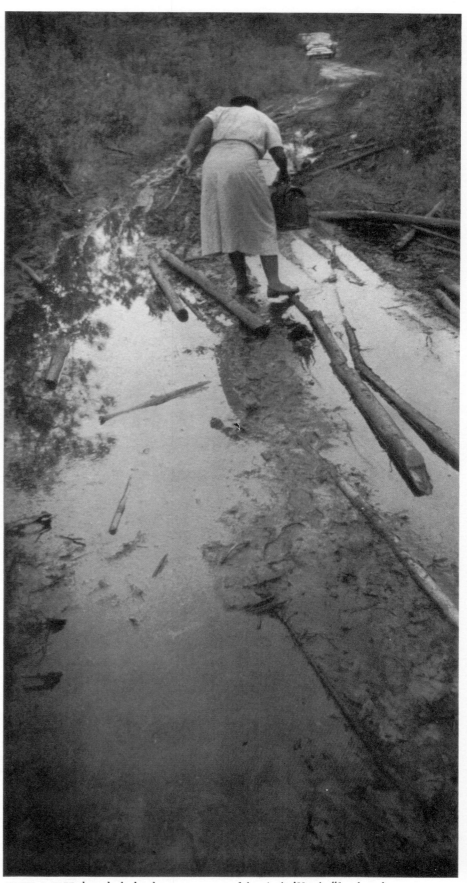

AFTER A CALL she wades back to her car. Roads like this are not unusual. At the end of some of them in the '20s, she "found people who did not know the use of forks and spoons."

CONTINUED ON NEXT PAGE

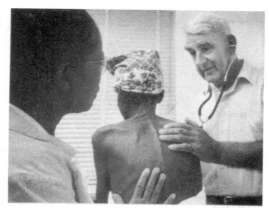

DR. W. K. FISHBURNE, head of the Berkeley County health department, examines a patient brought to hospital by Maude.

MAUDE AND M.D.

When she is not visiting her patients in their homes, Maude holds clinics in churches, school buildings and backwoods shanties throughout her district. Some are for a single purpose—inoculations, classes for mid-wives or expectant mothers, examinations for venereal disease. Others are open to all comers with all ills. All are part of the activities of the South Carolina State Board of Health, Maude's ultimate employer, which has perhaps the best state midwife-education program in the U.S., al-though a recent budget cut seriously threatens it.

At her clinics Maude does not compete with doctors. There are not enough M.D.s in any case to cover the territory, and whenever her pa-tients are in need of treatment that Maude is incompetent or unauthorized to give, she takes them to the health department clinic or the county hos-pital. There she works under the direction of Dr. William K. Fishburne (*above*), from whose shoulders she has taken an enormous amount of work.

DYING BABY who is suf-fering from acute enteritis is rushed to hospital. Moth-er brought her to Maude, who took her temperature (105°) and raced 27 miles in hope of saving her life.

TRANSFUSION was al-most impossible because fever's dehydration had affected arm veins and doctor had to try one in neck. Baby died before he could get blood flowing.

OUTSIDE A CLINIC held in school, crowd waits to see Maude. On one afternoon, with one assistant, she gave 810 typhoid shots, later went out and delivered another baby.

INSIDE A CHURCH, Maude inspects a patient behind a bedsheet screen. She dreams of having a well-supplied clinic but has small hope of getting the $7,000 it might cost.

CONTINUED ON NEXT PAGE

MAKING A DELIVERY PAD in patient's home according to classroom method, Maude crimps together the edges of several pieces of newspaper. Her materials must be makeshift; even paper is scarce.

INCUBATOR is made of box and whisky bottles full of warm water. The bottles are placed at foot and sides of box, then covered with layers of cloth. This will sometimes work for as long as two or three hours.

CRIB is made of an old fruit crate propped near a cold stove. Maude must demonstrate even this simple idea—she has seen newborn babies thrown into bed with older children where they might suffocate.

TEACHING A MIDWIFE CLASS, Maude shows how to examine a baby for abnormalities. She conducts some 84 classes, helps coach about 12 new midwives each year. These midwives, who are already

cticing, **return to Maude** for monthly refresher ... rses which open and close with a hymn. Few have ... more than fourth-grade education but are trained for two weeks at the state midwife institute and are ... very proud of their calling. Unlike Maude, they get fees for deliveries, set at $25 but often paid in produce.

Shooting Strategy: The Unobserved Observer

KK: In the past you previously talked about two kinds of methods of shooting. One you describe as "the unobserved observer," and the other you describe as "the intimately accepted participant." I was wondering how you are able to remain an unobserved observer, especially when you use flash?

WES: I don't really use flash or strobe. My view is use natural or available light, according to the situation. The other day, I ran across a picture made solely by the light of miners' helmets. When you are using strobes or flash, it is very difficult to be the unobserved observer.

KK: How do you become an intimately accepted participant? How long did you stay with Maude Callen in the essay, "The Midwife"?

WES: Six weeks altogether. I didn't wait very long before I took the first photographs of her, but you never know if the first ones are very valid. You never know if your idea is going to work. Will the relationship be compatible? I've been very fortunate in that many of my subjects have cooperated fully.

KK: Are there any things you do to help along this acceptance?

WES: It all depends on the subject I'm working on. I try to be friendly and understanding. I try not to intrude. I'm very careful of the moments when I feel subjects are being pressed too hard, and I pull back.

KK: Do you ever direct or pose the subjects?

WES: I wouldn't absolutely rule out these methods, if toward the end of an essay, I know a certain relationship between the subjects is true to the story, and yet the relationship just does not seem to be coming about naturally. At that time, I might take steps to set the connection. If there are two people together, I might move their chairs closer so that the people will show a better relationship. As far as directing a photo, this happens so seldom that I cannot remember the last time it happened. Yet, if I really felt that it was absolutely essential to the truth of the story, I would not hesitate to pose the subjects. Usually I don't do it.

KK: Is that because you have the time to wait for the proper moment for a photograph?

WES: Well, I've forced situations to occur that would have taken longer to happen by themselves. Newspaper photographers, because of their deadline pressures, are in a difficult spot.

KK: How long did you wait with the doctor in the essay about him?

WES: Twenty-three days and twenty-three nights.

KK: Was it because of the emotional situations in the doctor's life that you got honest pictures, or did the physician simply get used to you after twenty-three days and nights, and forget about you?

WES: He pretty much forgot about me, and also I worked very quietly. In his office, I had some photo floods set up. When we went into the office, I turned them on to get a little more light.

KK: Will you often introduce artificial lighting in a room?

WES: If necessary. On the midwife story, I knew I would have to have additional light, because I knew that in these little dark cabins there was little light. There was just no way I could photograph without additional light. Before the birth of the child, a situation shown in the sequence, I visited the home and put up a couple of white cards on the wall. I hooked a couple of strobes to the cards so I could bounce the light off the reflectors.

KK: You have taken some pictures in color. When is the best time to use color?

WES: Well, the kinds of essays that I do are done best in black and white, because color too often produces its own emotion separate from the subject. It's not that color is not valid, because it is. Color is a very strong tool of illustration, but I don't like to use color. I think my subjects just do not lend themselves to color.

Captions Cause the Reader to Think

KK: What is the relationship of the captions, or text block, to your pictures? Are captions necessary?

WES: Very important, because you can say in words what you cannot say in pictures. Captions which merely repeat what is in the photograph are ridiculous. In the "Midwife," several pictures showed the midwife with a Coleman miner's lantern sitting behind her while she was working. The captions stated that she uses the lantern because she does not have electricity. I felt this point was rather obvious to everybody. This fact in the caption was a waste of words and space. The captions should have said something about what she was doing beyond the scope of the pictures.

KK: What kinds of things cannot be shown in pictures and therefore require words?

WES: I shot a war picture in which there is a shell explosion. In the caption, I simply said, "Sticks and stones and bits of human bones." You can say something in the caption that will cause the viewer and the reader to think more. Then, consider the picture of the baby being pulled out from under the rock in Saipan. The caption said that, "The baby's head was under a rock. It's head was pushed in and its eyes were full of pus. We hoped it would die." The picture might have moved you on its own, but when printed with the caption, the photo had much greater impact in intensity and emotion.

KK: When you were with *Life,* did you feed the editors with information they could use to write the captions, or did they send reporters to write the story, and to write the captions later?

WES: On such essays as the "Midwife," I did all the research. The reporters wrote the story from my research.

KK: What should be the relationship between the photographer and the writer? Should the photographer write the story and take pictures?

WES: That all depends on the people involved. I wrote the text blocks for "Minamata." A great deal depends on how much understanding there is between the people involved.

KK: Is writing something you think the photographer should learn to do?

WES: Some people cannot learn to write. Some people cannot learn to take pictures either. You don't have to have multiple talents.

"Laying Out Pictures Is Like Writing Music"

KK: Do you consider designing the layout as important as taking the pictures?

WES: Certainly, because you can make a story go in many different directions. The layout can be done with vast distortion. The story-line can be superficial, or it can be strong, whatever the layout says. Building a layout is constructing the groundwork of the photographic essay.

KK: When you were not photographing, you said that you went home at night and did layouts. Do you consider horizontals and verticals when you are taking the picture?

WES: Yes. I very frequently try to frame a picture both as a vertical and as a horizontal. Then, when it comes to the picture layout, I'm able to use the photo that fits the design best. There are real problems in layout. Often the photographer is not aware of these problems if he has never designed a page.

KK: How did you learn to do layouts?

WES: I learned by actual experience. If I were an editor of a magazine, I would insist that a photographer be in on making the layouts.

KK: How do you go about selecting pictures from your contacts? Do you pick out the best photos, then make prints, then work them into a layout?

WES: First I make small prints. Then I usually form piles of the groups with possibilities and work from there.

KK: Which kinds of pictures should be played small?

WES: Sometimes you can use very good pictures and play them small, whereas if you were doing an exhibit, you would want to make the photos oversize. With the essay, you have to relate to what you are trying to say in the essay, and not flatter yourself as a photographer. You can have a picture that is so good that you hate to play it small. You have to think of a way legitimately to use it large.

KK: When you are laying out an essay, do you plan the beginning, middle, and the end, and let the other things fall into line?

WES: I do it very many different ways. Perhaps laying out the format begins with the ending; perhaps the layout begins with the opening. Sometimes the laying-out step begins by featuring certain interior relationships I know have to go together. After that, I build from either end of the layout. Layout patterns all depend on the subject. I lay essays out according to the same principle used in music, which has a beginning, middle, and end.

KK: What do you mean when you say that you "lay it out according to music"?

WES: It is a very private way of working so that I have pace, rhythm, and drama in the right places.

KK: How can you speed up the essay, using pictures, and how can you slow it down?

WES: There are lyrical pictures, and there are those which are strongly recorded.

KK: Can you give me an example of these two types?

WES: In the "Midwife" essay, the picture of the midwife waiting for the birth to take place is a very quiet picture. This photo did not have to open the essay, but the photo established a mood. The picture of her waiting is poignant. Then the picture of the actual birth is a very strong chord, an impression that lasts a long time.

KK: Do you think people will study this photo longer than other pictures?

WES: Whether they do or not, I feel this picture works on their emotions.

KK: Now the pictures at the end show the midwife holding up the child to a group of nurses, or to midwives who are being trained. Why was that chosen as the end picture?

WES: That was a way of showing how learning was passed on.

KK: When you originally took the pictures, did you have any idea that *this one* would be an opening picture, and *this other one* would be the closing picture?

WES: Yes, because I made layouts every night and slowly built the story exactly as you see it there. I tried to get as close as I could to the plan.

KK: When you did the "Country Doctor," your final closing picture showed the doctor slumped down with a cigarette. Was that preconceived? Did you want to end the essay with that picture?

WES: It was entirely logical that there would be some photograph which would show the doctor very tired. I did not know until I made the layout it would be that particular picture which would end the story.

KK: Have you ever had to go back when you realized that you did not have the pictures you wanted and had to pose them?

WES: No. The nearest that situation occurred was in the Pittsburgh story, when the night before I left I went through all the negatives I had and decided that I did not have the one showing man almost defeated—he was submerged by industry but not quite. I went out and shot that photo. It turned out to be the last photo I made. It was definitely an eye-opener.

Future of the Photo Essay

KK: Do you think photo essays are going to come back again?

WES: I think they *could* come back again. They would have to be edited differently. I think *Life* could make a comeback too.

KK: *People* magazine uses many pictures about persons. How do you feel about those photos? Are they photo essays?

WES: Oh, hell, no!

KK: What is missing about them?

WES: There is no depth. The illustrations don't tell you anything in depth about the person.

KK: Why?

WES: The photographers are probably not taking enough time on each point. Also the editors don't have the space, or desire, to do an in-depth story. There are all kinds of chatty, gossip magazines, which do not do the real kind of thing I am talking about.

KK: Are the individual pictures any worse or better than they were? Or is the problem that photographers don't integrate their photos to make a whole essay?

WES: Some of the pictures are fairly nice, but I don't think many of the pictures are very outstanding. In fact, I think these picture magazines are rather bad.

KK: In the future, will books be developed along photo essay lines?

WES: Such books could have a good future, but only a few thousand persons see a book, rather than the few million who would see an essay in a magazine.

KK: How many people have seen your book *Minamata*?

WES: I don't know how many have seen it. It has sold upwards of 35,000 copies. This figure is still a lot lower than *Life* circulation, which was six million.

KK: What effect has the book had?

WES: The pictures have helped the Japanese victims to win the sympathy of the Japanese nation. The book also had the effect of helping to get new laws enacted in Japan. The book is constantly being used in court for litigation in Japan and the United States. The book has helped also bring more attention to the mercury situation in Canada.

KK: What was it like to write a book project as most of your other essays were just a few pages in *Life*?

WES: I took my time. I had no deadline to worry about. I spent three-and-a-half years on the book.

KK: Are you planning any photo essays for the future?

WES: Yes, but I don't know what they are now. They will probably be in book form, but I may start a magazine and sell it on the street.

PRIVACY VERSUS THE PUBLIC'S RIGHT TO KNOW

WHERE CAN YOU TAKE PICTURES?

LIBEL LAWS AND THE PHOTOGRAPHER

PRESS CREDENTIALS' VALUE USEFUL, BUT LIMITED

COPYRIGHT—WHO OWNS THE PICTURE?

PHOTOGRAPHERS FACE ETHICAL ISSUES

The law section of this chapter was prepared by Mark Johnson Ph.D., Chairperson, Department of Communication, Mount Vernon College, Washington, D.C.

13
PHOTOGRAPHING WITHIN THE BOUNDS OF LAWS AND ETHICS

PRIVACY VERSUS THE PUBLIC'S RIGHT TO KNOW*

Cindy Fletcher, fourteen years old, died in a house fire in Jacksonville, Florida. Her mother, who was away at the time, learned about the tragedy in the next day's edition of the *Times-Union*. Alongside the story appeared a picture that showed where her daughter's burned body had left a silhouette scorched on the floor. The picture was shot by a newspaper photographer, Bill Cranford, who had entered the Fletcher home. Mrs. Fletcher sued the Florida Publishing Company, owner of the *Times-Union,* on grounds that the photographer had invaded her home—hence her privacy.

This actual court case serves to illustrate the problem for the working photographer. Did the photographer, as a representative of the news media, have the right to enter the house? Which right comes first: the right of Mrs. Fletcher's privacy or the right of the public to know what happened in that house? Would you have entered Fletcher's home if you were the photographer?

According to legal scholars, the First Amendment right to gather and disseminate newsworthy information far outweighs the nebulous "right of privacy." In *Times-Union* v. *Fletcher*, the court found in favor of the photographer: he had the right to enter the house and take the pictures. Yet, in other cases the courts have recognized the right of privacy over newsworthiness.

Privacy is widely defined as the "right to be left alone"; but this definition leaves unanswered questions. To start with, privacy is *not* a broad constitutional right basic to American citizens. Our Constitution does not grant us this general right to be left alone. In fact, most analysts believe there never will be a constitutional right of privacy similar to the right outlined in the First Amendment, which protects and guarantees free speech and press.

When does the right of privacy override other rights? Over the past 75 years, some commonly recognized rights or principles of privacy have evolved based on federal and state laws and court cases. These rights protect individuals from anyone:

- entering their house uninvited.
- using a picture of them to sell a product without their consent.
- harassing them.
- unfairly causing them to look bad.
- taking truthful but private or embarrassing photos of them.

At first glance this list might appear somewhat intimidating. You may ask yourself, "May I ever take a picture of anyone, anywhere?" In practice, though, the courts have severely limited the meaning of each of the five principles of privacy.

Entering Someone's Home Uninvited

Physical intrusion generally means entering someone's home, apartment, hotel, motel, or car without permission. This right of privacy prohibits the photographer from walking in and taking pictures inside a house, without the permission of the resident.

Why, then, did the court find that the *Florida Times-Union* photographer had the right to enter the Fletcher house and take pictures of the silhouette left

*(Author's note— Many laws differ from state to state. States pass new laws and drop old ones as courts set precedents. These laws and precedents are fairly clear about what is restricted but they are usually unclear about what is permissible. Therefore, no chapter on photojournalism law is totally comprehensive or definitive. This chapter should be read as a guide to your rights as a photojournalist. For more specific information about the law in your area of the country check with a member of your local bar association who specializes in media law.)

from Cindy Fletcher's burned body? Why was this not an invasion of privacy via intrusion?

In the Fletcher case, the news photographer was invited into the home by the police and fire marshal; no one objected to the cameraman's presence. In fact, the *Times-Union* photographer was asked to take pictures by the authorities because they needed pictures for their investigation and the fire marshal's camera was out of film. Mrs. Fletcher's suit was dismissed because it was "common custom" for the press to be invited onto private premises for the purposes of covering such newsworthy events. Also, no one objected to the photographer's presence.

"Invited in" by the Police

Immediately one asks, "How could Mrs. Fletcher object when she wasn't there?" That's the "Catch-22," a legal dilemma. If she had been there and had said "No," the photographer, despite legal invitation, would have been trespassing. But Mrs. Fletcher did not say "No," and the fact that she couldn't say "No" wasn't relevant, according to the law.

What would have happened if the fire marshal's camera had not run short

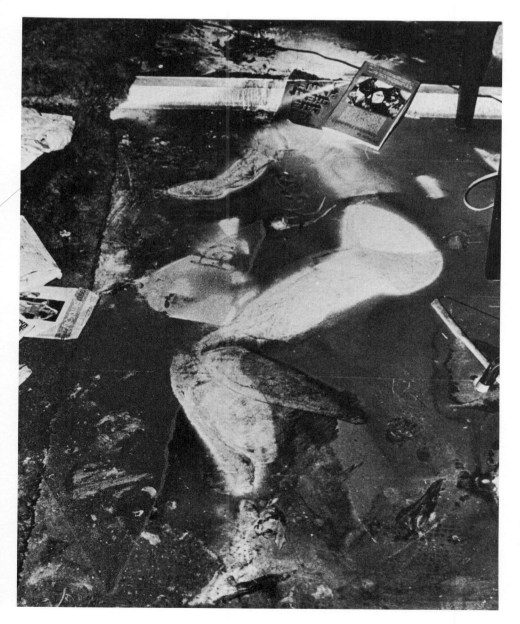

Here is the silhouette on the floor left from Cindy Fletcher's burned body. Did the photographer enter Fletcher's home legally? Did the newspaper have the right to publish this picture?
(Bill Cranford, *Florida Times-Union*, Florida Publishing Company [Jacksonville])

of film and the *Times-Union* photographer had not been invited into the Fletcher's house to take pictures? Could the photographer have legally entered anyhow if Mrs. Fletcher was not at home to object? The answer seems to be yes.

A recent case involving the coverage of the "Son of Sam" murders in New York indicates that photographers who are following a news story can legally enter private property without police invitation (*People* v. *Berliner*). The judge found that reporters and photographers did not commit criminal trespass in entering David Berkowitz's apartment, even though his room was off limits to photographers after the police designated it a crime scene. The judge found that the police had no right to refuse entry to the room—only the tenant or landlord had that right.

In the Fletcher case, how about the privacy of Cindy, the dead 14-year-old daughter of Mrs. Fletcher? Did the dead daughter have any rights? The law does not recognize invasion of privacy of the dead. In a recent court case, the widow of top Chicago gangster Al Capone lost a suit against Desilu, the producers of the TV show "The Untouchables," which included story plots about Capone's activities. The suit was lost on the grounds that Al Capone was dead and, therefore, had lost his right of privacy.

Shooting Surreptitiously

When do you need an invitation into someone's home? Take the case of Antone Dietemann, a West Coast herbal medicinalist who had achieved a considerable amount of public recognition and was newsworthy, but declined to be photographed in his home-laboratory-garden.

Life photographer Bill Ray posed as the husband of a patient and visited the medicinalist. With a hidden camera, the photographer snapped pictures of the herb man as he became engrossed in his therapy. *Life* editors published the photos without the medicinalist's permission. Dietemann sued the magazine because he claimed his privacy was invaded. He won on the grounds that the photographer took the pictures surreptitiously. Dietemann had not given his permission for the shooting of the photographs. Individuals do have privacy rights in their own homes.

Photographing from Public to Private Property

Without going onto persons' property, you may, from the street, photograph them in their yard, on their porch, or even inside their houses if you can see the people. You don't need the owner's permission. For instance, the courts consider people sitting on their verandas, or cutting the grass in their lawns, or standing behind a picture window in their living rooms, to be in "public view," and therefore photographable.

The photographer still should be somewhat cautious when shooting onto private property. The photographer should not step onto the grounds to get the picture. Nor should the photographer use an extremely long telephoto lens in this situation. This extra long lens would capture more than the naked eye could see. In fact, the court says, you shouldn't go to any extra trouble to get this porch-sitting, lawn-mowing, or window-standing shot. You shouldn't even climb a tree to help you get a better view. You are limited essentially to the view of an average passerby according to the courts, although not all photographers follow these guidelines.

Using Someone's Image to Sell a Product

The law holds that you cannot publish a photo of a person for commercial purposes without obtaining consent from that individual. A company can't sell a product by identifying that product with someone without getting permission first.

Publishing someone's picture on the cover of a magazine or the front page of a newspaper is permissible, if it is newsworthy. The court does not consider the newspaper or magazine itself a product. However, to print the same picture as part of an advertisement in a publication, without prior consent

This picture of Julia Child was published legally as a magazine cover. But without Child's written permission, this photo could not appear in an ad for a particular restaurant or for a brand of food.
(Ken Kobre, University of Houston)

of the subject, would mean the company had violated the person's right of privacy.

For instance, let's say that famous movie personality John Starstruck is driving down the street in a new Ford Thunderbird. As a photographer for the *Daily Sun*, you snap a picture of Starstruck, thinking your editor might want to use the photo, for no one knew Starstruck was in town. You were right. Your editor publishes, on the front page, the picture of Starstruck in his new car. No problem. You've done nothing wrong, nor has your editor done anything illegal.

However, the Ford Motor Company, seeing the picture, recognizes its advertising value because the photo shows a famous movie star driving in a Thunderbird. The company, after legally obtaining a copy of the photo's negative from your newspaper, uses the picture in an advertisement. If the viewer can recognize Starstruck in the Ford advertisement, then the movie star's privacy—in the sense of commercial appropriation—is violated. Ford is using Starstruck's image to sell its cars. Starstruck may sue the Ford Motor Company, and unless Ford can produce a consent form in court, the movie star will win. The consent form signed by the subject, gives the photographer or publication the right to use the photo in an ad.

Reserving the commercial use of a person's image is not limited to just the famous. All individuals have the right to protect themselves from this form of commercial exploitation. When you take a picture for the newspaper, you do not need a consent form from the subject, famous or unknown. But when you take a picture that you want to sell to a company for use in an advertisement, then you must get a consent form signed even if the subject is unknown.

Physically Harassing Your Subject

The case of Ron Galella, self-styled paparazzo and pursuer of Jacqueline Kennedy Onassis, exemplifies the problem of physical harassment. Jackie was newsworthy. Almost anything she did appeared in the gossip columns of papers. Any picture of her a photographer could grab was published on the cover of a national magazine.

Ron Galella is a full-fledged, full-time paparazzo who specialized in photos of Jackie. The word *paparazzo* means an Italian insect similar to a mosquito. In his movie "La Dolce Vita," director Federico Fellini named the free-lance photographers who covered the movie stars and other celebrities "paparazzo" because they buzzed like mosquitos. Paparazzo Galella, who made his living buzzing after the stars, started tracking Jackie Kennedy Onassis in 1967.

Galella hung around her New York City apartment waiting for her to step outside the door. When she bicycled in Central Park, he and his camera were tucked into the bushes. As she peddled by, he would shoot her picture. When she shopped at Bonwit Teller's, he ducked behind a counter and snapped away. When she ate at a restaurant in New York's Chinatown, he hid behind a coat rack

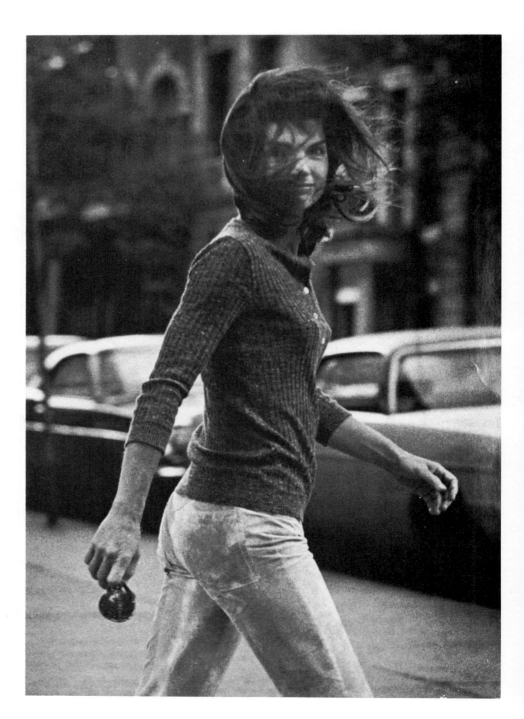

Seeing Jackie Onassis walking up Fifth Avenue, paparazzo Ron Galella hopped a cab and said to the driver, "Follow that woman." He took this photo from the window of the taxi. This incident plus a number of others caused Onassis to sue Galella for harassment.

312
Photojournalism: The Professionals' Approach

to get the first photographs of the former First Lady eating with chopsticks. He even dated her maid for a few weeks in an attempt to learn Jackie's schedule.

Onassis sued Galella, charging him with harassment and invasion of privacy. The court had to balance Onassis's right of privacy against Galella's right to take pictures.

The court found in Onassis's favor. Galella was restricted from coming closer than 100 yards of her home and 50 yards from her personally. This ruling was later modified to prohibit him from approaching within 25 feet of her. Note, however—the court did not stop Galella from taking and selling pictures of the former First Lady, as long as the pictures were used for news coverage and not advertising.

The court finding sets a dangerous precedent that might hamper other news photographers in years to come, noted Caroline Dow Dykhouse in her paper "Public Policy's Differential Effect on News Photographers," presented at the 1978 meeting of the Association for Education in Journalism. If Jacqueline Onassis could restrict Ron Galella's activities, then won't other public persons, like elected officials, try legally to muzzle the action of investigative photographers? Future law suits will determine whether *Onassis* v. *Galella* will serve as an extreme example of harassment or as a beginning for increased restrictions on the freedom of the press.

In June, 1973, Marlon Brando broke Ron Galella's jaw. The following year Galella wore a football helmet to protect himself when he snapped photos of Brando. What rights does a movie star have to privacy? What rights are lost when an actor or politician becomes famous?
(Paul Schmulbach)

Unfairly Causing Someone to Look Bad

Placing someone in a "false light" simply means making a person look bad without cause. For example, a photographer took a picture of a child struck by a car and the picture appeared in a newspaper. No problem so far. Two years later the *Saturday Evening Post* ran the same picture under the title, "They Asked To Be Killed," with a story about child safety. The original use of the picture was a legitimate publication of a newsworthy event. But when the *Saturday Evening Post* used the headline with the picture, and placed the subhead "Do You Invite Massacre with Your Own Carelessness?" next to the photo, the parents claimed that the words and photo implied carelessness on their part. The court decreed that the photo/headline combination placed the parents in a "false light." The parents won the lawsuit.

In another such incident, John Raible signed a consent form, allowing *Newsweek* magazine to publish his picture with a story about "Middle Americans." The editors chose the headline, "Troubled American—A Special Report

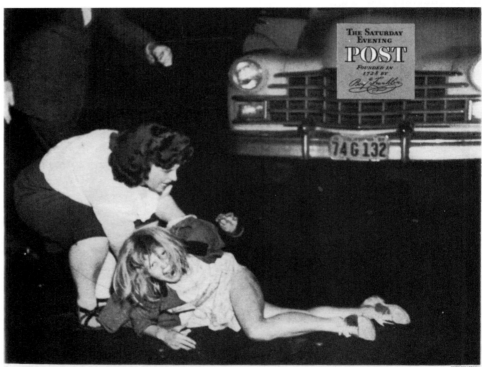

Safety education in schools has reduced child accidents measurably, but unpredictable darting through traffic still takes a sobering toll.

They Ask to Be Killed

By DAVID G. WITTELS

Do you invite massacre by your own carelessness? Here's how thousands have committed suicide by scorning laws that were passed to keep them alive.

SOME years ago, before time banked the fires of his temper, this writer did a thing which every pedestrian must often have been tempted to do—took a punch at a driver who forced him to scurry for his life.

The provocation in this case involved an all-too-common example of dangerous hoggishness by some drivers. The scene was 45th Street and 7th Avenue in New York, one of the busiest intersections in the world. The light changed in favor of pedestrians waiting to cross 45th Street, and this writer and several others stepped off the curb.

The big sedan, going west on 45th, acted as if we worms did not exist. It kept on coming and then, with a blast of its horn, sent us leaping back to the haven of the sidewalk. It did not halt until it was astride our proper path and its front bumper jutted into 7th Avenue. To get across, we pedestrians had either to detour around the rear of the sedan and weave through a pack of cars panting for the green light, or step into the perilous rush of 7th Avenue traffic. The driver, lordlike behind the wheel, did not even deign to look at us.

That did it. It was at least the fifth time that day that I had been forced to scuttle out of some driver's way. Something snapped. Hopping upon the running board, I punched the driver in the mouth. It was an illegal act of violence; it was taking the law into one's own hands, and, as such, it is not to be condoned. But it also gave a fine feeling of satisfaction, even though delivered awkwardly through a partly opened window, the punch didn't do much damage. For once a lowly pedestrian had turned; for once a hoggish driver got at least a taste of what was due him. Probably fortunately for me, the driver did not try to retaliate. After a moment of startled bewilderment, he did look as if he might get out of the car and make something of it. But just then the lights changed and horns began honking. Prodded by the horns and perhaps also by his conscience, the driver drove on.

This incident is cited not merely for the psychic satisfaction it may give fellow pedestrians but because it epitomizes the continual, curse-laden, running feud between pedestrians and motorists. It is a Doctor Jekyll and Mr. Hyde sort of feud, since all

motorists are at times pedestrians, and very many pedestrians are also motorists. The same man who rages at "the crazy drivers" will, when in the driver' seat himself, snarl at the "damn-fool pedestrians who get in his way.

It is a feud which has sired innumerable jokes, be cause man is a peculiar creature who helps conditio himself against the fear of recurring danger by laugh ing about it. But it is also a vicious, blood-drenche feud which almost continuously keeps the shadow o death hovering over every family in this country.

In this feud the pedestrian practically always lose He risks his life and limbs almost every time he step off the curb or strolls along a country highway. H literally would be safer on a lion-infested Africa veld or in man-eating-tiger territory than he is cros ing a downtown street at dusk. Steel-jacketed mor sters which outweigh him from 10 to 1 to 100 to come roaring at him from several directions. Th pedestrian is much like a hunted animal, always i season. Armored only by thin layers of clothing an

The parents of this child, claimed that the combination of words and pictures implied that they were careless, thus placing them in a false light. When they sued the Saturday Evening Post, *the court decided in their favor.*
(Reprinted from THE SATURDAY EVENING POST, © 1949 The Curtis Publishing Company)

on the Silent Majority," and printed Raible's picture below the headline. He felt that the headline, associated with his picture, implied he was troubled, thus putting him in a "false light." Raible sued and collected damages.

Both the *Saturday Evening Post* and the *Newsweek* cases indicate that the meaning of a picture can be affected drastically by the words associated with it. Although the picture itself might have been legal when it was taken, after captioning or headlining, the photo-plus-word combination can be considered illegal. Robert Cavallo and Stuart Kahan, in their book *Photography: What's the Law?*, say that "Pictures, standing alone, without caption or stories with them, generally pose little danger of defamation. However, an illustration is usually accompanied by text and it is almost always that combination of pictures and prose which carries the damaging impact."

The *Newsweek* case points up a second legal danger for the photographer to watch for. The consent form signed by Raible did not protect the photographer. The consent form is not a carte blanche; it is a limited authorization given by the subject to the photographer, warning the photographer to use the picture in an understood and agreed-on manner. A consent form does not give photographers, or picture editors, the right to use a picture in any way they see fit.

Taking Truthful But Private or Embarrassing Photos

The right of privacy does include some restrictions on printing truthful but private or embarrassing information about a subject. Generally, if the information is newsworthy and in the public interest, the press can photograph and publish the facts. The courts have liberally interpreted "public interest" to mean anything interesting to the public—and there are few things that won't interest some people.

The courts, however, have put certain limitations on the right of the public to know and see true but confidential facts about a person. Photographs, even if taken in a public place, should not ridicule or embarrass a private person unless the situation is patently newsworthy. A picture of Ms. Graham in a fun house with her skirt blown up was the basis for a successful suit against the *Daily Times Democrat*, in which the court awarded damages.

You may take pictures of children; however, if the child is in a class for the retarded or handicapped and you take his picture, his parents may consider that photo truthful, but embarrassing. They could sue you and your newspaper. Getting the teacher's permission is not sufficient. For you safely to run the picture of the retarded or handicapped child, you must have the consent of the parent or legal guardian.

You can take and publish pictures of children in schools and public parks. You are open to suit only if the photo might be considered embarrassing or derogatory. You are relatively safe from suit, even if the picture is potentially embarrassing, if the child understood you were going to use the picture for publication and was old enough to give an informed consent, or if you obtained the consent of the child's parents.

Hospitals Are Off Limits

In 1942 an International News Photo photographer entered the hospital room of Dorothy Barber. Barber was in the hospital for a weight loss problem. Without the woman's consent, the photographer took a picture of Barber, and *Time* magazine bought the photo and ran it under the headline "Starving Glutton." Barber sued the magazine and *Time* lost the case. The court in Missouri said, "Certainly if there is any right of privacy at all, it should include the right to obtain medical treatment at home or in a hospital without personal publicity."

Dorothy Barber had what the court considers a "private medical condition." Therefore, a photographer could not take her picture without her permission.

If someone is injured in an automobile accident or plane crash, falls out of a tree or drowns, or is struck by lightning, that person would have a "public medical condition." In addition, if a person is shot by someone who is in the process of committing a crime, that person's condition would be considered "public." People who are victims of a crime, accident, or act of God are considered newsworthy, and they can be photographed *outside* the hospital.

If an accident happens on First and Broadway, the photographer can begin taking pictures of the victim upon arriving on the scene, because the victim has a public medical condition and is not in the hospital. As the rescue team places the victim on the stretcher and slides the body into the ambulance, the photographer is still within legal rights to continue to photograph. Once the victim enters the emergency van the individual is covered by the right of privacy and, therefore, is off limits to press photographers. The same off limits rule inhibits photographers when the victim enters the hospital. An exception to the general rule on "public condition" involves rape victims, who generally have statutory privacy protection even though they are not in a hospital. Rape victims' identities remain confidential.

If a person's condition is newsworthy, interesting, and historic, but the condition is not caused by crime, accident, or act of God, the person's medical condition is considered "private." Barber's obesity treatment was "private." The first heart and kidney transplant operation by the world-famous Dr. Michael Debakey and the first test-tube baby were both "private medical conditions" even though they were newsworthy. Photographers could take pictures inside the hospital only if the patients involved granted permission.

Without Dorothy Barber's permission, a photographer took her picture in her hospital room. The photo was printed in Time *magazine. Barber sued for invasion of privacy and* Time *lost the case.*
(International News Pictures)

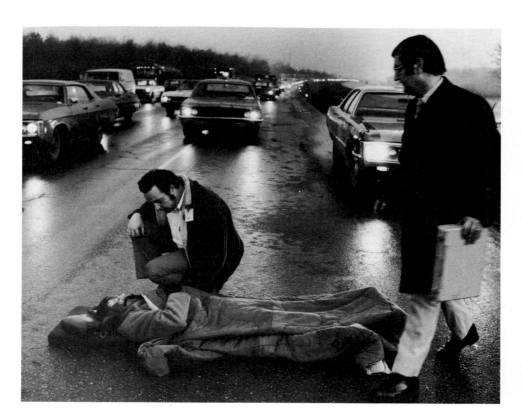

A photographer has the legal right to cover a person who has a "public medical condition." However, coverage stops when the person enters the emergency van or the hospital.
(Richard J. Bielinski, *Herald* File, Print Division, Boston Public Library)

WHERE CAN YOU TAKE PICTURES?

Shoot Freely in Public Places

You may photograph in public places and on public property. You can take pictures on the street, on the sidewalk, in public parks, as well as in the public zoo. You can photograph in the city-owned airport as well as in public areas of schools and universities. However, without the teacher's permission, you can't take pictures of a class in session.

You may take pictures of elected officials or private citizens in public places, such as the street or the park. The person may be the center of interest in your photo, or just a member of the crowd. If a news event occurs on public property, then you have the legal right to cover that event as long as you do not interfere with the police or the free flow of traffic.

There are times when bystanders or relatives try, by physical assault, to prevent a photographer from taking a picture. In such instances, the courts have generally stepped in to protect the photographer's right to take pictures in a public place, according to George Chernoff and Hershel Sarbin in their book, *Photography and the Law.* They note that some years ago New York State even made it unlawful to injure the equipment of news photographers engaged in the pursuit of their occupation in public places.

Difficulties arise when police authorities are not aware of the legal protection afforded photographers who are working on public property. In many situations, an overeager police officer may block the lens of the photographer. In Iowa, photographers were once prevented by highway patrol men and National Guardsmen from taking close-ups at the scene of a civilian airliner crash. When airline officials arrived, photographers were given a free hand. In Philadelphia, police forcibly prevented photographers from taking pictures as the officials bounced a heckler from a political rally. Philadelphia's city solicitor issued a formal opinion in which he told the police commissioner that, "Meaningful freedom of the press includes the right to photograph and disseminate pictures of public events occurring in public places."

Police and fire officials have the right to restrict any activity of a photographer that might interfere with the officials' action. But taking pictures and asking questions do not constitute interference. Unfortunately, if a police officer stops a photographer at the scene of a breaking-news event, the photographer might find it hard to argue a fine point of law with an insistent cop. Photographers who disregard police directives can be arrested for disorderly conduct or for interfering with a police officer in the performance of duty, constituting a possible felony.

Government Buildings—Public But Under Special Rules

Although facilities may be publicly owned, a photographer does not have unlimited access to government buildings, such as the U.S. Senate and House of Representatives, the state legislature, or the chambers of the city council. The mayor's office, city prison, and hospital also fall under the special-rules category.

As mentioned above, hospitals, even if they are publicly owned, publicly supported, and publicly operated, occupy a special place under the law. It's true that the admission list to hospitals is public information, but that's about all that is public. You might be allowed to photograph scenes in a hospital for, say, a feature story. But check your pictures. Are there people in the pictures? Yes. Are some of the people in the pictures patients? Yes? Are they identifiable? Yes. Do

Even though a hospital is publicly owned and operated, you still must get permission from each person appearing in your pictures.
(Ken Kobre, University of Houston)

you have a release form? No? But you say the people in the photo are "incidental." For instance, a picture taken of a corridor or waiting room shows several people sitting and reading magazines. No matter. The incidental defense won't work here. You should (a) get a release form; (b) don't run the picture; or (c) make the subjects unidentifiable in the darkroom or on the art table with the aid of an air brush.

The halls of the United States Congress are certainly public places, as are meeting rooms of state legislatures and city councils. But such places are generally run by their own unique rules. Even though the House of Representatives does allow television cameras limited access to debates, this legislative body will not allow photographers to take still pictures at a regular session of Congress. Politicians are afraid that the uncensored film of the still photographer will catch one of the members of this august body taking a nap, reading the newspaper, or, as is more often the situation, not present. Photographers are usually allowed in the U.S. House or Senate chambers only during ceremonial sessions, such as the opening day of Congress.

Photographers can snap legislators in committee meetings, elected officials in the halls of Congress, or legislators in their offices. Certain buildings—the Capitol and its grounds, all the House and Senate office buildings, the Library of Congress, and the General Accounting Office—are controlled entirely by the rules passed by Congress. The Constitution grants Congress the right to formulate special rules for operating these buildings. These rules are not subject to judicial review.

The Courtroom—Another Special Situation

What about the courtroom? The Sixth Amendment to the Constitution guarantees a defendent a fair, speedy, and *public* trial before an impartial jury.

Public trial has come to have two meanings. First, the trial will be in the open; there will be no secret trials. Second, the public has the right to attend the trial. Naturally, most courtrooms have a limited capacity, hence the public attends the trial through the press coverage. But the press, in covering the trial, might prejudice witnesses and jurors. This is the conflict between the First Amendment's free press guarantees and the Sixth Amendment's fair trial requirements. If the trial coverage by a newspaper or television station, however, prevents a fair trial, then the defendant, regardless of guilt or innocence, gets a new trial or goes free.

The Supreme Court feels that there is no First Amendment *requirement* to allow the photographer or the television camera operator into the courtroom. The court believes that the reporter and sketch artists are sufficient to fulfill free speech and press requirements.

History of the Camera in the Courtroom

The United States Supreme Court does forbid the presence of photographers in federal courtrooms but not in lower courts. The effort of photojournalists to obtain access rights to both federal and lower courtrooms has had a turbulent history. A low watermark occurred during the trial of Bruno Richard Hauptmann for the kidnapping and murder of Charles Lindbergh's infant child. Lindbergh had captured the imagination and admiration of the entire world for his solo trans-Atlantic crossing. The kidnapping and murder of his child attracted worldwide interest, and an estimated 700 reporters, including 129 photographers, came to the old courthouse in Flemington, N.J., to cover the trial.

Photographers were allowed to take pictures in the courtroom only three times each day; before court convened, at noon recess, and after court adjourned. Early in the trial, however, a photographer took unauthorized pictures of Lindbergh on the stand. The photographer claimed that he was "new on the job, having been sent as a relief man, and he did not know the rulings."

Another illegal picture was taken at the end of the trial. Dick Sarno of the *New York Mirror* concealed a 35mm Contax camera when he entered the courtroom on February 13, 1935, the day the verdict and sentence were announced. At the key moment of the proceedings, Sarno, who had wrapped his Contax in a muffler to conceal the noise, took a one-second exposure of the courtroom. Sarno later related, "As Hauptmann stood up and faced the jury, you could hear a pin drop. I tilted the camera which I had braced on the balcony rail. The judge was directly in front and below me. If he looked up, I was sure he could see me." As the foreman of the jury stood to recite the verdict, Sarno recorded the instant.

The three-ring circus atmosphere created by the photographers and reporters covering the trial outside the courtroom as well as the indiscretions of the still and newsreel cameramen shocked a committee of the American Bar Association (ABA) that reviewed the legal proceedings in 1936. The ABA Committee recommended banning photography and broadcasting. The 1937 convention of the group adopted this rule as the 35th canon of Professional and Judicial Ethics. Many, but not all, states adopted these canons, effectively slamming the courtroom door shut on photojournalists.

By the 1950s, the National Press Photographers Association (NPPA), led by Joseph Costa, began a drive to overcome the photo ban of Canon 35. Some states, such as Colorado, Oklahoma, and Texas, did allow photography in the courtroom under restricted conditions. In 1962 a Texas judge approved cameras in the pretrial hearing of Billie Sol Estes, who was accused of numerous counts of fraud. The trial judge allowed the courtroom to be modified to accommodate six television cameras (two inside the courtroom) and nine still cameras. This modification led to the hiring of carpenters to add platforms to the courtroom and required prospective jurors and witnesses to circumnavigate a maze of cables and lights on the way to the witness stand. Unfortunately, while one of Estes's attorneys was protesting this atmosphere, a news photographer walked behind the judge and photographed the lawyer as he delivered his objections! Estes's attorneys successfully appealed his conviction to the Supreme Court, arguing that the trial courtroom had been virtually turned into a studio.

During Richard Hauptmann's trial for kidnapping and killing Charles A. Lindbergh's baby, the judge allowed photographers to take pictures in the courtroom before court, during recess and after court ended. On January 3, 1935, Lindbergh himself took the stand. In spite of the judges orders a photographer snapped the picture during the trial. With only a few exceptions, after this trial, cameras were barred from the courtrooms until the 1970s.
(Wide World Photos)

The Supreme Court's 1965 reversal of Estes' conviction emphasized that the First Amendment rights of the press and the public "do not require, nor are they violated by, denying photographers, cinematographers, and television cameramen access to a courtroom." The Court stressed that the presence of cameras and of television equipment is likely to have a distracting impact on the jury and witnesses, and that this impact can potentially harm the rights of the defendant. Fortunately, however, the high court did not ban cameras per se, but the tone of the decision effectively closed the courtroom under all but the most unusual conditions for another decade, except in Colorado, which continued to allow cameras in the courtroom after the Estes decision.

Restrictions Easing

According to Frank White's monograph "Cameras in the Courtroom: A U.S. Survey," by late 1978 nineteen states had rules allowing photographers to cover *some trials.* The states leading the way were Florida, Alabama, Oklahoma and Ohio, with Florida being by far the most famous and most important.

Florida's judicial system and legal code are viewed as the model by many states. Thus, when the Florida Supreme Court opened the courtroom to photographers and television equipment on a limited basis for a one-year period, the event was significant. The Florida test allowed nation-wide broadcast of the Ronnie Zamora trial. Zamora, 15, was charged with killing his 82-year-old neighbor. Zamora's attorneys tried to blame commercial television for the murder committed by their client, claiming that the boy was under "involuntary subliminal television intoxication." This defense was unsuccessful. But the experiment allowing photographers to cover the trial worked well. With modern-day fast films and compact electronic television cameras, photographers did not require excessive lighting nor did their behavior interfere with the progress of the trial. Florida permanently opened its courts to the camera. Other states instituted trial periods for the camera in the courtroom. The press and, therefore, the public are the winners of this cameras-in-the-courtroom battle.

Private Property Open to the Public

Do you have the right to take pictures on private property that is open to the public, such as a restaurant or grocery store? This area of the law is murky. Some authorities hold that you can take pictures unless the management has posted signs prohibiting photography or unless the owners object and ask you to stop. For instance, CBS was sued when its photographer entered the Le Mistral restaurant in New York with cameras rolling to illustrate a story about the sanitation violations of the establishment. The management objected but CBS kept filming. CBS lost the suit on the ground that the photographer had entered without the intention of purchasing food and was therefore *trespassing.* CBS was covering a legitimate news story in a private establishment open to the public, yet CBS was found guilty of trespassing. The network is appealing the case. In an earlier case (*Lloyd Corp., Ltd.* v. *Tanner,* 1972) the court ruled that "the public's license to enter a private business establishment is limited to engaging in activities directly related to that business and does not normally extend to the pursuit of unrelated business, e.g., newsgathering." Camera journalists have no right to enter the property, even in a spot news situation, if they are prohibited by the owners of the establishment. Photographers must take their pictures from the public street or they can be sued for trespass. This means that if a fire is raging inside a business the management can exclude photographers. If the management asks you to leave, you must comply with the request or you can be arrested for trespassing. However, any pictures you have already taken, you can publish. The proprietor can stop you from taking more pictures but he can't restrict you from printing the ones you already have.

Sometimes a manager will demand the film you have taken inside his store. On this point the law is clear. You do *not* have to give up your film. The owner or manager can ask you to stop taking pictures, but can't take away your film. That film is your personal property and you have every right to keep it.

Limitations on Photographing People in Their Private Homes

Can you take a picture inside a person's home? As mentioned earlier in our discussion of the Fletcher case, you can photograph in a person's home if the owners do not object. If you were riding down the street and heard a gunshot followed by a scream coming from a house, you could park your car, enter the house, and begin photographing the victim and the assailant. If the homeowner realized what you were doing and didn't like it, the owner could ask you to leave. You would have to obey, or be arrested for trespassing. Even if the police are there, you would have to leave if the homeowner objected to your presence. However, if the resident did not object, the police shouldn't ask you to leave.

The Florida Highway Patrol, after a strong protest from the *Palm Beach Post Times* about the harassment of two staff photographers, issued a statement of policy regarding "Journalists' Right of Access to Crime, Arrest or Disaster Scenes." The statement in part said, "It is the longstanding custom of law-enforcement agencies to invite representatives of the news media to enter upon private property where an event of public interest has occurred. . . ." "Invite," in this instance, does not mean literally to receive a formal invitation. Invite means *to allow* the photographer to enter. The common custom exists for photographers to cover news events and not be harassed or otherwise blocked by the police. The photographer should not wait for an engraved invitation from the cop at the scene before beginning to photograph. The Florida Highway Patrols' policy statement goes on to say that "the presence of a photographer at an accident, crime, or disaster scene and the taking of photographs at the scene does not constitute unlawful interference and should not be restricted." Unfortunately, this position is a policy statement of the Florida Highway Patrol, not a national law; therefore, the policy is not followed by police and firefighters in every state.

The National Press Photographers Association and some of its chapters have for years worked with fire and police academies to improve the graduates' understanding of the role of news in society. The Pennsylvania and the Philadelphia Press Photographers Associations were among the first to undertake such a program beginning in the 1950s. The result has been improved cooperation between photographers and fire and police personnel.

LIBEL LAWS AND THE PHOTOGRAPHER

Libel is a printed, written, or pictorial statement that is defamatory to a person's character and reputation. Since truth is a defense in libel cases, and since photos represent actual scenes and are truthful, it might seem that a person should not be able to win a libel suit against a photographer because of a picture the photographer took.

A few successful libel suits have been based on photographs. Photographs can subject a person to ridicule, contempt, or hatred just as effectively as words can. Photographs can lie, or at least appear to lie, and photos in conjunction with print may form the basis for a libel suit.

Usually, a photo alone is not libelous, although such cases have happened. The most famous involved Mr. Burton, who was paid for a cigarette en-

Where and When a Photojournalist Can Shoot

	Any time	If No One Objects	With Restrictions	Only With Permission
Public Area				
Street	X			
Sidewalk	X			
Airport	X			
Beach	X			
Park	X			
Zoo	X			
Train Station	X			
Bus Station	X			
In Public School				
Preschool	X			
Grade School	X			
High School	X			
University Campus	X			
Class in Session				X
In Public Area—With Restrictions				
Police Headquarters			X	
Govt. Buildings			X	
Courtroom				X
Prison				X
Legislative Chambers				X
In Medical Facilities				
Hospital				X
Rehab Center				X
Emergency Van				X
Mental Health Center				X
Doctor's Office				X
Clinic				X
Private but Open-to-the-Public				
Movie Theatre Lobby		X		
Business Office		X		
Hotel Lobby		X		
Restaurant		X		
Casino				X
Museum			X	
Shooting from Public Street into Private Area				
Window of Home	X			
Porch	X			
Lawn	X			
In Private				
Home		X		
Porch		X		
Lawn		X		
Apartment		X		
Hotel Room		X		
Car		X		

dorsement. For an advertisement, Mr. Burton was photographed holding a saddle in front of him. In the photograph, quite by accident, the saddle's white girth strap appeared to be attached to the man, giving, in the court's words, a "grotesque, monstrous, and obscene" effect. The photo was libelous.

In some situations, when words have been added to photos either in the form of headlines, cutlines, or stories, the photo/word combination resulted in libel cases. The photograph itself may be harmless, but the caption or accompanying article may add the damaging element. For example, The *New York American* once printed a photograph of a wrestler, Zbyszko, next to that of a gorilla, with the caption: "Not fundamentally different in physique." The photo plus word combination was libelous. As in the privacy issues, the photographer must be particularly careful how his pictures are associated with words.

PRESS CREDENTIALS' VALUE USEFUL, BUT LIMITED

Press credentials issued by the newspaper or magazine for which you work are a means of identification and nothing more. Press passes don't entitle you to anything. Authorities use press credentials to determine if you are an official representative of the media. Once the officials have determined your affiliation they can "invite" you on to the scene of a crime or disaster.

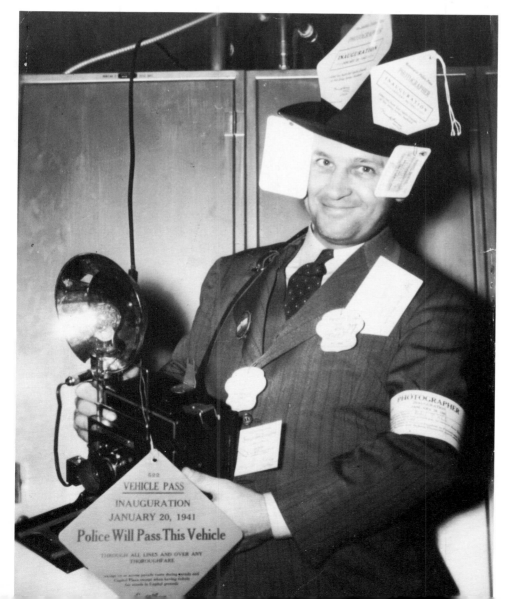

Press credentials provide identification. (Wide World Photos)

Essentially, that press pass does not give you any more rights than those rights held by the public. The press credential does not give you the right to break the law, even if you are in the hot pursuit of a big news story. The press credentials issued by the highway patrol or the state police carry no legal weight, other than proof that you work for a newspaper or magazine. Official credentials can be ignored or recalled at any time by the law enforcement agencies that issued them.

At the scene of a crime or disaster, the authorities cannot discriminate against you or your newspaper. All reporters, photographers, and TV camera operators must have an equal opportunity to cover the story. The police cannot select one newspaper photographer and reject another. Nor can police choose to let in television camera crews and keep out still-photographers. If the crime scene is crowded, however, they can ask photographers to cooperate and form a pool. One representative of the pool will photograph in the restricted area, and then share the pictures with the other photographers.

COPYRIGHT—WHO OWNS THE PICTURE?

When the Employer Owns the Photos

When you take a picture for your newspaper or magazine, or when you are hired for an assignment for free-lance work, the copyright of your photos is owned by your employer if you have signed or otherwise agreed to a "work for hire" agreement. If you have done so, the employer holds the rights to the pictures and can reprint or resell the photos. Protecting those rights is the employer's concern. Usually the entire newspaper or magazine is copyrighted, including all material contained in the issue.

You may, however, form other specific contractual arrangements with your employer whether you are full time or work on a free-lance basis. For instance, when a company hires you for a staff position or a single assignment, you can agree to take the job only with the stipulation that you own the negatives and transparencies, with the rights to sell the photos after the company has published the original story. In fact, you can negotiate any contract you want with your employer as long as you arrange the details before you sign on the dotted line.

Newspaper and magazine policies differ on their contractual arrangements with photographers. Some papers keep the negatives and prints permanently. When newspapers sell a picture to another organization, they retain the profits but usually give the photographer a credit line. Other papers give the photographer a percentage of the profits from any resales. Some papers give the negatives to the photographer after a fixed period of time; other periodicals let the photographer retain the negatives and prints immediately after the paper publishes the photos the first time.

If you take pictures on your own, however, and then sell those photos to a paper or magazine, you own the negatives and the copyright, as long as you did not make any other arrangement with the news agency that bought the pictures. When you sell a picture that you did not take on assignment, but, rather, shot on your own time with your own film, you can form several arrangements with the news agency buying the picture, as long as you form these agreements at the time of the sale. You can sell the agency one-time rights. After the newspaper or magazine publishes the photo you can resell the picture to another news outlet. In a second type of arrangement, you can sell the picture to the news agency giving them exclusive rights to the picture for a specified period of time. In a third type of agreement, for even more money, hopefully, you can sell your copyright. This means that only the agency has the right to distribute and sell the photo. You no longer have that right. If you formed no specific agreements

with the agency when you sold the picture, you automatically retain your copyright. The agency has first publication rights but you can resell the photo to other news outlets later.

Copyrighting Your Own Photos

If you don't work for a paper or you are not on a magazine assignment how do you protect yourself from someone reprinting your photos and not giving you credit or paying you? How do you prove the printed photo is yours if it does not carry your credit line?

To protect your rights, put your copyright notice on the back of each print with either of the following notations: ©, copr., or Copyright, your name and the date. Although it is not required, it is a fairly common practice to include a statement which reflects the concept of "all rights reserved" or "permission required for use."

After you've put the copyright notice on the back of the print, you can immediately register the print with the United States Copyright Office in Washington, D.C. by filling out a form, sending two copies of the print, and paying a fee, or after the photo is published sending two sheets from the publication issue and paying a fee. But you do not have to register the print with the Copyright Office immediately, as long as you mark the photo with a copyright notation

In fact, you never have to register the photo with the Copyright Office unless someone prints your picture without paying you, and you want to sue. Registration of the copyright in Washington is not necessary to maintain your rights, only to defend against infringement of them.

If you feel that someone is using your pictures in a manner that constitutes infringement, you must register your work as a prerequisite to filing an infringement suit. The advantage to registering your material as close to the original publication date as possible lies in the fact that the type of damages you can collect is tied to the registration date. For infringement prior to the registration date, the law allows only the award of actual damages and an injunction barring further infringement. However, for proven infringement after registration date, the law allows for the assessment of additional statutory damages and legal fees. Regardless of whether you decide on immediate or delayed registration, remember that registration must occur within five years of original publication and no suit may be filed and no damages collected without registration.

PHOTOGRAPHERS FACE ETHICAL ISSUES

The law does not restrict a photographer from setting up a "handshake" shot at an awards banquet. But should a photographer arrange the visual news in this way? The law does not restrict a photographer from taking pictures of a grieving woman at the scene of a grisly auto accident that killed her husband. But should the photographer aim the camera and snap the shutter at this tragic moment?

Stage-Managing the Picture

Certain news developments are predictable and scheduled; others occur without warning in places where photo coverage would be impractical or impossible. Photographers often attempt to stage-manage or re-create the situation to whatever degree they can.

Under what circumstances should you stage a photo? When Walter Wilcox was Chairman of the Department of Journalism at the University of California, Los Angeles, he designed a study to determine the attitudes of readers, photographers, and editors toward staging news pictures. He sent a questionnaire to three groups of subjects; general public, working photographers, and managing

editors. On a three-level scale, each group evaluated sample situations a photographer might face as "definitely unethical," "doubtful," or "not unethical." Here are three sample situations from Wilcox's study.

> *Murder trial:* A photographer attempts to get a shot of a woman murder trial defendant, but she consistently evades him by shielding her face, or ducking behind her escorting warden. The photographer spots another woman who looks like the defendant and by diffusing the light and adjusting the focus, he gets a striking picture which no one will challenge as being fake.

How would you rate the photographer's efforts? Why?

> *Ground breakers:* A photographer covers a ground-breaking ceremony for a new church. Local dignitaries have already turned the first bit of earth before the photographer arrives. He asks that the ceremony be repeated. The dignitaries cooperate, and he gets his picture.

What's your rating of this situation? Would you have had the scene repeated?

> *Cricket plague:* A plague of crickets is devastating the hinterland. A photographer goes out to cover the story but he finds the crickets are too far apart and too small to be recognizable in a picture. He feels that he could get a better picture if the crickets were shown in a mass, and to that end he builds a device which brings crickets through the narrow neck of a chute. He gets his shot of closely massed crickets on the march.

What about the ingenuity of this cameraman? Did he violate an ethical standard?

Wilcox found that the general public, managing editors, and working photographers agreed to a remarkable extent on what was ethical and unethical. In the trial example, 92 percent of the public, 93 percent of the photographers, and 99 percent of the editors felt that the photographer was *definitely unethical* to photograph one person and claim it was another, even if the two looked similar. By comparison, 83 percent of the public, 88 percent of the photographers and 94 percent of the managing editors thought it was not unethical to restage the ground-breaking ceremony. The public, the editors, and the photographers seem to operate within the same ethical guidelines allowing for "setup" pictures, but ruling out clearly faked photos.

All three groups, however, had a much harder time deciding whether the photographer who collected the crickets for a more dramatic shot acted ethically. The public was almost evenly divided between calling the photographer's action definitely unethical (29 percent), doubtful (39 percent), or not unethical (32 percent). Managing editors were similarly split between definitely unethical (23 percent), doubtful (34 percent), and not unethical (44 percent). Photographers, on the other hand, who probably have had to face this or similar problems, were much more likely to consider trapping the crickets to achieve a better photo part of a photojournalist's routine job. Only 7 percent of the photographers polled felt the photographer in the example was definitely unethical; 30 percent considered his behavior doubtful; but a whopping 63 percent felt that the cricket photographer was not wrong. One could assume that two-thirds of the photographers polled would have rigged the shot if they were faced with the same situation.

Fred Parrish, a teacher at the College of Journalism and Communication at the University of Florida, carried out a similar study, and reached the same conclusion as Wilcox.

Dignitaries break ground for the John F. Kennedy Presidential Library. Is it wrong to stage-manage a picture such as this? Most photographers, editors, and the general public believe that repeating a ground-breaking ceremony for the purpose of taking pictures is ethical. (George Rizer, Boston Globe)

Most photographers would prefer to avoid staging events. They like to be the proverbial fly on the wall—all seeing but never seen. Given the limitations of the camera, however, and the pressures of a deadline, not every picture a photojournalist takes will be candid. Perhaps a general rule of thumb might be that photographers are within ethical bounds as long as the photograph they shoot illustrates the news accurately, even if the picture does not record the event as an exact facsimile.

All Tragedies Don't Need Photo Coverage

When injuries occur at a car crash or hotel fire, bystanders and relatives often block a camera reporter from taking pictures. Understandably, these people are upset. They often view the photographer as a vulture, living off the misfortunes of others. While the law gives the photographer the right to take a picture, the law is not a human being who has just lost a son or daughter. John L. Hulteng in his book *The Messenger's Motives,* writes that, ''Photographers have acquired the reputation of being indifferent to the human suffering they frame in their viewfinders.''

Photographers, on one hand, have a moral responsibility to their readers

The woman on the right has just seen her grandson accidentally killed by the police. A photographer has the moral responsibility to picture the world accurately, but also the personal responsibility not to increase individual suffering of a victim's friends and relatives. (Bela Ugrin, copyright © The Houston Post)

to picture the world accurately, showing both its triumphs and its tragedies. On the other hand, they have a personal responsibility to themselves not to inflict greater psychological suffering than is necessary on the survivors of a tragedy.

If you are familiar with your equipment, at the scene of an accident you can usually take a few quick, available-light, candid shots nearly unnoticed. Beyond these photos, you must weigh the short-range pain of your presence versus the long-range value of your potential photos—a difficult judgment each photographer must make.

Eddie Adams, who took the photo of the Viet Cong suspect as he was assassinated in the streets of Saigon (see p. 222), told me about a photo he *didn't* take while he was covering that war:

On a hilltop in Vietnam, I was pinned down with a Marine company. Machine guns were going off. Dead bodies were lying on either side of me. Rocket fire seemed to be coming from everywhere. I was lying on the ground five feet away from an 18-year-old marine. I saw fear on that kid's face like I had never seen before. I slid my Leica, with its preset 35mm lens, in front of me. I tried to push the shutter but I couldn't. I tried twice more but my finger just would not push the button. Later, I realized that I was just as scared to die as that kid was. I knew my face looked exactly like his and I would not have wanted my picture seen around the world. I think his and my face said WAR, but I still think I did the right thing by not taking that picture.

Boris Yaro, a *Los Angeles Times* photographer, had no trouble making the

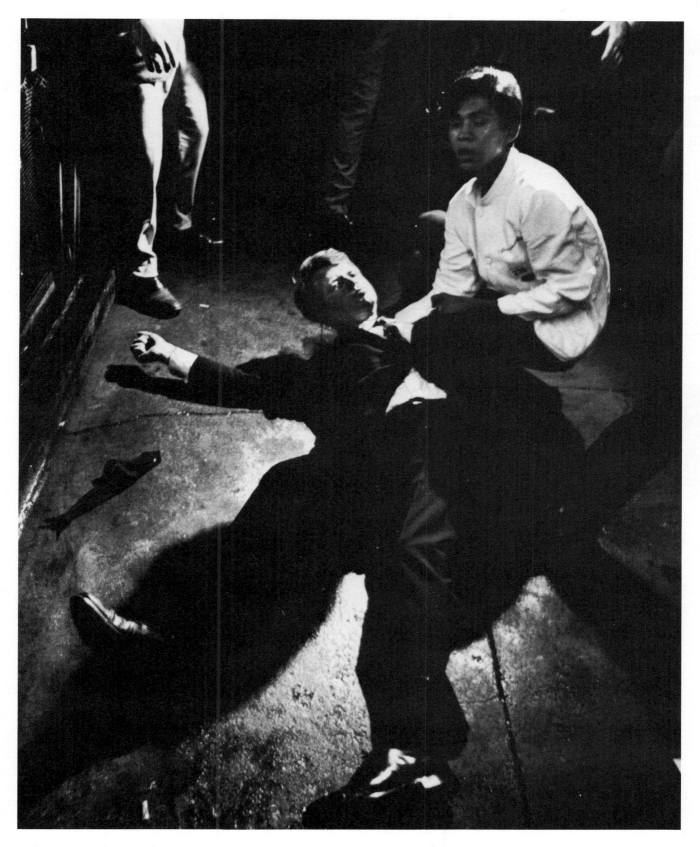

Robert Kennedy was shot in a Los Angeles hotel. A woman bystander blocked
Boris Yaro's camera. He said to her, "Goddammit, lady, this is history!" and
took this unforgettable picture.
(Boris Yaro, © Los Angeles Times)

decision to take pictures when he photographed Robert Kennedy's assassination at the Ambassador Hotel on June 5, 1968. Later he told the story to John Faber, author of *Great News Photos*.

"I was trying to focus in the dark when I heard a loud Bang! Bang! I watched in absolute horror. I thought, 'Oh my God it's happening again! To another Kennedy! I turned towards the Senator. He was slipping to the floor. I aimed my camera, starting to focus when someone grabbed my suit coat arm. I looked into the dim light, seeing a woman with a camera around her neck screaming at me. 'Don't take pictures! Don't take pictures! I'm a photographer and I'm not taking pictures!,' she said." For a brief instant, Boris Yaro was dumbfounded. Then he told her to let go of him. "I said, 'Goddammit, lady, this is history!' " He took his photographs.

Law References

Barber v. Time 1 med. L. Rep. 1779.

Burton v. Crowell Publishing Co., 81 Fed. 154 (2d Cir. 1936).

Daily Times Democrat v. Graham, 276 Ala. 380 162S. 2d 474 (1964).

dietemann v. Time 449 F. 2d 245.

Estes v. Texas, 381 U.S. 532, 536.

Florida Publishing Co. v. Fletcher 340 So. 2d 914.

Galella v. Onassis, 487 F. 2d 986.

Le Mistral v. Columbia Broadcasting System, N.Y. Sup. Ct., N.Y. L.J. 6/7/76.

Leverton v. Curtis Publishing Co., 192 F. 2d 974 (3rd Cir. 1951).

Lloyd Corp., Ltd. v. Tanner, 407 U.S. 551, 92 S. Ct. 2219, 33 L. Ed. 2d 131 (1972).

Maritote v. Desilu Productions, Inc. 345 F. 2d 418.

People v. Berliner 3 Med. L. Rep. 1942.

People v. Zamora 361 So. 2d 776.

Raible v. Newsweek, Inc. 341 F. Supp. 804 (1972).

Sbyszko v. New York American, 1930: 239 NYS, 411.

BIBLIOGRAPHY

Alland, Alexander. *Jacob A. Riis.* Millerton, N.Y.: Aperture, 1974.

Arnold, Edmond C. *Modern Newspaper Design.* New York: Harper & Row, 1969.

Aver, Michel. *The Illustrated History of the Camera: From 1839 to Present.* Boston: New York Graphic Society, 1975.

Baynes, Ken. *Scoop, Scandal and Strife.* New York: Hastings House, 1971.

Baxter, William S.; Quarles, Rebecca; and Kosak, Herman. "The Effects of Photographs and Their Size on Reading and Recall of News Stories." Paper read at the Photojournalism Division, Association for Education in Journalism, Seattle, 1978.

Bergin, David P. *Photojournalism Manual: How to Plan, Shoot, Edit and Sell.* New York: Morgan & Morgan, 1967.

Best of Photo Journalism II. New York: Newsweek Books, 1977.

Best of Photo Journalism III. New York: Newsweek Books, 1978.

Blake, Donald P. "Anybody with a Camera Can be a Newsman." *Popular Photography* (February 1967): 81.

Blumenfeld, Harold. "The Wire Services That Want You." *Popular Photography* (January 1974): 88–89.

Bourke-White, Margaret. *Portrait of Myself.* New York: Simon & Schuster, 1963.

Bowden, Robert. *Get That Picture.* Garden City, N.Y.: Amphoto, 1978.

Brill, Charles. "The Early History of the Associated Press Wire Photo: 1926–1935." Paper presented to the Photojournalism Division, Association for Education in Journalism, Madison, Wisconsin, 1977.

Brown, Theodore M. *Margaret Bourke-White, Photojournalist.* Andrew Dickson White Museum of Art. Cornell University, 1972.

Buell, Hal, and Pett, Saul. *The Instant It Happened.* New York: The Associated Press, 1975.

Byrne, Howard. *Without Assignment: How to Freelance in Photography.* New York: Pellegrini and Cudahy, 1952.

Callahan, Sean, ed. *The Photographs of Margaret Bourke-White.* Boston: New York Graphic Society, 1972.

Callahan, Sean, and Astor, Gerald. *Photographing Sports: John Zimmerman, Mark Kauffman and Neil Leifer.* Los Angeles: Alskog, 1975.

Capa, Cornell. *The Concerned Photographer.* New York: Grossman Publishers, 1968.

Carnes, Cecil. *Jimmy Hare News Photographer: Half a Century with a Camera.* New York: Macmillan, 1940.

Cartier-Bresson, Henri. *The Decisive Moment.* New York: Simon & Schuster, 1952.

Cartier-Bresson, Henri. *The World of Henri Cartier-Bresson.* New York: Viking Press, 1968.

Cavallo, Robert M., and Crown, Stuart Kahan. *Photography: What's the Law?* New York: Harmony Books, 1976.

Chapnick, Howard. "Words Tell the Reader What Pictures Can't; They Make a Photographer a Photojournalist." *Popular Photography* (February 1979): 70.

Chernoff, George, and Sarbin, Hershel B. *Photography and the Law.* 5th ed. Garden City, N.Y.: Amphoto, 1975.

Cohen, Lester. *The New York Graphic, The World's Zaniest Newspaper.* Philadelphia: Chilton, 1964.

Cohen, Stu. "Focusing on Humanity—The Life of W. Eugene Smith." *Boston Phoenix,* 31 October 1978.

Cole, Bernard, and Meltzer, Milton. *The Eye of Conscience: Photographers and Social Change.* Chicago: Follett, 1974.

Costa, Joseph, ed. *The Complete Book of Press Photography.* National Press Photographers Association, 1950.

Costa, Joseph. "Collected Papers," George Arents Research Library. Syracuse, New York: Syracuse University.

Daniel, Pete, and Smock, Raymond. *A Talent for Detail: Frances Benjamin Johnston.* New York: Harmony Books, 1974.

Deschin, Jacob. "W. Eugene Smith Recalls Brutal Beating While Documenting a Poison Scandal." *Popular Photography* (October 1973): 14.

Dobell, Byron. "The Picture Story." *Popular Photography* (June 1959): 49.

Duncan, David Douglas. *Self Portrait: U.S.A.* New York: Harry N. Abrams, 1969.

Durniak, John. "10 Stories Around You." *Popular Photography* (June 1959): 72.

Durniak, John. "Focus on Wilson Hicks." *Popular Photography* (April 1965): 59.

Dykhouse, Carolina Dow. "Public Policy's Differential Effects on News Photographers." Paper presented to the Photojournalism Division, Association for Education in Journalism, Seattle, 1978.

Dykhouse, Carolina Dow. "Privacy Law and Print Photojournalism." Michigan State University, East Lansing, Michigan, 1979.

Dykhouse, Carolina Dow. "The Detroit Workshop in Photojournalism 1950–1951." Master's Thesis, Michigan State University, 1979.

Edey, Maitland. *Great Photographic Essays From Life.* Boston: New York Graphic Society, 1978.

Edgerton, Harold E. *Electronic Flash/Strobe.* 2nd ed. Cambridge, Massachusetts: M.I.T. Press, 1979.

Edgerton, Harold E., and Killian, James R., Jr. *Moments of Vision: The Stroboscopic Revolution in Photography.* Cambridge, Massachusetts: M.I.T. Press, 1979.

Edom, Clifton. *Photojournalism: Principles and Practices.* Dubuque, Iowa: Wm. C. Brown Co., 1976.

Einsiedel, E.F., and Murray, A. "Content Analysis of the Use of Front-Page Photographs: *Akron Beacon Journal* 1936–1976." Paper presented to the Photojournalism Division, Association for Education in Journalism, Madison, Wisconsin, 1977.

Eisenstaedt, Alfred. *Witness to Our Time.* New York: Viking Press, 1966.

Eisenstaedt, Alfred. *The Age of Eisenstaedt.* New York: Viking Press, 1969.

Eisenstaedt, Alfred. *People.* New York: Viking Press, 1973.

Evans, Harold. *Pictures on a Page: Photo-Journalism, Graphics and Picture Editing.* New York: Holt, Rinehart and Winston, 1978.

Faber, John. "On the Record" [Development of the Halftone]. *National Press Photographer.* February 1957.

Faber, John. "On the Record." [Wire Transmission of Photos]. *National Press Photographer,* April 1958.

Faber, John. "On the Record." [Birth of Life Magazine]. *National Press Photographer,* August 1958.

Faber, John. "On the Record." [History of the Photo Syndicates]. *National Press Photographer,* December 1958.

Faber, John. "On the Record." [Development of the Electronic Flash]. *National Press Photographer,* March 1959.

Faber, John. "This is How NPPA Came into Being." *National Press Photographer,* June 1960.

Faber, John. *Great News Photos and the Stories Behind Them.* 2nd ed. New York: Dover Publications, 1978.

Feinberg, Milton. *Techniques of Photojournalism.* New York: John Wiley & Sons, 1970.

Fosdick, James A. "Stylistic Correlates of Prescribed Intent in a Photographic Encoding Task." Ph.D. dissertation, University of Wisconsin, 1962.

Fosdick, James A., and Tannenbaum, Percy H. "The Encoder's Intent and Use of Stylistic Elements in Photographs." *Journalism Quarterly* 41 (1964): 175–182.

Fox, Rodney, and Kerns, Robert. *Creative News Photography.* Ames, Iowa: Iowa State University Press, 1961.

Galella, Ron. *Jacqueline.* New York: Sheed and Ward, 1974.

Gans, Herbert J. *Deciding What's News: A Study of CBS Evening News, NBC Nightly News, Newsweek and Time.* New York: Pantheon, 1979.

Garrett, Lillian. *Visual Design.* New York: Van Nostrand Reinhold, 1967.

Garrett, W. E., ed. *Photojournalism '76.* Boston: Godine, 1977.

Gatewood, Worth. *Fifty Years in Pictures: The New York Daily News.* Garden City, N.Y.: Doubleday, 1979.

Geraci, Philip C. *Photojournalism: Making Pictures for Publication.* Dubuque, Iowa: Kendall/Hunt, 1976.

Germar, Herb. *The Student Journalist and Photojournalism.* New York: Richards Rosen Press, 1967.

Gidal, Tim N. *Modern Photojournalism: Origin and Evolution, 1910–1933.* New York: Macmillan, 1973.

Girvin, Robert E. "Photography as Social Documentation." *Journalism Quarterly* 24 (September 1947): 207.

Gould, Lewis L., and Greffe, Richard. *Photojournalist: The Career of Jimmy Hare.* Austin: University of Texas Press, 1977.

Gramling, Oliver. *AP, the Story of News.* New York: Farrar and Rinehart, 1940.

Gutman, Judith Mare. *Lewis W. Hine: Two Perspectives.* New York: Viking Press, 1974.

Halsman, Philippe. *Halsman on the Creation of Photographic Ideas.* New York: Ziff-Davis, 1961.

Harris, Louis. "Press Underplay News, Overdone Sports: Readers." *Editor and Publisher* 21 (January 1978): 33.

Harrison, Randall. "Pictorial Communication." *Search,* vol 6. National Project in Agricultural Communication, East Lansing, Michigan, 1962.

Hazard, William R. "Responses to News Pictures: A Study in Perceptual Unity." *Journalism Quarterly* 37 (1960): 515–524.

Hicks, Wilson. *Words and Pictures: An Introduction to Photo-Journalism.* New York: Arno Press, 1973.

Hine, Lewis. *America and Lewis Hine: Photographs 1904–1940.* Millerton, N.Y.: Aperture, 1977.

Horrell, William C. "A Survey of Motion Picture and Still Photography and Graphic Arts Instruction 1976–1977." Rochester, N.Y.: Eastman Kodak, 1978.

Hughes, Jim. "The Nine Lives of W. Eugene Smith." *Popular Photography* (April 1979) 116.

Hulteng, John L. *The Messenger's Motives: Ethical Problems of the News Media.* Englewood Cliffs, N.J.: Prentice-Hall, 1976.

Hurlburt, Allen. *Publication Design.* New York: Van Nostrand Reinhold, 1976.

Hurlburt, Allen. *The Grid: A Modular System for the Design and Production of Newspapers, Magazines and Books.* New York: Van Nostrand Reinhold, 1978.

Hurley, Forrest Jack. *Portrait of a Decade: Roy Stryker and the Development of Documentary Photography in the Thirties.* 1972, reprint. New York: Da Capo, 1977.

Hurley, Gerald D., and McDougall, Angus. *Visual Impact in Print: How to Make Pictures Communicate; A Guide for the Photographer, the Editor, the Designer.* Chicago: American Publishers Press, 1971.

Hurter, Bill. *Sports Photography: Breaking into the Field, How to Capture the Action.* Los Angeles: Petersen, 1978.

Jacobs, Lou, Jr. *Free-Lance Magazine Photography.* New York: Hastings House, 1970.

Jones, Bernard. *Encyclopedia of Photography.* 1911 reprint. New York: Arno Press, 1974.

Kalish, Stanley E., and Edom, Clifton C. *Picture Editing.* New York: Rinehart, 1951.

Karsh, Yousuf. *Portraits of Greatness.* New York: Thomas Nelson & Sons, 1959.

Kendall, Robert. "Photo 1978: Some Provisions of the 1976 Copyright Act for the Photojournalist." Paper presented to the Photojournalism Division, Association for Education in Journalism, Madison, Wisconsin, 1977.

Kerns, Robert L. *Photojournalism: Photography with a Purpose.* Englewood Cliffs, N.J.: Prentice-Hall, 1980.

Kerrick, Jean S. "Influence of Captions on Picture Interpretation." *Journalism Quarterly* 32 (1955): 177–184.

Kerrick, Jean S. "News Pictures, Captions and the Point of Resolution." *Journalism Quarterly* 36 (1959): 183–188.

Kielbowiez, Richard B. "The Making of Canon 35: A Blow to Press-Bar Cooperation." Paper presented to the Photojournalism Division, Association for Education in Journalism, Houston, Texas, 1979.

Kobre, Ken. "A Last Interview with W. Eugene Smith on the Photo Essay." Paper presented to the Photojournalism Division, Association for Education in Journalism, Houston, Texas, 1979.

Kobre, Sidney. *News Behind the Headlines: Background Reporting of Significant Social Problems.* Tallahassee, Florida: Florida State University, 1955.

Kobre, Sidney. *Behind Shocking Crime Headlines.* Tallahassee, Florida: Florida State University, 1957.

Kobre, Sidney. *Press and Contemporary Affairs.* Tallahassee, Florida: Florida State University, 1957.

Kobre, Sidney. *Modern American Journalism.* Tallahassee, Florida: Florida State University, 1959.

Kobre, Sidney. *The Yellow Press and Gilded Age Journalism.* Tallahassee, Florida: Florida State University, 1964.

Kobre, Sidney. *Development of American Journalism.* Dubuque, Iowa: Wm. C. Brown, 1969.

Juergens, George. *Joseph Pulitzer and the New York World.* Princeton, N.J.: Princeton University Press, 1966.

Lang, Wendy. "Sequences: Conceptual Relationships." *Peterson's Photographic Magazine* (June 1979): pp. 88–99.

Leekley, Sheryle, and Leekley, John. *Moments: The Pulitzer Prize Photographs.* New York: Crown, 1978.

Life Library of Photographs. *The Camera.* New York: Time-Life Books, 1970.

Life Library of Photographs. *Photojournalism.* New York: Time-Life Books, 1971.

Logan, Richard, III. *Elements of Photo Reporting.* Garden City, N.Y.: Amphoto, 1971.

Loosley, A.E. *The Business of Photojournalism.* New York: Focal Press, 1970.

Lukas, Anthony J. "The White House Press 'Club'." *New York Times Magazine* (15 May 1977).

Lyons, Nathan, ed. *Photographers on Photography.* Englewood Cliffs, N.J.: Prentice-Hall, 1966.

MacDougall, Curtis D. *News Pictures Fit to Print . . . Or Are They?* Stillwater, Oklahoma: Journalistic Services, 1971.

MacDougall, Kent A. "Geographic: From Upbeat to Realism." *Los Angeles Times,* 5 August 1977, p. 1.

MacLean, Malcolm S., Jr., and Hazard, William R. "Women's Interest in Pictures; The Badger Village Study." *Journalism Quarterly* 30 (1953): pp. 139–162.

MacLean, Malcolm S., Jr., and Kao, Anne Li-An. "Picture Selection: An Editorial Game." *Journalism Quarterly* 40 (1963): 230–232.

MacLean, Malcolm S., Jr., and Kao, Anne Li-An. *Editorial Predictions of Magazine Picture Appeals.* Iowa City, Iowa: School of Journalism, University of Iowa, 1965.

MacLean, Malcolm S., Jr., "Communication Strategy, Editing Games and Q." In Brown, Steven R., and Brenner, Donald J., eds., *Science, Psychology and Communication.* New York: Teachers College Press, 1972.

Magmer, James, and Falconer, David. *Photograph and Printed Word.* Birmingham, Michigan: Midwest Publications, 1969.

Mallen, Frank. *Sauce for the Gander.* [*The New York Evening Graphic*] White Plains, N.Y.: Baldwin Books, 1954.

Mallette, Malcolm F. "Ethics in News Pictures: Where Judgment Counts." Rochester Photo Conference, Rochester, N.Y.: George Eastman House, 1975.

Mallette, Malcolm F. "Should These News Pictures Have Been Printed? Ethical Decisions Are Often Hard, Seldom Absolutely Right." *Popular Photography* (March 1976): 73.

Marcus, Adriane. *Photojournalism: The Woman's Perspective. Mary Ellen Mark and Annie Leibowitz.* New York: T.Y. Crowell, 1974.

Martin, Peter. "Gene Smith as 'The Kid Who Lived Photography.'" *Popular Photography* (April 1979): 130.

Mason, Jerry. *The Family of Children.* New York: Grosset and Dunlap, 1977.

Meredith, Roy. *Mr. Lincoln's Camera Man Mathew B. Brady.* 1946 reprint. New York: Dover, 1974.

Mich, Daniel O., and Eberman, Edwin. *The Technique of the Picture Story.* New York: McGraw-Hill, 1945.

Morgan, Willard D., and Lester, Henry M. *Graphic Graflex Photography.* New York: Morgan and Lester, 1946.

Morris, Desmond. *Manwatching: A Field Guide to Human Behavior.* New York: Harry N. Abrams, 1977.

Morris, Joe Alex. *Deadline Every Minute. The Story of United Press.* Garden City, N.Y.: Doubleday, 1957.

Nelson, Roy Paul. *Visits With 30 Magazine Art Directors.* New York: Magazine Publishers Association, 1969.

Nelson, Roy Paul. *Publication Design.* Dubuque, Iowa: Wm. C. Brown, 1972.

Newhall, Beaumont. *The History of Photography from 1839 to the Present Day.* Rev. ed. New York: Museum of Modern Art, 1964.

Newman, Arnold. *One Mind's Eye.* Boston: New York Graphic Society, 1974.

Noble, Edward R. "Credible Cutlines." *Editor and Publisher,* 17 February 1979, p. 9.

Permutt, Cyril. *Collecting Old Cameras.* New York: Da Capo Press, 1976.

Pierce, Bill. "W. Eugene Smith Teaches Photographic Responsibility." *Popular Photography* (November 1961): 80–84.

Pierce, Bill. "Photography Down and Dirty: Tips from White House Press Photographers on How to Grab Those Candid, Travel and News Pictures That Everybody Else Misses." *Popular Photography* (November 1975): 88.

Pollack, Peter. *The Picture History of Photography.* New York: Harry N. Abrams, 1969.

Ragfield, Stanley. *How Life Gets the Story.* Garden City, N.Y.: Doubleday, 1955.

Reed, Pat. "Paparazzo, Meet Ron Galella, Nemesis of Jackie O., Brando, etc.," *Houston Chronicle Texas Magazine,* 15 April 1979, p. 20.

Rhode, Robert B., and McCall, Floyd H. *Press Photography.* New York: Macmillan, 1961.

Rigger, Robert. *Man in Sport.* The Baltimore Museum of Art. Baltimore, Maryland, 1967.

Riis, Jacob. *How the Other Half Lives.* New York: Scribner, 1904.

Rosen, Marvin J. *Introduction to Photography.* Boston: Houghton Mifflin, 1976.

Rothstein, Arthur. *Photojournalism.* Garden City, N.Y.: Amphoto, 1970.

Salomon, Erich. *Erich Salomon, Portrait of an Age.* New York: Macmillan, 1967.

Schuneman, R. Smith, ed. *Photographic Communication: Principles, Problems and Challenges of Photojournalism.* New York: Hastings House, 1972.

Self, Charles. *How to Take Action Pictures.* Garden City, N.Y.: Doubleday, 1975.

Sidey, Hugh, and Fox, Rodney. *1,000 Ideas For Better News Pictures.* Ames, Iowa: Iowa State University Press, 1966.

Six Decades: The News in Pictures. "A Collection of 250 News and Feature Photographs Taken from 1912 to 1975 by the Milwaukee Journal Co. Staff Photographers." Milwaukee Journal Co., 1976.

Smith, W. Eugene. "Saipan." *Life* (28 August 1944): 75–83.

Smith, W. Eugene. "Country Doctor." *Life* (20 September 1948): 115–126.

Smith, W. Eugene. "Spanish Village." *Life* (9 April 1951): 120–129.

Smith, W. Eugene. "Nurse Midwife." *Life* (3 December 1951): 134–145.

Smith, W. Eugene. "A Man of Mercy." *Life* (15 November 1954): 161–172.

Smith, W. Eugene. "W. Eugene Smith Talks About Lighting." *Popular Photography* (November 1956): 48.

Smith, W. Eugene. "Pittsburgh." *1959 Photography Annual.* New York: Ziff-Davis, 1958, pp. 96–133.

Smith, W. Eugene. *W. Eugene Smith: His Photographs and Notes.* Millerton, N.Y.: Aperture, 1969.

Smith, W. Eugene, and Smith, Aileen M., *Minamata.* New York: Holt, Rinehart and Winston, 1975.

Spaulding, Seth. "Research on Pictorial Illustration." *Audio-Visual Communication Review* 3 (1955): 35–45.

Spina, Anthony. *Press Photographer*. Cranbury, N.J.: A.S. Barnes, 1968

Spitzing, Gunter. *The Guide to Flash*. Garden City, N.Y.: Amphoto, 1974.

Steichen, Edward. *The Family of Man*. New York: Simon & Schuster, 1955.

Stein, Barney. *Spot News Photography*. New York: Verlan Books, 1960.

Stettner, Louis, and Zanutto, James M. "Weegee." *Popular Photography* (April 1961): 101–102.

Stettner, Louis. *Weegee*. New York: Alfred A. Knopf, 1977.

Stensvold, Mike. *Increasing Film Speed*. Los Angeles: Petersen, 1978.

Stott, William. *Documentary Expression and Thirties America*. New York: Oxford Press, 1973.

Sutton, Albert A. *Design and Makeup of the Newspaper*. Englewood Cliffs, N.J.: Prentice-Hall, 1948.

Swanson, Charles. "What They Read in 130 Daily Newspapers." *Journalism Quarterly* 32 (1955): 411–421.

Szarkowski, John. *The Photographer's Eye*. New York: The Museum of Modern Art, 1966.

Szarkowski, John. *From the Picture Press*. New York: The Museum of Modern Art, 1973.

Tannenbaum, Percy H., and Fosdick, James A. "The Effect of Lighting Angle on Judgment on Photographed Subjects." *Audio Visual Communication Review* 8 (1960): 253–262.

Thayer, Frank. "Legal Liabilities for Pictures." *Journalism Quarterly* 24 (September 1947): 233–237.

Turner, Richard. *Focus on Sports: Photographing Action*. Garden City; N.Y.: Amphoto, 1975.

Vitray, Laura; Mills, John Jr.; and Ellard, Roscoe. *Pictorial Journalism*. New York: McGraw-Hill, 1939.

Ungero, Joseph M. "How Readers and Editors Judge Newspaper Photos." *APME Photo Report*. 15 October 1977.

Walters, Basil L. "Pictures vs. Type Display in Reporting the News." *Journalism Quarterly* 24 (1947): 193.

Warner, Bob. "Photo Seminar Emphasizes Need For Picture Editors." *Editor and Publisher*, 15 (September 1962): p. 9.

Weegee. *Naked City*. New York: Essential Books, 1945.

Weegee by Weegee: An Autobiography. New York: Ziff-Davis, 1961.

Weegee. *Weegee's People*. 1946 reprint. New York: De Capo Press, 1975.

Welling, William. *Photography in America: The Formative Years 1839–1900, A Documentary History*. New York: Thomas Y. Crowell, 1978.

Welsch, Ulrike. *The World I Love to See*. Boston: Boston Globe/Houghton Mifflin, 1977.

White, Frank Wm. "Cameras in the Courtroom: A U.S. Survey." *Journalism Monographs* 60 (April 1979).

White, Jan V. *Editing by Design: Word and Picture Communication for Editors and Designers*. New York: R.R. Bowker, 1974.

Whiting, John R. *Photography Is a Language*. New York: Ziff-Davis, 1946.

Wilcox, Walter. "Staged News Photographs and Professional Ethics." *Journalism Quarterly* 38 (1961): 497–504.

Willem, Jack M. "Reader Interest in News Pictures." In Morgan, Willard D., and Lester, Henry M., eds. *Graphic Graflex Photography*. New York: Morgan & Lester, 1946.

Williamson, Daniel R. *Feature Writing for Newspapers*. New York: Hastings House, 1977.

Williamson, Lenora. "Page 1 Fire Photos Draw Reader Protests." *Editor and Publisher*, 30 August 1975, pp. 14–15.

Williamson, Lenora. "Editor Calls for More Decisive News Display." *Editor and Publisher*, 8 November 1975, p. 13.

Williamson, Lenora. "New Council Raps ABA Courtroom Camera Position." *Editor and Publisher*, 24 March 1979, p. 14.

Woodburn, Bert W. "Reader Interest in Newspaper Pictures." *Journalism Quarterly* 24 (1947): 197–201.

Wooley, Al E. *Camera Journalism*. Cranbury, N.J.: A. S. Barnes, 1966.

INDEX

Page numbers in italics refer to photographs appearing on that page.